W9-CDS-552

THE HEAVENLY WRITING

In antiquity, the expertise of the Babylonians in matters of the heavens was legendary, and the roots of both western astronomy and astrology are traceable in cuneiform tablets going back to the second and first millennia B.C. *The Heavenly Writing* discusses Babylonian celestial divination, horoscopy, and astronomy, the differentiations and interconnections within them, and their place in Mesopotamian intellectual culture. Focusing chiefly on celestial divination and horoscopes, it traces the emergence of personal astrology from the tradition of celestial divination and the way astronomical methods were employed for horoscopes. It further takes up the historiographical and philosophical issue of the nature of these Mesopotamian "celestial sciences" by examining elements traditionally of concern to the philosophy of science (empiricism, prediction, and theory) in relation to the Babylonian material without sacrificing the ancient methods, goals, and interests to a modern image of science.

This book will be of particular interest to those concerned with the early history of science and the problems introduced by modern distinctions among science, magic, and religion for the study and understanding of ancient cultures.

Francesca Rochberg is Catherine and William L. Magistretti Distinguished Professor of Near Eastern Studies at the University of California, Berkeley. She is a recipient of the John D. and Catherine T. MacArthur Fellowship and the John Simon Guggenheim Fellowship. She is the author of *Babylonian Horoscopes* (1998) and Aspects of Babylonian Celestial Divination: *The Lunar Eclipse Tablets of Enuma Anu Enlil* (1988).

THE HEAVENLY WRITING

—

DIVINATION, HOROSCOPY, AND ASTRONOMY IN MESOPOTAMIAN CULTURE

FRANCESCA ROCHBERG

University of California, Berkeley

 CAMBRIDGE
UNIVERSITY PRESS

CAMBRIDGE UNIVERSITY PRESS
Cambridge, New York, Melbourne, Madrid, Cape Town, Singapore, São Paulo, Delhi

Cambridge University Press
32 Avenue of the Americas, New York, NY 10013-2473, USA

www.cambridge.org
Information on this title: www.cambridge.org/9780521830102

© Francesca Rochberg 2004

This publication is in copyright. Subject to statutory exception
and to the provisions of relevant collective licensing agreements,
no reproduction of any part may take place without
the written permission of Cambridge University Press.

First published 2004
First paperback edition 2007

Printed in the United States of America

A catalog record for this publication is available from the British Library.

Library of Congress Cataloging in Publication Data

Rochberg, Francesca, 1952–
The heavenly writing : divination, horoscopy, and astronomy in
Mesopotamian culture / Francesca Rochberg.
p. cm.
Includes bibliographical references and index.
ISBN 0-521-83010-9
1. Astrology, Assyro-Babylonian. 2. Astronomy, Assyro-Babylonian. I. Title.
BF1714.A86R63 2004
133.5′0935 – dc22 2004043566

ISBN 978-0-521-83010-2 hardback
ISBN 978-0-521-71661-1 paperback

Cambridge University Press has no responsibility for
the persistence or accuracy of URLs for external or
third-party Internet Web sites referred to in this publication
and does not guarantee that any content on such
Web sites is, or will remain, accurate or appropriate.

For my parents,
my children Jacob and Gemma,
my husband Perce,
and in memory of Paul

It is the privilege of antiquity to mingle divine things with human.

Livy, *History of Rome*, Bk 1, 7

CONTENTS

PREFACE

Already more than 100 years since their decipherment and almost 50 years since their general availability in translation, the continued obscurity of Babylonian sources within the general history of science, as compared, for example, with those of ancient Greece, reflects a persistent historiography of science, influenced by a particular classification of knowledge and its implicit criteria. Although the argument for the legitimacy of Babylonian astronomy for the history of science has frequently been in terms of the degree to which it directly contributed to the European tradition, the classification and nature of Babylonian astronomy as "science" apart from its position in the patrimony of modern exact sciences still warrants discussion.

Largely through the work of Otto Neugebauer, efforts to reconstruct the history of science in ancient Mesopotamia have concentrated on the exact sciences. Neugebauer's focus on the relation between mathematics and astronomy, especially on the internal mathematical structures that distinguish the Late Babylonian astronomical texts, determined the tenor of research in Babylonian science for much of the twentieth century. His commitment to the recovery and detailed analysis of the Babylonian ephemerides stemmed from the belief that only specialization produces sound results. Indeed, the recovery of the contents of Babylonian mathematical astronomy and the subsequent work on this material by others, both before him (J. Epping and F. X. Kugler) and after (A. J. Sachs, A. Aaboe, B. L. van der Waerden, P. Huber, J. P. Britton, L. Brack-Bernsen, and N. M. Swerdlow), as well as the progress made in the study of what is sometimes referred to as the nonmathematical Babylonian astronomy by A. J. Sachs, H. Hunger, and D. Pingree, prove critical for our understanding of other aspects of Babylonian celestial inquiry, especially celestial divination and its relationship to astronomy.

Whether or how to differentiate between "astrology" and "astronomy" is strictly a matter of convenience when describing the content of a text from the cuneiform corpus of celestial science. There are no "native" Akkadian counterparts to the terms astrology (*astrologia*) or astronomy (*astronomia*). Even the distinction between these terms as applied from Late Antiquity through the Middle Ages varied from one author to another and did not necessarily imply a difference in status such as we make between science and magic. For the present purposes, then, if a text contains forecasts of mundane events it is "astrological"; otherwise it is "astronomical." I apply these terms strictly for descriptive convenience, without further implication that such a native classification existed, much less any of its connotations. There is a further potential terminological problem in applying "astrology," with its associations to Hellenistic Greek theories of stellar influence and fatalism, to the Babylonian material, which does not share a common cosmological or methodological basis with Greek astrology. But, I would argue, the term astrology may be used as a general rubric for Mesopotamian astral and genethlialogical omens as well as for the Babylonian horoscopes, without conflating these with later forms of Greek astrology, some of which in fact are the legacy of ancient Mesopotamian tradition.

Early in the twentieth century, within the confines of assyriology, sources for Babylonian "astrology," more properly celestial divination, claimed the attention, most notably, of C. Virolleaud and E. Weidner, whose work still provides a solid foundation for incorporation of these sources into a broader picture of science in the ancient Near East. Obviously the big picture cannot be restored without a systematic corpus. Editions of the primary texts still need to be completed, but the past decade has seen the publication of a great many celestial divinatory and otherwise astronomical texts. Research in the area of Babylonian celestial and other divinations, as well as a variety of classifications of magic, can only further our understanding of Babylonian science as conceived and practiced in ancient Mesopotamian culture and represented by an interrelated set of texts. In much the same way as historians of the Scientific Revolution now recognize the continuation of the tradition of natural magic and the significance of the religious background of Renaissance science, students of Babylonian science acknowledge the continuation of the traditions of divination and magic throughout the late period of the mathematical astronomical texts and are beginning to take account of the relationships among these diverse text types.

This book began with a desire to come to terms with the nature of science as a cultural phenomenon in ancient Mesopotamia. The core of Mesopotamian science has been traditionally identified in the corpus of mathematical astronomy along with its closely related materials, the so-called astronomical diaries and other nontabular astronomical texts (often designated as nonmathematical astronomy in the literature). With respect to the entire span of extant cuneiform texts, these sources are situated for the most part in the second half of the first millennium B.C., or roughly from 600 B.C. to the Common Era. This Late Babylonian astronomy represents one of, if not "the," principal body of sources for the history of the exact sciences in ancient Mesopotamia. Indeed, the chapters on Mesopotamia in Neugebauer's widely read *Exact Sciences in Antiquity* deal precisely with this corpus, as does Book II of his *History of Ancient Mathematical Astronomy*. These astronomical cuneiform texts, including the predictive and tabular as well as the observational and nontabular, were, however, products of a particular intellectual tradition that encompassed other astral sciences, such as celestial divination, personal horoscopy, and astral magic.

Sources for these other astral sciences have a history that reaches back to the second millennium B.C. and belong to an already highly diversified and formal scribal tradition, well known from Sumero–Akkadian lexicography, legal and economic, liturgical, and literary texts. The bulk of the surviving evidence of this earlier tradition in celestial science, in fact, consists not of astronomy but of celestial divination. An assessment of the character of celestial sciences in Mesopotamia must not only include this important body of sources, but also must take account of the persistent authority of the omen tradition as evidenced by the continued copying of these texts throughout the period of Late Babylonian astronomy. Despite obvious methodological differences among the text genres of Mesopotamian celestial science, close connections between the disparate parts of that scribal tradition argue forcibly against imposing any ideological separation between the texts considered to represent the "exact science" of astronomy on one hand and the divinatory or astrological forms of interest in the heavens on the other, as though these stemmed from two altogether different schools of thought.

This poses a question, now very much on the minds of historians of science, as to the implications of classifying sources such as the cuneiform corpus of celestial inquiry, or other similar premodern corpora, as "science." The reconstruction of the early history of science once suffered as a result of

circumscribing astrology and magic as "superstition" or, at best, "pseudo-science," and accordingly distorted early science in an effort to see a modern image of science in ancient sources. Although no longer accepted, that position was prevalent in studies in the history of science written over the course of the first half of the twentieth century, at a time when philosophers of science were keen to develop criteria by means of which science could be defined in an ideal ahistorical sense. As far as ancient Near Eastern science is concerned, an exposition of the interaction between "astronomy" and "astrology," which sees not only the distinctions but also the interconnections among the methods, goals, and basic content of these parts of Mesopotamian celestial science, can help to redress this old and in some ways lingering historiographical problem directly.

If we are to take account of the culture of ancient Mesopotamian science, we need to explore the ideological background for celestial divination and its related textual sources, including astronomy, which was rooted in an acceptance of divine influence in the world, not only the world of humankind, but of physical (natural) phenomena as well. The sources do not recognize a problem with reconciling knowledge of perceptible physical facts with beliefs about the participation of the divine in the phenomenal world. That ancient Mesopotamian scribes deemed the knowledge of heavenly phenomena and of the meanings of these phenomena as portents in some sense "sacred" does not diminish the relevance of their texts for the history of science. I have therefore opted not to avoid the use of the word "science" for the diverse products of Mesopotamian intellectual culture. If the material under study, to an ancient scribe, belonged to one coherent, albeit multifaceted, discipline, to a modern interpreter, the same body of evidence may be viewed within a variety of classifications of knowledge, namely, science, magic, or even, in some basic sense, religion. The demarcations between these intellectual and spiritual pursuits, by means of which we attempt to know and classify the ancient Mesopotamian tradition in our own terms, are exceedingly difficult to draw. Such demarcations carry implicit stakes as well, that of the identification of the origins of science being, perhaps, the highest, given the value our culture places on the "epistemic authority" of science.

This book is in no way a summary or a survey of the astronomical or astrological content of cuneiform astronomical and celestial divination texts. Such is available in Volume 44 of the Handbuch der Orientalistik, *Astral Sciences in Mesopotamia* (1999) of H. Hunger and D. Pingree. My interest in Babylonian astronomy is not to explicate its content in order to place it as an episode in the narrative history of astronomy. Nor is my

interest in Babylonian horoscopy to establish it as continuous with the later history of astrology. Such goals have been set and achieved already in the secondary literature on the subject. The primary goal of this study is to locate and define interconnections among the various and diverse parts of the Mesopotamian scribal traditions of celestial science, that is, celestial divination in the form of omens, personal astrology in the form of horoscopes, as well as some parts of the astronomical text corpus. The presentation of evidence is therefore selective rather than comprehensive.

I do not mean in the process of this inquiry to obscure the real and important distinctions also found throughout these sources, distinctions that led the ancient scribes to create divisions in text genres in accordance with method or subject matter. Such distinctions along the lines of content or method, however, are not viewed here as contradicting the central thesis that continuities in thought and objective, discernible in certain celestial scientific text genres, help us to reconstruct a cultural background for the activities of scribes engaged in the study of the heavens. Of particular importance is the location of the Babylonian horoscopes in relation both to celestial divination texts as well as to astronomical texts. By an examination of the extent to which elements of earlier divination and contemporaneous astronomical traditions are present in the content as well as the objectives of Babylonian horoscopes, a number of connections can be found there.

Secondarily, I wish to consider the place of Babylonian celestial inquiry, particularly with respect to celestial divination and horoscopy, within the history of science in a broader context. The cuneiform mathematical astronomical corpus, taken in isolation, is readily classifiable as scientific for its quantitative and predictive character as well as its firm empirical foundations. However, although the mathematical astronomical sources form a well-defined domain of knowledge and practice, they may be seen to come within the range of activities of a class of scribes whose interests also included celestial divination and horoscopy. If these diverse parts of Babylonian celestial inquiry, that is, astronomy, celestial divination, and horoscopes, indeed constituted branches of a single composite celestial science, how are we to understand those parts (celestial divination and horoscopes) that traditionally have been less readily classifiable as science? I do not claim that celestial divination can be classified as science in the same way as astronomy. At the same time, a classification of Babylonian celestial divination and horoscopy as sciences can be made in a more substantive way than simply by association with Late Babylonian astronomy or in terms of their status as ancestral to western astronomy and astrology.

In this work, the interest is less in tracing a historical development of astronomy from celestial divination, and more in the diverse intellectual occupations of the scribes who produced the cuneiform corpus in which astronomical subjects are central. By means of this perspective, the historical reconstruction that once derived "science," in the form of legitimate astronomy, from primitive lunar, planetary, and stellar omens in accordance with a religion-(or magic-)to-science scheme is seen to be untenable. Accordingly, science, hence the possibility of a scientific culture, is not viewed as emerging from a magical–religious culture, but as fully integrated with it. In the face of the cuneiform evidence, the dichotomy between such hypothetical cultures is artificial and ahistorical.

The first two chapters are stage setting in nature. Chapter 1 investigates and chronicles the early history of the reception of Babylonian celestial science, particularly the astronomical texts, into the history of science in general. This is of interest both for the light (or perhaps shade is the better word here) cast on the history of our understanding of science's past, and as a starting point for redressing the issues raised. Ideological obstacles to the reception and full integration of Babylonian celestial divinatory, astronomical, and astrological texts within the history of science are traced and then reconsidered in Chapter 7 in light of the evidence presented throughout this study, as well as more recent discussion among historians of science as to the classification of premodern sciences. To place celestial divination in its broader intellectual context, Chapter 2 surveys the omen corpora within which celestial omen texts must be viewed. In this way, the "astrological" part of Babylonian scholarly divination is not taken uncritically as a class of texts more suited to classification as science than other groups of noncelestial omens. Chapter 3 introduces our central evidence, which is the class of so-called horoscope texts. Chapters 4 and 5 examine the connections, both philological and ideological, between horoscopes and other sources for celestial inquiry, namely celestial omens and astronomical texts. An attempt is made to reconstruct the Mesopotamian conception of the role of the divine in celestial divination, by examining the evidence for the diviners' understanding of the relations between the gods, the heavenly phenomena, and human society. To recognize the central place of the divine in the belief and practice of celestial and other forms of divination, however, does not promote a classification of this material as part of "religion" rather than as "science." It only further demonstrates the inapplicability of a division between science and religion in this historical context. Chapter 6 focuses on the scribes who produced these text corpora, in particular, their activities within the institutions that supported them,

that is, the palace and the temple. I consider also the nature of knowledge in the scribal repertoire of texts and the relationships between the professional celestial science experts and those of other areas of scholarship. Finally, Chapter 7 reopens some of the chief issues in the investigation of the nature of science, for example, empiricism, prediction, and theory, in the light of ancient Mesopotamian evidence, in particular, astronomical texts, omens (celestial and otherwise), and horoscopes. The chief motivating historical problem of this chapter is how best to justify classification of ancient Mesopotamian scribal traditions of celestial inquiry as science. The exploration of this problem requires some reflection on the interpretation of another culture's systems of thought and belief, and the applicability of the categories available with which to classify them, especially with respect to science and scientific thought. My objective, though, is not to attempt to recapture the meaning of science "in Babylonian terms," either as a relativistic response to outmoded criticisms that there was no science in the ancient Near East, or as an alternative to the focus on the exact sciences as the chief contribution of Mesopotamia to the history of science. In fact, there are no Babylonian terms for science, so an investigation of their "science" is, strictly speaking, an exercise in anachronism. The dangers of anachronism are of course distortion and misrepresentation of historical ideas and practices. But we come to historical material from a distant vantage point, and with analytical categories that may or may not apply to the subject of interest. As long as the goal is, in this case, to make the cuneiform texts concerning celestial inquiry intelligible, the use of non-Mesopotamian categories to analyze these texts can be productive. I am also not concerned with "how true" or "how good" Mesopotamian science was. Here, the problem of demarcating cultural boundaries of science will be of a different kind from the oft-played demarcation game whose object is to separate real science from pseudoscience by means of epistemological or methodological criteria derived from modern construals of science. Some of these criteria, such as empiricism as a foundation of knowledge, theory as a result of the study of phenomena, or prediction as an aim, will still figure prominently as I consider possible ways of analyzing the cuneiform corpus of celestial divination and astronomy. At no point am I interested in establishing whether any of the cuneiform astronomical or astrological sources consist in a Babylonian "science" in any sense other than our own. But rather than condemn the very question of "how is cuneiform celestial inquiry classifiable as science" as unintelligible within the context of ancient Mesopotamian cultural values, I maintain its continuing interest and value for the history of science, because finally,

the question is not how "they" thought about science, but how we do. Indeed, cuneiform texts of divinatory, astrological, and astronomical content belong to the history of science not because the Babylonians thought of these intellectual inquiries as "science," but because, in assessing the nature and practice of their activities, we can reasonably place Mesopotamian divination, astrology, and astronomy in a larger context that is meaningful within and for the history of science.

ACKNOWLEDGMENTS

I want to acknowledge all the scholars who helped me along the way, all my teachers, whether directly or indirectly: My deepest gratitude must go to Erica Reiner, who, although certainly my most important direct teacher, has continued indirectly, yet no less strongly, to be a major influence on my scholarship. In addition, I owe an incalculable debt of gratitude to the assyriologists Abe Sachs, Douglas Kennedy, and Hermann Hunger, who each demonstrated the generosity characteristic of great teachers in their sharing of texts and insights. Neither will I ever be able to adequately thank my guides to Babylonian astronomy, Noel Swerdlow, Asger Aaboe, John Britton, David Pingree, and Bernard R. Goldstein, whose mastery of technical details will forever represent the ultimate standard to which I may aspire but never achieve. I also want to acknowledge significant influences on my thinking, hence on the present work, that have come from individuals I have had the great fortune to know from other disciplines: Arnaldo Momigliano, whose acuity in historiographical issues taught me to raise questions about the very presuppositions we bring to the investigation of our sources, encouraged me to press such questions within the context of my interest in celestial divination and astronomy. Ernan McMullin awakened in me a fascination for the philosophy of science and the recognition of its significance in matters of history and made me a student of philosophy perpetually trying to catch up. Finally, and most especially, to Otto Neugebauer for inspiring my interest in the very question of the nature of science in history.

Also special gratitude to my colleagues who read and commented on the manuscript in its various stages: G. E. R. Lloyd, Bernard R. Goldstein, David Pingree, Hermann Hunger, Erica Reiner, and Noel Swerdlow, who all saved me from a host of errors. Needless to say, the faults of the final

product are entirely my own. My husband, Percival Everett, the best there is, also deserves and has my ultimate gratitude for being beside me.

Parts of this book have had previous incarnations. All these previously published sections have been augmented, some significantly altered, and edited for continuity and to remove repetition. The following papers are included here by permission, for which I thank the editors: Chapter 2 is based on "Mesopotamian Divination," in Vincenzo Cappelletti, ed., *Storia della scienza*, Vol. I: *La scienza antica* (Rome: Istituto della Enciclopedia Italiana, 2001), pp. 249–66, and "The Transmission of Babylonian Astronomy," in *La scienza antica*, pp. 426–31, has been utilized in Chapter 7. With permission from Elsevier Science, my "A Consideration of Babylonian Astronomy within the Historiography of Science," in *Studies in the History and Philosophy of Science* 33 (2002), pp. 661–84, appears as Chapter 1 with minor emendations. Material from the following previously published articles has also been incorporated with kind permission from the editors: "Personifications and Metaphors in Babylonian Celestial Omina," *Journal of the American Oriental Society* 116 (1996), pp. 475–85; "Empiricism in Babylonian Omen Texts: Problems in the Classification of Mesopotamian Divination as Science," *Journal of the American Oriental Society* 119 (1999), pp. 559–69; "Scribes and Scholars: The *ṭupšar Enūma Anu Enlil*," in Joachim Marzahn and Hans Neumann, eds., *Assyriologica et Semitica, Festschrift für Joachim Oelsner anläßich seines 65. Geburtstages am 18. Februar 1997*, AOAT 252 (Münster: Ugarit-Verlag, 2000), pp. 359–75; and "Heaven and Earth: Divine–Human Relations in Mesopotamian Celestial Divination," in Scott B. Noegel, Joel Walker, and Brannon M. Wheeler, eds., *Prayer, Magic, and the Stars in the Ancient and Late Antique World* (University Park, PA: Pennsylvania State University Press, 2003), pp. 169–85.

I also thank Dr. Joost Kist for his generosity, not only in granting permission to use cylinder seal No. 360 from his collection, published in Joost Kist, with contributions by Dominique Collon, Frans Wiggermann, and Geoffrey Turner, *Ancient Near Eastern Seals from the Kist Collection: Three Millennia of Miniature Reliefs* (Leiden/Boston: Brill, 2003), but also for providing photographs for the cover image.

ABBREVIATIONS

A	tablets in the Oriental Institute, University of Chicago
AAT	Craig, *Astrological–Astronomical Texts*
ABCD	Rochberg-Halton, *Aspects of Babylonian Celestial Divination*
ABL	Harper, *Assyrian and Babylonian Letters*
ABRT	Craig, *Assyrian and Babylonian Religious Texts*
ACh	Virolleaud, *L'astrologie chaldéenne*
ACT	Neugebauer, *Astronomical Cuneiform Texts*
AfO	*Archiv für Orientforschung*
AMT	Thompson, *Assyrian Medical Texts*
AnOr	*Analecta Orientalia*
AOAT	Alter Orient und Altes Testament
ArOr	*Archiv Orientalní*
Bagh.Mitt.	*Baghdader Mitteilungen*
BBSt	King, *Babylonian Boundary Stones*
BH	Rochberg, *Babylonian Horoscopes*
BiOr	*Bibliotheca Orientalis*
BM	tablets in the British Museum
BMS	King, *Babylonian Magic and Sorcery*
BPO	Reiner and Pingree, *Babylonian Planetary Omens*
BRM	Clay, *Babylonian Records in the Library of J. Pierpont Morgan*
CAD	*The Assyrian Dictionary* of the Oriental Institute of the University of Chicago
CH	Code of Hammurabi
CRRAI	*Compte rendu, rencontre assyriologique internationale*

CT	*Cuneiform Texts from Babylonian Tablets in the British Museum*
EnEl	*Enūma eliš*
HAMA	Neugebauer, *A History of Ancient Mathematical Astronomy*
HUCA	*Hebrew Union College Annual*
Hunger–Pingree, *MUL.APIN*	Hunger and Pingree, *MUL.APIN: An Astronomical Compendium in Cuneiform*
Hunger–Pingree, *Astral Sciences*	Hunger and Pingree, *Astral Sciences in Mesopotamia*
JAOS	*Journal of the American Oriental Society*
JCS	*Journal of Cuneiform Studies*
JHA	*Journal for History of Astronomy*
JHS	*Journal of Hellenic Studies*
JNES	*Journal of Near Eastern Studies*
KAR	Ebeling, *Keilschrifttexte aus Assur religiösen Inhalts*
KUB	Keilschrifturkunden aus Boghazköi
LAS	Parpola, *Letters from Assyrian Scholars to the Kings Esarhaddon and Aššurbanipal, Parts I–II*
LBAT	Sachs, *Late Babylonian Astronomical and Related Texts*
LKA	Ebeling, *Literarische Keilschrifttexte aus Assur*
MAOG	*Mitteilungen der Altorientalischen Gesellschaft*
MARI	*Mari: Annales de recherches interdisciplinaires*
MDOG	*Mitteilungen der Deutschen Orient-Gesellschaft*
MNB	tablets in the Louvre Museum
MSL	Landsberger, *Materialien zum sumerischen Lexikon*
NABU	*Nouvelles assyriologiques brèves et utilitaires*
NBC	tablets in the Babylonian Collection, Yale University Library
ND	tablets in the Iraq Museum, Baghdad
OECT	*Oxford Editions of Cuneiform Texts*
OIP	Oriental Institute Publications
PAPS	*Proceedings of the American Philosophical Society*
P. Oxy.	Grenfell, Hunt, et al., *The Oxyrhynchus Papyri*
RA	*Revue d'assyriologie*
SAA	State Archives of Assyria

Sachs–Hunger, Diaries	Sachs and Hunger, *Astronomical Diaries and Related Texts from Babylonia*
SSB	Kugler, *Sternkunde und Sterndienst in Babel*
TCL	*Textes cunéiformes du Louvre*
UCP	University of California Publications in Semitic Philology
UET	Ur Excavations, Texts
UM	tablets in the University Museum, University of Pennsylvania
VAB	Vorderasiatische Bibliothek
VAT	tablets in the Vorderasiatisches Museum, Berlin
WO	*Welt des Orients*
WVDOG	*Wissenschaftliche Veröffentlichungen der Deutschen Orient-Gesellschaft*
YOS	Yale Oriental Series, Babylonian Texts
ZA	*Zeitschrift für Assyriologie*

CHRONOLOGICAL REFERENCES AND AKKADIAN AND ASTRONOMICAL TERMINOLOGY

CHRONOLOGY OF ANCIENT MESOPOTAMIAN HISTORICAL PERIODS

Babylonian astronomical texts and horoscopes give dates using the Seleucid Era (abbreviated S.E.). In this earliest civil era, the regnal years of Seleucus I, who conquered Babylon in 312 B.C., continued to be counted after his death. The relation between years S.E. and years in the Christian Era are S.E. $0 = -311/-310$ (=312/311 B.C.). Therefore S.E. $50 = -261/-260$ (=262/261 B.C.) and S.E. 400 = A.D. 89/90.

Also used (after 141 B.C.) is the era instituted with the Parthian conquest of Mesopotamia, the Arsacid Era (abbreviated A.E.), named for regnal years of Arsaces I (250–248 B.C.). The equivalence among A.E., S.E., and years in the Julian calendar is A.E. $0 =$ S.E. $64 = -247/-246$ (=248/247 B.C.).

The convention of representing Julian years B.C./A.D. is followed here, but note their equivalence to negative A.D. years, that is, year $(n + 1)$ B.C. $= -n$.

CHRONOLOGY OF MESOPOTAMIAN HISTORY AND THE PERIODIZATION OF CUNEIFORM TABLETS

Early Dynastic, 3000–2334 B.C.
Akkadian, 2334–2154 B.C.
Ur III, 2112–2004 B.C.
Old Babylonian, ca. 2000–1600 B.C. (includes Isin and Larsa dynasties)
Middle Babylonian (Kassite dynasty), ca. 1600–1100 B.C.
Neo-Babylonian (Chaldean dynasty), 625–539 B.C.
Old Assyrian, ca. 2000–1350 B.C.
Middle Assyrian, ca. 1350–1000 B.C.

Neo-Assyrian, ca. 1000–612 B.C.
Persian (Achaemenid dynasty), 539–331 B.C.
Hellenistic (Seleucid dynasty), 312 B.C.–A.D. 64
Parthian (Arsacid dynasty), 250 B.C.–A.D. 224
Sasanian, A.D. 224–A.D. 651

See C. B. F. Walker, "Mesopotamian Chronology," in Dominique Collon, *Ancient Near Eastern Art* (Berkeley, CA/Los Angeles: University of California Press, 1995), pp. 230–8 and J. A. Brinkman, "Mesopotamian Chronology of the Historical Period," in A. L. Oppenheim, *Ancient Mesopotamia: Portrait of a Dead Civilization* (Chicago/London: University of Chicago Press, rev. edition by E. Reiner, 1977), pp. 335–48.

TYPOGRAPHY OF SUMERIAN AND AKKADIAN WORDS

Sumerian: Lowercase Roman, separated by periods; for example, dub. mul. an. kù (holy tablet of the heavenly stars/writing). Akkadian transliteration: Lowercase Roman, separated by dashes; for example, A-ri-is-tu-ug-gi-ra-te-e (Aristokrates). Akkadian transcription: Italics; for example, *kima šiṭir šamê* (like the heavenly writing). Sumerian logograms: Small capitals, separated by periods; for example, MUL.APIN (Plow Star). Note also the following assyriological typographical convention: The use of determinatives is represented by superscripts preceding the word so determined. For example, divine names are indicated in cuneiform by means of the "divine determinative" dingir (the Sumerian word for god). In this work, the divine determinative is transcribed as a superscripted "d" preceding divine names, as in the writing of the name of the moon god dSin or d30.

AKKADIAN MONTHS (STANDARD BABYLONIAN/LATE BABYLONIAN LOGOGRAPHIC SPELLINGS)

I *Nisannu* (ITI.BARA$_2$/BAR), March/April
II *Ajaru* (GU$_4$), April/May
III *Simanu* (SIG), May/June
IV *Du'ūzu* (ŠU), June/July
V *Abu* (NE), July/August
VI *Ulūlu* (KIN), August/September
VII *Tašrītu* (DU$_6$), September/October
VIII *Arahsamna* (APIN), October/November
IX *Kislīmu* (GAN), November/December

X *Ṭebētu* (AB), December/January
XI *Šabaṭu* (ZÍZ), January/February
XII *Addaru* (ŠE), February/March
Intercalary XII *Addaru arkû* (ŠE.DIRI)

NAMES OF ZODIACAL SIGNS
(LATE BABYLONIAN SPELLINGS)

I Aries (HUN, LU), Hired Man
II Taurus (MÚL.MÚL), Stars, Bull of Heaven
III Gemini (MAŠ.MAŠ), Twins
IV Cancer (ALLA), Crab
V Leo (A), Lion
VI Virgo (ABSIN), Furrow
VII Libra (RÍN), Scales
VIII Scorpius (GÍR.TAB), Scorpion
IX Sagittarius (PA), Pabilsag
X Capricorn (MÁŠ), Goat-Fish
XI Aquarius (GU), Great One
XII Pisces (ZIB.ME), Tails

AKKADIAN NAMES OF THE PLANETS
(STANDARD BABYLONIAN/LATE BABYLONIAN
LOGOGRAPHIC SPELLINGS)

Moon, Sin (dEN.ZU, d30/d30)
Sun, Šamaš (dUTU/d20)
Jupiter, Akkadian unknown (SAG.ME.GAR/MÚL.BABBAR)
Venus, Dilbat (dDele-bat, d15/Dele-bat)
Mercury, Šiḫṭu (GU$_{4}$.UD/GU$_{4}$)
Saturn, Kajamānu (UDU.IDIM.SAG.UŠ/GENNA)
Mars, Ṣalbatanu (dṢal-bat-a-nu/AN)

THE GREEK LETTER PHENOMENA

Outer Planets (Saturn, Jupiter, Mars)

Γ, heliacal (morning) rising
Φ, first (morning) station
Θ, acronychal (evening) rising

Ψ, second (evening) station

Ω, heliacal (evening) setting

Inner Planets (Venus, Mercury)

Ξ, evening rising

Ψ, evening (first) station

Ω, evening setting

Γ, morning rising

Φ, morning (second) station

Σ, morning setting

THE HEAVENLY WRITING

PROLOGUE

T O THE ANCIENT MESOPOTAMIAN LITERATI OF THE MIDDLE OF the first millennium B.C., the patterns of stars covering the sky were a celestial script. The "heavenly writing" (*šiṭir šamê* or *šiṭirti šamāmī*) was a poetic metaphor occasionally used in Babylonian royal inscriptions to refer to temples made beautiful "like the stars" (*kīma šiṭir šamê*, literally, "like the heavenly writing").[1] In these Babylonian inscriptions, the metaphor is not used explicitly for astrology or celestial divination, but the notion of the stars as a heavenly script implies their capacity to be read and interpreted. Representing the work of the divine, the stars, "written" in the sky as they were conceived to be, could convey a sense of the eternal. When Neo-Assyrian King Sennacherib (704–681 B.C.) claimed of his capital city Nineveh that its "plan was drawn since time immemorial with the heavenly writing," he meant that, when the gods drew the stars upon the heavens, they also drew up the plans for that city.[2] A seventh-century scholarly text from Aššur explains the starry sky as the "lower heavens" (*šamû šaplûti*), made of jasper, on whose surface the god Marduk drew

[1] In the following inscriptions of Nebuchadnezzar: Stephen Langdon, *Neubabylonischen Königsinschriften* VAB 4 (Leipzig: J. C. Hinrichs, 1912), p. 178 i 39, also ibid. 74 ii 2, YOS 1 44 i 21; cf. *BBSt.* No. 5 ii 28, also Neo-Babylonian. In the form *šiṭir burūmê* literally, "writing of the firmament," see *CAD*, s.v. *burūmû* usage b, occurring predominantly in Neo-Assyrian royal inscriptions but also in a hymn to Aššur, for which see A. Livingstone, *Court Poetry and Literary Miscellanea*, SAA 3 (Helsinki: University of Helsinki Press, 1989), p. 4, No. 1:21. See also E. Reiner, *Astral Magic in Babylonia* (Philadelphia: American Philosophical Society, 1995), p. 9, and W. Horowitz, *Mesopotamian Cosmic Geography* (Winona Lake: IN: Eisenbrauns, 1998), p. 15, note 25, and p. 226.

[2] D. D. Luckenbill, *The Annals of Sennacherib*, OIP 2 (Chicago: University of Chicago Press, 1924), p. 94:64.

"the constellations of the gods" (*lumāši ša ilāni*).[3] The image of the heavens as a stone surface upon which a god could draw or write, as a scribe would a clay tablet, complements the metaphoric trope of the heavenly writing. In their discussion of the term *lumāšu* "constellation," used in the sense of a form of writing with astral pictographs or "astroglyphs," as they have been called, M. Roaf and A. Zgoll note that Sumerian mul "star" (or mul-an, "heavenly star") "can refer both to a star in the sky and to a cuneiform sign on a tablet."[4] They further remark on the relationship between the arrangement of stars in certain constellations and that of the wedges in cuneiform signs.[5] The metaphor of the heavenly writing therefore related the constellations to cuneiform signs from which one could read and derive meaning, and thus expressed the idea that written messages were encoded in celestial phenomena.[6] A remarkable coincidence of conception appears with explicit reference to astrology in *The Enneads* of Plotinus, in which he says "we may think of the stars as letters perpetually being inscribed on the heavens or inscribed once for all."[7]

Although the metaphor is not so often attested, it is entirely consistent with the abundant evidence of the Babylonian celestial divination texts. These presuppose the belief that, if one could read the celestial signs in the sky, written by the gods, and interpret their meanings, events concerning the welfare of the king, the state, and its people as a whole could be divined.[8] The major part of the written corpus of Mesopotamian scribal

[3] *KAR* 307 33; see W. Horowitz, *Mesopotamian Cosmic Geography*, pp. 3 and 13–15, also plate I, for text copy. Other references to the "drawing" of stars (*kakkabāni eṣēru*) may be found s.v. *eṣēru* in *CAD* E, meaning 1 b and c.

[4] Michael Roaf and Annette Zgoll, "Assyrian Astroglyphs: Lord Aberdeen's Black Stone and the Prisms of Esarhaddon," *ZA* 91 (2001), p. 289 and note 68.

[5] Ibid.

[6] The notion of the god (often Šamaš) as "writing" the signs on the exta of sheep is well known; see, e.g., *ina libbi immeri tašaṭṭar šīre tašakkan dīnu* "you (Šamaš) write upon the flesh inside the sheep (i.e., the entrails), you establish (there) an oracular decision," *OECT* 6 pl. 30 K.2824:12.

[7] Plotinus, *The Enneads*, 2nd ed., trans. Stephen McKenna (London: Faber and Faber, 1956), 2.3, p. 96.

[8] The importance of the metaphor of writing for the Babylonian literati is discussed in Piotr Michalowski, "Presence at the Creation," in *Lingering Over Words: Studies in Ancient Near Eastern Literature in Honor of William L. Moran*, Harvard Semitic Studies 37 (Atlanta, GA: Scholars Press, 1990), p. 395 with note 54. A parallel between hermeneutical techniques of Jewish Kabbalah and the cuneiform scribes' methods of interpretation of their own esoteric written traditions, in particular those relating to celestial divination and wisdom literature, has been hinted at by Michalowski, ibid., p. 395, and documented by

scholarship consisted of collections of a variety of "omens," omens that were by no means limited to those of the heavens. In such omen collections, prognostications, stated as cases in the form *if x occurs, then y will occur*, correlated physical phenomena with events of political, economic, or social significance. These omens functioned as a vehicle for much systematization and observation of diverse aspects of the natural world. As such, the divination corpora represent the product of the collective, systematic, and cumulative effort to study, among other things, many aspects of what we regard as nature, or natural phenomena, by Mesopotamian scribal scholarship.

To speak of Mesopotamian scribal scholarship in such a general way perhaps requires a note of explanation. Assyriologists are familiar with the connotation of the phrase "stream of tradition" in reference to Sumerian and Akkadian texts. The term was used by A. L. Oppenheim to represent the literary corpus preserved by cuneiform copyists over the course of nearly two millennia and over a wide geographical area within the Mesopotamian cultural sphere of influence.[9] This continuous tradition can be differentiated from the quantities of nonliterary texts, that is, documents recording transactions and events of many aspects of Mesopotamian civilization. Oppenheim spoke of a "cultural continuum" and "the scribal tradition," both of which notions are implied by "Mesopotamian scribal scholarship." However, although Oppenheim's "stream of tradition" was defined less in terms of an ideological stance and more in terms of the functional result of the training of scribes, my reference to Mesopotamian scribal scholarship carries more ideological weight as a term that unifies both the practices and the presuppositions of scribes associated with literary, meaning "scholarly," divination, while also rendering into English the Akkadian *ṭupšarrūtu* "scholarship" (literally, "the art of the scribe").

Although the motives for systematizing all the phenomena of interest had as much to do with the correlations found between the phenomena and the events presaged by them as with a desire to understand the phenomena alone, the systematization and understanding of the phenomena

S. Lieberman, "A Mesopotamian Background for the So-Called *Aggadic* 'Measures' of Biblical Hermeneutics?," *HUCA* 58 (1987), pp. 157–225. Cf. S. Parpola in "Mesopotamian Astrology and Astronomy as Domains of the Mesopotamian 'Wisdom,'" in Hannes D. Galter, ed., *Die Rolle der Astronomie in den Kulturen Mesopotamiens*, Grazer Morgenländische Studien 3 (Graz: Grazkult, 1993), p. 58, and again in his "The Assyrian Tree of Life," *JNES* 52 (1993), pp. 161–298.

[9] A. L. Oppenheim, *Ancient Mesopotamia: Portrait of a Dead Civilization* (Chicago/London: University of Chicago Press, rev. edition by E. Reiner, 1977), p. 13.

themselves, to whatever degree was possible, were products of scholarly divination. The physical phenomena collected in the omen texts and the principles of their organization reflect the interests and methods of Mesopotamian scribal scholarship. Characteristic of such methods are empirical study and the creation of schematic systems to interpret the meaning of the enormous variety of signs in the compilation and redaction of the omen collections.

The systematic recording of ominous celestial and terrestrial occurrences subject to observation, imagination, or experience was an intellectual expression of an assumption that the gods were not only inseparable from all possible natural phenomena by virtue of their cosmology, but were also responsible for the associations between phenomena in nature and events in human society. The gods were viewed as the ultimate causes of the ominous occurrences as well as the authorities behind the texts in which the omens were compiled. The importance of the heavens as a great field against which the gods made known certain mundane events is unmistakable in the culture of Assyria and Babylonia in the Neo-Assyrian and Neo-Babylonian periods. This is amply attested to by the omens of the official compilation of celestial omens, *Enūma Anu Enlil*, placed in the library of Nineveh and in the royal correspondence between Sargonid Kings Esarhaddon (680–669 B.C.) and Aššurbanipal (668–627 B.C.) and their learned advisors who used the handbook *Enūma Anu Enlil*.[10] The scholars' correspondence reveals an extensive observational activity combined with astrological interpretation and provides some insight into the practical response to the forebodings of celestial omens.

The perception of the world as a communication medium between humankind and god operated on two basic levels: one in which the diviner simply interpreted what was observed or observable without "interference" by the diviner; the second in which the deity responded to various manipulations by the diviner, for example, drops of oil in the water bowl or the inspection of the exta of a sacrificed sheep. The sources for Mesopotamian divination can typically be classified as one of these two basic divination techniques. The former serves to unify a number of quite disparate omen compilations (to be described in greater detail in Chapter 2) under a single category termed "unprovoked" divination. That the so-called unprovoked omens could have been viewed as a coherent whole is suggested by the

[10] See Parpola, *LAS* Parts I and II, H. Hunger, *Astrological Reports to Assyrian Kings*, SAA 8 (Helsinki: Helsinki University Press, 1992) and Parpola, *Letters from Assyrian and Babylonian Scholars*, SAA 10 (Helsinki: Helsinki University Press, 1993).

fact that some diviners were experts in a number of different fields of unprovoked divination. In a letter from the celestial divination expert Marduk-šāpik-zēri to King Aššurbanipal, the scribe reviewed for the king the extent of his learning:

I fully master my father's profession, the discipline of lamentation; I have studied and chanted the Series. I am competent in [...], "mouth-washing" and purification of the palace [...]. I have examined healthy and sick flesh. I have read the (astrological omen series) *Enūma Anu Enlil* [...] and made astronomical observations. I have read the (anomaly series) *Šumma izbu*, the (physiognomical works) [*Kataduqqû, Alamdi*] *mmû* and *Nigdimdimmû* [... and the (terrestrial omen series) *Šum*] *ma ālu*.[11]

For Marduk-šāpik-zēri, at least, celestial divination belonged within a broader field of knowledge that included terrestrial, physiognomic, and anomalous birth omens, as well as medicine.

If the outward form and underlying rationale is the same for all these omen types, it seems unjustified to separate celestial divination from the rest of the unprovoked omens in a study of Mesopotamian science. The fact that celestial divination dealt with astronomical phenomena, a legitimate object of scientific investigation from a modern point of view, has perhaps given this form of divination something of an edge in the history of science, measured by the relative attention given these texts as opposed to, say, the omens from malformed fetuses (*izbu*). The features of celestial divination that warrant its classification as "science," however, are found in all forms of scholarly omens. It is as important to an understanding of Mesopotamian celestial divination to see its connection to other, noncelestial, omen texts as it is its connection to astronomical texts that are not ostensibly divinatory.

Among the features of Mesopotamian scholarly texts discussed in this book will not be found the once-standard "Listenwissenschaft," defined in W. von Soden's classic "Leistung und Grenze sumerischer und babylonischer Wissenschaft."[12] The idea that ancient Mesopotamian science is to be found in word lists – or omen lists – that order and classify the world does not go far enough either in its assumption that science is systematized knowledge or that Mesopotamian thought about "the world" is

[11] S. Parpola, *Letters from Assyrian and Babylonian Scholars*, p. 122, No. 160:36–42.

[12] Originally published in *Die Welt als Geschichte* 2 (1936), pp. 411–64 and pp. 509–57, then reprinted with addenda in B. Landsberger and W. von Soden, *Die Eigenbegrifflichkeit der babylonischen Welt. Leistung und Grenze sumerischer und babylonischer Wissenschaft* (Darmstadt: Wissenschaftliche Buchgesellschaft, 1965).

limited to a desire to classify and systematize. A related problem with this approach is the search for an explanation for the "classificatory" nature of "ancient Near Eastern science" in literacy itself, the written (list-) form of this alleged science, but this aspect has been addressed by M. T. Larsen and more recently by N. Veldhuis and D. Brown.[13]

Extant from the same period in which the divination series were developed and standardized, or from the Old Babylonian up to the Neo-Assyrian period, are also astronomical texts, that is, texts in which celestial phenomena are treated in a strictly technical or descriptive way and, for the most part, are not combined with prognostication from heavenly phenomena. Early Babylonian astronomy is represented chiefly by the compendium MUL.APIN and several isolated texts covering subjects such as the seasonal appearances of fixed stars, planetary observations, or daylight schemes.[14] The astronomical compendium MUL.APIN focuses directly on cataloging and systematizing a wide variety of celestial phenomena. Subjects found in MUL.APIN include names and relative positions in the sky of fixed stars, dates of their heliacal risings, simultaneous risings and settings of certain stars and constellations, so-called *ziqpu* stars that cross the zenith of the observer, stars in the path of the moon, astronomical seasons, luni–solar intercalation rules with fixed stars, stellar calendar, appearances and disappearances of the five planets (Mercury, Venus, Mars, Jupiter, and Saturn), periods of visibility and invisibility of the planets,[15] length of daylight scheme, and lunar visibility scheme. Copies of this astronomical compendium date to the period of Aššurbanipal's library and

[13] See Mogens Trolle Larsen, "The Mesopotamian Lukewarm Mind: Reflections on Science, Divination and Literacy," in F. Rochberg-Halton, ed., *Language, Literature and History: Philological and Historical Studies Presented to Erica Reiner* (New Haven, CT: American Oriental Society, 1987), pp. 203–25, Niek Veldhuis, "Elementary Education at Nippur: The Lists of Trees and Wooden Objects," Ph.D. dissertation (Groningen: Rijksuniversiteit Groningen, 1997), pp. 137–46, and D. Brown, *Mesopotamian Planetary Astronomy–Astrology, Cuneiform Monographs 18* (Groningen: Styx Publications, 2000), p. 76, note 203.

[14] H. Hunger and David Pingree, *MUL.APIN: An Astronomical Compendium in Cuneiform* (Horn, Austria: Ferdinand Berger & Söhne, Archiv für Orientforschung, 1989), Supplement 24.

[15] The determination of such periods was not yet very precise. In fact, Brown, *Mesopotamian Planetary Astronomy–Astrology*, pp. 113–116, and 146–151, argues for the "ideal" function of the planetary period values, i.e., not to predict planetary appearances, but merely to gauge whether an appearance was early or late, and therefore to be made amenable to divinatory analysis as a favorable or unfavorable sign. This idea is confirmed by the evidence in the Neo-Assyrian letters from scholars.

later, but parts of this work no doubt antedate the earliest dated copy by some centuries.[16] From the calendric correspondences given in the text (MUL.APIN II i 9–18) between stellar heliacal and acronychal risings and the dates of equinoxes and solstices as well as the positions of sun and moon relative to certain stars at equinox and solstice, D. Pingree and H. Hunger have argued for a date of circa 1000 B.C. for the final formulation of the text.[17] Its primary interest is calendric, some of which is related to the risings, settings, and culminations of fixed stars. The fixed-star catalog of MUL.APIN contains sixty rising and setting stars, six circumpolar stars, and five planets. The stars are arranged in groups according to the "paths" on which they are seen to rise and set. Three broad paths are designated by the names of the three great gods, Anu, Ea, and Enlil, and describe only roughly demarcated bands of varying declination, Ea being to the south, Enlil to the north, and Anu in the middle, or close to the equator. As it is explained in a commentary to *Enūma Anu Enlil*, the Mesopotamian definition of the paths is not with respect to the celestial equator, a concept they did not have, but rather with respect to the eastern horizon.[18] Despite its primary interest in the phenomena themselves, and hence our classification of the text as astronomical, the final section of MUL.APIN is devoted to celestial omens (MUL.APIN II iii 22–39).

With the exception of the brief planetary sections of MUL.APIN (I i 38; I ii 13–15; II i 40–41; and II i 38–67), the nondivinatory astronomical sources from this early period concern themselves primarily with fixed stars, the calendar, and the length of daylight. The simplest of the fixed-star schemes is represented by the so-called Astrolabe, or "Three Stars Each," in which a schematic calendar associating the appearance of fixed stars of the three "paths" of Anu, Enlil, and Ea with certain months is found.[19] Other astronomical texts of this early period also deal with the fixed stars, such as the catalogs of stars on or near the zenith (*ziqpus*),[20]

[16] For the Late Babylonian period MUL.APIN, see W. Horowitz, "Two MUL.APIN Fragments," *AfO* 36/37 (1989–1990), pp. 116–117 and Hunger–Pingree, *Astral Sciences*, p. 57, idem, *MUL.APIN*, p. 9.

[17] Hunger-Pingree, *MUL.APIN*, pp. 11–12.

[18] The term for horizon is TÙR/ *tarbaṣu* "the cattle pen," see *Enūma Anu Enlil* 50–51 III 24b, *BPO* 2, pp. 42–3.

[19] B. L. van der Waerden, "Babylonian Astronomy II. The Thirty-Six Stars," *JNES* 8 (1949), pp. 6–26; C. B. F. Walker and H. Hunger, "Zwölfmaldrei," *MDOG* 109 (1977), pp. 27–34.

[20] J. Schaumberger, "Die Ziqpu-Gestirne nach neuen Keilschrifttexten," *ZA* 50 (1952), pp. 214–229, Hunger–Pingree, *Astral Sciences*, pp. 84–90.

alignments between *ziqpu* and other stars,[21] and other intervals between stars such as in the difficult DAL.BA.AN.NA text.[22]

These are the major astronomical texts to which the celestial omens of *Enūma Anu Enlil* bear close relation. Aspects of early planetary and lunar astronomy are also embedded within the omen series *Enūma Anu Enlil* itself.[23] Later, in the period immediately preceding the hellenization of Babylonia, or roughly between 600 and 300 B.C., changes occur both in Babylonian astronomy and celestial divination, but continuities with the older tradition persist. In astronomy a significant change from the earlier material is reflected in the appearance of many observational records, made on a nightly basis, and assembled in an archive in the city of Babylon. The nightly watch of the sky seems to have been standard Babylonian practice since the reign of King Nabonassar (747–734 B.C.). Although no eighth-century examples are preserved, observational texts were prepared at Babylon from the middle of that century, as is indicated in later compilations of lunar eclipse reports. These so-called astronomical diaries collected lunar, planetary, meteorological, economic, and occasionally political events night by night, usually (at least in the later diaries) for six (or seven) months of a Babylonian year, recording daily positions of the moon and planets visible above the local horizon, as in the following excerpted lines from a diary dated in the year 331 B.C.:

Night of the 20th, last part of the night, the moon was [nn cubi]ts below β Geminorum, the moon being ²/₃ cubit back to the west. The 21st, equinox; I did not watch. Ni[ght of the 22nd, last part of the night,] [the moon was] 6 cubits [below] ε Leonis, the moon having passed ¹/₂ cubit behind α Leonis. Night of the 24th, clouds were in the sky.[24]

In addition to observational data of astronomical interest, the diaries recorded observations of other events as well, some of a political nature.

[21] See D. Pingree and Christopher Walker, "A Babylonian Star Catalogue: BM 78161," in E. Leichty, M. deJ. Ellis and P. Gerardi, eds., *A Scientific Humanist: Studies in Memory of Abraham Sachs*, Occasional Publications of the Samuel Noah Kramer Fund 9 (Philadelphia: Babylonian Section, University Museum, 1988), pp. 313–22, and discussed in Hunger–Pingree, *Astral Sciences*, pp. 90–7; cf. J. Koch, "Der Sternkatalog BM 78161," *WO* 23 (1992), pp. 39–67.

[22] C. B. F. Walker, "The Dalbanna Text: A Mesopotamian Star-List," *WO* 26 (1995), pp. 27–42, J. Koch, "Der Dalbanna-Sternenkatalog," *WO* 26 (1995), pp. 39–67, and discussed in Hunger–Pingree, *Astral Sciences*, pp. 100–11.

[23] Hunger–Pingree, *Astral Sciences*, pp. 32–50.

[24] Sachs–Hunger, *Diaries*, Vol. I, 1988, No. −330, p. 177.

The previously quoted diary of 331 B.C., for example, contains the report of Darius III's defeat by Alexander the Great at Gaugamela:

that month (Month VI), on the 11th, panic occurred in the camp before the king [. . . .] lay? opposite the king. On the 24th, in the morning, the king of the world [. . . .] the standard? [. . . .] they fought with each other, and a heavy? defeat of the troops of [. . . .] the troops of the king deserted him and [went?] to their cities [. . . .] they fled to the land of the Guti [. . . . Month VII. . .]. . . . That month, from the 1st to [. . . .] came to Babylon saying "Esangila [. . . ."] and the Babylonians for the property of Esangila [. . . .] On the 11th, in Sippar an order of Al[exander. . . ."_. . . .] I shall not enter your houses". On the 13th, [. . . .] to? the outer gate of Esangila and [. . . .] On the 14th, these? Ionians a bull [. . . .] short, fatty tissue [. . . .] Alexander, king of the world, [came? in]to Babylon [. . . . hor]ses and equipment of [. . . .] and the Babylonians and the people of [. . . .] a message to [. . . .].[25]

Evidence of historical value such as that contained in this broken passage make the diaries a rich source for the Late Babylonian period. Above all, the diaries represent an invaluable source of contemporary dated observations, no doubt the source of the Babylonian observations utilized by Ptolemy in the *Almagest*. Those of Mercury in *Almagest* IX 7, for example, are dated "according to the Chaldeans," that is, in the Seleucid Era, and they make use of the cubit, as seen in the previously quoted excerpt, as well as the ecliptical norming stars known from their use in the diaries.[26]

To this same period, from circa 600 to 300 B.C., belong equally significant developments in the application of celestial divination. Sachs called attention to precisely this period, cautioning against an "a priori assumption of a static condition in Babylonian thought on astrology" during these centuries.[27] From the omens of *Enūma Anu Enlil*, traditionally concerned with the king and the state, a personal form of prognostication from the heavens evolved, which took two forms. Formally related to the traditional celestial omens were nativity omens, which gave forecasts for individuals born at the time of the occurrence of various astronomical phenomena.[28] Not in omen form were horoscope texts, although the resemblance to Greek texts of that designation is quite superficial. Few

[25] Sachs–Hunger, *Diaries*, Vol. I. 1988, No. −330, p. 179.

[26] G. J. Toomer, *Ptolemy's Almagest* (New York/Berlin/Heidelberg/Tokyo: Springer-Verlag, 1984), p. 13 and 450-2.

[27] A. Sachs, "Babylonian Horoscopes," *JCS* 6 (1952), p. 53.

[28] See for example, *TCL* 6 14 in ibid., pp. 65–75; also idem, *LBAT* 1593 rev. 3′–10′ (KI zodiacal sign *alid* "born in the region of such-and-such zodiacal sign").

personal predictions are ever given in the Babylonian horoscopes, although a few do include such statements. These are given as omen apodoses familiar from nativity omens. Although celestial divination in omen form was transmitted to the West, beginning already in the second millennium B.C. through Syria and Anatolia to the Aegean world, during the Persian and Hellenistic periods another phase of such intellectual transmission is evident in Egypt[29] and in Greece, where its traces can be seen in the so-called general or universal astrology. This latest form of astrology to develop in Babylonia, that is, the horoscope, would be decisive for the further development of western genthlialogy through Greek, Islamic, Jewish, and Christian channels. Personal birth omens and horoscopes, referred to collectively as "astrology" in Sachs's previous statement, became dependent on astronomy in a new way. In the horoscopes in particular, an interdependent relationship between astrology and predictive astronomy is demonstrable by the identification of connections among a variety of astronomical text genres and the content of horoscopes. Celestial divination, which carries through from the middle of the second practically to the end of the first millennium B.C., and the Babylonian astronomy of the post-500 B.C. period provide the intellectual context for the Babylonian horoscopes, which bear relation to both of these distinct traditions. Because of these relationships, the horoscopes afford a unique view into Late Babylonian astronomical science.

The present book considers celestial divination and horoscope texts most centrally, but in relation to these are the astronomical texts, both early and late, observational and mathematical, as well as the sizable corpus of correspondence from Neo-Assyrian scribe–scholars to Kings Esarhaddon and Aššurbanipal. All the texts produced by such scribes as a result of diverse forms of inquiry into heavenly phenomena, from those that subject the phenomena to rigorous mathematical description to those that forecast human events on the basis of the phenomena, fell under the purview of what was called *ṭupšarrūtu Enūma Anu Enlil* "the art of the scribe of (the celestial omen series) *Enūma Anu Enlil.*" As products of "the art of the scribe" in Mesopotamia, Babylonian divinatory, astrological, and astronomical texts reflect the ideas and concerns of an educated elite. Nothing whatever about the ideas of common Babylonian citizens about the heavens or the gods are contained within these sources. If they are, we have no basis on which to recognize them as such. When we consider the

[29] Richard A. Parker, *A Vienna Demotic Papyrus on Eclipses- and Lunar-Omens* (Providence, RI: Brown University Press, 1959).

many classifications of texts of diverse interests and objectives reflected in
the different text headings created by the scribes, we must acknowledge a
high degree of native classification and differentiation between the parts
of this coherent but multifaceted discipline of celestial inquiry. The in-
terrelations drawn by this study between various texts and their subjects
in no way is meant to obliterate these important genre distinctions, or
indeed, the sometimes fine differences in the nature of the omen texts,
such as between lunar and planetary omens.

One further historiographical point needs to be made before proceed-
ing. Whether one sees continuity or discontinuity from Babylonian ce-
lestial divination to the later developed astronomy can be correlated with
divergent historiographies of science. The diachronic relation between
celestial omens and nondivinatory astronomical texts was once taken as
evidence of a progressive development from the magical and divinatory
interest in celestial phenomena to the predictive and theoretical.[30] In ac-
cordance with an older historiography of science, such a model followed
largely from the idea of science as knowledge and that changes, especially
advancements, in knowledge signaled human progress. In more recent lit-
erature, however, the idea of the sciences comprising disembodied models,
theories, or methods of predicting phenomena has been rejected in favor
of the notion of a fully integrated historical, social, and culturally condi-
tioned phenomenon. Evidence of change is no longer taken to indicate
simply the forward march of a reified science, but rather more complex
creative or reactive processes at work within the cultural framework of the
historical science in question. This in no way is to dispute the element
of progress in some sciences that come within the scope of the history of
science. The present discussion, however, deals with a different problem,
namely, that to set up a question concerning a continuity or discontinuity
between divination and astronomy introduces a distinction, and indeed
propagates a distinction in our interpretation of the material between
the thinking and doing of divination and magic on one hand and the
thinking and doing of science on the other. In the ancient Near East, our
sources do indeed indicate an indisputable progressiveness in astronomy.
Nonetheless, the realms of "astronomy" and "astrology" were not separate
in Mesopotamian intellectual culture, and so a self-conscious distinction
between them such as we make in using these terms does not emerge in
the cuneiform corpus.

[30] For the historiography of this view, see Chapter 1. For a recent version of this model, see
Brown, *Mesopotamian Planetary Astronomy–Astrology*, pp. 218 and 234.

I take for granted further that the science–religion rift has no meaning in the context of the cuneiform sources. Indeed, that conflict, as S. Fuller put it,

is a product of the late nineteenth-century historical imagination. Only once the natural sciences had begun to assume religion's role as the seat of authoritative knowledge in Western society did the previous history start to be written in terms of science's deliberate attempt to wrench that role away from religion.[31]

One cannot find in Mesopotamian society a comparable institutional separation between the two enterprises of "science" and "religion." Mesopotamian scribal scholarship supported a wide diversity of textual forms and content, including divination of all kinds (celestial being only one), mathematics, observation, and predictive or theoretical astronomy. Distinctions of the order of form, content, or goal make for a diverse body of scribal scholarship, but these distinctions certainly do not carry dichotomous implications for "modes of thinking" of the order of divination/religion/naive/false versus astronomy/science/sophisticated/true.

Therefore, to speak of science in any way as emerging out of divination, or, put the other way around, to imagine that celestial omen literature provided some sort of ground out of which prediction of phenomena came to be a new and scientific goal and a new kind of thinking, in my view, merely recasts an outmoded historiography, namely, that from magic is born science. Magic becomes categorically prescientific or unscientific, and the science that develops later is dependent on some kind of cognitive difference. Although I recognize the anachronistic element in classifying the cuneiform texts as "science" or in using the terms "astronomy" and "astrology," the fact remains that in studying history we necessarily approach the material from an outsider's point of view. These texts are considered here to represent sources that have a contribution to make not only to our understanding of early forms of astrology and astronomy, but also to the earliest history of science.

The rediscovery and decipherment of Babylonian astronomical cuneiform texts more than 100 years ago by J. Epping, J. N. Strassmaier, and F. X. Kugler, and the subsequent penetrating technical analysis of their mathematical methods by the collaboration between historians of astronomy and assyriologists, pushed back the chronological and cultural boundaries of the history of the exact sciences in the western tradition.

[31] S. Fuller, *Thomas Kuhn: A Philosophical History for Our Times* (Chicago/London: University of Chicago Press, 2000), p. 80, note 107.

Related texts of divinatory and horoscopic content raise additional questions and shed a different light on our reconstruction of science in its earliest stages. Babylonian astronomy comprises a significant chapter in the history of western astronomy, one whose significance exceeds even the long duration of ancient Mesopotamian civilization in its continuing influence on Greek, Indian, Arabic, and Medieval European astronomy. The astrological, that is, celestial omen and horoscope, texts comprise an equally legitimate chapter in the history of science as it developed in the West, and, as did Babylonian astronomical techniques, made an impact beyond the cultural boundaries of the ancient Near East to the Aegean and greater Mediterranean and eventually the European milieu well into the Renaissance.[32] An eastern influence is also found in Sanskrit, Pahlavi, and Arabic texts of Late Antiquity and the Middle Ages.[33] By exploring the interrelated parts of the astronomical and astrological traditions of ancient Mesopotamia, this book examines the motivation and goals of Babylonian celestial divination and horoscopy, the approach to physical phenomena as manifestations of the divine, and the function of tradition and the "religious" in the context and (ancient) conceptualization of celestial inquiry within Mesopotamian scribal culture.

[32] See Valerie I. J. Flint, *The Rise of Magic in Early Medieval Europe* (Princeton, NJ: Princeton University Press, 1991); S. J. Tester, *A History of Western Astrology* (Woodbridge, Suffolk, England: Boydell, 1987); Laura Ackerman Smoller, *History, Prophecy, and the Stars: The Christian Astrology of Pierre d'Ailly 1350–1420* (Princeton, NJ: Princeton University Press, 1994).

[33] D. Pingree, *From Astral Omens to Astrology: From Babylon to Bīkāner*, Serie Orientale Roma 78 (Rome: Istituto Italiano per l'Africa e l'Oriente, 1997).

THE HISTORIOGRAPHY OF
MESOPOTAMIAN SCIENCE

I F SCIENCE HAS A UNIVERSAL ASPECT UNDERLYING ANY AND ALL its manifestations in human culture, then a reappraisal of the nature of scientific inquiry should pertain in some measure to modern and to Babylonian science alike. And even if no universal essence is to be found among the various attempts to understand the phenomena of nature, then certainly no cogent argument against inclusion of the attempts evidenced in cuneiform texts can be given as we would certainly want to know the extent of science's diversity. If our conception of science is necessarily grounded in evidence of both its results and its practice, then history has an important role to play, as was suggested in the opening statement of Thomas Kuhn's *The Structure of Scientific Revolutions* when he said, "History, if viewed as a repository for more than anecdote or chronology, could produce a decisive transformation in the image of science by which we are now possessed."[1]

The rediscovery of the earliest evidence for the cultural and intellectual practice we term science is a relatively recent achievement in the history of scholarship. From the first readings of cuneiform astronomical texts in the late nineteenth century by J. Epping and J. N. Strassmaier to the publication of *Astronomical Cuneiform Texts* by O. Neugebauer in 1955 and the *Astronomical Diaries* by A. J. Sachs and H. Hunger from 1988 to 2001, it is clear that the process of decipherment and analysis of Babylonian astronomy has taken place over a span of time during which the idea of science itself has undergone significant changes. The history of science is necessarily influenced by an attendant view of science "in general," even

[1] T. S. Kuhn, *The Structure of Scientific Revolutions* (Chicago: University of Chicago Press, 1962), p. 1.

if that view regards science as an entirely culture-specific, and therefore not a generalizable, phenomenon.

Because a working definition of science for historians has become increasingly subject to criticisms stemming from criteria employed to identify and demarcate science in history, especially criteria established by modern western standards, there seems to be little consensus any longer regarding such a definition. Efforts to understand science in history now reflect greater attention to cultural and social context and so represent a more broadly historicist or even relativistic approach, as compared against the historiography of the first half of the twentieth century with its emphatic demarcation criteria. Accordingly, the place of Mesopotamian science within a general history of science has shifted with the change in historiography. Equally significant to the reevaluation of the status and character of Mesopotamian science in the wider context of Mediterranean antiquity are recent changes in our understanding of the nature of Greek astronomy, and Greek science generally.

The aim of the following discussion is not to explicate particular Babylonian scientific texts or theories, but to address the historiographical issue of the reception of cuneiform astronomical texts into the history of science. The early stages of this history reflect textbook modernist ideas about the nature of science, ideas that, under the influence of a postpositivist orientation in the philosophy of science since the 1960s, have gradually been replaced in a new historiography of science. The terms of my discussion will be familiar enough. It is not the "historicization" of science or the break with old epistemologies per se that concerns this chapter, but rather the history of the perception of Babylonian science as a result of these significant changes in the fields of the history and philosophy of science.

1.1 THE RECEPTION OF BABYLONIAN ASTRONOMY INTO THE HISTORY OF SCIENCE

Until the relatively recent turn away from the pervasive influence of the logical positivists on historians of science, when the model of western science provided the standard against which all other sciences would be judged, the ancient Greeks were assumed to be the inventors of science. In the history of astronomy, the recovery of the civilizations of the ancient Near East eventually necessitated the updating of the view of Greek astronomical science by an acknowledgment of the Greek debt to their Near Eastern predecessors. Specifically, Greek astronomy came to be seen to

depend in significant ways on technical details borrowed from a Babylonian tradition.[2]

Despite the acknowledgment of an intellectual transmission from Babylonia to the Greeks, when it came to general histories of science, Babylonian learning (along with that of other non-Greek ancient sources such as those from Egypt, India, and China) would be contrasted with Greek "knowledge" in one of two ways. What the eastern ancients "knew" was categorized either as mere craft, developed out of practical necessity, or as theological speculation not anchored by logical, causal, or rational inquiry into physical phenomena. In his paper in M. Claggett's well-known 1957 "Critical Problems" conference, published in 1959, A. Crombie issued an authoritative formulation of this position:

I do not think that the opinion that science is organized common sense or generalized craftsmanship and technology survives comparison with the actual scientific tradition, a tradition which seems to me to be essentially Western and to begin with the Greeks. Impressive as are the technological achievements of ancient Babylonia, Assyria, and Egypt, of ancient China and India, as scholars have presented them to us they lack the essential elements of science, the generalized conceptions of scientific explanation and of mathematical proof.[3]

[2] Evidence, both literary and iconographic, of Greek awareness of Near Eastern tradition goes back to the Bronze Age, as documented in Sarah P. Morris, *Daidalos and the Origins of Greek Art* (Princeton, NJ: Princeton University Press, 1992), especially Chap. 5, "From Bronze to Iron: Greece and Its Oriental Culture," pp. 101–49; see also Peyton Randolph Helm, "'Greeks' in the Neo-Assyrian Levant and 'Assyria' in Early Greek Writers," Ph.D. dissertation (Philadelphia: University of Pennsylvania, 1980), M. L. West, *The East Face of Helicon: West Asiatic Elements in Greek Poetry and Myth* (Oxford: Clarendon, 1997), and R. Rollinger, "The Ancient Greeks and the Impact of the Ancient Near East: Textual Evidence and Historical Perspective (ca. 750–650 B.C.)," in R. M. Whiting, ed., *Mythology and Mythologies: Methodological Approaches to Intercultural Influences* (Helsinki: The Neo-Assyrian Text Corpus Project, Melammu Symposia II, 2001), pp. 233–64. As far as astronomy is concerned, the transmission of mathematical astronomy appears to have occurred not before the Hellenistic period (after 300 B.C.), but hints of earlier borrowings may be found, e.g., in the Metonic cycle; see A. C. Bowen and B. R. Goldstein, "Meton of Athens and Astronomy in the Late Fifth Century B.C.," in E. Leichty, M. deJ. Ellis, and P. Gerardi, eds., *A Scientific Humanist: Studies in Memory of Abraham Sachs*, Occasional Publications of the Samuel Noah Kramer Fund 9 (Philadelphia: Babylonian Section, University Museum, 1988), pp. 39–82; also B. R. Goldstein and A. C. Bowen, "A New View of Early Greek Astronomy," *Isis* 74 (1983), pp. 330–40, reprinted in Michael H. Shank, ed., *The Scientific Enterprise in Antiquity and the Middle Ages* (Chicago/London: University of Chicago Press, 2000), pp. 85–95.

[3] A. C. Crombie, "The Significance of Medieval Discussions of Scientific Method for the Scientific Revolution," in Marshall Clagett, ed., *Critical Problems in the History of Science*, (Madison, WI/Milwaukee, WI/London: University of Wisconsin Press, 1959), p. 81.

E. H. Hutten (1962) in *The Origins of Science* adopted the same stance with the statement that

the philosophers of the Ionian school combined theorizing about the universe with knowing some facts and this made their work so unique and so fruitful. Eastern "sages," too, were speculating about the world, but they were guided by religious and moral feelings rather than by the desire to understand external reality, while factual knowledge among the peoples of the Orient was mainly restricted to matters of everyday living, the concern of the artisan; thus the Orientals never developed science. Historically, Greek philosophy represents the first beginning of what we nowadays call "science."[4]

Similarly, and during the same period, F. Sherwood Taylor in his history of "science and scientific thought," said,

we shall see how the practical recipes and records of the Egyptians and Babylonians gave place to the theoretical and philosophical science of the Greeks....The contribution of the Greeks was nothing less than the creation of the very idea of science as we know it. As far as we know, the Egyptians and earlier Babylonians recorded and studied only those facts about the material world that were of immediate practical use, whereas the Greeks introduced what is still the chief motive of science, the desire to make a mental model of the whole working of the universe.[5]

Of the two divergent characteristics, the practical and the theological, the more damning was the latter because it indicated an inability to employ rational faculties, if not a deficiency in the possession of them. R. J. Forbes and E. J. Dijksterhuis, in *A History of Science and Technology*, offered that

[Ancient Near Eastern] Science, if we can call it such, only formed part of religious and philosophical wisdom. It did not construct a world-picture of its own built solely on the observations of natural phenomena and resting on certain supposed or established "laws of nature." Such a concept was totally foreign to pre-classical civilization; the world of the senses still formed part of the world as created by the gods "in the beginning."[6]

[4] Ernest H. Hutten, *The Origins of Science* (London: Allen and Unwin, 1962), p. 13.

[5] F. Sherwood Taylor, *A Short History of Science and Scientific Thought*, 2nd ed. (New York: Norton, 1963), pp. 3 and 20–1. Another practically identical statement is found in the introduction to W. C. Dampier, *A History of Science and Its Relation with Philosophy and Religion* (New York: Macmillan, 1946), pp. xiii–xiv.

[6] R. J. Forbes and E. J. Dijksterhuis, *A History of Science and Technology: Nature Obeyed and Conquered.* Vol. 1: *Ancient Times to the Seventeenth Century* (Baltimore: Pelican, 1963), pp. 15–16.

The same idea is echoed by A. Pannekoek (1961) in *A History of Astronomy*:

[The Babylonians] did not develop new geometrical world structures; they were not philosophical thinkers but priests, confined to religious rites, and therefore disinclined to adopt new cosmic ideas which did not conform to the holy doctrines. The planets to them were not world bodies in space; they remained luminous deities moving along the heavens as living men move on earth.[7]

As the previously quoted statements show, a clear distinction between science and religion, and therefore also between knowledge and belief, was an important device in the defining of science by the 1960s. The opposition rendered between reason and scientific knowledge on one hand and tradition, superstition, and unscientific belief on the other informed a historiography that saw the necessity of a break with some religious or mythological tradition, such as the Homeric in the context of Greek culture, before the "birth" of science was possible. Only then would the acquisition of (scientific) knowledge based on reasoned inquiry into empirical realities be possible, as opposed to the mere transmission of (religious) belief based on apprehensions of natural or phantasmic phenomena in terms of the gods. The birth of science implied conceptual liberation from primitivism and a move upward along a Comtean ladder of human thought, and this important transition occurred first in Ionia. This view evoked not only an Enlightenment sensibility, but also a neoevolutionist cognitive anthropology, as Near Eastern forms of inquiry into natural phenomena were deemed necessarily more primitive than those of the Greeks.[8] More is said in Section 1.2 on the interpretation of Mesopotamian expressions of interest in natural phenomena in terms of the divine as a certain and limited mentality or "unscientific" mode of thought.

The evolutionary cognitive model seemed wholly consistent with the progressive view of science itself as a growing organism, ever advancing along its linear path together with the human mind.[9] This reconstruction carried the weight of authority by the mid-1900s and is to some extent still

[7] A. Pannekoek, *A History of Astronomy* (New York: Dover, 1961), p. 65.

[8] On the reemergence of evolutionism in American anthropology of the 1960's, see Bruce Trigger, *A History of Archaeological Thought* (Cambridge: Cambridge University Press, 1989), p. 292.

[9] The reification of science as a living organism was explicitly stated by George Sarton, who used the metaphor as a means of justifying less attention to antiquity in teaching the history of science than to modern times, thus: "If the whole of science is considered as a continuous living body, which it is, moving with us toward the future, head forward, of course, and the tail trailing back to the beginnings, and if we have no time to study the whole beast, then we must concentrate our attention on the head rather than the tail. If we must let

with us, albeit mostly in the pages of very general histories, for example, in the (1996) Penguin *History of Europe*. There we are told that

whatever its ultimate foundations and the mysterious forces embodied in them, the natural world and universe were for the most part logical and coherent in their working and could, therefore, be investigated by human reason. This assumption lies at the heart of European science, whose story begins in Ionia.[10]

Here, the attempt to pinpoint origins, to set the boundary between pre-science and science through an alleged break with tradition, reflects the cognitive evolutionism that once saw science as the product of an advanced "mind." Again, Roberts:

Why this happened is still obscure, but Ionian science signals a revolution in thought. It crosses a crucial boundary between myth and rationality. That boundary had been approached by earlier men; it can hardly be doubted (for instance) that the practice of architecture by the Egyptians and the knowledge they won empirically of engineering and manipulating materials must have revealed to them something of the mathematics of mensuration. Babylonian astronomers had made important observations in the service of religion, and carefully recorded them. Yet when we confront those Greeks in Asia Minor who first left evidence of their thinking about the natural world, they are already investigating it in a different, more detached way.[11]

Although these comments were not made by a professional historian of science, they nevertheless signal a persistent current in the historiography of science that retains not only a notion of science no longer widely accepted in today's intellectual climate, but also a putative but unsubstantiated non-Greek ancient mentality. On these bases, interpreters such as Roberts misapprehend the nature of Babylonian celestial science.

The etiology of Babylonian astronomy's early reception within the larger framework of science in history was, as I see it, twofold. The first reason stems from the classification of sciences, and therefore science in general, as established by Bacon and then by nineteenth-century writers such as Comte, Whewell, and Spencer. This classification left a lasting imprint

something go, let it be the past, the more distant past. Yet, it is a pity, a thousand pities." G. Sarton, *A Guide to the History of Science: A First Guide for the Study of the History of Science With Introductory Essays on Science and Tradition* (New York: Ronald Press Company, 1952), p. 59.

[10] J. M. Roberts, *History of Europe* (London and New York: Penguin, 1996), p. 35.

[11] Ibid.

on the definition of science in terms of what ideas and what particular thinkers or developments were taken to constitute its history.[12] In consequence, as all of the previously quoted passages illustrate, the classical Greeks had invented nature and natural principles, hence science, whereas a variety of non-Greek ancients were viewed as capable only of practical technology and religion, but not of science.

Perhaps even more determinative in the case of Babylonian astronomy, however, was the second reason, again nineteenth century in origin, which stemmed from the history of astronomy itself. Shortly after the turn of the nineteenth century, the historical development of astronomy as well as actual historical astronomical data came to be of interest to the French, who then held a leading position in astronomical research.[13] The four-volume second edition of J. E. Montucla's monumental *Histoire des mathématiques* was published in 1802, and the first two volumes of Delambre's monumental *Histoire de l'astronomie* in 1817.[14] In such early works, the history of ancient astronomy was seen as a development of geometrical, specifically spherical, models of the motions of the heavens, beginning with Eudoxus in the classical period, Hipparchus and Ptolemy in the Greco–Roman period, and culminating with Copernicus and Kepler. This astronomy was concerned primarily with planetary motion in a finite spherical universe and with reconciling kinematic planetary models of uniform circular rotation – whether about a central earth, sun, or equant point – with the actual positions of planets observed in the heavens. As the rediscovery of the ancient Near East had only just begun and cuneiform was still decades away from decipherment, Babylonia obviously had no part to play in this reconstruction of the evolution of astronomy that began in classical

[12] For example, A. Comte, *Cours de philosophie positive*, 6 vols. (Paris: Bachelier, 1864); W. Whewell, *Philosophy of the Inductive Sciences*, 2 vols. (London: J. W. Parker, 1840); and H. Spencer, "The Genesis of Science," in *Essays: Scientific Political and Speculative*, first series (London: Williams and Norgate, 1874). For discussion, see R. G. A. Dolby, "Classification of the Sciences: The Nineteenth Century Tradition," in Roy F. Ellen and David Reason, eds., *Classifications in Their Social Context* (London/New York/San Francisco: Academic, 1979), pp. 167–93. The eighteenth-century background for this tradition in the French *philosophes* and the German Romantics is discussed by A. Cunningham and P. Williams, "De-centring the 'big picture': *The Origins of Modern Science* and the modern origins of science," *British Journal for the History of Science* 26 (1993), p. 427 and note 51.

[13] Neugebauer, *HAMA*, pp. 16–17.

[14] J. B. J. Delambre, *Histoire de l'astronomie ancienne* (Paris: Ve Courcier, 1817). N. M. Swerdlow has written on the historiographical importance of Montucla in "Montucla's Legacy: The History of the Exact Sciences," *Journal of the History of Ideas* 54 (1993), pp. 299–328.

Greece and, by means of a process of preservation and emendation in Arabic astronomy, culminated in Europe.

On the other hand, the West associated the "Chaldeans," that is, the Babylonians, with the practice of astrology. The Babylonian, or Chaldean, astrological tradition was already well known in Greco–Roman antiquity, but the disapproving attitude adopted in the West against astrologers had deep roots among the Biblical prophets, who railed against Babylonian "advisors... who analyze the heavens, who study the stars and announce month by month what will happen next" (Isa 47:13), just as the "deuteronomist" had condemned as abomination the worship of "the whole array of heaven" (2 Kgs 21:3 and 21:5) and the practice of "soothsaying and magic" (2 Kgs 21:6). That the Chaldeans were famed for the practice of astrology was also preserved, although without the derisive tone, in the medieval Arab scholar Ṣāᶜid al-Andalusī's description of what he knew of Babylonian celestial science in his *Book of the Categories of Nations*, written in A.D. 1068. He said,

Among the Chaldeans, there were many great scholars and well-established savants who contributed generously to all the branches of human knowledge, especially mathematics and theology. They had particular interest in the observation of planets and carefully searched through the secrets of the skies. They had well-established knowledge in the nature of the stars and their influence.[15]

Despite the fact that ultimately Babylonian elements were transmitted through Indian sources of Islamic astronomy during the twelfth- and thirteenth-century European revival of astronomy in Islamic Spain, Babylonian astronomy itself remained unknown, and it was only the Chaldeans' astrological fame that held on into the Middle Ages and the Renaissance.[16] Yet throughout the Middle Ages and Renaissance, while cuneiform tablets were still buried under ancient mounds, Greco–Roman astronomy, the heir to the Babylonian astronomical tradition, was preserved in the classical

[15] Ṣāᶜid al-Andalusī, *kitāb ṭabaqāt al-uman*, P. Louis Cheickho, ed. (Beirut: Imprimerie Catholique, 1912). New edition by Hayāt Bū-ᶜAlwān (Beirut: Dār al-ṭalīᶜa li-l-ṭibāᶜa wa-'l-nashr, 1985). French translation with notes by Régis Blachère, *Livre des catégories des nations* (Paris: Larose, 1935). I am indebted to Professor F. Jamil Ragep for these references. English translation from *Science in the Medieval World: "Book of the Categories of Nations,"* trans. and ed. Sema'an I. Salem and Alok Kumar (Austin, TX: University of Texas Press, 1991), p. 18.

[16] The survival of ancient "Oriental" astrology through the Greco–Roman and Arabic inheritance of Renaissance (and Reformation) Europe was uncovered by early twentieth-century scholars such as Franz Boll, Carl Bezold, Franz Cumont, and Aby Warburg.

languages of Greek, Latin, or Arabic, and as such entered the historical stream of European astronomy.

In the years immediately before and after the publication of Delambre's history of astronomy, there appeared in Europe two reports describing in detail the remains of the ancient city of Babylon by Claudius Rich, the British agent for the British East India Company in Iraq and resident in Baghdad between 1808 and 1821:

A little to the west of the ravine at (H) is the next remarkable object, called by the natives the Kasr, or Palace, by which appellation I shall designate the whole mass. It is a very remarkable ruin, which being uncovered, and in part detached from the rubbish, is visible from a considerable distance, but so surprisingly fresh in its appearance, that it was only after a minute inspection I was satisfied of its being in reality a Babylonian remain. It consists of several walls and piers (which face the cardinal points) eight feet in thickness, in some places ornamented with niches, and in others strengthened by pilasters and buttresses built of fine burnt brick (still perfectly clean and sharp) laid in lime – cement of such tenacity that those whose business it is have given up working, on account of the extreme difficulty of extracting them whole.[17]

Rich's *Memoir* stimulated both British and French interest in the archaeological investigation of the mounds of Iraq, and efforts to decipher the cuneiform script were already underway. At this time, no one anticipated the consequences this new interest would soon have for the history of astronomy, because few were perceptive enough to have deduced the existence of a Babylonian mathematical astronomy from Greek, Greco–Roman, or European sources.[18] Certain elements of Babylonian astronomy were embedded within European astronomy, such as the division of the circle into the 360 units we call degrees, the convention of measuring time as well as arc in the sexagesimal system,[19] the zodiac, and a number of

[17] Claudius James Rich, *Memoir on the Ruins of Babylon*, 3rd ed. (London: Longman, Hurst, Rees, Orme and Brown, 1818), p. 25.

[18] P. Tannery, *Recherches sur l'histoire de l'astronomie ancienne* (Paris: Gauthier-Villars, 1893), p. 185, was one of the few, as noted by A. Jones, "Evidence for Babylonian Arithmetical Schemes in Greek Astronomy," in H. Galter, ed., *Die Rolle der Astronomie in den Kulturen Mesopotamiens*, Grazer Morgenländischen Studien 3 (Graz: GrazKult, 1993), p. 78.

[19] In the sexagesimal, or base-60, system, numbers are notated from 1 to 59; then 60 is represented as 1 in the next higher "place." By modern convention, a comma separates digits representing integers and a semicolon separates digits representing fractions. The number 70 is written as 1,10. However, we read the number 1;10 as $1\frac{1}{6}$. Neither the comma nor the semicolon has a cuneiform counterpart. The place value of a digit must be determined by context. Each digit in the 60's place represents a multiple of 60, e.g., 8,20 = (8 × 60) + 20 = 500. The system is useful for calculating because 60 has many divisors

parameters such as the length of the mean synodic month (29;31,50,8,20 days), but their Babylonian origins were immaterial, as no one knew any longer to place these elements within a Babylonian context.

By the second half of the nineteenth century, scholars turned more intensively to the translation and analysis of the many cuneiform inscriptions that poured into Europe from sites throughout Iraq. In the last two decades of the nineteenth century, the assyriologist Strassmaier, working at the British Museum, copied the inscriptions on Late Babylonian tablets, that is, on those dated to the last half of the first millennium. For the many tablets consisting largely of numbers, month names, and technical terms unknown to him, Strassmaier secured the help of Joseph Epping, a professor of mathematics and astronomy. The result of their collaboration was the discovery of a mathematical astronomy in the tablets found in the two cities of Babylon and Uruk. The remarkable contribution of Epping and Strassmaier to our knowledge of ancient civilization was published in 1881 in a short paper in the Catholic theological journal *Stimmen aus Maria Laach*, and was later described by Neugebauer as "a masterpiece of a systematic analysis of numerical data of unknown significance."[20]

This was a positional astronomy of a completely different sort from any other ancient astronomy then known. It differed from the tradition of Ptolemy's *Almagest* and its descendants in its goals, methods, and in the nature of its planetary and lunar theory, yet the analysis of Babylonian mathematical astronomy led to the realization of its connection to Greek astronomy and, by extension, to the entire tradition of European astronomy. Indeed, a number of parameters attested in Ptolemy's *Almagest* and in many astronomical papyri were finally identifiable as of Babylonian origin.[21]

and there are advantages of place-value notation, where the place of a digit indicates its value. To the left of the 1's column the number's value is multiplied by a factor of 60; to the right it is divided by 60. In this way, fractions are represented with a digit moved to the right of the "sexagesimal point" to denote $1/60$, $1/3600$, and so on, just as the places to the left of the "sexagesimal point" indicate 1, 60, 60^2, 60^3, ..., 60^n. See A. Aaboe, *Episodes from the Early History of Mathematics* (New York: Random House, 1964), pp. 5–33.

[20] Neugebauer, *HAMA*, p. 349. Epping's 1881 article, with an introduction by Strassmaier, "Zur Entzifferung der astronomischen Tafeln der Chaldäer," *Stimmen aus Maria Laach* 12 (1881), pp. 277–92, was followed by J. Epping, *Astronomisches aus Babylon* (Freiburg im Breisgau: Herder'sche Verlagshandlung, *Stimmen aus Maria Laach Ergänzungsheft* 44, 1889).

[21] A. Aaboe, "On the Babylonian Origins of Some Hipparchan Parameters," *Centaurus* 4 (1955–6), pp. 122–5.

Figure 1. Periodic step function.

The legacy of Babylonian astronomy in Greek, Indian, Arabic, and European astronomy was demonstrable, but differences were also discernible between Babylonian astronomy and its western descendants. Babylonian astronomy did not rely or depend on a spherical cosmological framework, nor did it make use of geometrical models of a celestial body in motion around a central earth, although celestial coordinates, primarily degrees of ecliptical longitude and latitude, were used. Its goal was not to devise a model of a planet's motion such that visible synodic phenomena, such as first and last visibilities, stations and retrogradations, would be secondarily derived from the model. Rather, the synodic moments, the horizon phenomena of risings and settings particularly, were central, and any position of the body at arbitrary moments in between the special appearances would be derived by interpolation. In contrast to the interest in the position (geocentric ecliptical longitude) of a celestial body at some given time t, later to be developed in one of the branches of Greek astronomy, the Babylonian interest was in the position (geocentric ecliptical longitude) of a celestial body when t is one of the planet's synodic appearances (or disappearances).[22]

Underlying the Babylonian astronomy was an understanding of and arithmetical control over the variable "velocities" (progress in longitude over a certain period) of the sun and planets in the planetary theory (or sun and moon in the lunar theory) as well as the variable inclination between ecliptic and horizon throughout the year (a problem of spherical astronomy), and also visibility conditions near the horizon where most of the synodic appearances occur. What was of prime interest therefore was the "synodic arc," that is, the distance in degrees of longitude traveled

[22] See Neugebauer, *ACT* and *HAMA*.

Figure 2. Periodic zigzag function.

by the planet (or moon) between consecutive phenomena of the same kind, for example, from first visibility to first visibility. The synodic arc, defined as the progress in longitude of a body in a particular synodic phenomenon, was, in one method (System A), generated by (in accordance with the reconstruction by modern scholarship) a piecewise constant step function of longitude, and in another method (System B), by (again as reconstructed) a periodic zigzag function of the number of the synodic phenomenon in a certain sequence.[23]

The reconstruction of Babylonian mathematical astronomy in modern times in terms of the use of functions is fundamentally descriptive of the largely numerical tables containing the sequences of lunar and planetary longitudes (and dates of their occurrence). As explained by Neugebauer in *ACT*,[24] the numbers in the many columns of such tablets can be understood "as a function of the line number," that is, value y in line n can be expressed as $y(n)$. Plotting the values $y(n)$ on a graph produces either what is called a discontinuous and periodic step or a continuous and periodic zigzag function, as shown in Figs. 1 and 2.

In each method, the mathematical model of the synodic arc was anchored to the ecliptic (although more directly in System A than in System B[25]) by means of excellent values of relevant planetary and lunar periods, such as the sidereal year, the synodic and sidereal periods of all the

[23] A concise and lucid description of the Babylonian computation of the synodic arc ($\Delta\lambda$) and its general theory may be found in A. Aaboe, *Episodes from the Early History of Astronomy* (New York/Berlin/Heidelberg: Springer-Verlag, 2001). See also Subsections 4.2.4 and 7.4.2 for further clarification of Systems A and B.

[24] Neugebauer, *ACT*, p. 28.

[25] See Subsection, 4.4.4 and 7.4.3.

planets, as well as the synodic, anomalistic, and draconitic periods of the moon. An important component of the success of these essentially predictive theories of planetary and lunar phenomena was an understanding of the relations between the relevant periods. Indeed, as Neugebauer put it, "period relations . . . form the very backbone of Babylonian mathematical astronomy."[26] Suffice it to mention the "19-yr luni–solar calendric cycle" in which 19 years = 235 synodic months, or the famous "18-yr Saros cycle" underlying Babylonian eclipse theory in which 18 years = 223 mean synodic months.[27]

Even after Neugebauer's publications of the 1940s and 1950s disseminated knowledge of Babylonian astronomy to a wider scholarly public,[28] the reception of these new sources within general histories of science was not commensurate either with their character or significance. The revised second edition of J. L. E. Dreyer's *A History of Astronomy from Thales to Kepler*, for example, took no notice of the findings of scholars who had worked on cuneiform astronomy. In the Foreword to the revised edition of 1953, W. H. Stahl noted that,

one of the chapters, the Introduction, is notably deficient. Instead of treating the scientific aspects of early oriental astronomy – which would have been in keeping with the rest of the volume – he preferred for some strange reason to handle the childish cosmological conceptions. Kugler's pioneer work in deciphering Babylonian astronomical texts was known to him, but he made limited use of it. He does not refer to the Babylonian studies of Epping. Like many other historians of occidental science, Dreyer seems to have been reluctant to acknowledge the full extent of Babylonian influence upon Greek astronomy and mathematics. . . . Readers who desire to survey our present knowledge about Babylonian and Egyptian astronomy and mathematics will find summary treatment in the publications of Neugebauer, which since World War II, have been appearing in English.[29]

For historians of astronomy as of science in general of this early postwar period, the reputation of the Babylonians as astrologers was still strong, only now it was known that the astrologers were possessed of a quantitative and predictive astronomy. Outside the small circle of specialists,

[26] O. Neugebauer, *The Exact Sciences in Antiquity* (New York: Dover Press, 1969), p. 102.

[27] Neugebauer, *HAMA*, pp. 502–6.

[28] See especially Neugebauer, *The Exact Sciences* and *ACT*, as well as many articles in the *Journal of Cuneiform Studies* of the 1940s.

[29] J. L. E. Dreyer, *A History of Astronomy from Thales to Kepler*, rev. 2nd ed., with a Foreword by W. H. Stahl (New York: Dover, 1953), pp. vi–vii.

however, the mathematical astronomy of the Late Babylonian texts did not bring about a reconsideration of the nature of ancient astronomical science, much less of science in general. Rather, it became necessary to argue that, although Babylonian astronomy was technically sophisticated, its achievements did not have any impact on the kind of "thought" associated with science in the West, namely abstraction, axiomatic logic, demonstration, or mathematical proof.

Even some fairly specialized works, such as the widely received *Science Awakening II: The Birth of Astronomy* of van der Waerden in 1974, testify to the widespread acceptance of this view of science. Van der Waerden, a scholar whose contribution to the history of Babylonian astronomy is substantive and sizable, nonetheless judged Babylonian mathematical astronomy as not "theoretical," as compared against Ptolemy's *Almagest*, and his justification was that "the principal motive of the Greeks in developing their scientific astronomy was not the astrological application, but rather a specific interest in astronomy itself."[30] As recently as 1993, in O. Pedersen's *Early Physics and Astronomy*, ancient Near Eastern thought was found to be deficient in aspects considered to be essential to science:

Archaeology has shown the extent to which pre-Greek civilizations were dependent upon technology and mathematics. This seems to prove that exact science came into being before the Greeks. In a sense, this is true, but both Egyptian and Babylonian science and mathematics were...very different from those of the Greeks. A finer investigation reveals that the achievements of the Egyptians, and of successive peoples in Mesopotamia, were very closely related to the practical demands of everyday life, and involves none of the elements considered today as essential to science: the evidence so far suggests that these peoples knew nothing of logical proof or of natural laws.[31]

In a similar vein, A. M. Alioto concluded thus:

Predicting the phenomena added nothing to understanding them, making them intelligible. The application of rigorous methods to an understanding of nature was yet many centuries away. This is our method, and although we see the rudiments of it in the ancient Near East, we must realize that these people's picture of nature, their "science," came from other sources. Speculation was confined to the realm of myth, and though this strikes us as totally "unscientific," it is still

[30] B. L. van der Waerden, *Science Awakening II The Birth of Astronomy* (Leiden: Noordhoff International, 1974), p. 2.

[31] Olaf Pedersen, *Early Physics and Astronomy: A Historical Introduction*, rev. ed. (Cambridge: Cambridge University Press, 1993), p. 5.

speculation based upon the need to explain experience. And this it did quite well. It is only when man begins to desanctify nature, speculate upon the "it," that the use of reason comes into play. This we owe to the Greeks.[32]

These statements attest to the persistence of the view, characteristic of the early to mid-twentieth century, that, although Babylonian astronomy was quantitative and predictive, it was still merely practical, and, worse, participated in the "sanctification" of nature, and so was not yet science. Whereas the content of the cuneiform astronomical ephemerides was clearly something other than "religious speculation," it was produced by a group of literati holding priestly titles and carrying out their work within the institutional framework of the great temples of Babylon and Uruk. To account for this position as sheer Whiggism, though, would be to mistake the result for the cause. The reason lies rather in the interpretation of the Babylonian inquiry into natural phenomena, either as a matter of practical or merely technical understanding or as a form of (or influenced by) religious speculation, which, by definition, lacked reason and logic. It is interesting to note in this context that a similar incompatibility between magic and philosophy was brought to bear on the analysis of the Hellenistic Neo-Pythagoreans who were associated with a variety of doctrines on the medical and magical properties of planets, animals, and stones.[33] Here, a persistent evolutionism manifests in the following interpretation of late Pythagoreanism as a degeneration of Greek rational science:

A fundamental characteristic of this Hellenistic wisdom is that it was intensely *practical*: it aimed at control of the world, not at disinterested understanding. That indeed distinguishes it from the great rival tradition of Aristotle, in which *theoria*, the knowledge and contemplation of things for their mere beauty and order, is the goal of science. Practical arts lie at the origins of Hellenistic wisdom, and it was the interaction of the Greeks with the cultures and skills of the lands which Alexander had won that brought them into being.... [This new] science was always intensely practical and exploitive – Nature's sympathies and antipathies

[32] A. M. Alioto, *A History of Western Science* (Englewood Cliffs, NJ: Prentice-Hall, 1987), pp. 19–20.

[33] Such doctrines in fact are traceable to ancient Mesopotamia, for which see E. Reiner, "The Art of the Herbalist," *Astral Magic in Babylonia* (Philadelphia: American Philosophical Society, 1995), Chap. 2, pp. 25–42.

were there to be *used* – and that is why its manifestations . . . seem more magical than scientific even in a debased sense.[34]

Not only are Hellenistic natural philosophy and magic here judged on the basis of their practical nature to represent an epistemological decline from the great tradition of Aristotle, but blame for the corruption of Greek science is placed "with the cultures and skills of the lands which Alexander had won," that is, generic Orientals, but certainly the Babylonians.

1.2 PHILOSOPHICAL INFLUENCES

The negative assessment of the nature of knowledge in ancient Mesopotamia reflected in the historiography of science of mid-twentieth century and the generation following, as illustrated in the passages quoted in Section 1.1, can be partly attributed to the widespread influence of the logical–empiricist school of philosophy of science, admittedly oftentimes disseminated in oversimplified ways. The influence of the philosophical concerns basic to logical empiricism may be found in the background of each of the claims, as discussed in Section 1.1, namely, that ancient Near Eastern natural inquiry was incapable of creating or supporting science: first, because it produced practical knowledge, manifested in evidence of star lists and calendar-making instead of astronomical theory, and second, that it approached natural phenomena as a means to communicate with the divine, manifested in the predominance of astrology over astronomy. These can be construed as separate objections, the former being an epistemological problem configured around a dichotomy between practical and theoretical knowledge, the latter being a problem of aims, in which astronomy was compromised by association with astrology and the desire to communicate with the divine. Viewed in this way, Babylonian astronomy, in the period of its early reception into the history of science, seemed to have been conceived of as stuck between the too mundane and practical on one side and the too religious and metaphysical on the other. Both objections, however, coalesced to form an assessment of a Babylonian mode of thought, on the one hand as nontheoretical (hence cognitively

[34] Emphasis is in the text. See R. Beck, "Thus Spake Not Zarathustra: Zoroastrian Pseudepigrapha of the Greco-Roman World," in M. Boyce and F. Grenet, eds., *A History of Zoroastrianism*, Vol. 3 (Leiden: Brill, 1991), pp. 496, 559–60, *apud* Peter Kingsley, *Ancient Philosophy, Mystery, and Magic: Empedocles and Pythagorean Tradition* (Oxford: Clarendon, 1995), pp. 336–7.

ordinary as opposed to scientific) and on the other as nonrational (i.e., religious as opposed to scientific). Although I have separated these objections for the purpose of clarification, they are clearly related and interdependent.

1.2.1 Practical Knowledge: The Epistemological Problem

Characteristic of classic philosophy of science, through the intellectual patrimony of the logical positivists, was a focus on, as E. McMullin put it, "natural science as a highly specific mode of knowing and of explaining... There was a logic underlying the methods of validation and of explanation in science and the task of the philosopher was to disengage this logic once and for all."[35] In historical terms, the development of systematic and critical methods of knowing out of and beyond mere common sense has been attached to the evidence of Greek philosophy, beginning in the sixth and fifth centuries B.C. and culminating with Aristotle. This distinction was clearly drawn in M. Wartofsky's *Conceptual Foundations of Scientific Thought* as follows:

The tension between theoretical construction and common sense, between hypotheses framed to answer the questions of the speculative intellect and the plain facts of everyday know-how and observation thus gives rise to a criticism of a more complex sort. For our purposes, in examining the genesis of scientific thought, this is crucial. For it marks the radical transformation of acritical common sense into critical, rational scientific thought. It is not accidental that the earliest instances of philosophical speculation and criticism and the earliest instances of rational natural philosophy are one and the same... Out of this amalgam the Greeks fashioned a conceptual revolution so profound, so decisive in its impress that the main features of scientific thought – what we here call its conceptual foundations – retain to this day the features of that mold.[36]

Later, of course, some philosophers of science, principally Kuhn and Feyerabend, called for a more historical and less epistemological grounding of science. Even Feyerabend, however, while accusing the "rational account" of scientific change of failure, granted that

[35] E. McMullin, "The Shaping of Scientific Rationality: Construction and Constraint," in E. McMullin, ed., *Construction and Constraint: The Shaping of Scientific Rationality* (Notre Dame, IN: University of Notre Dame Press, 1988), p. 1.

[36] Marx Wartofsky, *Conceptual Foundations of Scientific Thought: An Introduction to the Philosophy of Science* (London: Macmillan, 1968), p. 68.

The sciences and especially the natural sciences and mathematics seem to be theoretical subjects *kat'exochen.* They arose when Greek theoretical traditions replaced the empirical traditions of the Babylonians and the Egyptians.[37]

Given the overwhelming presumption in the philosophy of science that ancient science meant Greek science, the importance of the philosophy of science to the reception of Babylonian astronomy into the history of science is obviously not found in any direct discussion of Babylonian material by philosophers, but in the creation of the criteria by which cuneiform scientific texts would be considered by those interested in the question of the relation between Babylonian science and science in general. Reflecting the central concerns of the philosophy of science in the era dominated by logical positivism, these criteria were epistemological, and were designed to describe the nature of scientific theory and thereby to demarcate science and its "thought" from nonscience.[38]

We have seen, in the early histories of astronomy, quoted in Section 1.1, the argument that Babylonian astronomy was not truly theoretical by virtue of its predictive goals and its manifest differences from Greek astronomy. In the judgment of these histories, the relationship between Greek and Babylonian astronomy paralleled the distinction between Greek thought and that of its "Oriental" predecessors, that is, that the former was abstract, general, and therefore theoretical, whereas the latter remained concrete, particular, and so merely predictive. Such was the understanding of Pedersen, who lauded the "amazing perfection" of the arithmetical methods of Babylonian planetary astronomy, but said that the numerical schemes were not

accompanied by any connected ideas of the physical structure of the universe. Here Babylonian astronomy was strictly phenomenological although as equally successful as the geometrico-physical astronomy of the Greeks. Nevertheless, the

[37] P. K. Feyerabend, *Problems of Empiricism,* Vol. 2 of Cambridge Philosophical Papers Series (Cambridge/New York/Port Chester/Melbourne/Sydney: Cambridge University Press, 1981), p. 11.

[38] This is not the place to engage in a review of specific hegemons of logical empiricism (Carnap, Reichenbach, Hempel), but discussion of the legacy as well as the demise of this philosophy of science may be found, for example, in Ronald N. Giere, *Explaining Science: A Cognitive Approach* (Chicago/London: University of Chicago Press, 1988), or Wesley C. Salmon, *Causality and Explanation* (New York/Oxford: Oxford University Press, 1998).

art of developing theories based upon physical models seems to have been un-known.[39]

The characterization as "strictly phenomenological" was a comment on the absence of explanation or of a deductive relationship between theory and predictions. But the particular data generated in the cuneiform ta-bles were the results of quantitative manipulation of a number of general methodological schemes, the two primary ones now dubbed System A and System B, which could be applied to any phenomenon of any planet, the results of course depending on the use of excellent parameters for a given phenomenon.[40] The lack of an explicit cosmological model within which Babylonian astronomical theory was to fit was of no consequence in view of the fact that the predictions did not derive from a geometrical concep-tion that attempted to make causal sense of the phenomena, but rather depended on period relations whose purpose was to enable the computa-tion of phenomena either forward or backward in time in an instrumental way. Exemplifying this kind of theoretical orientation are prediction rules for calculating the highly variable time intervals between moonrise and sunset, sunrise and moonset at opposition, which values require a solid grasp of the periodic progress of the moon in relation to the sun and the relationship of this to the variable inclination of the ecliptic and lunar path with respect to the horizon. These rules may be checked against modern computation with excellent agreement.[41] The development of Babylonian astronomical knowledge and the methods to deal with it was surely a long process, involving most of the features of inquiry familiar to inductive science in the standard sense, that is, observation, "hypothesis" construc-tion, and the introduction of "theoretical entities" specific to the theory of phenomena in a certain domain (such as lunar or planetary synodic phenomena) that do not themselves have direct correspondence in the physical world (such notions as mean synodic progress in longitude). It must be admitted, however, that the interaction between observation and theory construction remains a murky area of our understanding of Baby-lonian astronomy,[42] although it is not likely that the data generated by

[39] Pedersen, *Early Physics and Astronomy*, pp. 5–6.
[40] For the meaning of Systems A and B, see Subsections 4.2.4 and 7.4.2.
[41] Lis Brack-Bernsen, "Goal-Year Tablets: Lunar Data and Predictions," in N. M. Swerdlow, ed., *Ancient Astronomy and Celestial Divination* (Cambridge, MA/London: MIT, 1999), pp. 172–5.
[42] Evidence for the empirical grounding of Babylonian lunar theory is discussed in J. P. Britton, "Scientific Astronomy in Pre-Seleucid Babylon," in Hannes D. Galter, ed., *Die*

computation in the ephemerides were for the purpose of checking against observed data.[43]

Another epistemological issue at stake for classic philosophy of science was the special cognitive status of "theoretical" knowledge, hence theoretical thinking, that is, that it differed in kind from "ordinary" knowledge, the product of "ordinary" thinking. With the emergence of science from prescience, so too did scientific (read, theoretical) thought emerge from a stage of cognitive development within which "science" does not and cannot exist. D. Kuhn, however, has argued for the epistemological sophistication of scientific thinking and the "non-trivial differences between everyday and scientific thinking," but not for scientific thinking as an evolutionary achievement, rather a function of special training.[44] In her view,

it is a mistake to equate good or rigorous thinking with scientific thinking. To do so is to view the scientific enterprise and the thinking associated with it much too narrowly. Scientists employ the inferential thinking strategies that they do because they are powerful strategies that well serve the scientist's objectives. It does not follow that such strategies should be confined to or even associated predominantly with science...In carving the modes-of-thinking pie, then, the first cut, in my view, is not between scientific thinking and another form or forms that might be characterized variously as narrative or associative or creative. Instead, the most significant distinction to be made is between thinking that is more versus less skilled, with skilled thinking defined in its essence as thinking that reflects on itself and is applied under the individual's conscious control.[45]

Such an argument would mitigate a priori claims that ancient Near Eastern inquiry into natural phenomena could not have taken "scientific" form. In support of this idea we observe that the astronomical theories and methods of Babylonian scholars were indeed the product of trained specialists, and the body of texts in which these theories, methods, and their results were transmitted, namely, the ephemerides, was the province of a trained elite group.[46]

Rolle der Astronomie in den Kulturen Mesopotamiens, Grazer Morgenländischen Studien 3, (Graz: GrazKult, 1993), pp. 61–76.

[43] For the possibility that computed phenomena in one extant astronomical text were for the purpose of the construction of horoscopes, see J. M. Steele, "A 3405: An Unusual Astronomical Text from Uruk," *Archive for History of Exact Sciences* 55 (2000), p. 132.

[44] Deanna Kuhn, "Is Good Thinking Scientific Thinking?" in David R. Olson and Nancy Torrance, eds., *Modes of Thought: Explorations in Culture and Cognition* (Cambridge: Cambridge University Press, 1996), pp. 261–81.

[45] Ibid., p. 276.

[46] Neugebauer, *HAMA*, pp. 502–6.

Those historians who made the argument against the theoretical status of Babylonian planetary and lunar tables did so by pitting Babylonian astronomy against Greek and claiming a disparity between them precisely on the basis that the former was quantitative but not theoretical (lacking explanatory force), whereas the latter was theoretical and, at least from the *Almagest* onward, quantitative.[47] A presumed dichotomy between "Babylonian" and "Greek" astronomy, however, fails to take account of Greek papyri that continued the linear methods of the Babylonians.[48] This position, however, has been finally rendered obsolete for the nonspecialist by the publication by A. Jones of the astronomical papyri from Oxyrhynchus, the latest and most important of Greek sources for the history of astronomy.[49]

The quantitative contents of the papyri reflect the contemporary practice of technical astronomy during the late Greco–Roman period and, as such, determine geocentric longitudes of the sun, moon, and five planets (visible to the naked eye) for a certain date, and also determine the dates (and even sometimes time) of entry of the planets into the zodiacal signs, both of which goals clearly served the needs of astrologers constructing horoscopes. Whereas Greco–Roman astronomy has been closely identified with the Alexandrian tradition that culminated in the second century of the Common Era with Ptolemy's *Almagest* and its exposition of geometrical (or kinematic) methods to account for the motions of the planets, Jones has shown that "in contrast to the modern conception of Greek astronomy as a theoretical enterprise, the papyri portray a science that was overwhelmingly directed towards prediction."[50] Not only does the new edition of the astronomical papyri demonstrate the predictive character of a large part of Hellenistic Greek astronomy, but it gives us dramatic

[47] B. R. Goldstein and A. C. Bowen, "The Introduction of Dated Observations and Precise Measurement in Greek Astronomy," *Archive for History of Exact Sciences* 43 (1991), pp. 93–132, established a new dating for the introduction into Greek astronomy of quantitative elements (such as degrees) and the basis for a quantitative dimension of astronomical theory in dated observational data.

[48] For the continuation of the linear methods in the Sanskrit tradition, see David Pingree, "The Mesopotamian Origin of Early Indian Mathematical Astronomy," *JHA* 4 (1973), pp. 1–12; idem, "History of Mathematical Astronomy in India," in C. C. Gillespie, ed., *Dictionary of Scientific Biography* (New York: Scribner's, 1978), Vol. 15, pp. 533–633.

[49] A. Jones, *Astronomical Papyri from Oxyrhynchus*, Vols. 1 and 2 (Philadelphia: American Philosophical Society, 1999).

[50] Ibid., p. 5.

evidence of the preservation of Babylonian predictive methods in Greco–Roman astronomy until the fifth century of the Common Era. Although an ancient Near Eastern foundation for Greco–Roman astronomy has long been beyond dispute, the nature of the Babylonian legacy has been viewed as one of preserved elements within a system fundamentally different from that associated with the cuneiform ephemerides. Such elements are the sexagesimal number system, excellent Babylonian parameters, and period relations, as well as a number of observations embedded in the *Almagest*. Despite such lasting foreign elements within Greek science, it appeared that the arithmetical methods of the Babylonian tablets had been all but superceded by the Greeks' geometrical kinematic models. The geometrical spherical models of planetary motion exemplified in the *Almagest*, which in general histories of science previously were represented as the characteristic feature of Hellenistic astronomy, must now be recognized as one of two methods characteristic of the astronomy of the period, the other being the description of the behavior of the planets by means of a variety of linear arithmetical sequences originating with Babylonian mathematical astronomy. Consequently, a hitherto unacknowledged disunity in the methods and goals of ancient Greek astronomy must now be recognized.

The astronomical papyri from Oxyrhynchus provide powerful ammunition for relativist historians and philosophers of science who prefer to study science and its theories empirically, through the historical record, and to construct, or reconstruct, science accordingly. The Greek astronomical papyri do not undermine the assessment of the theoretical character of the kinematic model-making form of ancient astronomy, but, in showing that Greek astronomy was methodologically more diverse than previously acknowledged, they mitigate any attempt to draw cognitive historical conclusions about the nature of the Babylonian "mind" in contradistinction to the Greek, or to our own.

1.2.2 Religious Aims: The Pragmatic Problem

The second angle from which Babylonian astronomy was judged unscientific was that which saw astronomy in the service of divination and astrology. In this sense, astronomy was not scientific, but "religious," insofar as it enabled communication with the gods. Indeed, Babylonian astronomy belonged to an intellectual tradition of diverse content, including divination, magic, incantation and medical texts. The extensive

omen lists, the celestial omen compilation *Enūma Anu Enlil*,[51] among others, compile in systematic arrangements all manner of physical phenomena within the world of human experience. A divine immanence in that world is conveyed in some of the descriptions of phenomena in which clearly some gods were conceived of as manifested in celestial phenomena, such as the lunar eclipse viewed as the moon god, Sin, "covered" in mourning, or thunder as the voice of the storm god, Adad.[52] Although phenomena were more often referred to without a hint of divine embodiment, the very idea of an omen serves to remind us that, for the ancient Mesopotamian scholars, all physical existence and the divine sphere of influence were coextensive. Accordingly, all phenomena, including those above (in the sky) as well as those below (on earth), were subject to interpretation as signs, and such signs, in the Babylonian view, were brought about through divine agency as a manifestation of the gods' concern for human beings. Divination afforded indirect communication between humankind and god, to the benefit of humankind, in that steps could be taken to avert the bad consequences of omens through apotropaic magic, termed *namburbû*.[53]

Any investigation of the intellectual context of the exact sciences in ancient Mesopotamia must give due consideration to the ways in which disciplinary boundaries may have been conceived, in particular whether such boundaries existed, for example, between "astronomy" and "astrology," in any way akin to our own. We turn here from an epistemological problem regarding the nature of astronomical knowledge to one of the motivations and goals of astronomy. The two concerns are closely connected inasmuch as the attribution of religious motive and the consequent "theological" conceptualization of the celestial phenomena, for example as manifestations of deities, have been taken as evidence for a nonrational mode of thought about that world of phenomena, as discussed in Subsection 1.2.1.

Behind the charge that Babylonian astronomy was unscientific (or pseudoscientific) were both the influences of the conflict model of the relation between science and religion and also the evolutionary scheme that put

[51] For a summary of the sources and their contents, see Hunger-Pingree, *Astral Sciences*, pp. 5–22.

[52] For further discussion, see Chap. 5.

[53] Stefan M. Maul, *Zukunftsbewältigung: eine Untersuchung altorientalischen Denkens anhand der babylonisch–assyrischen Löserituale (Namburbi)* (Mainz am Rhein: Verlag Philipp von Zabern, 1994).

science as a later development, even a liberation, from magic and religion. Of course, for historians of western science in the early to mid-twentieth century, who transferred modern demarcations between sciences and pseudosciences to the premodern world, astrology was "spiritual" as well as "occult," and therefore located on the margins of science proper. As long as the study of astrology was regarded as tainted or primitive science, however, our ability to reconstruct and interpret the history of ancient astronomy remained not only partial, but plainly ethnocentric. Recognition of the complexity of Mesopotamian interest and investigation of celestial phenomena underscores just how distorting it was, in early treatments of the Mesopotamian approach to nature, to allow cosmogonic mythology to stand in for astronomical source material as evidence for "Mesopotamian thought" about nature. The focus on mythological texts, not surprisingly, supported the idea that "mythopoeic" thought was characteristic of the ancient Near East, and promoted the image of an ancient Mesopotamian "mentality" in nonspecialist histories of science, such as those quoted in Subsection 1.2.1.

The *locus classicus* for the analysis of the alleged traditional "mentality," was the well-known and widely quoted book by H. Frankfort et al., *Before Philosophy: The Intellectual Adventure of Ancient Man*:

When we turn to the ancient Near East...we find that speculation found unlimited possibilities for development; it was not restricted by a scientific (that is, a disciplined) search for truth...For them nature and man did not stand in opposition and did not, therefore, have to be apprehended by different modes of cognition...The fundamental difference between the attitudes of modern and ancient man as regards the surrounding world is this: for modern, scientific man the phenomenal world is primarily an "It"; for ancient – and also for primitive – man it is a "Thou."[54]

Frankfort et al. generalized from the evidence of cosmogonic mythology to a cognitive stage of development in human thought, one which could not "become part of a progressive and cumulative increase of knowledge,"[55] that is, one incapable of producing "science":

We are here concerned particularly with thought...we cannot expect in the ancient Near Eastern documents to find speculation in the predominant intellectual

[54] H. and H. A. Frankfort, John A. Wilson, and Thorkild Jacobsen, *Before Philosophy: The Intellectual Adventure of Ancient Man* (Chicago/London: University of Chicago Press, 1946, Pelican Reprint, 1961), pp. 12–15.
[55] Ibid., p. 251.

form with which we are familiar and which presupposes strictly logical procedure even while attempting to transcend it.[56]

The analysis by Frankfort et al. harks back to a nineteenth-century rationalist perspective, such as that exemplified by Sir James Frazer's *The Golden Bough*, in which humanity's relation to nature evolves from one expressed through magic, followed in genealogical descent by a refinement to religion, and finally to science, or indeed by Comte's scheme of the religious, metaphysical, and finally positive society.[57] From such evolutionist ideas stemmed the claim that, in antiquity, the human mind was capable only of the (primitive) magical understanding of the world. If, by modern criteria of logic, instrumentality, and rationality, magic is classified as irrational, then the ancient mode of reasoning must be irrational.[58] With no argument to support the use of myths as evidence for a Mesopotamian cognitive history, the "mythopoeic thought" thesis purported to deduce a "mode of thought," an irrational one at that, as well as a stage of cognitive development from evidence belonging to religious or ritual expression. The problem of deducing from expressions of a religious or ritual nature a mode of thought, not to speak of an evolutionary stage of cognitive development, was already of concern to Frankfort's contemporary, Malinowski, who described the concurrent existence within any society of a practical/rational outlook with a sacred/"mystical" one.[59] The evolutionism inherent in this early approach to "mentalities" constituted one of its chief problems,[60] as it seemed to stem from ethnocentrism on one hand and led to simplistic dichotomies, such as "traditional" and "modern," on the other.

Since the work of Frankfort et al., our understanding of ancient Near Eastern cosmogonic thought, based in large part on the study of a corpus

[56] Ibid., p. 14.

[57] On evolutionism and nineteenth-century rationalism, see John B. Vickery, *The Literary Impact of* The Golden Bough (Princeton, NJ: Princeton University Press, 1973), p. 18. See also the comments in G. E. R. Lloyd, *Demystifying Mentalities* (Cambridge: Cambridge University Press, 1990), p. 39.

[58] See R. Horton, *Patterns of Thought in Africa and the West: Essays on Magic, Religion and Science* (Cambridge/New York: Cambridge University Press, 1993), pp. 105–37, in the section "Back to Frazer?," especially pp. 127–32.

[59] B. Malinowski, *Magic, Science, and Religion and Other Essays* (New York: Anchor, 1954), pp. 26, 34–35; also Lloyd's comments on the concurrence of these "mentalities" even in modern society, in Lloyd, *Demystifying Mentalities*, pp. 40–2.

[60] See Peter Burke, "Strengths and Weaknesses in the History of Mentalities," *History of European Ideas* 7 (1986), esp. pp. 444–45.

of god lists, has deepened, as, for example, in the work of F. Wigger-mann.[61] Although Wiggermann aims to differentiate the Mesopotamian attitude toward physical phenomena from our own, and is correct in his assertion that "nature" was not a Mesopotamian concept, he perpetuates a Frankfortian view of a mode of reasoning in which "the tools of logic" were "not yet completely activated."[62] He explains that

The assumption underlying my contentions is not that the inhabitants of Mesopotamia could not think, but that they did not do it often. . . . The simple fact that the documents show little explicit logic then means that logical expla-nation was not commonly practiced, and not accepted in the explanation of the facts of life and nature.[63]

That elements of the pantheon and cosmological mythologies appear in the omens of *Enūma Anu Enlil* does not surprise us, but what of the ves-tiges of such "lore" in astronomical terminology, preserved even in the mathematical astronomical texts? The description of the appearance of the moon (also the sun and planets) by means of an anthropomorphic personification, such as the grief-stricken moon, certainly reveal theolog-ical and mythological elements in the background of celestial divination. Even in strictly astronomical contexts, "eclipse" may be written with the lo-gogram ÍR, the writing for the Akkadian word "to cry," or when said of the moon, "to be eclipsed." Despite such elements, the omens of *Enūma Anu Enlil* indicate that the celestial phenomena were largely the subject of sys-tematic empirical consideration, usually without overt reference to gods. Whereas Babylonian (and earlier Sumerian) cosmogonic myths represent the creation of the cosmos as an allegory involving personified cosmic elements (sea, earth, sky, wind), celestial omens as well as astronomical texts consider and seek to describe the behavior of the phenomena them-selves.

The phenomena of the omen lists are meaningful as physical signs of future, often catastrophic, events, but they remain the objects of an inquiry focused on an entirely separate goal: the understanding and even predic-tive control over the recurrence of those phenomena. As physical signs,

[61] Frans Wiggermann, "Mythological Foundations of Nature," in Diederik J. W. Meijer, ed., *Natural Phenomena: Their Meaning, Depiction and Description in the Ancient Near East* (Amsterdam/Oxford/New York/Tokyo: Koninklijke Nederlandse Akademie van Weten-schappen Verhandelingen, Afd. Letterkunde, Nieuwe Reeks, deel 152, 1992), pp. 279–306.

[62] Ibid. p. 279.

[63] Ibid., p. 297, note 4. Note the echo of the statement of Frankfort et al., in *Before Philosophy*, p. 19, that "[the ancients] could reason logically; but they did not often care to do it."

therefore, it would seem that, despite the occasional overt personification, or even reference to the moon as "the god" (*ilu*), the lunar phenomena were of interest *qua* phenomena, not as objects of worship. Apart from the possibility that we cannot understand and therefore will never be able to define how the Babylonians perceived the phenomena, the evidence of the omens presents the coexistence of (to us) contradictory "modes" of thought about phenomena, for example, that which views the full moon as the moon god wearing a crown, as well as that which sees the full lunar disk on the horizon opposite the sun on the fourteenth day of the lunar month. Interestingly, it seems that "natural" phenomena became objects of study not in spite of their being products of divine agency and will, but precisely because they were physical signs of divine agency and will. The evidence of the texts that deal with the heavens or with celestial phenomena, that is, cosmological myth, celestial omens, or astronomical texts, argue for the existence of different modes of thought as the function of different aims or attitudes, not that the Mesopotamian scribes were cognitively lacking in some way.

I find it important to maintain a distinction between speculation about a Babylonian "mode of thought," and the wholly different problem of categorizing celestial divination as "religion" or "science." The former problem seems to follow from an insufficiently developed or nuanced historical anthropology of ancient Mesopotamian culture, whereas the latter is more a function and consequence of employing anachronistic terms, as indeed religion and science are, in the context of Babylonian civilization. Whereas the boundaries between these terms may be definable and even useful where our explications of texts in our terms are concerned, the separation of science and religion, much less the conflict between them, within Mesopotamian culture, finds no support in ancient Near Eastern texts. It seems preferable, as J. H. Brooke has argued, to use science and religion as designations of "complex social activities involving different expressions of human concern, the same individuals often participating in both."[64] Clear evidence of participation "in both" is found in Mesopotamia, as seen in the letter from the celestial divination expert Marduk-šāpik-zēri to King Aššurbanipal, previously quoted.[65]

If celestial divination, and later, personal astrology, belonged within a religious framework, it was in terms of the fact that the agency of the

[64] John Hedley Brooke, *Science and Religion: Some Historical Perspectives* (Cambridge: Cambridge University Press, 1991), p. 42.

[65] See Prologue.

gods was a functional element in the scheme of celestial divination, and presumably horoscopy, and, from a social point of view, Late Babylonian astronomy was supported by the institution of the temple. Astronomy functioned without appeal to the gods, although the gods were no less present in the world of Babylonian astronomy. It is clear that the individuals who computed astronomical phenomena were the same as those who copied omen texts and constructed horoscopes. Such an example may be seen in the person of Anu-aba-utēr, a professional "scribe of Enūma Anu Enlil," a title sometimes rendered astronomer/astrologer in English. This scribe wrote a text now known as ACT 600 (written 194 B.C.),[66] which computes the first stations of Jupiter according to one of the planetary theories (System A), as well as an astrological text relating lunar eclipse omens with zodiacal signs and making associations with cities, temples, stones, and plants.[67] In addition to holding the professional title ṭupšar Enūma Anu Enlil, "scribe of the omen series Enūma Anu Enlil," Anu-aba-utēr was also designated as kalû Anu u Antu, meaning "lamentation priest of the sky gods Anu and Antu."[68] His father, Anu-bēlšunu, also a kalû and a ṭupšar Enūma Anu Enlil, appears as a tablet owner of many astronomical table texts, and his personal horoscope is extant.[69] Anu-bēlšunu's horoscope adds to the evidence for the integration of the astronomical and astrological sides of the Babylonian study of heavenly phenomena. This particular horoscope provides a rare example of the computation of solar and lunar positions that uses degrees and fractions of degrees within zodiacal signs. Another notable feature of Anu-bēlšunu's horoscope as compared against other examples of the genre is the inclusion of omen apodoses as interpretation of the computed planetary positions.[70] Finally, J. Steele has added another tablet to Anu-bēlšunu's collection, an astronomical text from the city of Uruk containing dates and longitudes of lunar eclipses and many

[66] Neugebauer, ACT, text no. 600.

[67] E. F. Weidner, Gestirn-Darstellungen auf babylonischen Tontafeln (Graz: Hermann Böhlaus Nachf., 1967), text 2, p. 47.

[68] See Neugebauer, ACT, Vol. I, p. 16.

[69] For a study of this scribe, including his curriculum vitae, see Laurie E. Pearce and L. Timothy Doty, "The Activities of Anu-belšunu, Seleucid Scribe," in Joachim Marzahn and Hans Neumann, eds., Assyriologica et Semitica, Festschrift für Joachim Oelsner anläßich seines 65. Geburtstages am 18. Februar 1997, AOAT 252 (Münster: Ugarit-Verlag, 2000), pp. 331–41. For Anu-belšunu's horoscope, see P.-A. Beaulieu and F. Rochberg, "The Horoscope of Anu-Bēlšunu," JCS 48 (1996), pp. 89–94.

[70] See for example: "At that time, the sun was in $9\frac{1}{2}°$ Capricorn, the moon was in 12° Aquarius: His days will be long" (lines 3–4).

synodic planetary phenomena, which Steele has argued were computed for the purpose of horoscopy.[71]

The history of science and the philosophy of science have together exerted a determinative influence on the modern reception and evaluation of Babylonian astronomy. The reconstruction of a linear evolutionary development of science depended on a certain philosophical position, one in which science, viewed as a distinctive form of knowledge, was seen to have originated in a particular historical context and to have followed a course characterized by progressive growth ever since. Emerging around mid-twentieth century, however, was the position concerned with whether or not science should be viewed as a distinct form of intellectual belief at all, as well as what criteria should be valid in deciding this issue. The idea, as Joseph Rouse put it, "that positivism offered a model of science to which no actual science had ever even approximated, and which would be disastrous if prescribed as an ideal,"[72] in a sense liberated the history of science. Far from its being useful to raise the question of whether evidence for "theory" is found in Babylonian astronomy in accordance with criteria meant to define the special status of scientific over ordinary thought, the universality of those criteria has itself been called into question, with historical implications for the validity of its application, both outside and inside modern western contexts.[73] The parallels and accord between "postpositivist" philosophy of science with its significantly sociological dimension and the new historiography of science with its interest in "constructivism" may well, as J. R. R. Christie suggested, reflect a postmodern loss of confidence in any "big-picture synthesis," and a tendency toward "internal differentiation and localization."[74] It has accordingly not been

[71] Steele, "A 3405: An Unusual Astronomical Text from Uruk."

[72] Joseph Rouse, "Philosophy of Science and the Persistent Narratives of Modernity," *Studies in History and Philosophy of Science* 22 (1991), p. 153.

[73] In the panel discussion section that concluded the conference proceedings, published in E. McMullin, ed., *The Shaping of Scientific Rationality: Construction and Constraint* (Notre Dame, IN: University of Notre Dame Press, 1988), pp. 223–4, Gary Gutting's statement reflects the awareness of a turning point in attitude among philosophers of science. He said that "there is a historical and social character to scientific rationality, an assumption that would surely not have been accepted only a short while ago. We have now come to take seriously the historical, and perhaps the social, character of scientific rationality."

[74] J. R. R. Christie, "Aurora, Nemesis, and Clio," *British Journal for the History of Science* 26 (1993), p. 394. An excellent examination of "challenges to the classical view of science" may be found in Jan Golinski, *Making Natural Knowledge: Constructivism and the History of Science* (Cambridge: Cambridge University Press, 1998).

my objective here to replace Greek with Babylonian science as the new starting point of the old big picture. It is rather to show that the characterization of Babylonian astronomical texts, in accordance with the old historiography, as either "practical" or "religious" in an effort to differentiate the Babylonian inquiry from science, and further, to define a Babylonian "mentality" in terms of its incapacity for "theory" and "science," testified to the power of the image of science of that era and had little to do with a consideration of the cuneiform sources themselves.

CELESTIAL DIVINATION IN CONTEXT

2.1 AN INTRODUCTION TO MESOPOTAMIAN
SCHOLARLY DIVINATION

The prognostication of events through signs discerned in all sorts of phe-
nomena of the natural and human social world was practiced throughout
the ancient Mediterranean. Before Hellenistic times, when the truth value
of divination was first subject to philosophical and logical evaluation, div-
ination was assumed to provide a legitimate means of determining the
course of future events. Even after divination came under severe criticism
in some Platonist and Stoic circles, various divinatory practices continued.
Its widespread nature as well as its antiquity is well defined by Cicero in
his work *De Divinatione*, in which he mentions both the Assyrians and
the "Chaldeans" (Babylonians) as especially noted for celestial divination
and nativities:

Now I am aware of no people, however refined and learned or however savage
and ignorant, which does not think that signs are given of future events, and that
certain persons can recognize those signs and foretell events before they occur. First
of all – to seek authority from the most distant sources – the Assyrians, on account
of the vast plains inhabited by them, and because of the open and unobstructed
view of the heavens presented to them on every side, took observations of the
paths and movements of the stars, and, having made note of them, transmitted
to posterity what significance they had for each person. And in that same nation
the Chaldeans – a name which they derived not from their art but their race –
have, it is thought, by means of long-continued observation of the constellations,
perfected a science which enables them to foretell what any man's lot will be and
for what fate he was born.[1]

[1] Cicero, *De Divinatione.* I i 2, trans. W. A. Falconer (Cambridge, MA: Loeb Classical Library,
1979).

Although Cicero's attribution to the Assyrians of the foretelling of personal fortunes from the stars is anachronistic, and his claim that the Chaldeans predicted personal fortunes from the constellations reflects ignorance of the actual method developed in Late Babylonian horoscopic omens, the statement attests accurately both to the pervasiveness of divination in Near Eastern and classical cultures, as well as to its Mesopotamian antiquity.

The study of Mesopotamian divination affords us some insight into Assyro–Babylonian ideas about the nature of physical phenomena as well as about the relationship between human and divine. Although we recognize that a division between science and religion as two institutions with disparate attitudes does not apply in the Mesopotamian context, these two "aspects" of Mesopotamian divination are separable insofar as the study of the phenomena as signs entails an empirical consideration of the physical world that we would classify without difficulty as "scientific" in nature. All the systems of divination preserved in the cuneiform omen corpora reflect a belief in the involvement of gods in the physical natural as well as in the human social worlds. The "overlapping" of scientific activity and religious thought is also evident in the social dimension of Assyro–Babylonian divination as viewed through the various professions associated with divination in ancient Mesopotamia, that is, the *ṭupšarru* "scribe–diviner," the *ṭupšar Enūma Anu Enlil* "celestial diviner," the *āšipu* "magician–exorcist," the *šā'ilu* "dream interpreter," and the *bārû* "haruspex," as well as the uses of these scribes' special knowledge.

This introductory chapter on divination attends in a descriptive way to the various classes of omen texts, among which are the celestial omens, so that celestial divination may be better situated within a literary and intellectual framework. The following survey should serve to demonstrate the consistency between celestial omens and the other omen series and therefore the unity of the program of Mesopotamian scholarly divination as a whole. This should also make clear how important it is from a historiographical point of view not to isolate celestial omens from their larger divinatory context, especially when the question of the classification of celestial divination as science is at stake.

The conception of a divinely created order underlies the various forms of Mesopotamian divination, which functioned as a system of divine communication with human beings by means of perceptible patterns of phenomena. The idea of an ordered universe is defined in Sumerian and Babylonian mythology and expressed clearly in, for example, the divine epithet that refers to certain gods as the "ones who draw the cosmic designs." In a very general way, this mythology underpins divination by establishing

the belief that the gods (e.g., Marduk in the epic poem *Enūma eliš*) created a universe in which phenomena occurred with observable regularity. Situating the scholarly divination series within a particular worldview or system of belief, which we define with the help of mythological texts and divine epithets, is not tantamount to using mythology as grounds for a claim about a mode of thought peculiar to the ancient Near East, especially one incapable of generating science. I have criticized this method in Chapter 1 as resulting in a literal-minded attribution to ancient Mesopotamia of a certain limited "mythopoeic," that is, irrational animistic, mode of cognition. Certainly, however, aspects of the world held by the scribes to be true in accordance with a particular "Mesopotamian" worldview are evidenced in mythological as well as scientific contexts. Accordingly, textual sources for these separate domains can and sometimes do exhibit a continuity of thought. The appeal therefore to evidence in the form of divine epithets, the prayer literature, and even mythological epic poetry as a method of piecing together elements of a system of belief that formed the context for Mesopotamian divination is, I think, fully justified.

Although celestial omen texts compiled lists of observable, or at least potentially observable, celestial phenomena, the evidence of the omen texts and their related literature points to a conception of the world order not as a mechanistic system, but as intimately tied to the creative acts of divinities. Some phenomena seem to have been perceived as manifestations of certain deities, for example, those of the moon as manifestations of the moon god Sin, those of Mars as manifestations of the god of pestilence Nergal, of Venus as the goddess Ištar, or of Sirius, "the Arrow," as manifestations of the warrior deity Ninurta. Such a presumed connection between natural phenomena and the actions and influences of deities within a contingent universe justified appeals to the responsible deities to undo or redirect bad portents. Divination thereby developed and maintained a close relationship to a form of theurgic magic.[2] By this comparison, no claim is made here of a Babylonian origin of the Neoplatonic system known from the reign of Marcus Aurelius and codified

[2] For a synopsis of apotropaic methods for release from bad omens, see Stefan M. Maul, "How the Babylonians Protected Themselves Against Calamities Announced by Omens," in Tzvi Abusch and Karel van der Toorn, eds., *Mesopotamian Magic: Textual, Historical, and Interpretative Perspectives* (Groningen: Styx Publications, 1999), pp. 123–9. See also E. Reiner, *Astral Magic in Babylonia* Transactions of the American Philosophical Society Vol. 85/4 (Philadelphia: American Philosophial Society, 1995), Chapter V, "Apotropaia."

in the *Oracula Chaldaica* of Julian the Theurgist.[3] The term is used here merely in the descriptive sense of a technique for communication with the gods.

Because all the phenomena of the physical world were interpreted as divinely ordered and ordained, and because the phenomena in the natural as well as the human experiential world were viewed as potential signs (roughly the equivalent of Greek *semeia* and Latin *omina*), these phenomena were believed to indicate to humankind the divinely determined events. Every phenomenon in heaven or on earth, every experience, every symptom of a disease, every birth and human physical attribute, were potential conveyors of divine messages, and so forecasts, or correlations to social, political, or economic events, were obtainable from all these phenomena. But within this vast field of omens, two broad classifications can be made. One category includes omens that were the messages from gods given in response to questions posed to them by various methods of manipulation by a diviner, what we call provoked omens (*auguria impetrativa*), and the other category includes omens that were "unprovoked" or simply observed by a diviner without a specific request for the appearance of a sign from a deity (*auguria oblativa*).[4]

Each of these types of omen would fall under the Ciceronian classification of "artificial" divination, which entailed a two-step process: first, the observation of a "sign" and second, the interpretation of what the sign

[3] Edouard Des Places, ed., *Oracles chaldaïques* (Paris: Société d'édition "Les Belles Lettres," in Collection des universités de France, 1971).

[4] These terms are used in I. Starr, *Queries to the Sungod: Divination and Politics in Sargonid Assyria*, SAA 4 (Helsinki: Helsinki University Press, 1990), p. xxxii. They are the equivalent of Oppenheim's categories of "magical" and "operational" divination; see his *Ancient Mesopotamia* (Chicago: University of Chicago Press, 1977), p. 207. See also the discussion in Jean Bottéro, *Mesopotamia: Writing, Reasoning, and the Gods*, trans. Zainab Bahrani and Marc van de Mieroop (Chicago: University of Chicago Press, 1992), p. 106, which, in a way similar to the categories of subjective and inductive divination of A. Bouché-Leclercq, *Histoire de la divination dans l'antiquité*, 4 vols. (Paris: Leroux, 1879–82), pp. 107–9, focuses on the difference between "prophecy" or direct divine communication on the one hand, and omens, or "deductive" divination, on the other. This categorization originates with Cicero, *De Div.* I vi 12, xviii 34, and xxxiii 72, in which Quintus offers the terms "artificial" and "natural," to distinguish between methods of obtaining knowledge from a divine source. The artificial method was available to one who studied and learned the techniques of interpretation of signs, whereas the natural method was the result of direct "prophetic" reception of divine knowledge. See also Ann K. Guinan, "Divination," in W. W. Hallo, ed., *The Context of Scripture* (Leiden/New York/Cologne: Brill, 1997), Vol. I, pp. 421–6.

forecasted by deduction.[5] This terminology has been adopted in the modern analysis of Mesopotamian divination, for example, by Bottéro, who speaks of *divination déductive*.[6] The important distinguishing feature of artificial divination, according to Quintus in Cicero's *De Divinatione*, was that it was in effect rational. One who was educated in the method could divine the future from signs by reason or deduction, without a native ability to communicate with the divine directly, such as in a prophetic frenzy. Various designations of those in the business of communication with the deity indicate that this distinction has validity within the Mesopotamian context. A scribe trained in the omen literature, and thereby a diviner by artifice, was designated by the title *ṭupšarru* (LÚ.DUB.SAR or LÚ.A.BA) "scribe," or *ummânu* (LÚ.UM.ME.A) "scholar" or "literatus." By contrast, the natural diviner was, in the Ciceronian sense, a "prophet" (*raggimu*, or the feminine "prophetess"[7] [*raggintu*]), an "ecstatic" (*mahhû*[8]), or a "seer" (*šabrû*[9]).

Impetrated omens came about through such techniques as oil divination, in which the diviner dropped oil into water, smoke divination, in which the smoke rising from a censer was interpreted as a response from the god, and extispicy, in which the diviner, in an incantation before an extispicy, sometimes requested that the gods "write" their answer on the liver.[10] The idea that the gods provide, or "write," signs, whether in the liver, in the divination bowl of the lecanomancer, or in the heavens, further testifies to the distinction between the deductive and hermeneutical methods of the diviner and the auditory hallucinations of the prophet.

[5] Cicero, *De Div.* I vi 12, xviii 34, xxxiii 72, and cf. II xi 27.

[6] J. Bottéro, "Symptomes, signes, écriture en Mésopotamie ancienne," in J. P. Vernant, ed., *Divination et Rationalité* (Paris: Éditions du Seuil, Recherches anthropologiques, 1974), pp. 70–196, especially pp. 99–122.

[7] Parpola has pointed out how the derivation from the verb *ragāmu* "to shout," or "shriek," or "to proclaim" is indicative both of the activity and of the mental state of the one delivering a prophetic oracle in his *Assyrian Prophecies*, SAA 9 (Helsinki: Helsinki University Press, 1997), p. xlv and notes 212 and 217.

[8] From the verb *mahû* "to be (come) frenzied" or "to go into a trance."

[9] This categorization is based principally on the evidence from the "terrestrial" omen series *Šumma ālu* (*CT* 38 4 81–88) where *šabrû* "seer" is found in association with the prophet and the ecstatic. See *CAD* s.v. *šabrû* B b) and Parpola, *Assyrian Prophecies*, p. ciii, note 222. Note also the equivalence between lú.šabra (PA.AL) and *raggimu* in *MSL* 12 226.

[10] See *BMS* 6:110 and W. R. Mayer *Untersuchungen zur Formensprache der Babylonischen 'Gebetsbeschwörungen,'* Studia Pohl, Series Maior 5 (Rome: Biblical Institute Press, 1976), p. 505:III, cited in *CAD* s.v. *šaṭāru* 1e.

Unprovoked omens were taken from the many observations of the behavior of animals, birds, insects, human beings, and heavenly bodies. The scribes devoted a separate divination series to a number of categories of "unprovoked" phenomena: Celestial phenomena were collected in the series *Enūma Anu Enlil* "When Anu and Enlil"; the terrestrial phenomena in the series *Šumma ālu* "If a city"; dreams in the series *Ziqīqu* "Dream god"; human physiognomical traits in the series *Alamdimmû* "The form"; anomalous animal births in *Šumma izbu* "If the anomalous newborn"; and medical symptoms in the series SA.GIG "Symptoms" (the first tablet of which was titled *Enūma ana bīt marṣi āšipu illiku* "When the magician goes to the house of the sick man"). A survey of these series follows in Section 2.2.

A compilation of hemerological omens, titled *Iqqur īpuš* "He tore down and rebuilt," gives indications for phenomena occurring or activities undertaken on different dates and organized by the twelve months of the year.[11] Some of the omens from the other major series are found excerpted in *Iqqur īpuš*, and part of it may well be a kind of calendrical supplement to the series *Šumma ālu* and *Enūma Anu Enlil*. The first sixty-six sections deal with human activities of daily life, such as are found in *Šumma ālu*. The seventh section, for example, which echoes the name of the series, has the omen "if he tears down his house" for each month of the year. Each section gives the consequences of the various actions were they to be done in a certain month, simply listing the twelve (or thirteen when an intercalary month is required) months of the year and giving forecasts for "the man" (who tears his house down), his wife, or indeed, the house itself ("that house will be scattered," "that house will be grand," "the foundations of the house will be unstable."). Alternatively, a version of *Iqqur īpuš* presented the same material organized by month instead of by activity. The last third of the series lists occurrences in nature by month of the year. These omens overlap to a great extent with the series *Enūma Anu Enlil* as they concern conjunctions of sun and moon, new moon, lunar and solar eclipses, haloes, rising and visibility of Venus, luminous phenomena, thunder, rain, clouds, earthquake, mudslide, and flood.

As observed by E. Reiner, another categorical distinction applies within the body of divinatory texts,[12] namely between the corpora whose object seems to be the foretelling of future events and those whose apodoses do

[11] R. Labat, *Un calendrier Babylonien des travaux des signes et des mois (séries Iqqur Îpuš)* (Paris: Librairie Honoré Champion, 1965).

[12] Reiner, *Astral Magic*, pp. 84–5.

not predict the future, but rather function as diagnosis. The "diagnostic" omens are collected within the two series SA.GIG, the medical diagnoses, and *Alamdimmû*, the physiognomic omens, which disclose a person's character based on physical as well as behavioral characteristics, such as "If he is obliging: people will be obliging to him," or, "If he is pusillanimous: he will be (easily) scared (from the so-called Sittenkanon, or guide to moral behavior in omen form[13]). The two categories defined in this way have a secondary and correlated distinction in whether the predicted or diagnosed consequence of the omen protasis was deemed avoidable or changeable by means of an appeal to the deity or deities with prayers and ritual acts. The prayers and rituals needed to counteract bad omens were written in texts termed *namburbû*, meaning literally "its (the omen's) undoing." *Namburbû* rituals were designed to dispel or avert the "evil" decisions of the gods portended in omen apodoses of both public and private effect, from a ritual "to prevent the evil portended by a snake from approaching a man" or against "the evil portended by a hole cut in a man's house," to the ritual "for the case when sun and moon have become a grievance to the prince and his country," or, indeed, "the apotropaic ritual against every evil."[14]

The diagnostic omens do not seem to have had their complement of apotropaia as did the predictive omens. It would seem, on this basis, that the diviners did not believe it was possible to undo the connection between one's personality or affective behavior and the effects these had in the world. Even within the physiognomic omen series, when an untoward event was forecasted for the individual – such as "If the hair on his head is sparse: His days (=life) will be short; he will become critically ill" – such forecasts do not appear to have been viewed as amenable to magical manipulation or appeal to the gods. Although an attribution to the god Nabû (?) of the ability "to turn an untoward physiognomic omen (*alamdimmû*) into something favorable" is made in a hymn to that deity,[15] no apotropaia against such omens are known.

Perhaps some aspect of the Babylonian conception of individual "fate" as a function of one's individual "nature" is discernible here. In the Babylonian sense, "fate," expressed with the term *šīmtu* "that which is

[13] F. R. Kraus, "Ein Sittenkanon in Omenform," *ZA* 43 (1936), pp. 77–113.

[14] See Maul, *Zukunftsbewältigung.*

[15] O. R. Gurney and J. J. Finkelstein, *The Sultantepe Tablets* I (London: The British School of Archaeology at Ankara, 1957), No. 71:20.

decreed," designated a disposition of some quality, right, or power from a higher authority to a lower subject. A person's nature seems to have been conceived of as the result of the allotment by a god of the characteristics and qualities possessed, as well as the length of life itself. Such was the individual's share or "lot" in life. The physiognomic omens served as indications of various characteristics or experiences in store for an individual, but could not be "undone" by ritual magic or prayer.

In the other, the predictive category, omens were susceptible to undoing by incantations and rituals addressed to particular gods. Recourse from unlucky portents, the results of divine "law," in the Babylonian conception, was through appeal to the gods, who were viewed as rulers with the power to "decide decisions" and "determine destinies." The resort to *namburbû* represented a theurgic form of magic and a thoroughly religious act, as it depended on a particular relationship between a human being and god, characteristic of ancient Mesopotamian religion, that involved a willingness on the part of the deities to listen to and respond favorably to the appeals of humankind.

Depending on whether the omen apodosis pertained to an individual or to the king, appropriate prayers would be recited with their accompanying ritual acts. In response to a snake omen, such as from the series *Šumma ālu*, an incantation to Šamaš makes this adjuration:

On account of the evil omen of a snake which I saw come right into my house for prey, I am afraid, anxious, frightened. Deliver me from this evil![16]

In the case of the private omens, a general entreaty to prevent anything bad from happening as a result of the ominous occurrence was addressed to Šamaš in the form of a *namburbû* prayer:

Šamaš, king of heaven and earth, judge of the things above and below,
light of the gods, leader of mankind, who acts as judge among the great gods!
I turn to you, seek you out: among the gods, grant me life;
may the gods who are with you grant me well-being.
Because of the dog who urinated on me, I am afraid, worried, terrified.
If only you make the evil (portended by) this dog pass by me,
I will readily sing your praise![17]

[16] Benjamin R. Foster, *Before the Muses: An Anthology of Akkadian Literature* (Bethesda, MD: CDL Press, 1993), p. 649.
[17] Foster, *Before the Muses*, p. 650.

In the private omens of *Šumma ālu*, occasionally brief instructions for undoing the predicted consequence of the omen are given in the omen text itself, with the assurance that, by performing the apotropaic act, the subject will "be released."

Apparently the timing of a ritual could be critical, which suggests the importance of hemerologies, such as the series *Iqqur īpuš* and other texts that indicate specific days considered favorable or unfavorable for the undertaking of certain activities. The following letter from a Neo-Assyrian royal scholar indicates the importance of correct timing in the performance of apotropaia:

Concerning the apotropaic ritual against evil of any kind, about which the king wrote to me "Perform it tomorrow" – the day is not propitious. We shall prepare it on the 25th and perform it on the 26th.[18]

That the use of theurgic magic presupposes the willingness of the gods to change the outcome of an omen is expressed in the next line of the same letter, in this statement by the scribe:

The king, my lord, should not be worried about this portent. Bēl and Nabû can make a portent pass by, and they will make it bypass the king, my lord. The king, my lord, should not be afraid.[19]

The phenomena and their correlations were set in relation to one another in the form of conditionals, that is, an if-clause (protasis) is followed by a then-clause (apodosis). Lists of such if–then statements were built up by a variety of methods and over long periods of time. The major texts in which omens are collected represent highly redacted scholarly works with well-defined manuscript histories. Despite the differences in subject matter, all omen text categories display this uniform and formulaic style.

The fomulation of the omens is the result of a particular scribal method of data collection and organization, seen early in the history of cuneiform writing, specifically in the organization of Sumerian lexical texts. In the lexical tradition, typically each entry, whether it is a single sign, a compound sign, or several words, was given its own line. If more than the space of a single line in a column of signs or words in a lexical list were needed, the scribes indented the part exceeding the alotted space. The same practice was followed in scholarly divination texts, in which omens consisted

[18] Parpola, *Letters from Assyrian and Babylonian Scholars*, No. 278.
[19] Ibid.

of fairly short subjects, many of which fit onto one line of a tablet. In the same way as in lexical lists, each new line was indicated by means of a vertical wedge. The adaptation of the vertical wedge to divination, however, caused a reinterpretation of its meaning. Instead of indicating "item," or the like, it came to represent the first word of the omen formula "if," that is, the Akkadian word *šumma*. Attested in later scholarly terminology is a term "the ifs," coined for the omens and written with the scholarly pseudologogram ŠUM.MA.ME.[20] The reinterpretation of the initial vertical wedge (DIŠ) as the lexeme *šumma* (if) in omen collections was, as noted by Oppenheim,[21] influenced by the casuistic formula of Sumerian and Akkadian law collections, in which the traditional Sumerian tukumbi "if" was rendered into Akkadian as *šumma* (if); hence a formal relationship between standard Old Babylonian legal formulary, exemplified by the Code of Hammurabi, and scholarly divination may be established. If, moreover, the lists of omens were viewed as collections of divine "verdicts," as indicated in prayers, incantations, and in the use of the term *purussû* "verdict" in the omens themselves to mean "apodosis," the parallel formulary between omens and laws is significant in more than a strictly formal way.[22]

Omen lists eventually attained standardized form, being divided into tablets according to subject matter and having each copy of a given series include the same tablet numbering and the same order of omens in each tablet. Catalogs compiled by scribes indicated the accepted standard order and number of tablets within a series. This order was indicated by lists of incipits and a final tally of the number of tablets contained in a series. Individual tablets typically ended with colophons indicating the number of omens on the tablet and the "catchline," or first line of the next tablet in the standard sequence. It must be stated, however, that the "standard" versions of omen series were not rigidly fixed. Some variation was apparently permitted, and omens designated as "noncanonical (BAR/ *ahû*)," are known for each of the series of unprovoked omens under discussion. The faithful copying of traditional omen texts therefore extended to

[20] Irving L. Finkel, "Adad-apla-iddina, Esagil-kīn-apli, and the Series SA.GIG," in Erle Leichty, Maria deJong Ellis, and Pamela Gerardi, eds., *A Scientific Humanist: Studies in Memory of Abraham Sachs*, Occasional Publications of the Samuel Noah Kramer Fund 9 (Philadelphia: Babylonian Section, University Museum, 1988), p. 152, note 82, in the summary to a catalog of SA.GIG ND 4358+ :93 to line A 93.

[21] Oppenheim, *Ancient Mesopotamia*, p. 211.

[22] For further discussion, see Section 5.4 and Subsection 7.3.2.

several variant traditions. Evidence for the rejection of certain omens as noncanonical, and therefore illegitimate, is completely lacking.[23]

The six series of unprovoked omens are subsequently surveyed individually and in more detail. However, it was the case that several sections from each one of these separate series appear to have been inserted within the framework of some other one of this group of "unprovoked" omen series. Omens from *Šumma ālu*, for example, can be found within the series SA.GIG, *Alamdimmû*, *Šumma izbu*, *Ziqīqu*, and *Iqqur īpuš*. Given the present state of our knowledge of the contents of these omen texts, the identification of which series borrowed from which other series is impossible to discern. Many omens from the general series of *Iqqur īpuš* may be found in *Šumma ālu*, specifically those concerning houses, repairs, digging wells, snakes, fields and gardens, rivers and floods, and activities of the king. The first two tablets of SA.GIG concern the things that may occur on the magician's way to the house of the sick person. The situations mentioned in these omens bear a close relation to some found in *Šumma ālu*, and some omens having to do with snakes, scorpions, lizards, and hawks are identical. Not all the contents of Tablets 1 and 2 of SA.GIG are repeated in *Šumma ālu*. And, more puzzling, there is a short section of SA.GIG, Tablet 2 (lines 78–81), concerning fire and lights. These are not parallel to the omens of *Šumma ālu*, Tablet 94, preserved in an excerpt text, which has omens from the appearance of lights around a sick person. Neither are the *birṣu*-omens about flashing lights from Tablet 21 of *Šumma ālu* the same as the *birṣu*-omens of SA.GIG, Tablet 2. Moreover, the omens that are parallel in these two series rarely occur in the same order or in identical contexts, and some do not have identical apodoses. In the series *Šumma izbu*, the tablets dealing with animal births, that is, Tablets 5 and 17–24, bear relation to some material in *Šumma ālu*'s omens about animals. Other aspects of animal behavior also correspond, but it is difficult to determine which series provided the material and which series represents the borrower.

In general, the way in which the signs were compiled and arranged in the various omen handbooks suggests that the diviners viewed the signs as forming a structurally complex but systematic whole. Protases illustrate a variety of schematic patterns into which phenomena were arranged. The

[23] Evidence for this claim is presented in F. Rochberg-Halton, "The Assumed 29th *aḫû*-tablet of Enūma Anu Enlil," in F. Rochberg-Halton, ed., *Language, Literature and History: Philological and Historical Studies Presented to Erica Reiner*, American Oriental Series 67 (1987), pp. 327–50.

schematic patterns typically exhibit symmetries of direction (right and left, up and down, or north, south, east, and west), temporal relationships (beginning, middle, end), or other descriptive features and their opposites (bright and dull, light and dark, thick and thin). One such scheme is found in the omens referring to the color of the object of interest, for example, the color of ants crossing the threshold of a house, the color of a lunar eclipse, the color of a sick person's throat, or the color of a dog that urinates on a man. These items from the series *Šumma ālu, Enūma Anu Enlil*, SA.GIG, and *Šumma izbu*, respectively, are all organized similarly, that is, white, black, red, green–yellow, and variegated, a standard set of colors utilized as well in Sumero–Akkadian lexical lists.[24]

Schematic patterns are also characteristically found in impetrated or provoked omens, such as lecanomancy (oil divination), such as "If (the oil) becomes dark to the right/left,"[25] or "If it dissolves to the right/left"[26]; libanomancy (smoke divination), for example, "If the smoke, when you scatter it, rises to its right but does not rise to its left," or "If the smoke, when you scatter it, rises to its left but does not rise to its right."[27] In the everyday life omens of *Šumma ālu* are omens for a house that has doors that are high, doors that are low, or if the doors open to the east, west, south, north.[28] Such simple symmetrical schemata do not represent the entire extent to which phenomena were arranged in omen texts. Nonetheless, the schematic organization of phenomena is so frequent and widespread enough throughout the divination literature (i.e., found in impetrated and nonimpetrated omens alike, be they oil, smoke, exta, astral, birth, or medical omens) that the schemata may be viewed as a characteristic feature of Mesopotamian divination and a clue to the categories by means of which natural phenomena were viewed by diviners.

The methods whereby a sign (omen protasis) was interpreted in a prediction (omen apodosis) seem to be held in common by all the omen series. Some of these methods constitute evidence that the omen, the link between the sign and its prediction, does not necessarily represent a record of an observed simultaneous or sequential occurrence of those two

[24] B. Landsberger, "Über Farben im Sumerisch-akkadischen," *JCS* 21 (1969), pp. 139–73.

[25] See *šumma ana imittim/šumēlim tarik, CT* 3 2:20–21.

[26] Ibid., lines 25–26.

[27] See UCP 9, pp. 373–7.

[28] Sally M. Freedman, *If a City is Set on a Height: The Akkadian Omen Series* Šumma Alu ina Mēlê Šakin, Vol. 1: Tablets 1–21, Occasional Publications of the Samuel Noah Kramer Fund 17 (Philadelphia: Babylonian Section, University Museum, 1998), Tablet 5, 66–67 and 71–74.

elements. Rather, it appears that associations between the sign and the predicted event could be made in a variety of "theoretical" ways, independent of any observation. The use of paronomasia, playing on the sound of a word from the protasis to a word in the apodosis, is one such method that appears to be a result of scribal imagination, presumably when the omens were being compiled and set down. In the dream omen series *Ziqīqu,* a dream in which a man eats a raven (*arbu*) portends income (*irbu*) for that man. Similarly, a dream that presents fir wood (*mihru*) portends no rival (*māhiru*) for the dreamer. In *Šumma ālu* an omen concerning spilled water links the appearance of the puddle – if it looks like "someone holding his heart" – to a prediction that the person "will experience heartache."[29]

Another common method was that of analogy. Simple analogies from form and appearance are found in the physiognomic omens, in which, for example, a short face means a short life, and its opposite, a long face, means a long life. A clear example from *Enūma Anu Enlil* is the omen that correlates the "entering" (usurpation) of the king's throne by the crown prince to the "entering" of the planet Venus within the moon, an expression used to describe the occultation of the planet by the lunar disk. Occasionally analogy also plays a role in the apotropaic manipulation of something designed to eradicate the evil predicted by a sign. There is a *namburbû* ritual against the "evil of a bow" (HUL GIŠ.PAN),[30] which calls for offerings to be made at separate altars to the god Ea and the goddess Ištar. The goddess Ištar, daughter of Anu, was identified with the heavenly Bow as a result of Anu's declaration in Tablet VI of *Enūma eliš,* the creation account, that the bow was "his daughter." Ištar therefore represents the Bow Star (Akkadian Qaštu, a star in the constellation Canis Minor).[31] Given the mythological equation of the Bow Star with Ištar, reflected in the scholarly substitution of the name Qaštu for the planet Venus, the planet associated with the goddess Ištar, the logic of the ritual is straightforward. The Bow Star receives supplication by means of sacrifice to Ištar, who stands for the star Qaštu. And when the Bow Star receives its supplication, the evil of the bow should be dispelled.

Symbolic association by analogy could be used to determine whether a sign was favorable or unfavorable. The lion, for example, was regarded as

[29] *Šumma ālu* Tablet 15:16, See Freedman, *If a City,* pp. 230–1.

[30] Reiner, *Astral Magic,* p. 88.

[31] A new identification of Qaštu as δ, ϵ, σ, ω Canis Minoris and κ Puppis, Hunger–Pingree, *Astral Sciences,* p. 271, sub Bow, replaces the earlier identification τ, δ, σ, ϵ + Canis Maioris in Reiner-Pingree, *BPO* 2, p. 11, sub BAN.

good, the dog as bad. Accordingly, omens comparing a person's features to a lion's face, hands, or toes are considered positive, whereas those comparing these same features to a dog are invariably bad; or, for example, the forecasts for the first two omens of the series *Šumma ālu* are "If a city is situated on a high place: the inhabitants of that city will not prosper," and "If a city is situated on low ground: the inhabitants of that city will prosper," suggesting that, from a Mesopotamian point of view, high ground was bad, low ground good. This may, however, be an example of *per contrariam* prediction, like that in *Ziqīqu*, Tablet IX, col. i, "If (a man) ascends to heaven: his days will be short," and "If he descends to the netherworld: his days will be long."

Other forms of symbolic association to the simple good–bad distinction can be identified. In the case of the common right–left polarity, for example, the lexical tradition attests to the association of good/pure/clean/fortunate with the right hand and bad/impure/dirty/unfortunate with the left. For example, the lexical text titled *Antagal* groups the terms [šu].silig = šu KU-*tum* "pure hand," [šu].silig.ga = *im-nu* "right hand," together with [šu] níg.gig = šu *ma-ru-uš-tum* "dirty hand," [šu] níg.gig.ga = *šu-me-lu* "left hand."[32] Concerning the use of the right–left polarity in omens, it appears frequently that right is good and left is bad (in which bad can be signified by the outcome's being good for one's enemy). Some examples from the anomalous birth omens of *Šumma izbu* are illustrative: The presence on the malformed newborn of a right ear but not a left is good, whereas a left ear without a right is bad.[33] A deformity to the right ear is bad, to the left ear is good.[34] Two right ears are good whereas two left ears are bad.[35] The same is applied to nostrils (having only a left nostril is bad, only a right is good,[36] hands and fingers,[37] feet and toes[38]). If an *izbu*, i.e., a malformed newborn (animal), has horns (Tablets V and IX) something pertaining to the right horn is good, to the left is bad, in the

[32] Antagal C 240–43, see *CAD*, Vol. 7 (Chicago and Glückstadt: The Oriental Institute and J. J. Augustin, 1960), p. 136 s.v. *imnu*, and *MSL* 17 201. This passage is discussed in the context of the complex meaning of the Sumerian níg.gig by M. J. Geller, "Taboo in Mesopotamia," *JCS* 42 (1990), pp. 105–17, esp. p. 109.

[33] E. Leichty, *The Omen Series Šumma Izbu*, Texts from Cuneiform Sources 4 (Glückstadt: J. J. Augustin, 1970), Tablet III:20–1.

[34] Ibid., III:5, 11, 14 and 16 and 9, 12, 15, and 17.

[35] Ibid., III:18 and 19.

[36] Ibid., III:30–1.

[37] Ibid., III:48–58.

[38] Ibid., III:58–62.

same way as with other features of the body. Similarly, in lunar crescent omens from the celestial omen series, in which the moon has "horns," if the moon's right horn "pierces the sky" there is a good outcome,[39] or if the moon's right horn is long and the left is short, this is a good omen.[40] Even the medical diagnoses follow the same principle. Symptoms observed on the right or the left will be interpreted as less severe or more severe respectively, for example, "If a man's right ear is discolored, his disease will be severe but he will recover," versus "If a man's left ear is discolored, he is in a dangerous condition."[41]

Structurally similar systems of symbolic association can be found in much anthropological literature, and investigation of dualistic polarities has also been pursued in the context of ancient Greek philosophy and science by G.E.R. Lloyd.[42] Although it may well be that structural elements such as up and down, right and left, and so on, are shared by many cultures for which inquiry into the nature of phenomena has given rise to descriptive analyses, the moral or spiritual associations attached to these descriptive categories are revealing of a given culture. Some of the methods by which the cuneiform scribes linked protases to apodoses, such as paronomasia, analogy, and contrast, can be identified directly from the omen texts. But how such connections originally came to be made between a "sign" and an "event" is entirely speculative.

As already stated, all Babylonian omens were formulated as conditionals: If x occurs (or has occurred), (then) y will occur. The grammar of the statement dictates that the verb of the protasis is in the preterite, "x occurs/occurred," and that of the apodosis is in the present–future aspect, "y will occur." The relationship between x the phenomenon and y the predicted event has given rise to much discussion, the consensus being that the relationship is not causal, but more of the order of simple association or correlation. The omen statement would be interpreted therefore, not as x causes y, but rather, if x, (expect also) y. In fact, the nature of the connection between protasis and apodosis is difficult to define, because

[39] H. Hunger, *Astrological Reports to Assyrian Kings*, SAA 8 (Helsinki: University of Helsinki Press, 1992), p. 35, No. 57:5.

[40] Ibid., No. 373:5 and No. 511:5'.

[41] R. Labat, *Traité akkadien de diagnostics et pronostics médicaux* (Leiden: Brill, 1951), p. 68: 1–2.

[42] G. E. R. Lloyd, *Polarity and Analogy: Two Types of Argumentation in Early Greek Thought* (Cambridge: Cambridge University Press, 1966), and idem, "Right and Left in Greek Philosophy," in G. E. R. Lloyd, ed., *Methods and Problems in Greek Science* (Cambridge: Cambridge University Press, 1991), pp. 27–48 with bibliography.

the manner in which a phenomenon came to be associated with an event that affected human lives (pestilence, war, rise or fall of prices, etc.) is not known to us. E. A. Speiser defined a principle of "circumstantial association" as the basis of all Mesopotamian omens.[43] His theory implied that not only was event y originally observed under certain circumstances represented by event x, but that in the Mesopotamian understanding the occurrence of the two events could not be due to chance. Consequently, whenever x would be observed again, it was to be interpreted as a warning of y. The circumstantial association thesis avoids the issue of causality, but does assume an empirical dimension, that is, that events x and y were observed to co-occur. This problematic claim is discussed at greater length in Chapter 7.

Nothing in the omens themselves suggests that the causal agent of the event predicted in the apodosis was the ominous phenomenon itself. Because the literature of hymns, prayers and other nondivinatory texts relating to the gods reflect the view that deities governed nature and all its phenomena, it seems only fair to assume that the phenomena were viewed as mere indicators, not causes of future events, the agencies of cause in the universe being limited to the gods. Because the universe, in ancient Mesopotamian terms, was not mechanistic but was affected by deities, the functioning relationship in Mesopotamian divination may be said not to be between sign and predicted event, but rather between the deity, or giver of signs and humankind, for whose benefit the signs were given. As already noted, the predictions given for signs were even sometimes termed *purussû* "(divine) decisions."

The conditional formulation of omens makes an explicit association between a sign in the protasis and an event in the apodosis. Although the predicted events may be regarded as divinely decided, the protases are nonetheless related to the apodoses in a formal way. Obviously not all relations are causal, but an analysis of the logical and physical relationship between the sign and its predicted event in the omen texts may in fact be describable in terms of cause in the following particular sense. This analysis is predicated on the assumption that the events forming both protasis and apodosis were viewed as recurrent. That is, if these events were believed to be irregular or random, there would be no point in recording the associations between protasis and apodosis for future consultation.

[43] E. A. Speiser, "Ancient Mesopotamia," in Robert C. Dentan ed., *The Idea of History in the Ancient Near East*, 4th ed. (New Haven, CT: Yale University Press, 1967), p. 61. See also J. J. Finkelstein, "Mesopotamian Historiography," *PAPS* 107 (1963), esp. pp. 463–4.

On this basis, the signs and their predicted events may be described in terms of a sense that conceives of cause as the repeated association of one thing with another, expressed by "if (or "whenever") x, then y." Whether the omens reflect a sequential relation between protasis and apodosis, "if x occurs first then y occurs next," or, alternatively, a co-occurrence, "whenever x occurs y also occurs simultaneously," is difficult to determine from the evidence of the omens. Regardless of whether x and y were sequential or coincident, the important element is their recurrence, that is, the particular instances are assumed to recur together, whenever the indicating phenomenon occurs. If such associations were believed to hold in every instance, then the associations that form the lists of omens can be said to represent a certain kind of lawlike statements, namely, that in which the particular association expressed between protasis and apodosis is believed to hold. We would not want to grant the status of law to the associations in omen statements because they in fact hold only for the single instance referred to in the omen. But the belief that events can be predicted also hints at something akin to a lawlike conception of the connection between protasis and apodosis, because the association of x and y enables the prediction of y whenever x.

These formal and logical relationships between elements of omens seem valid within the framework of the omen statements, but it must be remembered that alongside the omen lists were the apotropaia (*namburbû*) designed to subvert the association between protasis and apodosis by direct appeal to the gods. The reliance on apotropaic magic, which effectively asked the gods to undo the connection between the omen and its prediction, seems to undermine the entire logical structure of the omens. Implicit in each omen statement, at least those amenable to apotropaic means, is the possibility that some procedure will prevent the occurrence of the predicted event by persuading the gods to do so. As previously discussed, the application of magic pertained only to the omens whose apodoses contained predictions, not to those whose function was diagnostic, and especially not to those which seem simply to express truisms, such as "If someone heaps up straw in his silo: grain will be lacking in his house," and "If someone cultivates the clay-pit of the city: he will be impoverished."[44]

Apart from the question of whether the purpose of an omen was to predict the future or to diagnose an individual's character, the omen apodoses

[44] S. Moren, "A Lost 'Omen' Tablet," *JCS* 29 (1977), p. 67, lines 14 and 15.

had two basic applications, the public and the private. The public apo-
doses refer primarily to the king, who in effect represented the state and
the people as a whole. Matters relevant to the health and well-being of
the king, his palace, and his campaigns were common, as were subjects
of general economic significance, for example, the harvest, the coming
of destructive floods or locusts, and the like. Of all the categories of
unprovoked omens, only the series *Enūma Anu Enlil* seems to be exclu-
sively public in its interests. The anomalous birth, physiognomic, daily
life, dream, and medical diagnostic omens all contain forecasts referring
to the person associated with the event or condition described in the
protasis.

In the series *Šumma izbu*, the private apodoses refer to the owner of
the animal or the head of the household where the anomalous birth was
observed. This person is identified as *bēl bīti* "the master of the house,"
amēlu šû "that man," *amēlu* "the man," or even *bēltu* "the lady (of the
house)." For example, "If a woman gives birth to a dog: the owner of the
house will die, and his house will be scattered; the land will go mad; pesti-
lence."[45] A number of birth omens make forecasts for the child involved,
for example, "If a woman gives birth, and the chin (of the child) is short:
(the child) will be endowed with prosperity."[46] However similar protases
can have different targets, for example, "If a woman gives birth and (the
child) has no chin: the house of the man will be scattered"[47]; or a similar
protasis with a public apodosis: "If a woman gives birth, and the mouth
(of the child) is closed(?): a city will revolt and kill its lord; the settled
land will be conquered; the enemy will enjoy the harvest of the land;
ditto (i.e., same protasis) – there will be famine."[48] Indeed, the bulk of
the anomalous birth omens have public apodoses, much in the manner of
those of the celestial omens series *Enūma Anu Enlil*, as, for example, "If
a ewe gives birth to a lion, and it has the snout of a wild cow: the reign
of the king will not be prosperous." But the very similar "If a ewe gives
birth to a lion and it has the face of a pig," has the private apodosis "the
lady (of the house) will die."[49]

It was not until the Persian period that omens for the lives of individuals
were derived from celestial phenomena. These were not integrated within

[45] Leichty, *Izbu* I:7.
[46] Ibid., III: 36.
[47] Ibid., III: 35.
[48] Ibid., III: 38.
[49] Ibid., V: 55.

Enūma Anu Enlil but formed a separate category of nativities. These texts give the following sort of personal forecasts:

(If) a child is born in Taurus, the Bull of Heaven (is) Great Anu of heaven: That man will be distinguished, his sons and daughters will return and he will see gain.[50]

(If) a child is born and during his infancy a solar eclipse occurs: He will die in a foreign city (lit. in a city not his own) and the house of his father will be scattered.[51]

[A child is born and . . .] there will be anger in his heart . . . for 3 years whatever he takes(?) will not remain in his hands (meaning "he will lose what he has"?), (then) he will keep(?) his own property and will see a profit.[52]

These apodoses find their closest parallels in the physiognomic omens, as in the following omens:

If there is a mole on his right finger: He will suffer financial loss.[53]
If there is a mole on his right thigh: He will enjoy great[?] prosperity.[54]
If he has a mole on the right half of his thigh: His reputation will be damaged by his own doing.[55]

The Late Babylonian celestial and nativity omens, as well as texts designated in modern translation as "horoscopes," reflect distinct changes in celestial divination beginning in the Achaemenid and persisting through the Seleucid and Arsacid periods. Among a number of significant changes in celestial divination during these centuries was the expansion beyond the scope of prior concerns about state and king to a new concern for the individual. In parallel development, chronologically speaking, was planetary and lunar theory in Babylonian mathematical astronomy. The horoscope texts open the possibility of considering what connection, if any, there was between the two new developments. In particular, the degree to which various contemporary Babylonian astronomical practices, observational as well as computational, are reflected in the horoscope texts

[50] Thanks are due the Trustees of the British Museum for permission to cite BM 32224 ii 13′–15′, from an unpublished tablet in the British Museum.

[51] Thanks are due the Trustees of the British Museum for permission to cite BM 32488 obv. 10′, from an unpublished tablet in the British Museum.

[52] Thanks are due the Trustees of the British Museum for permission to cite BM 32304 ii 6, 8, 9, 10 from an unpublished tablet in the British Museum.

[53] A. Goetze, *Old Babylonian Omen Texts*, YOS 10 (New Haven, CT/London: Yale University Press, 1947), No. 54:8.

[54] Ibid., 20.

[55] Ibid., 24.

illuminates connections not otherwise apparent among the disparate astronomical text genres. Suffice it to say here that the astronomical data, that is, planetary positions as well as other phenomena regularly recorded in the horoscopes, for example, equinox and solstice dates, lunar longitudes, and eclipses, derive primarily from a variety of astronomical texts in which such data are collected (e.g., astronomical texts belonging to the ancient classifications of diaries and almanacs, for which see Chapter 4). In some few cases in which horoscopes cite solar or lunar positions in degrees and fractions of degrees of a zodiacal sign, we must consider the possibility that procedures akin to those known in Late Babylonian mathematical ephemerides may have been used to derive such solar or lunar data for use in horoscopy.[56]

The Mesopotamian practice of divination represents a tradition many centuries in development and differentiation. Enough evidence is extant to support a general claim that Mesopotamian scholarly, or literary, divination had Old Babylonian origins, placing the beginnings of the written omen tradition sometime in the early part of the second millennium (ca. 1800 B.C.). The textual tradition was generated wholly within an Akkadian context, with representative Old Babylonian exemplars of Šumma izbu, the dream book Alamdimmû, the celestial omens, and Bārûtu, the repertoire of the haruspex. These omen texts have no Sumerian forerunners or counterparts, although traces of the practice of divination as early as the Early Dynastic period are left by a number of professional titles for diviners already in the Early Dynastic period, such as azu, ugula.azu, máš.šu.gíd.gíd and ugula máš.šu.gíd.gíd,[57] and the fact that the early Lagashite ruler Urnanshe (twenty-fifth century B.C.) consults the ugula.azu "head diviner" in connection with building a temple.[58] Later Sumerian terms for cultic functionaries associated with divination and dream incubation

[56] Steele has in fact argued for this very point in "A 3405: An Unusual Astronomical Text from Uruk," pp. 103–35, especially pp. 132–5.

[57] A. Falkenstein, "'Wahrsagung' in der sumerischen Überlieferung," in La divination en Mésopotamie ancienne et dans les régions voisines: XIVe Rencontre Assyriologique Internationale (Paris: Presses Universitaires de France, 1966), pp. 45–68. See also J. Renger, "Untersuchungen zum Priestertum der altbabylonischen Zeit," ZA 59 (1969), p. 203, note 940. These professions are better attested in Old Babylonian, as outlined in detail here by Renger, and even occur in omen protases: "If he sees a diviner (bārû)/ an exorcist (āšipu)/ a physician (asû)."

[58] Finkelstein, "Mesopotamian Historiography," p. 464, note 12; for text, see F. Thureau-Dangin, Die sumerischen und akkadischen Königsinschriften, Vorderasiatische Bibliothek, 1 Bd., Abt. 1 (Leipzig: J. C. Hinrichs, 1907), pp. 6–7.

are known in Ur III (ca. 2100–2000 B.C.) economic texts,[59] and late third-millennium Sumerian literature also attests to the association of divination and cult. A cylinder inscription of Gudea, governor of Lagash (ca. 2140 B.C.[60]), suggests some aquaintance with dream omens, extispicy, and even celestial signs, and places divination in the context of a temple building ritual.[61] This poetic inscription describing Gudea's building of Ningirsu's temple Eninnu refers to the goddess Nisaba's consulting a tablet, dub mul.an "the tablet 'star of the heavens'" on her knee.[62] This tablet is also mentioned in the Sumerian composition "The Blessing of Nisaba," in which it is said to be made of lapis lazuli.[63] Just what the blue tablet "mul.an" refers to is not at all clear. Thorkild Jacobsen translated it as "a tablet (treating) of the stars above,"[64] W. Horowitz suggested a "replica or chart" of the sky, conceived of as a cosmic tablet, but Å. Sjöberg went another step and interpreted this mul as "script," thus "the tablet of heavenly writing,"[65] a most suggestive interpretation in view of the later Babylonian metaphor "the heavenly writing." Although the idea of divine communication through signs seems to be found as early as Mesopotamian culture itself, the existence of a written scholarly corpus of such signs and their meanings does not antedate the Old Babylonian period.

Support for Old Babylonian origins is available for most of the omen compendia known from the seventh-century scholarly library

[59] See *CAD* sub *bārû* discussion section, p. 125.

[60] P. Steinkeller, "The Date of Gudea and His Dynasty," *JCS* 40 (1988), pp. 47–53.

[61] Gudea *Cyl.A* xii 17; xiii 17; xx 5 refers to the performance of extispicy; and the dreams (máš-gi₆ "night vision") are found in i 18; i 27; xx 7–8. See Dietz Otto Edzard, *Gudea and His Dynasty*, The Royal Inscriptions of Mesopotamia, Early Periods, Vol. 3/1 (Toronto/Buffalo, NY/London: University of Toronto Press, 1997), pp. 69, 76–7, and 81. Note also the use of the word giskim "sign," viii 19; ix 9, and xii 11, Edzard, *Gudea*, pp. 74 and 76. See also U. Koch-Westenholz, *Mesopotamian Astrology: An Introduction to Babylonian and Assyrian Celestial Divination* (Copenhagen: The Carsten Niebuhr Institute of Near Eastern Studies, Museum Tusculanum Press, 1995), pp. 32–3.

[62] Gudea *Cyl.A* iv 26 and v 23. See Edzard, *Gudea*, p. 72.

[63] For The Blessing of Nisaba, see Å. Sjöberg and E. Bergmann, *The Collection of the Sumerian Temple Hymns*, Texts from Cuneiform Sources 3 (Locust Valley, NY: J. J. Augustin, 1969), 49:538–39. See also W. Hallo, "The Cultic Setting of Sumerian Poetry," in André Finet, ed., *CRRAI* 17 (1970), p. 125:29–31, cited in Horowitz, *Mesopotamian Cosmic Geography*, pp. 166–7.

[64] Thorkild Jacobsen, *The Harps That Once . . . : Sumerian Poetry in Translation* (New Haven, CT/London: Yale University Press, 1987), p. 393.

[65] Å. Sjöberg and E. Bergmann *Temple Hymns Sumerian*, p. 138b. Nisaba holds the "holy tablet of the heavenly stars/writing (dub.mul.an.kù)" as well in the composition "Nisaba and Enki," lines 29–33; see Hallo, "The Cultic Setting of Sumerian Poetry," pp. 125, 129, and 131.

of Aššurbanipal at Nineveh and elsewhere in first-millennium scribal centers. These include both the provoked and unprovoked types of omens: extispicy (*Bārûtu*), anomalous births (*Šumma izbu*), physiognomy (*Alamdimmû*), celestial (*Enūma Anu Enlil*), terrestrial (*Šumma ālu*), and dreams (*Ziqīqu*). Even in the absence of surviving tablets from the Old Babylonian period, Old Babylonian-style uncontracted writings and vestiges of the Old Babylonian way of writing certain syllables seen in later omen texts are generally regarded as orthographic indicators of an Old Babylonian origin.

The earliest extant omen texts place the origins of written, or scholarly, divination in the second millennium, that is, the Old Babylonian period. In view of the evidence from Sumerian literature, however, it is possible that the roots of that scholarly tradition may begin in an even earlier period in which the concepts of divinity and the relation between the gods and the world that support the belief in divination were first formed and are expressed in mythology and poetry. P. Huber has advanced the hypothesis that some lunar-eclipse omen apodoses may refer to historical events from periods before the Old Babylonian period, specifically, the Akkadian and the Ur III periods, thereby attesting already to the existence of celestial divination in the third millennium B.C.[66] The omen texts, however, do not make mention of royal names or specific events, but remain typically vague in their reference to "the king of Agade" or "the king of Ur," and such events as "the reign of Agade will fall into anarchy, but its future will be good,"[67] or "the grandson, descendant of the king, will seize the throne."[68] Nevertheless, the oldest known omen texts in the form of scholastic collections date from the late Old Babylonian period, and, in the category of unprovoked omens, are limited to forerunners of *Enūma Anu Enlil*, *Šumma izbu*, *Šumma ālu*, *Ziqīqu*, and *Alamdimmû*. By far the bulk of surviving exemplars of scholarly omen series come from the palace of Aššurbanipal, who acquired these series in the building of his reference library. Copies continued to be transmitted through the Persian and into the Seleucid periods, testifying to the preservation of the traditional texts by scholar–scribes whose work was by then supported not by the palace but by the temple.

[66] Peter J. Huber, "Dating by Lunar Eclipse Omens with Speculations on the Birth of Omen Astrology," in J. L. Berggren and B. R. Goldstein, eds., *From Ancient Omens to Statistical Mechanics: Essays on the Exact Sciences Presented to Asger Aaboe* (Copenhagen: University Library, 1987), pp. 3–13.

[67] *Enūma Anu Enlil* 20 I B 7; see *ABCD*, p. 182.

[68] *Enūma Anu Enlil* 20 IV B 7; see *ABCD*, p. 194.

2.2 A DESCRIPTIVE SURVEY OF THE "UNPROVOKED" OMEN TEXTS

2.2.1 Celestial Omens (*Enūma Anu Enlil*)

Anu and Enlil were the deities of sky and earth, respectively. As the two leading members of the Babylonian pantheon, these gods figured in much of the aetiological mythology of the world order traceable in Sumerian and Sumero–Akkadian versions. In some versions of their mythology, Enlil is descended from Anu.[69] In the myth of *Atrahasīs* (Tablet I, 11–16),[70] Anu and Enlil with Enki cast lots and divided the universe. Anu went to heaven, Enlil to earth, and Enki received the waters, particularly the sweet underground-spring waters. In the Sumerian composition "Gilgamesh, Enkidu, and the Netherworld," these deities are said to have taken possession of their respective cosmic regions immediately on their differentiation from the primordial unity:

After heaven had been moved away from earth,
After earth had been separated from heaven,
After the name of man had been fixed;
After An had carried off heaven,
After Enlil had carried off earth,
After Ereshkigal had been carried off into Kur (the Netherworld) as its prize [71]

By the seventh century B.C., a version of *Enūma Anu Enlil* was in the holdings of the library of Aššurbanipal at Nineveh. This Neo-Assyrian *Enūma Anu Enlil* comprised seventy tablets devoted to "celestial" signs, meaning any visible (or anticipated) phenomenon occurring in the sky during the day or night. Weather phenomena, especially cloud formations and other features of the daytime sky, counted as "celestial phenomena" along with lunar, solar, stellar, and planetary phenomena.[72] *Enūma Anu*

[69] See K. Tallqvist, *Akkadische Götterepitheta* (Hildesheim/New York: Georg Olms Verlag, 1974), p. 297.

[70] W. G. Lambert and A. R. Millard, *Atra-Hasīs: The Babylonian Story of the Flood* (Oxford: Clarendon, 1969), pp. 42–3.

[71] Lines 8–13; see S. N. Kramer, *Sumerian Mythology* (New York/Evanston/London: Harper & Row, 1961), p. 37. Cf. the edition of Aaron Shaffer, *Sumerian Sources of Tablet XII of the Epic of Gilgamesh*, Ph.D. dissertation (Philadelphia: University of Pennsylvania, 1963), pp. 48–9 and 99 for a slightly different rendering of these lines.

[72] Textual sources may be found in *ACh, BPO* 1, 2, and 3, *ABCD*, W. H. van Soldt, *Solar Omens of Enūma Anu Enlil: Tablets 23 (24)–29 (30)* (Leiden: Nederlands Historisch-Archaeologisch Instituut Te Istanbul, 1995) and L. Verderame, *Le Tavole I-VI della Serie astrologica Enūma Anu Enlil*, Nisaba 2 (Messina: Dipartimento di science dell'antichità, Università di Messina, 2002).

Enlil Tablets 1–22 contain the manifestations of the moon god Sin and include such phenomena as the dates and duration of lunar visibility, the appearance of the "horns" of the lunar crescent, a variety of halos seen around the moon, eclipses, and conjunctions with planets and certain fixed stars. Great interest in the moon's position with respect to the sun is evident, the most important synodic moments for the omen protases being the day of the first lunar crescent or the first day of the Babylonian month, and opposition, the day of full moon, considered ideally to fall on the fourteenth day. The lunar section of *Enūma Anu Enlil* is itself divided into two parts focused on these times in the lunar synodic cycle: Tablets 1–14 deal with the appearance of the moon in its first crescent, termed *tāmarāti* (IGI.DU₈.A.MEŠ) *ša Sin* "the visibilities of the moon," and Tablets 15–22 concern the middle of the month when eclipses occur. *Enūma Anu Enlil* Tablets 23–36 relate to the sun god Šamaš. In the solar section, phenomena such as coronas, parhelia, and eclipses are found. *Enūma Anu Enlil* Tablets 37–49/50 relate to the storm god Adad, and include such occurrences as lightning, thunder, rainbows, cloud formations, earthquakes, and winds. Finally, *Enūma Anu Enlil* Tablets 50/51–70 contain planetary signs such as the positions of planets with respect to stars or other planets, first and last visibilities in the morning, evening risings, a diverse array of descriptions of the appearances of planets in terms of their luminosity or color, as well as prognostications for fixed stars. The terrestrial events recorded in the apodoses are almost entirely public concerns. Of uppermost importance are conditions concerning the prosperity or downfall of the king and his army, or the country as a whole and its enemies. Floods, crop failure, and pestilence also frequently appear.[73]

The integration of heavenly phenomena, that is, lunar, solar, and planetary, with weather and optical phenomena of the atmosphere says something about the conception of "astronomical phenomena" as a category. Perhaps the distances from the observer to any of these phenomena was not considered to be greatly different, in which case clouds or meteors would not be different from stars in our sense of their being nearer to earth.[74]

In several respects, the phenomena comprising the omens of *Enūma Anu Enlil* cannot be regarded as representing observed occurences. Some

[73] These are typical concerns of general astrology and were transmitted to Greek astrology as shown by Ptolemy, *Tetrabiblos* Bks I–II.

[74] The few texts (for which, see Horowitz, *Mesopotamian Cosmic Geography*, pp. 177–87) that concern or make reference to distances in the heavens between stars or between cosmic regions do not shed light on the question of whether relative distances of celestial objects from earth were ever considered.

phenomena are included in the text that are simply unobservable. The schematic arrangement of omens for lunar eclipses, for example, takes into account all four cardinal directions, that is, the east, west, north, and south sides of the lunar disk. Because the moon travels in an easterly direction from the point of view of an observer on earth, an eclipse will never be seen to begin on the west side of the moon. Nonetheless, the "sides" of the moon represent quadrants of the lunar disk, termed right, left, upper, and lower parts. These in turn are correlated with geopolitical regions of the world where the evil of the eclipse is to have its effect. In this way all four divisions of the lunar disk could be worked into a scheme for associating eclipses with parts of the world to be affected by the eclipse. In the case of protases that are potentially observable, none of the astronomical phenomena cited in the protases of *Enūma Anu Enlil* are likely to represent actual datable observations, with the possible exception of parts of Tablet 63.[75]

Old Babylonian celestial omen texts are concerned primarily with lunar eclipses, although solar and weather omina occur as well. It is already clear that aspects of lunar eclipses, such as the date, time, duration, and direction of the motion of the eclipse shadow, were observed and recorded in such a way as to permit future reference to and checking of eclipses. The following excerpt is from an unpublished Old Babylonian list of lunar eclipse omens. Note the absence of the formulation with "if":

An eclipse in the evening watch is for plagues.

An eclipse in the middle watch is for diminished economy.

An eclipse in the morning watch is for [the curing of illnesses].

The right side of the eclipse was crossed; nothing was left: There will be a devastating flood everywhere.

An eclipse in its middle part; it became dark all over and cleared all over: The king will die; destruction of Elam.

An eclipse began in the south and cleared: Downfall of the Subarians and Akkad.

[75] For discussion of this aspect of Tablet 63, so critical to arguments for chronology, see H. Gasche, J. A. Armstrong, S. W. Cole and V. G. Gurzadyan, *Dating the Fall of Babylon: A Reappraisal of Second-Millennium Chronology*, Mesopotamian History and Environment Series II, Memoirs IV (Ghent: University of Ghent and the Oriental Institute of the University of Chicago, 1998), and the review by Peter J. Huber in *AfO* 46/47 (1999/2000), pp. 287–90. See also Peter J. Huber, "Astronomical Dating of Ur III and Akkad," *AfO* 46/47 (1999/2000), pp. 50–53, idem, "Astronomy and Ancient Chronology," *Akkadica* 119–120 (2000), esp. pp. 159–66.

An eclipse in the west: Downfall of the Amorites.

An eclipse in the north: Downfall of the Akkadians.

An eclipse in the east: Downfall of the Subarians.

The moon rose darkly (=eclipsed) and cleared: Omen of the destruction of Elam and Gutium.[76]

The text continues with omens for eclipses on different dates, beginning with the 14th of *Nisannu*, followed by the 15th, 16th, 19th, 20th, and 21st, then the same days of the second month and so on through the calendar year, including the intercalary twelfth month, *Addaru arkû*. The lunar-eclipse omens are placed within a 7-day period beginning in the middle of the month, but clearly the days on which opposition of the sun and the moon occur are not the only days given over to eclipse omens.

Three of the four extant Old Babylonian lunar-eclipse tablets comprise a single corpus of eclipse omens, albeit not a fully standardized corpus. Textual variants are numerous, but only within the framework of the fixed set of omens (protasis + apodosis) representing the systematic organization of phenomena observed during lunar eclipses. The fourth text is an excerpt from Months XI–XII$_2$ of the other three texts. In the Old Babylonian texts the foundation can be seen for practically all the later lunar-eclipse omens, including those attested in Middle Babylonian, Middle Assyrian, and those of standardized Tablets 15–22 of the *Enūma Anu Enlil* known from the library at Nineveh. The thematic elements and organization of the protases of the four Old Babylonian eclipse omen texts are seen to continue throughout the later recensions of the series. A comparison between the apodoses of the Old Babylonian texts and those of *Enūma Anu Enlil* proper further serves to identify specifically the Old Babylonian exemplars as forerunners to *Enūma Anu Enlil* Tablets 17–18.

A coherent reference work for scholars engaged in the study and interpretation of the heavens seems to have been compiled during the Kassite Period around the thirteenth to twelfth centuries, at roughly the same time as the standardization of many works of Akkadian literature.[77] The

[76] BM 22696 obv. 1–12, unpublished tablet in the British Museum cited with kind permission from the Trustees of the British Museum.

[77] See F. Rochberg-Halton, "Canonicity in Cuneiform Texts," *JCS* 36 (1984), pp. 127–44, and literature cited therein. See also idem, "The Assumed 29th *ahû*-tablet of *Enūma Anu Enlil*." For a much broader discussion of canonicity in cuneiform texts with bibliography, see William W. Hallo, "The Concept of Canonicity in Cuneiform and Biblical Literature: A Comparative Appraisal," in K. Lawson Younger, Jr., William W. Hallo, and Bernard F. Batto, eds., *The Biblical Canon in Comparative Perspective: Scripture in Context IV, Ancient*

material in the Old Babylonian forerunners to the canonical series is embedded within the later text. *Enūma Anu Enlil* Tablets 17 and 18 in particular reflect a strong Old Babylonian foundation. Although the compendium in its Neo-Assyrian form seems to have had the character of a reference handbook, in the sense of numbered tablets containing sets of omens of a given content, the textual tradition was not rigidly fixed, and it seems that the work maintained various recensions. Nonetheless, catalogs of *Enūma Anu Enlil* were eventually produced, listing the tablets by number and incipit, and commentary texts referred to the work by tablet number. At an early date, the compendium was given the title *Enūma Anu Enlil*, after the three opening words of its bilingual (Sumerian and Akkadian) introduction[78]:

When An, Enlil, and Enki, the great gods, in their firm counsel established as a great "me" of heaven and earth the boat of Sin (crescent moon), they established the waxing of the crescent moon, the renewal of the month and the sign of heaven and earth. (Sumerian text)

Or, alternatively, When Anu, Enlil, and Ea, the great gods, by their firm counsel established the designs of heaven and earth and (also) established that the creation of the day (and) the renewal of the month for humankind to see were in the hands of the great gods; (then) they saw the sun in (his) gate (and) they made (him) appear regularly in the midst of heaven and earth. (Akkadian text)

Despite the existence of recensions and supplementary (noncanonical) collections of omens, we can refer to a standard work titled *Enūma Anu Enlil* for which there are extant multiple copies, ancient catalogs presenting the work as a series with numbered tablets and commentary texts referring to these tablets by number. The scholars who transmitted the celestial omen series and who observed the heavens in order to check the expected results in *Enūma Anu Enlil* were also known as the "scribes of *Enūma Anu Enlil.*"

The body of knowledge mastered by the scribes of *Enūma Anu Enlil* was that of the series *Enūma Anu Enlil* as well as the related literature of celestial science, especially the compendium MUL.APIN.[79] This knowledge was

Near Eastern Texts and Studies (Lewiston/Queenston, Ontario/Lampeter: Edwin Mellen Press, 1991), Vol. II, pp. 1–19.

[78] See L. W. King *Enuma Elish: The Seven Tablets of Creation*, vol. 1 (London: Luzac, 1902), pp. 124–7 and Vol. 2, pl. 49, *ACh* Sin 1, 2, S. Parpola, "A Letter from Šamaš-šumu-ukīn to Esarhaddon," *Iraq* 34 (1974), p. 26, and U. Koch-Westenholz, *Mesopotamian Astrology*, pp. 76–7.

[79] Hunger-Pingree, *MUL.APIN*.

therefore deductive rather than intuitive. Interpretation of heavenly phenomena was not a matter of direct communication from god to diviner, but a result of an understanding of celestial phenomena and hermeneutic interpretation of the *Enūma Anu Enlil* text. The term "*ṭupšar Enūma Anu Enlil*" therefore designates a scribe who specialized in celestial science. The inclusiveness of this designation underscores the close relationship between astrology and astronomy, but the training and knowledge of a scribe referred to as such necessarily changed over the course of the 500-year span from the Neo-Assyrian period to the Arsacid period. Although the term occurs in texts over the course of this long period, including colophons of the late mathematical astronomical texts, Babylonian celestial sciences of the last three centuries B.C. differed considerably from those of the seventh century B.C.

By contrast with other categories of ominous phenomena, some of the celestial phenomena, because of their cyclical nature, were and are amenable to the recognition of periodic recurrence. This was obviously not employed as a criterion for ominous celestial phenomena, many of which were not periodic, yet this aspect is one which distinguishes *Enūma Anu Enlil* from other omen series. Well before Babylonian astronomy developed methods of predicting astronomical phenomena such as lunar eclipses and synodic planetary phenomena, omen lists already reflected an empirical foundation and attested to a systematic practice of observation, as well as, in some cases, the recognition of crude periodicities.

The Old Babylonian lunar-eclipse omens therefore give lunar-eclipse omens for the days around opposition, when lunar eclipses indeed occur. Additionally, the reddish color of the moon during total eclipses, the various times of night when the eclipse occurs, and the duration are all appropriate phenomena relevant to eclipses. By Neo-Assyrian times, lunar-eclipse omens became more descriptive and detailed, such as in the following example from *Enūma Anu Enlil* Tablet 20:

If an eclipse occurs on the 14th day of *Ṭebētu*, and the god (=the moon), in his eclipse, becomes dark on the east upper part of the disk and clears on the west lower part; the west wind (rises and the eclipse) begins in the last watch and does not end (with the watch); his cusps are the same (size), neither one nor the other is wider or narrower. Observe his eclipse, i.e., of the moon in whose eclipse the cusps were the same, neither one being wider or narrower, and bear in mind the west wind. The prediction (lit. verdict) applies to Subartu. Subartu and Gutium. . . . brother will smite brother; the people will suffer defeat(?); there will be many widows; the king of Subartu will make peace with the lands. . . . It

(the eclipse) began in the middle watch and did not end (the *watch*). Thus is its omen and its consequence (lit. verdict).[80]

It is noteworthy here that the moon is referred to as "the god." This term was interchangeable with the other two names for the moon, that is, ^dSin, the name of the moon god, or ^d30, one of the logographic writings of the name Sin. Elsewhere in *Enūma Anu Enlil*, in the lunar, solar, and planetary omens, some celestial phenomena were described in metaphorical terms that called on anthropomorphic images. The metaphors refer in each case to the particular diety of which the heavenly body is considered to be a manifestation. The heavenly body is in this way personified as a god. The behavior of the god in turn becomes a vehicle for describing the appearance of the heavenly body. We must, however, interpret the two as separate, otherwise the "omen" would no longer refer to a physical sign, but would merely stand as a statement about a god, having no physical reference. One example is the use of the expression "the moon god mourns," or "cries," as a metaphor for the state of being eclipsed. The use of metaphorical language in the omens has the force of conveying the appearance of something observed, or potentially observable, and thus constitutes suggestive evidence for how the ancient Mesopotamians conceptualized some natural phenomena as manifestations of gods. Undoubtedly this manner of conceiving of the celestial phenomena rendered this particular sphere of nature of special interest for the watching of signs.

Another example of the descriptive nature of the celestial omens can be seen in the following from the solar section of *Enūma Anu Enlil*, Šamaš Tablet 23. Here the predictions include weather, celestial phenomena as well as mundane phenomena. In this example the prediction of a solar eclipse at the end of the month is given, based on the appearance of the sun on the first of the month. The prediction of weather and eclipses is paralleled in other omen series, such as *Šumma ālu*. Note also the use of the color schema in the omens referring to clouds seen with the sun:

If the sun is red like a torch when it becomes visible on the first of *Nisannu*, and a white cloud moves about in front of it, variant: stands at its side, and the east wind blows: in *Nisannu* the east wind will blow and in that month, on the 28th, 29th, or 30th an eclipse of the sun will take place and during that eclipse, . . . , variant: in that month the king will die and his son willl seize the throne, and the land, . . . , variant: the land will be happy, the sky will . . . its rains, and the earth its produce in the proper season.

[80] Adapted from *ABCD*, p. 209.

If the sun is yellow when it becomes visible on the first of *Nisannu*, and its light is, . . . , in that month an eclipse will take place and, since its appearance is yellow, . . . , or an enemy will rise and defeat the king's troops and . . .

If the sun when it becomes visible on the first day of *Elūlu* appears in a black cloud and when it sets it does so in a black cloud, variant: there is a black cloud in front of the sun: a light rain will fall during the first night watch, on the second day the day will be gloomy and the south wind will blow, Adad will thunder, a light rain will fall at midday; if during that month Adad does not thunder, the day will be frequently gloomy but it will not rain.

If the sun when it becomes visible on the first day of *Elūlu* appears in a black cloud and when it sets it does so in a black cloud and the east wind blows: in that month the day will be frequently gloomy and heavy rain, variant: little rain will fall, there will be rains in the latter part of the year and the land's harvest will prosper.

If the sun when it becomes visible on the first day of *Arahsamna* appears in a yellow cloud and when it sets it looks as when it became visible: in that year heavy rain will not fall, the west wind will abate, variant: there will be west wind, and there will be ice, variant: snow, the country will decrease, until the 30th day (*are*) *its appearances* and then it will rain.[81]

Perhaps most clearly representative of a desire to render celestial phenomena predictable is *Enūma Anu Enlil* Tablet 14, which contains no omens but instead provides an arithmetical scheme concerning the duration of visibility of the moon each night. The significance of Tablet 14 for the history of astronomy lies in its status as one of the earliest pieces of evidence for the application of a particular methodology that, much later and in a more sophisticated form, still characterized a large part of Hellenistic astronomy. This methodology is defined as arithmetical or linear because it is characterized by difference sequences of first (or higher) order. Linear methods are typical of Babylonian mathematical astronomy and all those forms of Hellenistic Greek astronomy that derived from the Babylonian tradition.

The simplest of the early applications of arithmetical or linear methods is found in the treatment of the variation in length of daylight throughout the year. Empirical observation was necessary to establish the basic grounds of the early numerical scheme for daylight length, and evidence of such observation is preserved not only in the omens of *Enūma Anu Enlil*, but also in the early cuneiform astronomical compendium MUL.APIN, in

[81] Translation based on van Soldt, *Solar Omens of Enuma Anu Enlil: Tablets 23 (24)–29 (30)*, pp. 5–11.

which, among many other phenomena, the shadow lengths of a gnomon are tabulated.

The daylight scheme according to MUL.APIN and another group of early texts called Astrolabes lies at the basis of the model of lunar visibility given in *Enūma Anu Enlil* Tablets 14. This scheme gives the length of day at the equinoxes as 3 (=3,0 or 180° = 12 hours), representing one-half of a 24-hour period. The daylight increases steadily until it reaches a maximum of 4 at summer solstice, then decreases steadily to the equinoctial point and continues decreasing until it reaches a minimum value of 2 at winter solstice. These values are given in MUL.APIN II i 9–18 for the lengths of day and night at the cardinal points of the year, and MUL.APIN states that "the sun which rose towards the north ... turns and keeps moving down towards the south at a rate of 40 NINDA per day. The days become shorter, the nights longer."[82] The constant rate of change in the length of daylight, given as 40 NINDA per day, is equivalent to the change given in the scheme underlying *Enūma Anu Enlil* Tablet 14 as 0;20 (= 1/3) per month. The scheme assumes perfect symmetry among the lengths of all four seasons and also of the lengths of days throughout the year. To represent and account for the inequality of the seasons, whether it was known empirically by the Babylonians at this stage or not, was beyond the capability of their numerical scheme.

Although the entries in the columns of Tablet 14 are not omens, the scribe has nonetheless introduced each line of the numerical table with the phrase "if the moon." In the first column, numerical values are tabulated not only with days of an ideal 30-day month, but on the assumption that the length of each daylight (or in this case night, as it deals with visibility of the moon at night) is that of the equinox, precisely 1/2 day or 12 hours. In the second and third columns, the function for lunar visibility is derived from the lengths of night. Values for the change in lunar visibility are obtained by multiplication of the length of night by 1/15. This implies that the daily increment of the interval sunset to moonset in the first half of the month and sunset to moonrise in the second half of the month is equal to 1/15 of the night, whatever that may be in time degrees depending on the month of the year. In other words, the daily retardation of the appearance of the moon is computed by a factor of 1/15 of night, in terms of the intervals sunset to moonset or sunset to moonrise. Column three forms a zigzag function of daily difference 0;2,40°, a maximum value of 16 and a minimum of 8. From the value for the constant difference (0;2,40°), the daily difference for the lunar visibility can be calculated for any date.

[82] Hunger-Pingree, *MUL.APIN* II i 11–13.

And from this interpolated value, the lunar visibility can be obtained by multiplication by the desired day of the month.

Planetary phenomena were less relevant to the concerns of the calendar than were the appearances of the moon. Yet planetary appearances were arranged into the omen tablets comprising approximately the last twenty tablets of *Enūma Anu Enlil*. Tablets 59–63 concern the planet Venus, whereas 64 and 65 deal with Jupiter. Tablet 64 begins with this omen: "If Jupiter remains in the sky in the morning: enemy kings will become reconciled." Perhaps one or two tablets were devoted to Mars, although their numbering in the sequence is unknown. Mercury and Saturn have omens as well, but are less well represented. Omens for fixed stars and constellations, contained in Tablets 50–51, sometimes include the appearances of the five planets:

If at Venus's rising the Red star enters into it: the king's son will seize the throne.

If at Venus's rising the same star enters into it and does not come forth: the king's son will enter his father's house and seize the throne.

If the Bow comes close to UD.AL.TAR (Jupiter): Elam will eat fine food.[83]

One planetary tablet that has received much attention is the so-called Venus Tablet of Ammiṣaduqa, or *Enūma Anu Enlil* Tablet 63. This text became important for modern scholars because it was thought to provide astronomical data datable to the First Dynasty of Babylon, specifically the first half or more of the reign of Ammiṣaduqa (1646–1626 B.C.). These data were considered to be crucial for establishing the relative chronology of the ancient Near East based on the fixing of a date for the First Dynasty of Babylon. *Enūma Anu Enlil* Tablet 63 can be divided into four sections. Sections I and III concern pairs of last and first visibilities of Venus. The omens of Section II (omens 22–33) begin with the appearance of Venus and follow the pattern "In month M_1, day n, Venus appeared in the east/west: apodosis$_1$; it remains present in the east/west until month M_2, day n; it disappears in month M_2, day $n+1$, and remains invisible for 3 months/ 7 days; in month M_3, day n (=Month M_2 day $n+1$ plus 3 months or 7 days), it rises in the west/east: apodosis$_2$," for example, omen 22:

If on the second day of *Nisannu* Venus appears in the east: there will be mourning in the land; it remains present in the east until the sixth day of *Kislīmu*; it disappears on the seventh of *Kislīmu* and remains invisible for three months; on the eighth day of *Addaru* Venus rises in the west: king will send messages of hostility to king.[84]

[83] Reiner-Pingree, *BPO* 2, p. 49, Text VI 5, 5a, and p. 67, Text XIII 8.

[84] Reiner-Pingree, *BPO* 1, p. 39.

An excerpt of *Enūma Anu Enlil* Tablet 63 is also included in the series *Iqqur īpuš*.[85]

The apodoses in *Enūma Anu Enlil* concern the health and life of the body politic rather than those of the individual. Predictions commonly found in this series refer to agricultural concerns (the harvest, scarcity of rainfall, devastating floods) and political concerns (the king's military campaigns, diplomatic relations, downfall of kingdoms), for example, from Tablet 63:

The harvest of the irrigated land will prosper, the land will be happy.
There will be scarcity of barley and straw in the land.
The arable land will prosper.
There will be rains and floods, the harvest of the land will prosper.
Downfall of a large army.
Adad will bring his rains, Ea his floods, king will send messages of reconciliation to king. There will be hostilities in the land.

Although groups of "astrological" sources covering the period from the late second millennium to the first century B.C. may be enumerated, the chronological as well as the cultural gaps between these groups, as well as the sheer unevenness of the available material (e.g., two letters in the Mari archive relevant to the practice of celestial divination versus hundreds from the Sargonid archive of correspondence between king and scholars, or five Old Babylonian celestial omen tablets versus seventy in the corpus from Nineveh), place tremendous limitations on our ability to reconstruct "a history" of Babylonian celestial divination. Only from the seventh century B.C. is there enough evidence, apart from the copies of *Enūma Anu Enlil*, to gain some insight into the practical application of celestial divination.

This evidence comes in the form of letters from diviners, magicians, lamentation priests, and other kinds of scholars to two kings of the Sargonid dynasty. The correspondence between Assyrian and Babylonian scholars and the kings Esarhaddon and his son Aššurbanipal attests to the expertise of the diviners not only in the celestial and other omen literature, but also in incantations, rituals, and sacrifices necessitated by ominous signs. As evidenced by the Neo-Assyrian royal correspondence, such scribes not only knew what to watch for in the heavens and when, as well as where to find the corresponding prognostication in the compendium *Enūma Anu Enlil*, but also knew what to do in magical or cultic terms about one's findings in the text, and to advise the king accordingly.

[85] Labat, *Calendrier*, p. 200, Section 104A.

Because the affairs of state, not the least of which was the fate of the king, were the very things of central import in the omen apodoses, a regular watch of the heavens, and interpretation of what was observed by reference to the forecasts contained in the series *Enūma Anu Enlil,* was established in a number of Mesopotamian cities of the Assyrian empire. In the Neo-Assyrian period, therefore, observation of the heavens was an institution sponsored by the royal court for the purpose of celestial divination. The Sargonid kings employed diviners for their own protection, and by extension for the protection of the state as a whole. If untoward signs were observed, these royal advisors saw to it that apotropaia to protect the king were performed. Some of the celestial diviners were able to perform these magical incantations themselves. A body of texts known as "reports" (*u'ilātu*) attest to this scholarly, yet politically charged and also religious, activity during the Neo-Assyrian period. *Enūma Anu Enlil* was used as a basic reference work by the celestial diviners, such as Bēl-ušēzib, whose job it was to observe the heavenly signs and inform the king of their meaning.[86] The following report indicates that an eclipse occurred but was not visible in Nineveh:

To the king of the lands, my lord: your servant Bēl-ušēzib. May Bēl, Nabû and Šamaš bless the king, my lord! (If) an eclipse occurs but is not seen in the capital, that eclipse has passed by. The capital is the city where the king resides. Now there are clouds everywhere; we do not know whether the eclipse took place or not. Let the lord of kings write to Aššur and all the cities, to Babylon, to Nippur, to Uruk and Borsippa; maybe they observed it in these cities. The king should constantly be attentive. Many signs of the eclipse came in *Addaru* and in *Nisannu,* and I communicated all of them to the king, my lord; and if they perform the apotopaic ritual of the eclipse..., will that do any harm? It is advantageous to perform it, the king should not leave it. The great gods who dwell in the city of the king, my lord, covered the sky and did not show the eclipse, so that the king would know that this eclipse does not concern the king, my lord, and his country. The king can be glad.[87]

The most extreme situation posed by an omen was that of the lunar eclipse that portended the death of the king. Because the possibility of a lunar eclipse was predictable by the seventh century B.C., the danger portended for the king by this phenomenon could occasionally be addressed before the fact, as is implied in the letter quoted in the preceding abstract. More

[86] Hunger, *Astrological Reports.*

[87] S. Parpola, *Letters from Assyrian and Babylonian Scholars,* SAA 10 (Helsinki: Helsinki University Press, 1993), No. 114.

often, the eclipse had first to be observed to determine particular factors affecting the Assyrian king, such as the portion of the lunar disk darkened by the eclipsing shadow and the presence or absence of the planet Jupiter in the sky during the eclipse.[88] The response to such an eclipse was to put in motion the ritual of the substitute king, who acted as a scapegoat, taking on himself the portended evil in place of the king, and who, when the danger period (100 days) was over, was to be put to death in order that the evil be carried with him into the netherworld. One letter concerning the substitute king says

I wrote down whatever signs there were, be they celestial, terrestrial, or of malformed births, and had them recited in front of Šamaš, one after the other. They (the substitute king and queen) were treated with wine, washed with water and anointed with oil; I had those birds cooked and made them eat them. The substitute king of the land of Akkad took the sins on himself.[89]

Confirmation that this was not only a substitution rite but also an expiatory sacrifice is found in the ritual text concerning the substitute king, in which following the burning of "his royal throne, his royal table, his royal weapon, and his royal scepter," the instructions assert "the purification of the land will be achieved, ditto the purification of the king will be achieved."[90]

After the introduction of celestial omens for individuals, based on phenomena occurring on the date of birth, no further evidence is found for the kind of celestial divination practiced under the Sargonid kings, that is, although copies of *Enūma Anu Enlil* continued to be made as late as the Seleucid period, evidence is lacking for the Persian or Seleucid kings requesting consultation from that reference handbook, and nativities as well as horoscopes do not seem to antedate the fifth century B.C.

2.2.2 Terrestrial Omens (*Šumma Ālu*)

In its seventh-century standardized form, the series *Šumma ālu* represents the largest collection of unprovoked omens.[91] The incipit "if a city is situated on high ground" served as its title. Only approximately

[88] See the discussion in Parpola, *LAS*, Part II pp. xxii–xxxii.

[89] S. Parpola, *Letters from Assyrian and Babylonian Scholars*, No. 2, p. 4; also published as Parpola, *LAS* 31.

[90] W. G. Lambert, "A Part of the Ritual for the Substitute King," *AfO* 18 (1957–58), p. 110, column B:8.

[91] For a review of the publication history of this series, see Freedman, *If a City*, pp. 3–4.

one-third of the seventh-century B.C. Nineveh library edition of *Šumma ālu* is extant, and the highest tablet number preserved in a text colophon is 104. However according to catalogs and extant catchlines, *Šumma ālu* consisted of at least 107 tablets of varying length, with an estimated number of omens approaching 10,000. The various tablet lengths are provided by the scribes in colophons, many of which, however, are no longer preserved. As many as 225 and as few as 34 omens are given in scribal tallies. For example, Tablet 105 "If father and son are at odds," seems to be complete and has a mere 20 omens. Additional parts of the series can be identified through scribal catalogs, excerpts, and commentaries, rendering our ability to describe its content somewhat better, but still incomplete.

The history of *Šumma ālu* parallels that of the other major omen series, which is to say the textual beginnings of the series can be traced to the Old Babylonian period. An Old Babylonian tablet from Ur (BM 113915) seems to represent a forerunner to the *Šumma ālu* bird omens.[92] Other Old Babylonian animal omens, although not duplicated in the standard series, are also known.[93] In keeping with the interchangeable nature of some of the unprovoked omens, an Old Babylonian tablet of physiognomic omens (VAT 7525) corresponds to some degree with *Šumma ālu*'s as well as the *Ziqīqu* series' omens concerning things that occur during sleep.[94] This overlapping of some omens seems reasonable enough, given the shared concern with things human in each of these series.

The characterization of the omens in *Šumma ālu* as "terrestrial" is not precisely descriptive of its content. The series begins with omens having to do with aspects of cities and houses (Tablets 1–18) but moves on to deal with demons and supernatural entities (Tablets 19–21). The appearances and behavior of animals, insects, lizards, and birds belong to this series, as do a wide array of behaviors and experiences of human beings (Tablet 53 has omens about the king), such as what happens to a person on the way to prayer, sleeping, immediately on waking, sexual behavior, and family relations. In keeping with the classification "terrestrial" are other omens from things that occur in fields, gardens, rivers, and marshes. There are even several tablets devoted to the appearance of fire (Tablets 52–54) and of strange lights (Tablets 92–94). A list of incipits of the tablets of *Šumma*

[92] David B. Weisberg, "An Old Babylonian Forerunner to Šumma Ālu," *HUCA* 40 (1969–70), pp. 87–104.

[93] See Freedman, *If a City*, p. 13 and note 61.

[94] Franz Köcher and A. L. Oppenheim, "The Old-Babylonian Omen Text VAT 7525" (with appendix by H. G. Güterbock), *AfO* 18 (1957), pp. 62–80.

ālu, found in S. M. Freedman's edition of Tablets 1–21, serves as a guide to the extensive and diverse nature of its content.[95]

The organization of tablets in this series bespeaks a prodigious effort to assemble and classify phenomena of widely disparate subjects within a work of some coherence. Of all the series that deal with human concerns and human phenomena, *Šumma ālu* is the most comprehensive, *Alamdimmû* focuses on the physiognomic characteristics of people, and SA.GIG studies the symptoms of the sick. Dream omens of the series *Ziqīqu* are limited to an event or events from a person's dream that serves as the protasis. *Šumma ālu*, on the other hand, deals with the things of "real life," observable in cities and houses, flora, fauna, water, fire, or lights, or things that describe an individual's thoughts, prayers, actions of daily life (sex, sleep, family quarrels), and the perception of demons and ghosts. The practice of "terrestrial" divination, just as is the case for celestial divination, is attested to in the Neo-Assyrian scholars' letters. S. Parpola points to a letter in which "Nergal-šarrāni informs the king that lichen has been sighted on the walls of the Nabû temple and suggests that Adad-šumu-uṣur perform an apotropaic ritual against the misfortune it predicts."[96] It is this series more than any other that reflects a belief that the world, in all its aspects, real and imagined, was rife with meaning.

The forecasts derived from the *Šumma ālu* omen collections relate to both the individual and to the collective, that is, the land, the city, the king, the army. In Tablet 2 (also Tablet 88) can be found predictions of the destruction of a number of Mesopotamian cities:

If the parapet of a fortification-wall looks [like a monkey (but) you climb up the wall and] it is normal: [destruction of Nippur.]

If pits in the middle of a city are open and [full of] blood-destruction of Sippar.

If a white partridge is seen in a cit[y, prices will diminish-destruction of Adab.][97]

Some *Šumma ālu* omens even predict weather (rain) and astronomical events (eclipses). In Tablets 5–7, concerning the construction of houses, predictions refer to the owner of the house and the inhabitant of the house, as well as to the house itself. Sometimes predictions are given a time limit (e.g., "an Ardat Lili (demon) will afflict him for two years."[98]).

[95] Freedman, *If a City* pp. 19–23.

[96] Parpola, *LAS*, Part II Appendix N no. 52, p. 463. For additional letters referring to *Šumma ālu*, or *Šumma ālu*-type omens, see *LAS* 15 r.8, 36:7, 38 r.1.

[97] Freedman, *If a City* pp. 66–7, lines 18, 23, and 25.

[98] *Šumma ālu* Tablet 20:27; see Freedman, ibid, p. 299.

Apodoses aimed at individual persons generally concern good and bad luck, happiness and misery, health, wealth, marriage, and deaths in the family.

If the celestial omens presuppose a systematic program of celestial observation, the *Šumma ālu* corpus points to a similar, largely empirical, basis for the organization of "terrestrial" phenomena. Because the range of phenomena was so great and the nature of the subjects so varied, the cumulative weight of "knowledge" in the diverse fields of observation did not "add up" in the same way as it did in the area of astronomical knowledge, although a similar tendency toward schematization is characteristic.

2.2.3 Dream Omens (*Ziqīqu*)

The word *ziqīqu* (*zaqīqu*) is a designation for the dream god. Its Sumerian equivalent is líl, meaning literally "wind," but having the connotation "spirit" or "phantom." The collection of dream omens, known from the Nineveh library, opens with the invocation: ᵈ*Ziqīqu* ᵈ*Ziqīqu* ᵈMA.MÚ *ilu ša šunāte* "Oh Dream God!, Oh Dream God!, ᵈMA.MÚ, god of dreams."[99] This work probably consisted of eleven tablets, the first and last of which contained apotropaia (*namburbû*) for dispelling unwanted forecasts from dream omens. Tablets 2–8 are estimated to have compiled about 500 omens in each, but only a small fraction of this total is extant.

As is the case with the other forms of scholarly divination, examples of dream omens are known from the late Old Babylonian period. The dream interpreter, called *šā'ilu*,[100] appears in a well-known hymn to Šamaš, whose material, if not some form of the hymn itself, may go back to Old Babylonian times:

Šamaš, the universe longs for your light. In the seer's bowl with the cedar-wood appurtenance, you enlighten the dream priests and interpret dreams.[101]

The following earliest known example of dream omens reflects the binary system characteristic of other types of unprovoked omens, in which the object is simply to determine whether the sign is favorable or unfavorable:

[99] Assyrian Dream-book Tablet I obv. Col.i 1 (K. 3758), see A. L. Oppenheim, *The Interpretation of Dreams in the Ancient Near East*, Transactions 46/3 (Philadelphia: American Philosophical Society, 1956), p. 338.

[100] Literally, "the one who asks," as the participle of the verb *šālu*, "to ask," "to inquire," or, more specifically, "to ask for an oracle." See *CAD* s.v. *šālu* A 1d.

[101] W. G. Lambert, *Babylonian Wisdom Literature* (Oxford: Clarendon, 1960), pp. 128–9, lines 52–4.

If a man, while he sleeps, dreams that the entire town falls upon him and that he cries out and no one hears him: this man will have good luck attached to him. If a man, while he sleeps, dreams that the entire town falls upon him and he cries out and someone hears him: this man will have bad luck attached to him.[102]

It is likely that these lines represent only an extract from an already well-organized collection of omens from things seen in dreams. From the second half of the second millennium B.C. is preserved part of a collection of dream omens from Susa. Like the exemplars of other Akkadian divinatory texts found at Susa, for example, the celestial omens, these texts not only bridge the gap between Old Babylonian and standard Babylonian (seventh century) versions, but they attest to an eastward dissemination of the tradition of scholarly divination from Mesopotamia to Elam.

Evidence for the extreme antiquity of a belief in mantic dreams may be found in Sumerian texts in which dreams are interpreted as messages from the divine. A Sumerian dream incubation priest, ensi (EN.ME.LI = Akkadian šā'ilu), is attested to in lexical texts.[103] Outside the lexical tradition the term is found in a cylinder inscription of King Gudea of Lagash,[104] who reigned circa 2200 B.C. Akkadian egirrû "oracular utterance" is a loan word from Sumerian inim.gar (i_5.gara$_x$) "utterance" and occurs in a lexical list together with "dream" and "vision." Personal letters from the Old Babylonian period make mention of oracular utterances (egirrû) and dreams (šunātu).

Within the various expressions of a belief in mantic dreams, a qualitative distinction applies between dreams as divine revelations recorded in literary, historical, and epistolary contexts, on one hand, and oneiromancy or dream divination on the other. Events "observed" in dreams and collected in omen series were treated in the same manner as other observed phenomena were and were interpreted in accordance with their recorded apodoses. In literary contexts, for example, the dreams of Gilgamesh, dreams represent symbolic messages sent by a god and understood intuitively by the dreamer or a dream interpreter, such as Gilgamesh's mother. Such dreams can become literary devices for conveying certain aspects of a character or of the story. In these cases, the principles of deductive scholarly divination do not appear to have been applied. We may see them as reflections of a belief in divine revelation through dreams, which

[102] VAT 7525 iii 28–30, see Köcher and Oppenheim, "The Old-Babylonian Omen Text VAT 7525," p. 67.

[103] See *CAD* s.v. šā'ilu lex.

[104] Gudea Cylinder A iii 26; see Edzard, *Gudea*, p. 71.

is attested to, for example, in a number of inscriptions of kings who were warned or reassured in a dream of the outcome of some royal undertaking. The literary and historical dream messages were meaningful specifically to the person presented as the dreamer and the message was understood or interpreted intuitively as a result of divine revelation. The meaning of dreams collected in omen form were "collective," that is, applicable to anyone who observed or experienced a given phenomenon in a dream.

Oppenheim defined two media for the communication from deity to human being, one the symbolic dream and the other a "divine communication which materializes through apparently accidental utterances of some chance person which strike the receiver of this type of 'message' with such persuasiveness that he realizes that a divine agent has put these words into the mouth of that person."[105] The latter is the equivalent of the Greek *kledon* or chance utterance. These two modes of divine communication seem to be related in the ancient Mesopotamian context, as they (*šuttu u egirrû*) are often paired, and in texts spanning the Old Babylonian to Neo-Assyrian periods.

The omens collected in the handbook of dreams known as the *Ziqīqu* series present the phenomena occurring in dreams as "observed." Dreams are termed literally "visions of the night" (*tabrît mūši*) and their descriptions as objective experience seem to categorize them in the same way as other unprovoked signs, such as the observation of a celestial phenomenon or a peculiarly formed animal at birth. The practice of dream interpretation, however, as reflected in texts referring to the professional dream interpreter, the *šā'ilu*, involved the solicitation of the ominous message from the god in the manner of an extispicy. In view of this, the pairing of the dream interpreter and the diviner of liver omens (haruspex), as in the following passage from the literary work *Ludlul Bēl Nēmeqi* "I will praise the Lord of Wisdom," is understandable:

The diviner did not determine the future by extispicy, the dream interpreter did not elucidate my case with the incense.[106]

Many texts make reference to the *šā'ilu*'s use of incense as part of his craft. A Neo-Assyrian report[107] informs the king of the ritual (for obtaining good dreams?) performed for a particular month and makes mention of the censer set up for the dream god *Zaqīqu*:

[105] Oppenheim, *Interpretation of Dreams*, p. 211.
[106] Lambert, *Babylonian Wisdom Literature*, p. 38:6–7.
[107] Parpola, *Letters from Assyrian and Babylonian Scholars*, No. 298.

On the 16th you set a table made of tamarisk wood before Sin. At the head of the bed you place a censer of juniper for *Zaqīqu*. You wash his hands and feet with siderites and cassia. You bind lumps of salt, cassia, juniper, and lumps from the outer door to the hem of his garment.

The incense (*ma/uššakku*) functioned as an offering to the dead, and it played the part in the process of dream omen solicitation involving libanomancy, as is clear in the line previously cited from *Ludlul Bēl Nēmeqi*. The scholastic commentary to this particular line explains the word *ma/uššakku* as "the offering of the dream interpreter (*surqinnu ša šā'ili*)."[108] And finally, the term *surqinnu*, used as a synonym for *maššakku* in this commentary, means clearly "incense offering" in other contexts. Libanomancy, or divination from smoke, was decidedly one of the types of "provoked" omens. Therefore the classification of oneiromantic omens appears rather more complex than that of the other omen categories discussed here.

It has also been suggested that the *šā'ilu*'s incense was an offering to the spirits of the dead, evidenced by the grouping of the profession *šā'ilu* with *mušēlû eṭemmi* "necromancer" in the lexical text *Lu*, devoted to listing professions. Elsewhere, as in the literary passage previously cited, the *šā'ilu* appears, not with the *ṭupšarru* "scribe–diviner" associated with the greater part of the unprovoked omen corpora, but with the *bārû* "diviner," whose name means literally "one who inspects" the phenomena created by him for the purpose of soliciting a response from the gods. The phenomena inspected by the *bārû* were the exta, oil on water, smoke from the censer, or other kinds of *auguria impetrativa*.

Yet another text listing the omens that belonged to the craft of the *āšipu* "magician–exorcist" includes the dream omens together with the anomalous birth and hemerological omens. This particular classification would effectively place the series *Ziqīqu* in the same category as that of *Šumma izbu* and the dual series SA.GIG with *Alamdimmû*. Perhaps the connection between them had to do with the fact that these are the omens whose portents belong in the private domain. These series constituted part of the repertoire of the magician, whose profession was distinct from both the *ṭupšarru* "scribe–diviner" and the *bārû* "haruspex." As previously mentioned, however, the various scribal experts in the written divination corpora worked with many text series, not only

[108] Lambert, *Babylonian Wisdom Literature*, p. 38, commentary to line 7, and p. 288 notes to Tablet II 6–7, also cited in *CAD* s.v. *muššakku*.

that or those formally associated with his particular professional title. The following is a selection from *Ziqīqu* Tablet IX:

If a man in his dream enters the gate of his city: wherever he turns, [he will (not?) attain his desire].

If he goes out of the gate of the city: wherever he turns, [he will (not?) attain] his desire.

If he goes up to heaven: his days will be sh[ort].

If he goes down to the netherworld: his days will be long.

If [he . . .] to the "Land-of-no-return": [his days] will be long.

(gap)

[If he (in his dream) goes to the temple]: good news.

[If he goe]s to [the temple]: his prayers will be listened to.

If he goes to the temple of the god UR.SAG: he will go forth from his present state of uncleanliness.

If he goes to the temple of the "Divine Seven": he will be well.

(gap)

If (in his dream) he goes to Nippur: sorrow, well-being for one year.

If he goes to Babylon: sighs, well-being for one year.

If [he goes to Ba]bylon and enters [Es]agila: [. . .]

(gap)

If he (in his dream) goes to an orchard: (someone) will pronounce his release.

If he goes to a garden: his work will get worse, or he will be free of hardship.

If he goes to set a wood-pile afire: he will see days of sadness.

If he goes to plant a field: he will be free of hardship.

If he goes to hunt in the desert: he will become sad.

If he goes to a fold for big cattle: he will . . . the help of the deity.

If he goes to a fold for sheep: he will become a chieftain.

If he goes to a fold for goats: he will . . . the mercy of the deity.

If he goes into a cane-break, cuts reeds and makes bundles: [he will recover(?)] from a dangerous disease.[109]

These omens represents selections from an unidentified tablet concerning eating in a dream:

If he eats the meat of a [do]g: rebellion, not obtaining his desire.

If he eats the meat of a beaver: rebellion.

If he eats the meat of a gazelle: (the disease) *sahal šēri*.

If he eats the meat of a wild bull: his days will be long.

If he eats the meat of a fox: (an attack of) *sihil šēri*, for an unfortunate person: good (luck).

If he eats [the meat of a . . .]: deliverance from evil.

[109] Adapted from Oppenheim, *Interpretation of Dreams*, pp. 267–9.

If he eats the meat of a mo[nk]ey: he will make acquisitions by force.

If he eats meat he knows: peace of mind.

If he eats meat he does not know: no peace of mind.

If he eats human meat: he will have great riches.

If he eats meat from a dead man: somebody will take away what he owns, [his] mind will [(not?)] be at peace.

If he eats meat from a corpse: [somebody] will take away what he owns, his mind [will (not?) be at pe]ace.

If he eats his own entrails: his possessions [. . .]

If he eats his own flesh: his property will [. . .]

If he eats the flesh of a friend: he will enjoy a large share.

If his friend eats his face: he will enjoy a large share.

If he eats the eye of his friend: his bad (luck) is straightened out, his property will prosper.

If he eats the flesh of his hand: his daughter will d[ie].

If he eats the flesh of the hand of his friend: something he does not know (yet) is lost, imprisonment will seize him.

If he eats the flesh of his foot: his eldest son will die.

If he eats the flesh of the foot of his friend: among those near to him [. . .]

If he eats his penis: his son [will die].

[If he eats the penis of] his [fri]end: he w[ill have] a son.[110]

Clearly the dream omens list elements of dreams, not entire dreams, as subjects for prediction. In this way, the analysis of an actual dream could be put together by hermeneutic elaboration of the meaning of individual elements as they are explained in the text. One might even conjecture that an overall pronouncing of the dream as positive or negative might result from such an analysis, much as it was done in extispicy, in which the diviner tallied the meanings of all the various markings seen on the liver to arrive at an overall verdict of favorable or unfavorable.[111] The salient feature, however, is the general character of the dream omens. Like other omens, in which the phenomena cannot be viewed as specific observations of something occuring at a particular time but only a general reference to any such phenomena occurring at any time, so in the dream omens are the dream events of a general nature, not traceable to any particular dream, but a guide to the interpretation of dreams that could at some time occur.

[110] Oppenheim, *Interpretation of Dreams*, pp. 270–1.

[111] Ivan Starr, *The Rituals of the Diviner*, Bibliotheca Mesopotamica 12 (Malibu, CA: Undena, 1983), pp. 16–18.

2.2.4 Physiognomic Omens (*Alamdimmû*)

The title of the physiognomic omen series is known from colophons as *Šumma alamdimmû* "If the form."[112] An ancient text catalogue states that "*Alamdimmû* (concerns) external form and appearance (and how they imply) the fate of man." The word *alamdimmû* ("form" or "figure") is borrowed from the Sumerian alam.dím, itself a rarely attested lexeme. A number of subseries of this collection are known from catalogs of these texts. The related subseries are *Šumma nigdimdimmû* "if the appearance," *Šumma kataduggû* "if the utterance," *Šumma sinništu qaqqada rabât* "if a woman's head is large," and *Šumma liptu* "if the spot." The first three of these were occasionally mentioned alongside the medical diagnostic omen series titled SA.GIG (*sakikku*) "symptoms," or were cataloged together, as in a number of extant catalogs. A Late Babylonian commentary text from Kutha, which relates a number of omen series to astrological elements, refers to SA.GIG and *Alamdimmû* along with *Šumma izbu* as a group termed secret of heaven and earth.[113] As was the case for the celestial omen series, the authorship of the physiognomic (and medical) omens was attributed to the god Ea.

The physiognomic omen series was complete in twelve tablets and the series as a whole was arranged *a capite ad calcem*. The principle of organization exhibited in some individual tablets of the physiognomic series is also that which considers the human body from the top down. This organizational pattern is shared with the series *Šumma izbu* and SA.GIG (see Subsections 2.2.5 and 2.2.6). The following selection from the Old Babylonian forerunner to the physiognomic omens dealing with moles on the body illustrates:

If there is a mole on the right side of a man's forehead []

If there is a mole on the left side of a man's forehead []

If there is a mole on the dividing line of his forehead: he will not escape from the hard times which will seize him.

If there is a mole to the right of his eyebrow: what his mind is set on, he will not attain.

If there is a mole to the left of his eyebrow: what his mind is set on, he will attain.

[112] Barbara Böck, *Die Babylonisch-Assyrische Morphoskopie*, *AfO* Supplement 27 (Vienna: Institut für Orientalistik der Universität Wien, Orientforschung, 2000).

[113] R. D. Biggs, "An Esoteric Babylonian Commentary," *RA* 62 (1968), pp. 51–8.

If there is a mole on the dividing line of his eyebrows: that which he strives for, in one year [. . .].

If there is a mole on his right eyelid: his son, the heir, [. . .] in the estate.

If there is a mole on his left eyelid: his son, the heir, will be well and [].

If there is a mole below his right eye: his sons will not have good luck.

If there is a mole below his left eye: his sons will have good luck and [].

If there is a mole on his nose: evil speech will const[antly follow(?) him.]

If there is a mole on the corner of his right eye: his profit [. . .]

If there is a mole on the corner of his left eye: his dowry will be stolen on the street.

If there is a mole on his right cheek: his city ward will always be mentioned negatively.

If there is a mole on his left cheek: he will prevail against his ward in a legal dispute.[114]

The remainder of this tablet contains omens for moles found on the chin, neck, hands, fingers, pubic area, penis, testicles, thigh, shin, and foot.

Besides the physical features of the external human anatomy, the physiognomic omens included omens describing behaviors as well as things that happen when someone speaks (*Šumma kataduggû*). Related omens append diagnoses about the person's future based upon aspects of their personalities or idiosyncrasies of their behavior, such as:

If his eyebrow waggles: he will be happy.
If his hands shake: he was given bewitched food to eat.
If he talks to himself: he will acquire barley.
If he talks to himself: he will build a house.
If he is a grumbler: he will come to ruin.[115]

2.2.5 Malformed Birth Omens (*Šumma Izbu*)

Šumma izbu arranges in twenty-four tablets approximately 2,000 omens concerning unusual births. Within this arrangement, three classifications serve to further organize the contents, that is, omens from odd human births (Tablets 1–4), from physically malformed births (Tablets 6–17), and omens from specific animals (goats in Tablet 18, cattle in Tablet 19, horses

[114] Goetze, *Old Babylonian Omen Texts*, No. 54.

[115] E. Reiner, "A Manner of Speaking," in G. van Driel, ed., *Zikir Šumim: Assyriological Studies Presented to F. R. Kraus on the Occasion of His Seventieth Birthday* (Leiden: Brill, 1982), p. 287.

in Tablets 20 and 21, pigs in Tablet 22, dogs in Tablet 23, and sheep in Tablet 5, thought to be the oldest tablet of the series, going back to the Old Babylonian period). Finally, within these three broad classifications, omens follow a sequence by body part, running from head to toe. For example, the first twenty-three omens of Tablet 3 concern ears, whereas the last twenty-two have to do with feet. (The very last omen, III 101 concerns an unknown part of the foot(?) termed SAL.LA, which is described as "thin."[116]). Tablet 11 has 142 omens concerning ears, beginning with (line 1) "If an anomaly has no right ear: the reign of the king will be at an end; his palace will be scattered; overthrow of the elders of the city; the king will have no advisers; the land will go mad; the herds of the land will decrease; he (the king) will be obedient to the enemy," and ending with (line 142') "If an anomaly is covered with ears: there will be a king as powerful as the king, (variant), in the land."

The word *izbu* means "malformed newborn human or animal." In lexical lists, the word occurs alongside other terms for unformed matter and a premature fetus, even a stillborn child. These synonymns would suggest that the *izbu* was thought to be malformed because of its prematurity. It did not attain its complete and proper form as a result of having, as the Sumerian equivalent expression put it, "not completed its months." One of the synonyms, *kūbu*, also carries the meaning "monstrous shape," and was the name of a demon, who is mentioned in the medical omens in connection with a sick infant: "If the infant cries during the evening without interruption and does not want to drink the milk: (diagnosis is the illness called) 'hand of Kūbu.' And, "If the infant wheezes before it is put to bed: 'hand of Kūbu.'"

The series *Šumma izbu* is known in an Old Babylonian version, some of which contains material parallel to the canonical (i.e., Neo-Assyrian Library edition) Tablets 5–17 and some of which parallels Tablet 4. Very fragmentary remains of the Akkadian anomalous birth omens from Boghazköy are also extant.[117] The fixed sequence of tablets known from the copy kept in the library of Aššurbanipal at Nineveh seems to be the work of late Middle Babylonian scribes. As noted by E. Leichty, the organization of the series during the Middle Babylonian period resulted in two separate series. One comprised Tablets 1–4 and was titled "if a woman is pregnant" (*Šumma sinništu aratma*). This part contained the omens from human births. The other part, comprising Tablets 6–17, was titled simply *Šumma izbu* and contained the omens from all other malformed births.

[116] See Leichty, *Izbu*, p. 64.
[117] Leichty, *Izbu*, pp. 207–10.

The separate titles of these two parts of the anomalous birth omens derive from the first line of the first tablet of each part respectively. After a time, however, the series *Šumma izbu* no longer retained its original tablet numbering, but instead became Tablets 6–17 of the series as a whole. The combined series carried both names and was arranged with the "if a woman is pregnant" part first and continuing directly with *Šumma izbu*. The remaining seven tablets of the series constitutes a third part, consisting of birth omens of various animals. Leichty observed that these tablets and some of the tablets of the series *Šumma ālu* probably derived from a common source, although the system of determining which omens were classified as *Šumma izbu* and which as *Šumma ālu* is unclear. For the most part, the birth omens came to be part of *Šumma izbu* and the behavior omens part of *Šumma ālu*, although this rule is not rigorously followed. In some cases, without the help of a colophon to designate the series to which the omens belong, it is wholly impossible to decide.

As was the case with the twin series SA.GIG and *Alamdimmû*, the series *Šumma izbu* is mentioned in a Late Babylonian commentary that brings the subjects of these omen series into relation with astrology. The commentary is abstruse and obscure (to us), but the following passage conveys this relation:

If you want to find the *izbu*: (If) the constellation of the month passed by and you see half of it in the second month, there will be an *izbu* (such that) the child who will be born will be defective. If at the beginning of Capricorn one of the planets reaches first visibility or reaches a stationary point or is high (and) another (planet) remains visible: women will bear twins. Capricorn (is relevant) for cattle. The *izbu* which began in Leo inside the constellation Leo in front of the star Erua.[118]

As in the following series of omens, the apodoses of the series *Šumma izbu*, like those of *Enūma Anu Enlil*, generally concern the king and country as a whole. These omens are from *Šumma izbu* Tablet 8, lines 33–44:

If a malformed newborn has two heads, and the second one is on its back, and its eyes look in different directions: the king's reign will end in exile.

If a malformed newborn has two heads, and the second one is on its back, and faces its tail: the crown prince will be in enmity with his father.

If a malformed newborn has two heads, and the second one is above its right shoulder: pestilence in the land; revolt against the king.

[118] R. D. Biggs, "An Esoteric Babylonian Commentary," p. 54.

If a malformed newborn has two heads, and the second one is above its left shoulder: pestilence in the land of the enemy; the prince will take (booty) from the land of the enemy.

If a malformed newborn has two heads, and the second one is on its chest: the crown prince will seize the throne.

If a malformed newborn has two heads, and the second one is on its right rib cage: an enemy will take the land of the prince; an entirely different king will be in the suburbs of the king, and the crown prince will be in enmity with his father; dissension; one land will consume the other land for no apparent reason.

If a malformed newborn has two heads, and the second one is on its left rib cage: the king will deposit possessions in the land, and he will take the land of his enemy.

If a malformed newborn has two heads, and the second one is on its diaphragm and faces away (from the other head): the prince will fall in his own palace; (variant), he will go out from his city.

If a malformed newborn has two heads, and the second one is on its diaphragm, and one faces the other: the prince's palace will be abandoned and he will go out from his city and his people; he will not leave his land, but outside his palace. . . .; his son will not take the throne; an exile who was driven out will return to his city.

If a malformed newborn has two heads, and the second one is on its tail: dissension; one land will consume the other without apparent reason; a second king will pillage the suburbs of the king.

If a malformed newborn has two heads, and the second one is on its tail, and it has four ears: there will be dissension in the land.

If a malformed newborn has two heads, and the second one is on its tail, and it has four shoulders and four (sets of) ribs: dissension; one land will consume the other for no apparent reason.[119]

Because of the public nature of the *izbu* apodoses, it is therefore not surprising to find evidence in the Neo-Assyrian scholars' correspondence of a concern on the part of the king with *izbu* omens. In one letter, it seems as though the king was made nervous by the inconclusive nature of an *izbu* omen:

Concerning the *izbu* omen about which the king wrote to me: "It is obscure" – I sent the king exactly what is written of the tablet.[120]

[119] Leichty, *Izbu*, pp. 104–5.
[120] Parpola, *Letters from Assyrian and Babylonian Scholars*, No. 276.

Another letter has the same tone:

When the king, my lord, formerly two or three times asked his servant about malformed births or anything at all, did I conceal (anything), be it good or bad, from the king, my lord?[121]

That the appearance of birth oddities was of interest well into the Seleucid period is demonstrated by the occasional mention of such births in the astronomical diaries. In 134 B.C., a diary reports that "That month, a goat gave birth, and there was no right thigh (of the young)."[122]

2.2.6 Medical Diagnostic Omens (SA.GIG/ *Sakikku*)

The 40-tablet series titled SA.GIG,[123] whose first tablet begins with the incipit *enūma ana bīt marṣi āšipu illiku* "when the magician goes to the house of a sick person," was devoted to medical diagnostic omens, such as the following:

If the sick man turns his neck constantly to the right, his hands and feet are rigid and his eyes close and roll back, saliva flows from his mouth and he makes a croaking sound: epilepsy.

If when it attacks him he is aware: he will recover. If he does not know himself: he will not recover.

If he turns his neck constantly to the left, his hands and feet are stretched out, his eyes are open towards the sky, saliva flows from his mouth and he makes a croaking sound and he does not know himself; he still collapses: epilepsy, the hand of Sin.

If his neck hurts him: the "hand of his god" disease, variant: the "hand of Šamaš" disease. Upon pronouncing for himself a benediction (to Šamaš) he will recover.

If his neck hurts him and he is always wanting water: "hand of Ištar," he is stricken on his neck, he will die.

If his neck and hips both hurt: "hand of Adad."

If his neck, hips, hands and feet are stiff: "SA.DUGUD"-disease.

If he twists his neck and his face is restless, from time to time he is restless: "SA.DUGUD"-disease.

If his necks throbs, his head constantly droops, his hands and feet become swollen and he rubs them against the ground: the female demon has seized him.[124]

[121] Parpola, *Letters from Assyrian and Babylonian Scholars*, No. 265.

[122] Sachs-Hunger, *Diaries*, No. −133:26′, cf. No. −125 rev. 7′.

[123] See N. P. Heessel, *Babylonisch-assyrische Diagnostik*, AOAT 43 (Münster:Ugarit-Verlag, 2000).

[124] Labat, *Traité akkadien*, pl. XIX = SA.GIG Tablet 10:1–9.

In a catalog of the series SA.GIG and *Alamdimmû* with its subseries, it is said "SA.GIG (concerns) all diseases and all (forms of) distress."[125] In some contexts, the word *sakikku* seems to mean "symptom," as in the following letter from the chief physician of the Neo-Assyrian court, Urad-Nanāia

The king, my lord, keeps on saying to me: "Why do you not diagnose the nature of this illness of mine and bring about its cure?"-formerly I spoke to the king at the audience and could not clarify his symptoms (*sakikkēšu*).[126]

The series formed part of the textual reference material of the *āšipu* "magician," whose authority stemmed from the gods, and who was trained in the performance of rituals and incantations in which he spoke in the name of particular deities. His ritual manipulations and recitation of incantations were for the purpose of healing the sick, and he was also consequently expert in medical diagnosis. From the earliest periods, Babylonian medical practice was divided between the *āšipu*, who executed the diagnosis, gave a prognosis for recovery, and attempted a cure through the use of incantation, amulets, figurines, magic circles, and other ritual acts, and the *asû*, who primarily dispensed drug therapy. These two distinct professionals appear, generally side-by-side, in Sumerian lexical lists and in other enumerations of personnel.[127]

The *āšipu's* handbook, SA.GIG, represented in omen form the collected knowledge of diseases, their symptoms, and their etiologies. As stated in the scholastic catalog previously mentioned,

SA.GIG (concerns) all diseases and all (forms of) distress; *Alamdimmû* (concerns) external form and appearance (and how they imply) the fate of man which Ea and Asalluhi/Marduk ordained in heaven.... [Let the *āšipu*] who makes the decision, and who watches over people's lives who comprehensively knows SA.GIG and *Alamdimmû*, inspect (the patient) and check (the appropriate series), [let him ponder], and let him put his diagnosis at the disposal of the king.[128]

That illness was viewed as a "sign," that is, a matter for divination is expressed in a passage from the Babylonian *Ludlul Bēl Nēmeqi* ("I will praise the Lord of Wisdom"), a work that in many ways represents a Mesopotamian version of the Job story. When the sufferer is near death after an entire year of physical deterioration, he says, "The exorcist recoiled

[125] Finkel, "Adad-apla-iddina," pp. 148–9.
[126] Parpola, *Letters from Assyrian and Babylonian Scholars*, No. 315.
[127] See Jo Ann Scurlock, "Physician, Exorcist, Conjurer, Magician: A Tale of Two Healing Professionals," in Tzvi Abusch and Karel van der Toorn, eds., *Mesopotamian Magic: Textual, Historical, and Interpretative Perspectives* (Groningen: Styx Publications, 1999), pp. 69–79.
[128] Finkel, "Adad-apla-iddina," pp. 149–50.

from my symptoms, while my omens have perplexed the diviner. The exorcist did not clarify the nature of my complaint, while the diviner put no time limit on my illness."[129] The association of the *āšipu* with the work of medical divination and healing the sick through incantation and ritual magic is attested in the Neo-Assyrian scholarly correspondence. The following letter assures the king that the rituals against disease were dutifully performed:

Concerning the rites about which the king, my lord, wrote to us, in *Kislev* we performed "To keep malaria, plague and pestilence away from a man's home"; in *Ṭebet* we performed "To keep disease and malaria away from a man's home" and numerous counterspells; in *Shebat* we performed "hand-lifting" prayers, an apotropaic ritual to counteract evil sorcery and a ritual against malaria and plague. On the 1st day we initiated the rites to be performed in Adad.[130]

This letter makes clear that disease and magic were seen as linked.

How the Babylonians regarded the work of the *āšipu* is similar to their perception of the diviner's skill. That is, these professions, which required mastery of a literary and scholastic corpus, were nonetheless linked with the divine. A text addressed to the sun god Šamaš says

without you, the diviner (LÚ.HAL/ *bārû*) cannot make the proper arrangements, without you, the exorcist cannot lay his hand on a sick person, without you, the exorcist, the ecstatic, the snake charmer cannot go about the streets (to do their work).[131]

The god therefore enabled the practice of divination, medical diagnosis, as well as in this case the work of the sorcerer (*eššebû*) and snake charmer (*mušlaḫḫu*). It is clear that the exorcist performed his duties in accordance with the written text of SA.GIG, just as the *bārû* diviner interpreted the livers in accordance with the extispicy series *bārûtu*. In cases in which the etiology of an illness was determined to be due to a god, ghost, or demon, the magician–exorcist was also expected to exorcise these forces. The treatise says "If his shins and his ankles both hurt him and the pain will not subside even with the ministrations of the exorcist, it means a ghost has seized him."[132]

The professional magician, or exorcist, as the term *āšipu* is sometimes translated, was one of five distinct scholarly professions for which the

[129] *Ludlul Bēl Nēmeqi* II 110–111; see W.G. Lambert, *Babylonian Wisdom Literature*, p. 45.
[130] Parpola, *Letters from Assyrian and Babylonian Scholars*, No. 296.
[131] *KAR* 26:24–25.
[132] Labat, *Traité akkadien*, p. 20:14.

various omen compendia and other scholarly corpora were developed. The divisions between the various professions therefore correspond to divisions in the scholastic textual repertoire, although it is clear that individual members of these professional groups holding one professional title or another had practical knowledge beyond the literature of his particular discipline. The astrological (and other unprovoked) omen literature was the specialty of the "scribe–diviner" (ṭupšarru), extispicy was the discipline of the "diviner–haruspex" (bārû), incantations were for the "lamentation priest–chanter" (kalû), the medical pharmacopaeia and apotropaia were for the "physician" (asû), whereas SA.GIG, the treatise on symptoms, was the handbook of the magician–exorcist (āšipu). Although the āšipu was a court advisory post in the Neo-Assyrian period, later, in Seleucid Babylonia, this scribe functioned within the temple and was supported by temple prebend. In any case, the āšipu was a distinct profession from ṭupšarru, the scribe–diviner. Before treating his clients or before approaching patients to cure them, as indicated in a colophon from the second tablet of "When the āšipu goes to the house of a sick man," the āšipu ritually cleansed himself with an incantation, presumably to Marduk (Asalluhi) and/or Ea. An example of the incantations in the āšipu's repertoire is the following:

May Ea, possessor of the incantation of life, ruler of the sweet water under the earth cast a spell over you . . . may Asalluhi, magician of the gods, cast the spell of life over you.[133]

Like the other diviner–scribes, methodologically speaking, the āšipu viewed diseases as the manifestation of a combination of events and circumstances whose outcome was subject to prediction by the reading of the symptoms as signs. The āšipu's diagnosis was based on his determination of the signs, and by means of these signs he could determine the cause or agent responsible for the patient's condition. On this basis a prognosis could be offered in accordance with those written in the apodoses of SA.GIG. The first level of prognosis was always whether the patient would live or die. If the patient were to recover, further interventions would have to take place at the hands of the āšipu to release the patient from the malevolent influences causing the disease. The causes of disease are most often identified as supernatural agents, expressed in the form of the influence of a god (either generic or a specifically named deity), demon, ghost, or the

[133] CT 23 ii:32.

power of an oath. These influences are all similarly expressed as "the hand of" the particular agent. Consequently, the patient is referred to as having been "seized," "grasped," "touched," or "stricken" by the identified agent. Sometimes the *āšipu* is warned in SA.GIG not to approach a man who is deemed subject to dangerous influences.[134]

The various unprovoked omen series comprised the major part of the written corpus of Mesopotamian scribal scholarship and functioned as a vehicle for much systematization and observation of diverse aspects of the world of phenomena, both real and imagined. As such, these corpora represent the chief products of a Mesopotamian "inquiry into nature," although it is abundantly clear even from the selected evidence presented here that the category nature does not encompass all the contents of the omen texts. This demonstrates the limited use of nature as an appropriate category from the Mesopotamian point of view. Instead, what is classified for us as natural seems to be subsumed under a broader notion of physical existence, or, to employ a native classificatory term, "whatever pertains to complementary elements of celestial and terrestrial parts of the universe (and) those of the cosmic subterranean waters."[135] The observation and systematization of ominous phenomena, as we find these activities embodied in the omen texts, were to facilitate divination. The more systematic the treatment of phenomena in omen protases, the more amenable the phenomena were to schematic correlations of various kinds.

Whether the omen compendia contain a body of Mesopotamian scientific knowledge is assessed in more detail in Chapter 7. In a preliminary way, however, it might be suggested that, apart from the divinatory purpose of the omen series, the status of these series as systematically acquired corpora of "what was known" justifies an identification as science. Indeed, our word science means "knowledge" by etymology to the Latin *scientia*. To say this may seem something of an oversimplification, but it gains support by reflection on the way we ourselves view knowledge as afforded by science, that is, as the ultimate in credibility and authority. On the other hand, the reason for today's identification of science as the supreme

[134] Labat, *Traité akkadien*, p. 2: 2, 12, and 13, and see the discussion in E. K. Ritter, "Magical Expert (= *Āšipu*) and Physician (= *Asû*): Notes on Two Complementary Professions in Babylonian Medicine," in *Studies in Honor of Benno Landsberger on His 75th Birthday*, Assyriological Studies 16 (Chicago: University of Chicago Press, 1965), pp. 299–321.

[135] Alasdair Livingstone, *Mystical and Mythological Explanatory Works of Assyrian and Babylonian Scholars* (Oxford: Clarendon, 1986), p. 28, rev. 33.

source of intellectual authority about the workings of nature has to do with what T. Gieryn called "credibility contests," the results of which are anything but simple.[136] However no such evidence of competition for authority between discrepant accounts of the physical world comes to light within Mesopotamian scribal scholarship; neither is there a lexical equivalent to the words *scientia* or science in Akkadian. Nevertheless, the contents of the Mesopotamian divination series together with their various scholia, the production of a particular kind of knowledge and the activities on which that depended, create a context within which features of science in our sense become useful descriptive and analytic categories for our understanding of the content of these cuneiform texts. At no point should such descriptions or analyses in terms of "science" be taken to reflect a Mesopotamian point of view. In terms of standard criteria for the classification of knowledge as science, further consideration of the celestial divination corpus is found in Chapter 7.

[136] See Thomas F. Gieryn, *Cultural Boundaries of Science: Credibility on the Line* (Chicago/London: University of Chicago Press, 1999).

PERSONAL CELESTIAL DIVINATION:
THE BABYLONIAN HOROSCOPES

C ELESTIAL DIVINATION EMERGED WITHIN A CUNEIFORM SCRIBAL
tradition devoted to the systematic reckoning of "signs," taken as
messages from the gods as to what lay in store for humanity. The tech-
nique of divining the future in this way lay in the methods of scholarship
involved in the copying, consulting, and commenting on lists of omens.
This was evidently conceived of as categorically different from the direct
reception of the gods' message through visions, frenzy, or dream incuba-
tion. Since the end of the second millennium B.C., the reading and the
interpretation of heavenly signs in some form or another are well attested
in Mesopotamia, and the spread of this tradition is already well evidenced
in states influenced by the cuneiform literate culture, such as the Hittite
Empire, Syria, and Elam, which bordered Mesopotamia.[1] Textual evidence
for the history of Babylonian divination from celestial signs, attestation
of this activity in Mari letters notwithstanding,[2] can be defined as be-
ginning with late Old Babylonian omen texts and continuing through
Middle Babylonian and Middle Assyrian forerunners to the canonical ce-
lestial omen series *Enūma Anu Enlil* to the variety of celestial and nativity
omens as well as horoscopes of the Achaemenid, Seleucid, and Arsacid pe-
riods. Over the course of this nearly 2,000-year-long history, changes and
developments certainly occurred. But despite changes in textual formali-
ties and even specific content and methods, the coherence of Babylonian

[1] For an overview of the "peripheral" sources, see Koch-Westenholz, *Mesopotamian Astrology*,
pp. 44–51.

[2] Georges Dossin, "Les archives économiques du Palais de Mari," *Syria* 22 (1939), p. 101, and
idem, *Seconde Rencontre Assyriologique* (Paris: Imprimerie Nationale, 1951), pp. 46–8. More
evidence for divination at Mari relates to extispicy, for which see D. Charpin, "Les archives
du devin Asqudum dans la résidence du 'Chantier A,'" *MARI* 4 (1985), pp. 453–62.

astrology may be found in the persistent belief that the sky could be read as symbolic for the human realm, as expressed in the metaphor of the heavenly writing.

The Babylonian horoscopes come mostly from the city of Babylon, with the exception of five from Uruk[3] and one (of Achaemenid date) from Nippur.[4] This corpus of horoscopes, with the exception of two documents from the fifth century B.C., belongs for the most part to the last three centuries B.C. The chronological range is from the oldest at 410 B.C.[5] to the youngest at 69 B.C.[6] With five documents from the first century B.C., these are among the youngest extant cuneiform texts. In addition, the youngest horoscopes, all from Babylon, come from the same general period (between 89 and 69 B.C.) associated with the last texts from Babylon. The latest datable cuneiform texts, which are astronomical almanac texts presumably from the Esagila temple, judging by their use of the invocation to that temple's patron deities Bēl and Bēltīja, extend into the Common Era from 31/32 to 74/75.[7]

The cuneiform horoscopes begin three centuries before any extant Greek exemplars, and from the time one sees Greek horoscopes, the Babylonian texts cease.[8] Consistent with the general dearth of Greek scientific

[3] *BH* Texts 5, 9, 10, 11 and 16a and b.

[4] *BH* Text 1.

[5] *BH* 1 and 2.

[6] *BH* 27.

[7] A. J. Sachs, "The Latest Datable Cuneiform Texts," in Barry L. Eichler ed., *Kramer Anniversary Volume. Studies in Honor of Samuel Noah Kramer*, AOAT 25 (Neukirchen-Vluyn: Verlag Butzon & Bercker Kevelaer, 1976), pp. 379–98 and pls. XV–XIX. For other genres of late temple texts, see G. J. P. McEwan, "Arsacid Temple Records," *Iraq* 43 (1981), pp. 131–43 and R. J. van der Spek, "The Babylonian Temple During the Macedonian and Parthian Domination," *BiOr* 42 (1985), pp. 541–62.

[8] O. Neugebauer and H. B. van Hoesen, *Greek Horoscopes* (Philadelphia: American Philosophical Society, 1959), pp. 161–2, discuss the chronological distribution of horoscopes, including Babylonian, Demotic, Greek, and Arabic (extending up to the ninth century), and make the comment that the dearth of cuneiform horoscopes in the period between the fifth and first centuries B.C., in the context of the over 1,800 texts of astronomical content from the same period, can be no accident. Additional Greek horoscopes are published in Alexander Jones, *Astronomical Papyri from Oxyrhynchus*, Vols. 1 and 2, Memoirs of the American Philosophical Society 233 (Philadelphia: American Philosophical Society, 1999). For Demotic horoscopes, see O. Neugebauer, "Demotic Horoscopes," JAOS 63 (1943), pp. 115–26; O. Neugebauer and Richard A. Parker, "Two Demotic Horoscopes," *The Journal of Egyptian Archaeology* 54 (1968), pp. 231–4, and Parker, "A Horoscope Text in Triplicate," in Heinz-J. Thissen and Karl-Th. Zauzich eds., *Grammata demotika: Festschrift für Erich Lüddeckens zum 15. Juni 1983* (Würzburg: Zauzich, 1984), pp. 141–3.

literature during the last three centuries B.C., extant Greek horoscopes be-
gin only in the first century B.C. The first extant is the famous coronation
horoscope of Antiochus I of Commagene. This is, however, not a text but
a monument, located on the Nimrud Dagh in the Taurus Mountains,
on which was carved in iconographic relief the horoscope for the date
of the king's coronation in 62 B.C. The earliest preserved Greek horo-
scope in an original document is dated 10 B.C.[9] In literary sources, that
is, those preserved in Byzantine codices, the earliest known horoscope
was cast for 72 B.C., but recorded not before 22 B.C.,[10] in a collection
of the Roman Balbillus, the astrologer of Nero and Vespasian.[11] Greek
horoscopes then continue to the beginning of the Islamic period.[12] Greek
horoscopic astrology, or genethlialogy, was therefore a Hellenistic develop-
ment, particularly given the multiplicity of its theoretical roots in various
Hellenistic philosophical trends, such as the Stoic theory of signs and Aris-
totelian physics.[13] The likelihood of any pre-Hellenistic Greek horoscopy
is consequently remote, and the existence of the two Achaemenid period
Babylonian horoscopes[14] is sufficient to establish chronological priority
for Babylonian horoscopy.

The period in which Babylonian horoscopes emerged (fifth century
B.C.) was a formative period in the history of Babylonian celestial science.
Belonging to this period is not only the expansion of celestial divination

[9] See Neugebauer and van Hoesen, *Greek Horoscopes*, p. 16.

[10] Ibid., *Greek Horoscopes*, p. 78.

[11] Ibid., p. 76, Neugebauer, *HAMA*, p. 575, and Frederick H. Cramer, *Astrology in Roman
Law and Politics*, Memoirs Vol. 37 (Philadelphia: American Philosophical Society, 1954),
passim.

[12] The documents in question consist of papyri from Egypt and Byzantine codices that
contain the "literary horoscopes" such as those in the *Anthology* of Vettius Valens (second
century of the Common Era); see Neugebauer and van Hoesen, *Greek Horoscopes*, and see
A. Jones, *Astronomical Papyri from Oxyrhynchus*, Vol. I, Part V, pp. 249–95 and App. C,
pp. 308–9, and Vol. II, pp. 372–447.

[13] For the Aristotelian physics and cosmology underlying Greek horoscopy, see F. Solmsen,
Aristotle's System of the Physical World (Ithaca, NY: Cornell University Press, 1960), A. A.
Long, "Astrology: Arguments Pro and Contra," in J. Barnes, J. Brunschwig, M. Burnyeat,
and M. Schofield, eds., *Science and Speculation: Studies in Hellenistic Theory and Practice*
(Cambridge: Cambridge University Press, 1982), pp. 165–92, and relevance to Mesopotamia
in F. Rochberg-Halton, "Elements of the Babylonian Contribution to Hellenistic Astrol-
ogy," *JAOS* 108 (1987), pp. 51–62. For Stoic physics and theory of signs, see S. Sambursky,
Physics of the Stoics (London: Routledge and Kegan Paul, 1959), Chaps. I and II, David E.
Hahm, *The Origins of Stoic Cosmology* (Columbus OH: Ohio State University Press, 1977),
and Josiah B. Gould, *The Philosophy of Chrysippus* (Leiden: Brill, 1970), pp. 92–123.

[14] *BH* Texts 1 and 2.

beyond the scope of its prior concerns about state and king to a new branch of astrology whose objective concern was the individual rather than the king or the state, but also the development of mathematical astronomy. It is clear that the astronomical data – planetary positions as well as other phenomena regularly recorded in the horoscopes, for example, equinox and solstice dates, lunar longitudes, and eclipses – derive from a variety of astronomical texts in which such data are collected (e.g., diaries, almanacs, goal-year texts).[15] The degree to which various contemporary Babylonian practices, observational as well as computational, are reflected in the horoscope texts affords some insight into the way astronomy and astrology were interdependent in Mesopotamia.

In its early history, as discussed in Chapter 2, Babylonian astrology belonged to the general sphere of divination and was limited to the interpretation of celestial omens, whereby a celestial sign was associated with a terrestrial event concerning the king or the country as a whole. This early form of astrology developed on the basis of observational activity, although the schematic nature of the omens themselves occasionally produced entries in the texts that cannot be observed, such as an eclipse of the moon in which the eclipse shadow passes from west to east across the lunar disk. After the formulation of the text *Enūma Anu Enlil*, containing the traditional omens and their forecasts, observation of the heavens continued for the purpose of interpreting the planetary, astral, and otherwise atmospheric phenomena, as the scholars' correspondence with Esarhaddon and Aššurbanipal amply shows.[16]

After circa 500 B.C., judging by the appearance of horoscopes, the purpose of which was to predict an individual's fortune from celestial signs, the heavens were thought not only to bear meaning for the king and the state as in the traditional body of omen texts, but also for the individual. Not many of the extant horoscope texts contain forecasts for someone's life, but all of them are introduced by the date of birth of a child. Also a basic and significant departure from traditional celestial divination was the method of obtaining astronomical phenomena of interest to horoscopic astrology. Because not every planet would necessarily be above the horizon at the moment of birth, nor obviously would every birth occur at night, observation of the heavens for the purpose of interpretation was no longer sufficient. The development of the various computational

[15] For discussion of the relation between horoscopes and these genres of astronomical texts, see Chapter 4.

[16] Parpola, *LAS* Parts I and II; Hunger, *Astrological Reports*; Parpola, *Letters from Assyrian and Babylonian Scholars.*

methods of obtaining astronomical data on which astrology depended was an innovation of roughly the same period as the appearance of horoscopy, that is, mid-first millennium. Not only do the mathematical ephemerides evidence the results of such a development, but examples of astronomical diaries from the seventh century to those of the middle of the third century[17] already attest to the fact that a considerable number of phenomena were predicted on the basis of the knowledge of relevant periodicities. Goal-year texts exemplify the same method of astronomical prediction by use of underlying periods, a method whose origins precede the fifth century by a generous margin, as the use of some periods as a way of anticipating celestial phenomena deemed ominous is documented in the scholars' correspondence with the Sargonids. By the time horoscope texts are extant, it appears that a range of available predictive methods were employed.

In astrological texts, both omens and horoscopes, celestial phenomena had significance for human affairs. The significance of the heavens for human life was a function of divine agency and not stellar determinism. Regardless, the ability to predict the ominous phenomena was advantageous, and so a number of astronomical text genres dealing with the phenomena as "phenomena" apart from their astrological meaning developed as a result of their various treatments (observational vs. mathematical). In consequence, we refer to two "corpora," the astronomical and the astrological. It seems difficult to extrapolate from the difference between the approach to celestial phenomena in the two "corpora" (one practical, descriptive, mathematical, and focused exclusively on the phenomena; the other interpretative and focused not only on the relevance of the phenomena for human affairs but also on the manifestation of divine will in natural phenomena) two separate worldviews, that is, one interested only in the physical world, the other in the divine world and its interaction with the human. Not only is there no evidence that Babylonian astronomers consciously rejected the interpretative aspect of the study of the heavens and as a consequence separated themselves intellectually from those who practiced astrology,[18] the horoscope texts supply evidence that they did not. To identify more accurately the cultural place of the disciplines of astrology and astronomy in ancient Mesopotamia, as well as the worldview of their practitioners, it seems preferable to study them as two parts of one enterprise. Yet the nature of cuneiform scientific texts in which no explanations or justifications are given by the scribes for

[17] See Sachs–Hunger, *Diaries*, Vol. I.

[18] As in Neugebauer, "From Assyriology to Renaissance Art," *PAPS* 133 (1989), p. 393.

what they observe or compute, or for their astrological prognostications, imposes great limitations on such a study. In my view, however, the small corpus of cuneiform horoscopes sheds some light on the question.

If in the context of other astronomical cuneiform texts Babylonian horoscopes are to be viewed as a separate genre, their content needs to be defined. In succeeding chapters, we examine the particular sources, methods, and goals of the horoscopes in order to see them in relation to other astrological and astronomical texts. This section sets out the basic elements of a typical Babylonian horoscope for reference. It should be noted, however, that these documents are not rigidly uniform in form or in their inclusion of particular elements.

The purpose of the Babylonian horoscope document was, above all, to record positions of the seven planets (moon, sun, and five classical planets) in the zodiac on the date of a birth. The astronomical data was presented following a standard formulation: "Month x, (the previous month being) full/hollow, night of the nth, the child was born." Thereupon follow the positions of the planets in the zodiac, plus a number of lunar and solar data of presumed astrological interest, for example, eclipses, equinox and solstice dates, and dates of lunar visibility durations in the middle and end of the month.

The majority of horoscopes do not name the person for whom the horoscope is cast, and simply use the phrase "the child is born." In only four horoscopes is the name of the native recorded. Two Greek personal names, Aristokrates[19] and Nikanor,[20] are found in horoscopes from the early third century. Despite the fact that the names are Greek, conclusions as to the nationality of those for whom horoscopes were cast need to be based on supplementary evidence, as Babylonians with Greek names are known in this period. Evidence of the use of Greek names by Akkadian citizens is, however, limited.[21] A Seleucid text from Nippur, dated s.e. 158, shows that the son of a cult priest of Enlil, who had an Akkadian

[19] Written IA-ri-is-tu-ug(?)-gi-ra-te-e, *BH*10 obv. 2, and written [IA-r]i-is-tu-ug-ra-te-e, *BH*11 obv. 2.

[20] Written INik-(?)-nu-ú-ru, *BH* 12 obv. 2, and probably not the prominent official and friend of Antiochus III, who was appointed chief priest of the "sanctuaries in the region beyond the Taurus," according to a letter written by Antiochus III in s.e. 101 or 102. Two cuneiform documents attest to a *šatammu* of Esagila during the years s.e. 75–85 who was the LÚ *paqdu* INikanuru "deputy of Nikanor," who could be this individual. But the date of the horoscope (*BH* 12) for "Nikanor" in the year s.e. 82 (230 B.C.) precludes the identification of the two.

[21] See L. Timothy Doty, "Nikarchos and Kephalon," in E. Leichty, M. DeJ. Ellis, and P. Gerardi, eds., *A Scientific Humanist: Studies in Memory of Abraham Sachs*, Occasional

name and patronym, also had an alternative Greek name, which is des-
ignated as such in a tablet as "(so-and-so), whose other ("second") name
is Eudoxos."[22] It would seem likely, at any rate, that the horoscope sub-
jects would have been of high social standing, in which case Greek names
would confirm the elite status of the native. A fourth horoscope contains
a Babylonian name, well known from colophons in Uruk texts from the
Seleucid period: Anu-bēlšunu, son of Nidintu-Anu, descendant of Sin-
leqe-unninnī.[23] Again, the fact that a horoscope was cast for a member
of a family of scholars and priests of the Anu temple of Uruk, suggests
similarly that horoscopy was not for any but the upper class. If Babylonian
horoscopy is to be understood as an extension of the traditional scholarly
celestial divination, which above all served the king,[24] then it would not
seem unlikely that the new form of celestial prognostication should also
be confined to privileged individuals.[25] However reasonable these guesses
might be, they are mere conjecture, as prosopographical evidence from
horoscopes is so slim that the social aspect of the new type of astrology
remains necessarily inconclusive.

The date of the birth was accompanied by the time of birth, given with
respect to a part of the day, for example, "in the last part of night"[26] or

Publications of the Samuel Noah Kramer Fund 9 (Philadelphia: Babylonian Section, Uni-
versity Museum, 1988), pp. 95–118.

[22] See UM 29-15-802 obv. 5 in R. J. van der Spek, "Nippur, Sippar, and Larsa in the Hellenistic
Period," in M. De Jong Ellis, ed., *Nippur at the Centennial*, Occasional Publications of the
Samuel Noah Kramer Fund 14 (Philadelphia: Babylonian Section, University Museum,
1992), esp. pp. 250–2.

[23] See *BH* 9 obv. 2.

[24] Note also the fact that the physiognomic omens (e.g., YOS 10 54), which have been found
to be internally related to nativity omens (and perhaps horoscopes) insofar as their forecasts
for individuals are concerned, address the elite in society. Apodoses from the physiognomic
series contain subject matter that points to the palace and its personnel; see, for example,
YOS 10 54:22, 23, 30 and 31.

[25] Many basic aspects of the social structure of first-millennium Babylonia, such as the social
and economic "classes," are still to be fully understood, as attested to in statements such
as those by M. Dandamaev, *Slavery in Babylonia* (DeKalb, IL: Northern Illinois Univer-
sity Press, 1984), pp. 44–6; and J. Klíma, "Beiträge zur Struktur der neubabylonischen
Gesellschaft," CRRAI 11 (Leiden: Brill, 1964), pp. 11–21; see also the remarks concerning
the status of the "free citizen" (*mār bânûti*) in M. Roth, "A Case of Contested Status,"
in *DUMU-E₂-DUB-BA-A: Studies in Honor of Åke W. Sjöberg*, Occasional Publications of
the Samuel Noah Kramer Fund 11 (Philadelphia: Babylonian Section, University Museum,
1989), pp. 486–7. In this context, to attach anything more than vague social significance
to the prosopographical evidence from the horoscopes would be premature.

[26] See *BH* 1:1, 19:4, and 20:2.

"beginning of night."[27] The other convention for stating the time of birth was with respect to the seasonal hours, in which a diurnal seasonal hour represents one-twelfth of the time from sunrise to sunset, and a nocturnal seasonal hour one-twelfth of the time from sunset to sunrise. As there were always twelve seasonal hours, the length of these hours varied throughout the year. Termed *simanu* in Akkadian, the seasonal hours were designated by ordinal numbers (i.e., 7 SI-MAN = the 7th *simanu*).[28] Elsewhere, *simanu* has the basic meaning "interval," but in the horoscopes the twelve intervals represent the divisions of the halves of the day, from sunrise to sunset or from sunset to sunrise (not the 12-*bēru* division of the day in which the 360° circle of the sky from sunset to sunset was divided into twelve 30° units), and denote the time of birth.[29] The enumeration of the planetary positions usually follows the expression "in his hour (of birth)."

The body of the horoscope contains the planetary positions in the zodiac. These data may follow several introductory expressions, for example, "at that time," "in his hour (of birth)," or "that day." The first astronomical datum provided in a horoscope is the position of the moon on the date of the birth. This appears in two forms: first, as a position with respect to a Normal Star, in the manner of the diaries, and second as a position with respect to a zodiacal sign, or occasionally in degrees within a sign. The first form is familiar from the daily observation of the moon's position with respect to the stars made systematic in the astronomical diaries. In a horoscope, however, the moon's position is not, as in the diaries, given for the purpose of an observational record, but rather, presumably, for whatever influence that position was thought to have on the life of the native. The second lunar position, with respect to a zodiacal sign, is sometimes also found in diaries as part of the final summary of zodiacal locations of the planets during a given month.[30] Because the horoscope was prepared after the birth, the Babylonian astrologer must have relied either on available records, such as diaries, or on computational methods to derive the position of the moon on the date in question, depending on whether a Normal Star position or a zodiacal sign was desired. The method of direct computation, hypothetically at least, would have derived the zodiacal position of the moon for a particular date by the application of numerical schemes known from the ephemerides. Another possibility would have

[27] See *BH* 6 rev. 2, 7 rev. 2, 13:2, 15:2, and 17:2.
[28] *BH* 21:2'.
[29] F. Rochberg-Halton, "Babylonian Seasonal Hours," *Centaurus* 32 (1989), pp. 146–70.
[30] See Chapter 4, Subsections 4.1.1.1 and 4.2.1.

been to deduce from a Normal Star position the corresponding zodiacal sign.

Use of the Normal Star reference system is more characteristic of the earlier horoscopes, in which case the evidence argues somewhat more forcibly for the first method, that is, excerpting the desired lunar position with respect to a Normal Star from the appropriate diary text. We have the following excerpt from a third-century B.C. horoscope (*BH* 7 rev. 1–3, dated 258 B.C.): "night of the 8th, beginning of night, the moon was $1\frac{1}{2}$ cubits below (the bright star of the Ribbon of) the Fishes, the moon passed $\frac{1}{2}$ cubit to the east." Similarly, from another third-century example (*BH* 13:2–4, dated 224 B.C.), we have "night of the 4th, beginning of night, the moon was below the bright star of the Furrow by $1\frac{5}{6}$ cubits, the moon passed $\frac{1}{2}$ cubit to the east."[31] This horoscope also gives the zodiacal sign of the moon[32]: "In his hour (of birth), the moon was in Libra" (*BH* 13:5).

These two forms of expressing the lunar position in Babylonian horoscopes overlap chronologically until about the middle of the second century B.C., after which time the zodiacal reference system seems to become the norm. The earliest attested zodiacal position for the moon comes in a horoscope from Uruk, dated to the middle of the third century (263 B.C.).[33] Interestingly, the texts before 150 B.C. (*BH* 9, 10, 12, and 19) that give the zodiacal sign for the moon, with the exception of *BH* 12, are also from Uruk. The most precise manner of citing the lunar position is, of course, in degrees of ecliptical longitude with respect to a zodiacal sign, in the manner of Babylonian mathematical astronomy. An example is *BH* 5:4: "(That day) the moon was in 10° Aquarius." Such computed zodiacal positions are attested for the third to the first centuries B.C. Unlike the values found in the ephemeris columns, however, degree values, when found in horoscopes, are generally integers without fractions (exceptionally to $\frac{1}{2}$ degree, as in *BH* 5, 9, and 10).

The use of the ephemerides or their methods to generate degrees of longitude to many sexagesimal fractional places for horoscopes may therefore seem like overkill. However, Neugebauer pointed out with respect to the Greek horoscopes that although the computation of longitudes by means of "perpetual tables" meant that longitudes were computed to three or four sexagesimal places in order to guarantee the period relations, the

[31] Other positions of the moon with respect to the Normal Stars are found in *BH* 2, 4, 8, 14, 15, and 18.

[32] See *BH*, pp. 30–3 and 39.

[33] Other horoscopes giving the zodiacal sign for the moon are *BH* 9, 10, 12, 16, 19, 20, 21, 22a and b, 23, 24, 25, 26, and 27.

horoscopes simply used the integer value and dropped the fractions as those fractional places had no practical value for horoscopy.[34] This argument would apply equally well in the case of the Babylonian ephemerides and horoscopes. The purpose of the sexagesimal fractions in the cuneiform astronomical tables was also to preserve the period relations, and the horoscopes would presumably not have needed anything more than rounded values. Computed longitudes could also have been generated for sets of dates over the course of a number of years, such as in a tablet from Uruk discussed by J. Steele.[35] Steele's argument in part stems from the unusual feature of that tablet, which is that its content gives, in chronological order, longitudes for synodic phenomena of all the planets as well as the occurrence of eclipses. Of course, horoscopes (with the exception of the anomalous fifth-century example, *BH* 1) do not make use of the longitudes of the synodic phenomena, but attested interpolation methods would have provided a means to obtain the longitudes on arbitrary dates on the basis of prepared collections of planetary longitudes such as are found in A 3405.[36]

It seems worth noting at this point that the consideration of the moon's location near the ecliptic, that is, with respect to fixed stars, is evident in *Enūma Anu Enlil.* Omens for the position of the moon with respect to fixed stars were part of *Enūma Anu Enlil* Tablet 6, which collects omens for the first visibility of the moon in conjunction with a number of Astrolabe stars,[37] mostly those in the "path of Ea," whose stars have relatively small declinations.[38] In the first omen, the Pleiades stand at the side of the moon:

[34] Neugebauer and van Hoesen, *Greek Horoscopes,* p. 24.

[35] Steele, "A 3405: An Unusual Astronomical Text from Uruk," pp. 103–35, especially pp. 132–5.

[36] The situation is a bit more complicated than this, as Steele has pointed out in his discussion, ibid., pp. 132–3. The Uruk horoscopes do not refer to the Lunar Three, or to eclipses, although they contain remarks on lunar latitude. The horoscopes from Babylon, on the other hand, make regular reference to the Lunar Three and to eclipses, but not to lunar latitude. Speculation on the use of a text such as A 3405 obviously must take account of such discrepancies.

[37] For the stars of the Astrolabe, see the discussion of Reiner and Pingree in *BPO* 2, p. 3, with Table II. For the text, see E. F. Weidner, *Handbuch der Astronomie* (Leipzig: J. C. Hinrichs, 1915), pp. 65–6, also C. B. F. Walker and H. Hunger, "Zwölfmaldrei," *MDOG* 109 (1977), pp. 27–34, V. Donbaz and J. Koch, "Ein Astrolab der dritten Generation: NV. 10," *JCS* 47 (1995), pp. 63–84, and W. Horowitz, *Mesopotamian Cosmic Geography* (Winona Lake, IN: Eisenbrauns, 1998), pp. 154–66.

[38] The following declination values are given in Reiner-Pingree, *BPO* 2, p. 4, Table II: Pegasus −0.3°, Pleiades +8.0°, Orion −0.5°, Bow −26.6°, Arrow −18.2°, and Scorpius −12.2°.

"If in the first visibility of the moon the Pleiades stand at its side."[39] This is followed by omens for the Pleiades standing "within" the moon, that is, in occultation, for the Pleiades standing in the "horns" or cusps of the crescent, in the right cusp, the left cusp, and finally "in front of" the moon.[40] This pattern of omens is followed in turn by the same for the True Shepherd of Anu (MUL.SIPA.ZI. AN.NA, Orion), the Bow (MUL.PAN= *Qaštu*), the Arrow (*Šukūdu*, Sirius), and Scorpius (MUL.GÍR.TAB=*Zuqaqīpu*). Here only Scorpius is located close enough to the path of the moon for the omen to make astronomical sense. *Enūma Anu Enlil* Tablet 8 presents omens for the appearance of the moon with a surrounding halo within which stand various stars or planets, namely, Jupiter, Venus, and the some of the same stars of the Astrolabe as were found in *Enūma Anu Enlil* Tablet 6: "If (in the moon's appearance it is surrounded by a halo) and Pegasus stands inside it, depletion of barley and straw."[41] The remaining omens in the section are arranged by conjunctions of the moon with the Astrolabe stars cited, that is, Pegasus, Pleiades, Bow, Orion, Crab, Plow, Arrow, and so on.[42] *Enūma Anu Enlil* Tablet 2 shows that, when the moon is eclipsed in various ecliptical stars, that is, stars in the path of the moon,[43] predictions (lit. "verdicts" or "decisions") are given for a variety of subjects:

If the moon is dark in the region of Leo, the decision: the king will die and lions will go wild.

If the moon is dark in the region of Virgo, the decision is for the furrow: The furrow will cut off its produce (and so) there will be a famine of barley and straw.

If the moon is dark in the region of the stars to the west of Cancer, the decision (is for) the Tigris: The Tigris will diminish its flood waters.

If the moon is dark in the region of the stars to the east of Cancer, the decision (is for) the Euphrates: The Euphrates will diminish its flood waters.

If the moon is dark in Cancer, the decision (is for) the Euphrates.

If the moon is dark in the region of Pisces, the decision (is for) the Tigris and Akkad and a decision for the sea and Dilmun.

[39] *ACh* Suppl. II 9:1, and Verderame, *Le Tavole I–VI della serie astrologica Enūma Anu Enlil*, p. 170, sub VI.4 Section 1, text d.

[40] *ACh* Suppl. II 9:1–6; see Verderame, *Le Tavole I–VI della serie astrologica*, pp. 176–7.

[41] DIŠ-*ma* MUL.AŠ.GÁN (=*Ikû*) *ina libbišu izziz nušurrê šei u tibni*; see *ACh* Suppl. II 1 iv 17.

[42] *ACh* Suppl. II 1 iv 17–35.

[43] Eighteen stars in the path of the moon are listed in MUL.APIN I iv 31–39; see Hunger-Pingree, *MUL.APIN*, pp. 67–9. The star names are given in Chapter 4, note 21.

If the moon is dark in the region of Aries, the decision (is for) Uruk and Kullaba.[44]

The correlations between places and the ecliptical stars in the path of the moon is also found in an unpublished tablet from the British Museum (BM 47494),[45] as in this example:

If Virgo: Elam . . .
If Scorpius: Dilmun and . . .
If Sagitarrius: Babylon and Marad . . .
If Capricorn: Subartu . . .

The zodiacal signs also came to represent regions of significance for geographical localities, as in the following excerpt from the text just cited, in which the traditional second, third, and fourth triplicities associated with the cardinal directions south, west, and east are given:

Taurus, Virgo, and Capricorn (are) 3 regions (of significance) for Elam; Gemini, Libra, and Aquarius (are) 3 regions (of significance) for Amurru; Cancer, Scorpius, and Pisces are 3 regions of significance for Subartu.[46]

These selected examples of the use of the moon's location in celestial omens, whether expressed by reference to Astrolabe stars, ecliptical stars in the path of the moon, or zodiacal signs, establish a foundation on the basis of which the later adaptation of the moon's importance for nativities might be argued.

[44] *ACh* Suppl. I 1:2–8; cf. Verderame, *Le Tavole I–VI della serie astrologica*, p. 54. These lines are also found the the text MNB 1849 rev. 37–54; see E. Weidner, "Astrologische Geographie im Alten Orient," *AfO* 20 (1963), p. 118. The section begins with a short heading: line 37, *qaqqarē kakkabāni ša ina libbi Sin attalû ištakanu purussû ana alāni ittadanu* "Regions of stars in which the moon becomes eclipsed (for which) a decision is given for cities."

[45] DIŠ MUL.AB.SÍN KUR.NIM.MA.KI [. . .]
DIŠ MÚL.GÍR.TAB Dil-mun u bar-x-[. . .]
DIŠ MUL.PA.BIL.SAG Tin.Tir.KI Marad.da.KI u x x x x [. . .]
DIŠ MUL.SUHUR.MÁŠ KUR Su-bar-tu.KI [. . .], BM 47494: 8–12. I wish to thank C. B. F. Walker for bringing this text to my attention. Thanks are also due the British Museum photographic services for providing a photo, and the Trustees of the British Museum for permission to study and cite this unpublished text.

[46] DIŠ MÚL.GU₄.AN.NA MÚL.AB.SÍN *u* MÚ[L.SUHUR.MAŠ] 3
KI.MEŠ a-[na KUR][NIM].m[A.KI] DIŠ MÚL.MAŠ.TAB.
BA.LAGAB.GAL MÚL.ZI.BA.AN.N[A] [u] MUL.GU.LA 3 KI.MEŠ
a-n[a KU]R.MAR.TU.KI DIŠ MÚL.AL.LUL MUL.GÍR.TAB *u*
MÚL.AŠ.GÁN 3 KI.MEŠ [a-na KU]R Su-<bar-tu>KI, BM 47494 rev. 17–22.

After giving the data for the moon, the horoscope provides other planetary positions on the day of the birth in the standard sequence, (moon), sun, Jupiter, Venus, Mercury, Saturn, and Mars, generally with respect to a zodiacal sign alone, less often in specific degrees within a sign. With several exceptions,[47] horoscopes do not generally record positions of planetary synodic phenomena, but rather positions in the zodiac at the arbitrary moment of someone's birth. In fact, only one horoscope does not provide the planetary positions on the birth date, but rather the dates of synodic appearances, omitting Mars, and mostly within a few months of the birth. This anomalous horoscope is also the earliest exemplar, dated in the thirteenth year of Darius, for a birth on January 12/13, 410 B.C. The synodic phenomena given are first and last visibilities of Mercury as a morning star, Venus's last visibility as a morning star, Jupiter's second station and last visibility, and Saturn's first visibility, first station, and visible evening rising, or "opposition."[48] In the other horoscopes, when a planet is in conjunction with the sun and therefore not visible, the planet is said to have set and/or to be "with the sun."[49]

To the basic data concerning the positions of the planets on the date of birth, other astronomical events occurring in the same month or even the year of the birth are regularly added, such as dates of solstices and equinoxes.[50] Among these additional data, those concerning the moon at syzygy figure prominently. Such data indicate whether the month was full (30 days) or hollow (29 days), the date of the time interval termed *na* (=*nanmurtu*) around a full moon, usually on the 14th day, which measured the interval between sunrise and moonset, and the date of the particular time interval of last lunar visibility before sunrise of the month in question, a datum termed KUR.[51] Why the dates of lunar syzygies, not coinciding with the date of birth, are a regular feature of the Babylonian horoscope is a question that further relates to the significance of the moon for a nativity in the Babylonian system. That the moon was held to be of utmost importance in prehoroscopic Babylonian celestial prognostication is clear in the celestial omens of *Enūma Anu Enlil*, but alone cannot account for the inclusion of statements about the position or indeed the dates of certain lunar phenomena in horoscopes.

[47] See *BH* i throughout, 4:6–7, 6 upper edge 2; 7 obv. (?) 2–3, 23:6, 25:7–8, and 28 rev. 2.

[48] See *BH* i passim.

[49] See *BH*, pp. 45–6, Subsection 3.3.2.

[50] See Chapter 4, Subsection 4.1.2.

[51] Further discussion of *na* and KUR may be found Subsection 4.1.3.2.

From the point of view of celestial divination, the most important synodic moments of the moon's cycle were the day of the first lunar crescent or the first day of the month, and opposition, the day of full moon, considered ideally to fall on the 14th day. The lunar section of *Enūma Anu Enlil* is itself divided into two parts focused on these times in the lunar synodic cycle: Tablets 1–14 deal with the appearance of the moon in its first crescent, termed *tāmarāti* (IGI.DU₈.A.MEŠ) *ša Sin* "the visibilities of the moon," and Tablets 15–22 concern the middle of the month when eclipses occur. The dates of opposition were a significant feature of the omen texts, which focused on whether or not the syzygy was timely, early, or late. The 14th and 15th days were considered normal for opposition, hence of good portent, as in the following passages from Neo-Assyrian astrological reports:

If the moon reaches the sun and follows it closely, and one horn me[ets] the other: there will be truth in the land, and the son will spe[ak] truth with his father. – On the 14th day the moon and sun will be seen with each other. If the moon and sun are in opposi[tion]: the king of the land wil[l widen] his understanding; the foundation of the king's throne will becom[e stable]. – On the 14th day one god will be seen with the other.[52]

If on the 13th day [the m]oon and sun are seen together: unre[liab]le speech; the ways of the land will not be straight; there will be steps of the enemy; the enemy will plunder in the land. If the moon in Abu is not seen with the sun on the 14th or on the 15th day: there will be deaths; a god (i.e., pestilence) will devour.[53]

The date of the day of the last visibility of the moon was also of importance as it had an impact on the date of the new moon, and indeed, one horoscope (*BH* 2:8) makes mention of this date (*bubbulu*). *Enūma Anu Enlil* Tablet 1 concerns the appearance of the lunar crescent between the 27th and 2nd days and whether the moon's appearance and disappearance was *ina la minâtišu* "not according to its (normal) count," the noun *minītu* coming from the verb *manû* "to count."[54] As in the case of the date of opposition, the day of disappearance of the moon was interpreted according to its timeliness, as in the following astrological report:

[If the day of disapp]earance of the moon is at an inappropriate time: the ruin of the Gutians will take place. That means the moon disappears on the 27th

[52] Hunger, *Astrological Reports*, 294.
[53] Hunger, *Astrological Reports*, 306.
[54] *ACh* Suppl. 2 II:25–31.

day. If the day of disappearance of the moon in the third month[...]. there will be an eclipse, and the gods [....] 3 days [it stayed] in the sky. If the moon in Elul [becomes visible] on the 30th day: dispersal of the land [Subartu]. On this 30th day [the moon became visible]. The lord of kings will say: "Is [the sign] not affected?" The moon disappeared on the 27th; the 28th and the 29th it stayed inside the sky, and was seen on the 30th; when (else) should it have been seen? It should stay inside the sky less than 4 days, it never stayed 4 days.[55]

Conjunctions and oppositions of the sun and moon were clearly of interest to the celestial diviners, but later, the several time intervals around the beginning, middle, and end of the month, around conjunction and opposition of the sun and moon, such as were included in horoscopes, were defined and systematically recorded in nonmathematical astronomical texts such as diaries, almanacs, and goal-year texts.[56] A. Sachs termed these intervals the "Lunar Three" and the "Lunar Six,"[57] depending on which of the data were referred to in a given text. Horoscopes,[58] like almanacs, provide only the Lunar Three. No astrological indication for these phenomena is evident in Late Babylonian astronomy outside the horoscopes. Yet the evidence of the omens concerning the moon at the beginning, middle, and end of its synodic cycle may suggest a foundation for the later genethlialogical application, and the idea that the moon's behavior could be read as positive or negative, lucky or unlucky, for the king or state may have become an indication for the individual as well. What is interesting in the context of horoscopes is the fact that these phenomena, occurring as they do throughout the month, do not belong to the situation of the heavens solely on the date of birth. It is also interesting to note here that syzygies close to the date of birth are included both in the Greek literary horoscopes[59] and in a papyrus horoscope (P. Oxy. No. 4282) of the late third or early fourth century. A. Jones points to the fact that this is the first papyrus horoscope that gives the date (and longitude to the degree and minute) of full moon preceding the birth.[60] These horoscopes attest to the same sort of practice seen in the Babylonian horoscopes, that is, that

[55] Hunger, *Astrological Reports*, 346.

[56] Lis Brack-Bernsen, "Goal-Year Tablets: Lunar Data and Predictions," in N. M. Swerdlow, ed., *Ancient Astronomy and Celestial Divination* (Cambridge, MA/London: MIT Press, 1999), pp. 149–78.

[57] A. J. Sachs, "A Classification of the Babylonian Astronomical Tablets of the Seleucid Period," *JCS* 2 (1948), pp. 273 and 281; see also Subsection 4.1.3.2 of this book.

[58] The Uruk tradition seems to be somewhat different, as none of the extant Uruk horoscopes include the Lunar Three. See *BH* 5 and 9–11.

[59] Neugebauer and van Hoesen, *Greek Horoscopes*, p. 174 sub 2. Syzygies.

[60] Jones, *Astronomical Papyri from Oxyrhynchus*, Vol. 1, Text No. 4282, p. 288.

the moon was viewed as having astrological impact on the birth through other significant moments in the lunar cycle occurring in proximity to the birth.

Another important lunar datum not associated with the date of birth but included in the Babylonian horoscopes is the lunar eclipse. Here the practice seems to have been to include the eclipse which occurred within five months of the birth.[61] This too is paralleled in a papyrus horoscope (P. Oxy. 4281), albeit in broken context.[62] Jones surmises that this eclipse, mentioned in the first line of the horoscope, may have occurred within a month of the birth date.[63] Based on the preponderance of eclipse omens in the lunar section of *Enūma Anu Enlil*, the astrological significance of lunar eclipses in the Babylonian system is a given, although the application in an individual's horoscope eludes us. Eclipse omens are built around well-defined aspects of eclipses, such as the date, time, and direction of the shadow, as can be seen in the representative series of omens of *Enūma Anu Enlil* Tablets 15–22.[64] A commentary text specifies thus:

[If] the moon makes an eclipse, the month, day, watch, wind, path, and regions of stars in which the eclipse occurs are mixed, [the decision] for that of its month, its day, its watch, its wind, its path, and its star is given.[65]

Later developments of eclipse omens include the zodiacal sign in which the eclipse occurred, as in the Late Babylonian tablet BM 36746+.[66] These omens follow those of *Enūma Anu Enlil* in every way except the addition of the zodiac:

If the moon is eclipsed in Leo and finishes the watch and the north wind blows, Jupiter is not present during the eclipse, Saturn and Mars stand in Aries or in Sagittarius or in Pisces (*Ikû*). Variant: In its eclipse [a halo surrounds (the moon) and Regulus stands within it]. For this sign: [The king] of Akkad will experience severe hardship/*šibbu* disease; variant, it (*šibbu* disease) will seize him, and they will oust him from his throne in a revolt.[67]

The presence of eclipse data in horoscopes, although again not occurring on the date of the birth, can perhaps be accounted for by the interest

[61] See *BH* pp. 40–42 and Table 3.1, which tabulates the dates of the eclipses and the birth dates preserved for all the eclipses attested in the horoscopes.

[62] P. Oxy. No. 4281:1, Jones, *Astronomical Papyri from Oxyrhynchus*, pp. 430–1.

[63] Ibid., p. 288.

[64] *ABCD*.

[65] *ACh* Suppl. 1 II 19–20.

[66] F. Rochberg-Halton, "New Evidence for the History of Astrology," *JNES* 43 (1984), pp. 115–40.

[67] *BM* 36746 + obv. 5′–7′; see Rochberg-Halton, "New Evidence," pp. 134 and 136.

in lunar eclipses as omens. The reliability of the eclipse data recorded in horoscopes is predicated on further developments in methods to make lunar-eclipse predictions. Crucial to this development was the definition of the concepts of lunar nodes and latitude and the derivation of a parameter used to predict the return of the moon in eighteen years to the position of eclipse, the Saros.

Statements about lunar latitude using terms consistent with the mathematical astronomical texts concerning lunar latitude occur in three horoscopes from Uruk[68]:

1. The moon keeps going from the node to (increasing) positive latitude.
2. The moon keeps going from negative latitude toward the node.
3. The moon keeps going from positive latitude toward the node.

The terms node (MURUB$_4$), and positive and negative (latitude) (nim u sig) are well known from procedure texts, such as *ACT* 200 Section 4.[69] Noteworthy here too is the third-century papyrus horoscope that contains a reference to the motion in latitude of the moon.[70]

Yet the appearance of the lunar node, or of lunar latitude, in horoscopes seems to signal the development of a notion that the position of the moon with respect to the nodes had astrological significance, lending itself to interpretation as favorable or unfavorable depending on the positive or negative orientation of the moon to the nodal zone. Indeed, each of the three horoscopes making mention of the lunar latitude follows the statement about lunar latitude with a determination of favorable portent.

Outside the appearance of the node in the Uruk horoscopes, late astrological tradition attests to the notion that the position of the node itself had an impact on the nativity, just as did the positions of the other heavenly bodies. Evidence of the treatment of the lunar nodes as planets is found in fourth- and fifth-century India.[71] This practice was carried on in Sasanian and Mandaean astrology in which the Head and the Tail of the eclipse Dragon became the personified ascending and descending nodes, respectively.[72] Finally, the longitude of the lunar node was also included in Arabic horoscopes.[73]

[68] See *BH* 10, 16a and 16b, and see Chapter 4, Subsection 4.1.3.4.

[69] See the discussion in *BH* pp. 42–43.

[70] P. Oxy. no. 4245; see Jones, *Astronomical Papyri*, pp. 259 and 382–3.

[71] D. Pingree, *From Astral Omens to Astrology*, p. 40, note 5.

[72] F. Rochberg, "The Babylonian Origins of the Mandaean Book of the Zodiac," *Aram* 11–12 (1999–2000), p. 245.

[73] See D. Pingree, *The Thousands of Abū Ma'shar* (London: The Warburg Institute, University of London, 1968), pp. 24–25, 51, and 55.

Although the form in which the lunar phenomena *na*, KUR, and the length of the month previous to the birth are recorded is influenced by the fact that the data derive from astronomical texts, a relation to the ominous lunar phenomena previously enumerated is arguable. This suggests a continuity of focus, if not of form, if indeed the importance of the dates of significant lunar synodic moments remains consistent from Babylonian celestial divination to genethlialogy in horoscope form. A principal feature of celestial omens, as of all Mesopotamian omens, is the binary interpretive scheme good–propitious: bad–unpropitious, attached to the many empirical contrasts comprising the omen protases, bright–dark, on time–late, right–left, up–down, fast–slow, and so forth. One cannot help but wonder whether the inclusion in the Babylonian horoscope of the lunar data for the first day of the month, the day of opposition, and the last appearance before conjunction continued this practice of determining the propitious nature of signs. In a horoscope, of course, the indication would be for the quality of the life of the individual born at the time or in proximity to those significant lunar phenomena. The dates of *na* and KUR as well as the indication of the length of the previous month, although obviously no longer directly parallel in form to protases known from *Enūma Anu Enlil*, nonetheless resonate with such omens for the day of first visibility, the date of opposition, and the day of last visibility. Insofar as the dates of the Lunar Three can be correlated with the earlier and less precisely formulated *Enūma Anu Enlil* omens for these synodic moments, some sense can be made of their incorporation within a horoscope as a contribution to the overall interpretation – lucky or unlucky – of the heavens on, or near, the date of a birth.

Apart from the content of the horoscope relevant to the astronomical positions on the birth date, a number of horoscopes contain another element shared by other astronomical texts. This is the formulaic invocation to the deities associated either with the temples of Babylon or Uruk, that is, Bēl and Bēltija for Babylon, Anu and Antum for Uruk: *ina amat Bēl u Bēltīja lišlim* or *ina amat Ani u Anti lišlim* "by the word of Bēl/Anu and Bēltīja/Antum, may it be whole/well." The translation is subject to some interpretation regarding the verb *šalāmu*, which can either mean "to be whole," referring to the tablet, or "to be successful," referring to the endeavor of writing the tablet. The few texts that preserve a longer version of the prayer would suggest the latter interpretation, for example, "by the command of Anu and Antu, may whatever I do be successful."[74] The

74 See *TCL 6* 31, a mathematical text from Seleucid Uruk. Other texts with variants include *BRM* 4 8 and W. Mayer and J. van Dijk, *Texte aus dem Rēš-Heiligtum in Uruk-Warka*,

other possibility is that the referent is the tablet itself. In this case, the aim of the prayer would be that the tablet should remain unbroken or safe in its repository. This interpretation finds support in colophons that curse the removal or damage of a tablet.[75] The formula is known exclusively in Seleucid period texts, but from a range of text genres, including literature (*Lugale*[76]), magic,[77] divination,[78] astronomy,[79] legal documents,[80] and an isolated administrative text.[81]

A comparison between the appearance of the divine invocation on texts of scientific content, particularly the mathematical ephemerides, and that of the legal texts has been made by M. Roth, who collected the evidence from legal documents. She found no evidence that the invocation "has any particular significance for the marriage, loan, or other matter recorded, just as it has no particular significance for the scientific or literary treatises," and concluded that the invocation was included "as a matter of habit – and the invocation had no particular importance."[82] The presence of such divine invocations on texts of such a diversity of content clearly bears no direct connection with the texts' contents, but the nature of its significance, external to the actual content of the tablet, still invites speculation. Roth's observation that the invocation was a habitual, more or less formal, addition to a text is certainly correct, but perhaps, in addition, some significance can be attached to the place of the invoked deities in the wider belief system of the scribes. Consistent with the belief that the gods play the decisive role in all things is the invocation's use of

Baghdader Mitteilungen Beiheft 2 (Berlin: Gebr. Mann Verlag, 1980), No. 12, edited in W. Mayer, "Seleucidische Rituale aus Warka mit Emesal-Gebeten," *Orientalia* NS 47 (1978), pp. 431–58. M. T. Roth has collected the data in "ina amat DN$_1$ u DN$_2$ lišlim," *Journal of Semitic Studies* 33 (1988), pp. 1–9.

[75] H. Hunger, *Babylonische und assyrische Kolophone*, AOAT 2 (Neukirchen-Vluyn: Verlag Butzon & Bercker Kevelaer, 1968), No. 319, 320, or 333. See also G. Offner, "A propos de la sauvegarde des tablettes en Assyro-Babylonie," *RA* 44 (1950), pp. 135–43. For the entreaty not to damage a tablet, see *āmiru la itappil* "let the reader not damage it (the tablet)," in A. Livingstone, *Mystical and Mythological Explanatory Works of Assyrian and Babylonian Scholars* (Oxford: Clarendon, 1986), p. 28f. K 2670 colophon line 9 (=I.NAM.GIŠ.ḪUR.AN.KI.A).

[76] See Hunger, *Kolophone*, No. 87.

[77] Ibid., No. 425.

[78] Ibid., No. 95, from the *bārûtu* series.

[79] See *ACT* I, pp. 11 and 16.

[80] See Roth, "ina amat," p. 1.

[81] NBC 8456:1, see P.-A. Beaulieu, "Textes Administratifs Inedits d'Époque Hellenistique Provenant des Archives du Bīt Rēs," *RA* 83 (1989), pp. 79–80 (Text 5).

[82] Roth, "ina amat," p. 5.

the word *amatu* "word," understood here as "divine command or order."[83] The invocation can be seen to reflect the perception of deities as rulers, who make decisions, order existence, and determine the nature of things. The dedicatory expression may then be of some significance for the text itself, in that its physical state and/or its content would be kept intact and/or made successful by divine power invoked by the scribe.[84] Perhaps the parallel between the Mesopotamian invocation *ina amat* DN "by the command of DN" and that made in Galilean Aramaic and later medieval Jewish documents "by the name of" God is not as close as it appears at first, especially when differences in the underlying conceptions of deity between the two sets of sources are taken into account.[85] Perhaps alternatively we can look to the Hellenistic (Greco–Roman) dedications made in the form *ex epitagēs* "by the command of" deities considered as absolute rulers, such as Zeus *kurios* or Helios *despotēs*.[86] Like the Mesopotamian invocation, the Greco–Roman invocations may be connected to the concept of deity as ruler and patron, a concept that spread throughout the Hellenistic world as a direct influence from the ancient Near East.

Only after the introduction of the zodiac, as twelve signs of 30° each, sometime in the fifth century B.C., did changes occur in the classical celestial omen tradition. The *Enūma Anu Enlil* series continued to be transmitted in its traditional form well into the Seleucid period, but the introduction of personal forecasts from celestial phenomena at the time of birth, both in the old form of omens and in the new form of horoscopes, can be identified after about 500 B.C. A. Kuhrt and S. Sherwin-White point toward the increasing institutionalization of the Persian Empire and consequent transformation of the older political structures. At the same time, they show evidence for continuity in temple and cult throughout the Achaemenid period, which not only undercuts the historiography of Xerxes' destruction of the Esagila, but implies little disruption of temple life, including, presumably, that of the scribes and scholars who worked within.[87] Whereas the innovations evidenced within the scholarly

[83] *CAD* s.v. *amatu* 4a.

[84] See R. Borger, "Geheimwissen," in E. Weidner and W. von Soden eds., *Reallexikon der Assyriologie*, Vol. 3 (Berlin/New York: de Gruyter, 1964), pp. 188–91.

[85] Roth, "ina amat," pp. 7–8.

[86] See A. D. Nock, "Studies in the Greco-Roman Beliefs of the Empire," *JHS* (1925), 84–101, reprinted in Z. Stewart, ed., *Arthur Darby Nock: Essays on Religion and the Ancient World* (Oxford: Clarendon Press, 1972), pp. 45–8.

[87] A. Kuhrt and S. Sherwin-White, "Xerxes' Destruction of Babylonian Temples," in H. Sancisi-Weerdenburg and A. Kuhrt, eds., *Achaemenid History II. The Greek Sources*,

traditions of Babylonian astronomy and astrology around 500 B.C. are difficult to account for by external forces such as the change of political administration, it is equally difficult not to see some instrumental effect from such fundamental changes in the social structure of the period. Somehow, between the Neo-Assyrian and the Seleucid periods, a shift of the locus of astronomical activity from the palace to the temple occurred.[88] The attenuation of the former connection between the court and the scholars would seem a likely consequence of the change of infrastructure, and perhaps developments in scholarship were made possible by the preservation of Babylonian culture that continued within the Achaemenid Babylonian temple. At the same time, a rise in the importance of Anu, the sky god, and his consort Antum, in the Uruk pantheon may signal a change more widespread than within the literate scribal elite. The evidence for the prominence of Anu and Antum comes from Achaemenid period personal names.[89]

Although the aim to provide personal forecasts from celestial phenomena at the time of birth marks the horoscopes from the celestial divination of *Enūma Anu Enlil,* the Babylonian horoscopes rarely include personal forecasts. As a result, our knowledge of the interpretative aspect of Babylonian "horoscopic astrology" is rather poor. That prognostication from the heavens for the life of an individual was already an established practice is evidenced by the corpus of nativity omens that begin to appear around the same time as the earliest horoscopes. These took the form "If a child is born and Jupiter comes forth"[90] or "If a child is born in the begining/middle/end of Aries"[91] and the like. The nativity omen protases have as their scholastic forerunners the birth omens of the sort attested to in the omen series *Iqqur īpuš,* in the form "If a child is born on such-and-such a date"[92] Also related are the menologies and hemerologies in

Proceedings of the Groningen 1984 Achaemenid History Workshop (Leiden: Nederlands Instituut voor het Nabije Oosten, 1987), p. 77.

[88] See F. Rochberg, "The Cultural Locus of Astronomy in Late Babylonia," in H. Galter ed., *Die Rolle der Astronomie in den Kulturen Mesopotamiens,* Grazer Morgenlandische Studien 3 (Graz: GrazKult, 1993), pp. 31–47, and for further discussion, see Chapter 6.

[89] See A. Kuhrt, "Survey of Written Sources Available for the History of Babylonia under the Later Achaemenids," in H. Sancisi-Weerdenburg ed., *Achaemenid History I: Sources, Structures and Synthesis,* Proceedings of the Groningen 1983 Achaemenid History Workshop (Leiden: Nederlands Instituut voor het Nabije Oosten, 1987), p. 151.

[90] *TCL* 6 14; see Sachs, "Babylonian Horoscopes," *JCS* 6 (1952), Appendix II, pp. 65–75.

[91] BM 32583 (unpublished) seems to have carried this pattern for the entire zodiac.

[92] See Labat, *Calendrier,* p. 132f., Section 64 (K.11082), for divination from the birthdate of a child.

which actions on particular dates were determined to be propitious or unpropitious, containing remarks such as "on the 6th day one should not approach a woman."[93] The propitious nature of a particular day is also reflected in ritual texts in which certain actions were to be performed on specified dates, as in "on the 3rd day, a propitious day, you dig a hole on the steppe at sunset."[94] Almanacs giving advice and warnings of events to occur on each day of a certain month also attest to the attention paid to the correspondence between calendar dates and occurrences in the world.[95]

Other ancient Near Eastern parallels for such birth omens based on date of birth are attested from Hittite as well as Egyptian sources.[96] As pointed out in Chapter 2, the nativity omens utilize a stock of apodoses already known in the series *Alamdimmû*, for example, and refer to such personal concerns as children, wealth, property, reputation, and death. The scholarly tradition underlying the development of horoscopy therefore can be seen as a combination of the tradition of celestial divination as represented by the omen series *Enūma Anu Enlil*, which always retained its concern with public matters (king and state), and the tradition of birth omina.

Only a few horoscopes, all coming from Uruk, contain personal forecasts. The Uruk horoscopes contain very much the same repertoire of apodoses known from the nativity omens. The subjects are generally concerned with family and fortune, such as "he will be lacking in wealth" (*BH* 5 rev. 2), "his food will not ... for his hunger" (*BH* 5 rev. 4), "he will have ...'s and women" (*BH* 5 rev. 10), "his days will be long," and "he will have sons."[97] The resulting impression is that the horoscope appears

93 *KAR* 147 rev. 1. See also Stephen Langdon, *Babylonian Menologies and the Semitic Calendars* (London: The British Academy, 1935).

94 *KAR* 184 rev. 5; see Erich Ebeling, *Tod und Leben nach den Vorstellungen der Babylonier* (Berlin/Leipzig: de Gruyter, 1931), p. 83.

95 R. Labat, "Un almanach babylonien," *RA* 38 (1941), pp. 13–40. See also from the Middle Babylonian period, R. Labat, "Un calendrier cassite," *Sumer* 8 (1952), pp. 17–36; L. Matouš, "L'almanach de Bakr-Awa," *Sumer* 17 (1961), pp. 17–59; and A. R. George, "Babylonian Texts from the Folios of Sidney Smith," *RA* 82 (1988), pp. 151–5.

96 A Hittite fragment, KUB 8 35, translated from an Old Babylonian original, derives forecasts from the date of a child's birth and is cited by A. L. Oppenheim, "Man and Nature in Ancient Mesopotamia," in C. C. Gillespie, ed., *Dictionary of Scientific Biography* (New York: Charles Scribner & Sons, 1978), Vol. 15, p. 644, and B. Meissner, "Über Genethlialogie bei den Babyloniern," *Klio* 19 (1925), p. 434; see also K. Riemschneider, *Studien zu den Bogazköy-Texten* 9 (Wiesbaden: O. Harrassowitz, 1970), p. 44 note 39a; and for an Egyptian parallel, see Abd el-Mohsen Bakir, *The Cairo Calendar No. 86637* (Cairo: General Organisation for Government Printing Offices, 1966), especially pp. 13–50.

97 *BH* 9 obv. 4f.; cf. "he will have sons and daughters," *BH* 10 obv. 10.

to take the situation of the heavens on the date of birth as a compila-
tion of celestial omens. If this is the case, horoscopes represent a variant
form of celestial divination, one formed from the combination of tra-
ditional birth omens, celestial omens, and the later developed nativities.
Babylonian horoscopes are perhaps best understood as the extension and
elaboration of nativity omens, but the construction of the horoscope it-
self required an astronomical apparatus in a way quite different from the
earlier traditions of celestial omens or nativity omens. I consider the as-
tronomical sources for the horoscopes in the next chapter.

4

SOURCES FOR HOROSCOPES IN ASTRONOMICAL TEXTS

B Y THE LATE FIFTH CENTURY B.C., JUDGING BY THE APPEARANCE of horoscopes whose purpose was to determine aspects of an individual's life from celestial signs, the heavens were thought to bear meaning not only for the king and the state as in the traditional body of omen texts, but also for the individual. Not many of the extant horoscope texts contain statements concerning the life of the native, but all are introduced by the date of a birth. The intent is thereby unequivocal. Cuneiform horoscopy of necessity relied on the availability of recorded planetary and lunar data, rather than on observation, because not every planet is necessarily above the horizon at the moment of birth, nor obviously does every birth occur at night. This chapter aims to show the dependence of the Babylonian horoscopes on a variety of predictive and observational astronomical texts. From this it appears that the scribes who drew up horoscopes, although competent in all the aspects and methods of celestial science, or so we must assume, did not compute planetary positions for horoscopes directly, but utilized a wide range of astronomical texts at their disposal as reference material.

The development of the astronomical methods on which horoscopy depended can be traced back centuries before their culminating phase in the mid-first millennium, if one includes the evidence of early work on periodicities in the form of visibility and invisibility periods attested in texts such as MUL.APIN, *Enūma Anu Enlil,* or the astrological reports of the Neo-Assyrian period.[1] But recording visibility and invisibility periods, as

[1] For a brief sketch of the likely outline of the development of the methods of mathematical astronomy, as it pertains to the lunar theory, and the evidence for such an outline, see J. P. Britton, "Scientific Astronomy in Pre-Seleucid Astronomy," in H. Galter, ed., *Die Rolle der Astronomie in den Kulturen Mesopotamiens,* Grazer Morgenländische Studien 3 (Graz:

reflected in *Enūma Anu Enlil* Tablet 63 or MUL.APIN, for the purpose of determining whether the appearance of a celestial body is "early" or "late," as argued by D. Brown,[2] represents an altogether different goal from that of the late astronomy wherein the synodic periods of the planets are used to determine where and when a celestial body will next appear. As N. M. Swerdlow put it, "our attempt to make sense out of combining the visible and invisible periods into synodic periods may be premature because it appears that there was as yet no consistent idea of synodic period."[3]

By the time of the appearance of horoscopes, a number of well-defined genres of astronomical texts begin to take shape and ultimately comprise two chief classifications of what can be generally designated as Late Babylonian astronomy.[4] These text types may be described in a purely formal way as the nontabular and the tabular, being distinguished primarily by the arrangement and character of their content. The two basic types of astronomical texts also correspond roughly to two chief methods, the non-mathematical and mathematical astronomy,[5] which is a different distinction from that between observational and predictive. Nonmathematical texts, such as the diaries, contain both observations and predictions. Other nonmathematical texts, such as almanacs and Normal Star almanacs, record only predictions. These predicted data, however, do not seem to have been derived by the same methods as those of the ephemerides, or "mathematical" astronomical texts. Regardless of form or method, the objective here is to show that this astronomical repertoire of texts and the various methods represented therein were utilized by the scribes who constructed horoscopes. By means of a straightforward comparison of the astronomical content of the horoscopes with that of various nonmathematical and mathematical astronomical texts, it should be clear that this is the case.

To facilitate comparison of the horoscopes with texts of strictly astronomical content, some definitions and discussion of basic astronomical concepts found in these texts will be useful to the nonspecialist. The following discussion in no way purports to be an exposition of Babylonian astronomy or the sources for its study in any sense other than as a guide to

GrazKult, 1993), pp. 61–76. See also Paul-Alain Beaulieu and John P. Britton, "Rituals for an Eclipse Possibility in the 8th Year of Cyrus," *JCS* 46 (1994), pp. 73–86.

[2] Brown, *Mesopotamian Planetary Astronomy–Astrology*, pp. 113–22.

[3] N. M. Swerdlow, *The Babylonian Theory of the Planets* (Princeton, NJ: Princeton University Press, 1998), p. 26.

[4] See Section 4.2 for the history of this classification by Sachs.

[5] See A. J. Sachs, "A Classification of Babylonian Astronomical Tablets of the Seleucid Period," *JCS* 2 (1948), pp. 271–90.

understanding the astronomical content of the horoscopes. This section is therefore necessarily selective, treating only those aspects of astronomy relevant to the discussion of horoscope documents. In Subsections 4.2.1–4.2.4 the parallels between horoscopes and specific examples of astronomical texts of a variety of genres are considered. In several cases, such parallels constitute evidence of the methods used by the astrologers, namely, the use of diverse astronomical records as reference tools. The boundaries between the astronomical and astrological text types, which seem externally striking (e.g., certain data found in Normal Star almanacs are never found in almanacs), are thereby erased by the connections established between horoscopes and many other astronomical texts.

4.1 ASTRONOMICAL ELEMENTS OF THE HOROSCOPES

4.1.1 The Ecliptic

Perhaps the most obvious feature of the night sky is that the stars conform to recognizable patterns relative to one another (constellations) and that these remain fixed even though those patterns move continuously with respect to an observer's horizon (diurnal rotation). Characteristic of this continuous movement is that the stars appear to turn about a certain point in the sky. That is, most constellations rise and set in arcs, some larger, some smaller, but all have the same pole. The stars appear to move westward across the sky because of the eastward rotation of the earth. The period of rotation of the stars about their fixed axis each day is just under 24 hours (23 hours, 56 minutes, 4.1 seconds). Per year, the heavens appear to revolve at a fixed rate of nearly $366\frac{1}{4}$ revolutions. All the stars complete the diurnal rotation in the same time because these are only apparent motions produced by the rotation of the earth.

In Mesopotamia, the most important category of stars was that of those located on or near the ecliptic. The ecliptic traces the annual path of the sun relative to the fixed stars. The sun shares the diurnal motion of the entire heavens, rising in the east and setting in the west each day, but it also has its own apparent eastward motion with respect to the fixed stars. As the sun progresses around its path with respect to the fixed stars, its position may be "observed" just before sunrise or just after sunset in relation to stars, its eastward progress thereby becoming traceable. Stars seen to be near the setting sun, for example, will appear lower in the sky on successive evenings until they are no longer visible above the horizon at all. The stars appearing on the western horizon at sunset will change

throughout the year until, after the passage of one (sidereal) year, the sun will again be seen to set against the same background of stars as it did at the beginning of this cycle. In the course of the sidereal year, the sun moves from west to east relative to the stars at a rate of nearly 1° per day, and returns again to the same place among the stars.

The travel of the sun through the path of the stars that lie on or near the ecliptic creates a pattern, or phases, of visibility and invisibility for these stars. At some point in the cycle of a star's visibility, the star will be so near the sun (speaking in terms of direction against the celestial background, not in actual distance) that it will be invisible. One day the sun will rise and set in the same place as that star, but the next day the star will rise a bit before the sun as the sun proceeds in its 1° daily eastward motion. As the sun appears to move 1° away from the star each day, the interval increases between the rising of the star and sunrise. On the day when this star rises sufficiently before sunrise while the sky is still dark, that stellar rising will be visible. This first visible rising on the eastern horizon before sunrise that follows the period of the star's invisibility is known as the heliacal rising. In this appearance, the star is seen over the eastern horizon only briefly before the morning sunlight erases it. The interval of the star's visibility increases each night thereafter as the sun moves farther and farther away from the star.

Heliacal risings of ecliptical stars are listed already in the compendium MUL.APIN,[6] and this phenomenon, as well as other fixed star phases, for the star Sirius (MUL.KAK.SI.SÁ; or MUL.KAK.BAN = Šukūdu) began to be predicted by the late seventh century.[7] These early predictions can be said to be only schematic as the civil calendar was not yet regulated by the 19-year cycle introduced during the Achaemenid period for the purpose of regulating intercalations.[8] By the Seleucid period, the dates of Sirius phenomena (heliacal rising in July [Γ], heliacal setting in May [Ω], and apparent acronychal rising, or "opposition" in between [Θ]) were predicted according to a mathematical model set in fixed relation to a

[6] MUL.APIN I ii 36–iii 12 (dates of heliacal risings); I iii 34–48 (time intervals between the dates of heliacal risings); and II i 25–37 and 68–71 (heliacal risings observed together with wind directions); see Hunger–Pingree, MUL.APIN.

[7] Sachs–Hunger, *Diaries* I, p. 27.

[8] Britton places the first attested use of the 19-year cycle in a text from the reign of Cyrus (530 B.C.) and the earliest date to which we can attach the standardization of the intercalation scheme in the reign of Xerxes (484 B.C.). See J. P. Britton, "Treatments of Annual Phenomena in Cuneiform Sources," in J. M. Steele and A. Imhausen eds., *Under One Sky: Astronomy and Mathematics in the Ancient Near East*, AOAT 297 (Münster: Ugarit-Verlag, 2002), pp. 30–6.

scheme for equinox and solstice dates (the "Uruk Scheme"[9]), a scheme that presupposes the existence of the 19-year cycle.

Omens for the dates of heliacal risings of fixed stars are known from *Enūma Anu Enlil*,[10] but no mention is made of fixed-star phases in the horoscopes. The references to ecliptical stars in horoscopes are confined to their use as observational reference points, and defined by a group of stars called *kakkabū mināti* (MUL.ŠID.MEŠ) "counting stars," translated as Normal Stars after J. Epping's "Normalsterne."[11] These stars lie close to but are unevenly distributed around the ecliptic, that is, falling within a fairly narrow band of latitude between +10° and −7;30° within which the moon and planets can be seen. The ecliptical Normal Stars are known primarily from their use in the nonmathematical astronomical texts, such as the diaries. No complete list as such is attested in an ancient source, but about thirty-four Normal Stars are presently known.[12]

The Normal Stars provided a positional system in which distance with respect to a certain Normal Star was noted in cubits (KÚŠ = *ammatu*) and fingers (ŠU.SI = *ubānu*). The equivalence between the finger and the degree is 12 fingers = 1°. Because some astronomical texts seem to be at variance where the cubit is concerned, some measuring this unit apparently as 30 fingers, others as 24 fingers, it has been assumed that the Babylonian cubit was reckoned variously as 2° or 2½°.[13] The 2½° cubit, however, does not accord with the distances from Normal Stars as determined from the diary texts directly, in which the size of the cubit seems to be something just a little more than 2°.[14] The directional terms

[9] See A. Slotsky, "The Uruk Scheme Revisited," in H. Galter, ed., *Die Rolle der Astronomie in den Kulturen Mesopotamiens*, Grazer Morgenländische Studien 3 (Graz: GrazKult, 1993), pp. 359–366, for summary and previous literature.

[10] For example, Reiner–Pingree, *BPO* 2, pp. 56–9 (Text IX).

[11] J. Epping, *Astronomisches aus Babylon* (Freiburg im Briesgau, Stimmen aus Maria Laach, Ergänzungsheft 44, 1889), p. 115.

[12] A useful list of the thirty-two most commonly occurring may be found in Sachs–Hunger, *Diaries*, pp. 17–19, and Hunger–Pingree, *Astral Sciences*, pp. 148–9.

[13] Neugebauer, *ACT* I, p. 39; O. Neugebauer and A. J. Sachs, "Some Atypical Astronomical Cuneiform Texts I," *JCS* 21 (1967), esp. pp. 204–205; *HAMA*, pp. 536 and 591; Marvin Powell, "Masse und Gewichte," in D. O. Edzard, ed., *Reallexikon der Assyriologie*, Vol. 7 (Berlin: de Gruyter, 1990), pp. 457–517.

[14] See G. Grasshoff, "Normal Star Observations in Late Babylonian Astronomical Diaries," in N. M. Swerdlow, ed., *Ancient Astronomy and Celestial Divination* (Cambridge, MA/ London: MIT Press, 1999), pp. 97–147, especially Section 6.2, "First Approximations to the KÙŠ," and the discussion in Swerdlow, *The Babylonian Theory of the Planets*, p. xi. On a number of other grounds, J. M. Steele has dismissed the existence of the 30 finger,

above and below, used in expressions of distances from Normal Stars, are equally difficult to interpret astronomically, so much so that Swerdlow noted,

it is now my belief that such measurements of distance at conjunctions of planets with stars, like the identical measurements at conjunctions of planets with each other, were purely for purposes of divination, and had no role whatever in the planetary theory of the ephemerides.[15]

In light of the horoscopes, this radical position gains ground. The Normal Star distances, used as an observational aid to noting the position of a body in the ecliptic, appear in the horoscopes, although they are found exclusively for citing the position of the moon just after conjunction, not on the date of birth.[16] Because the Normal Star distances represent observations, it would make sense for the horoscopes to draw on such recorded observational statements only for a time independent of the time of birth, such as on the first day of each month. If the conjunction of the moon and a Normal Star were interpretable as an omen, the moon's position on the first day would contribute to the overall nativity in the same manner as other lunar phenomena occurring on or near the date of birth. In such statements, the use of the expressions above and below, just as in front of (=west of) and behind (=east of), accords well with the binary terms characteristic of many divinatory schemata, although no interpretation of this sort is attested.

Otherwise, horoscopes employ the established positional system of the zodiac for the location of sun, moon, and planets on the date of birth. The horoscopes make reference to zodiacal signs both with and without degrees of longitude.

4.1.1.1 *The Zodiac*

The zodiac is a beltway through the heavens through which the sun, moon, and planets may be seen to move. In a conception of the sky as a sphere, the zodiac is a circular belt bisected by the ecliptic and extending roughly 8° north and south of it. Nothing in the astronomical cuneiform

or 2.5° cubit, altogether, in "Planetary Latitude in Babylonian Mathematical Astronomy," *JHA* 34 (2003), pp. 15–18.

[15] Ibid. Cf. Hunger–Pingree, *Astral Sciences*, pp. 147–8, in which they seem more sanguine about the use of distances in cubits from Normal Stars as a coordinate system.

[16] *BH* 2, 4, 6, 7, 8, 13, 14, 15, 18, and 21.

texts suggests that the Babylonians thought in terms of a celestial sphere. Indeed, no appeal to spatial depictions of any kind is made in Babylonian astronomical texts, whether observational or computational.[17] Certain terms encountered in mythological and cosmological literature may be taken to imply some such conception of celestial circles, but considering the gulf between these mythological texts and the sources in which we find reference to the zodiac, no connection need be made. In Sumerian, an.ki.nigin.na "the entire universe" has its equivalent in the Akkadian expression *kippat šamê u erṣeti* "the totality (lit. "circumference") of heaven and earth." In the Akkadian, the basic meaning of *kippatu* is a loop or circle,[18] and in the Sumerian, the element nigin is the counterpart to Akkadian *lamû* "to encircle" or "to move in a circle."[19] Reference to the bowl shape of the heavens and earth appears in the hymn to Šamaš: "the heavens are not enough as the vessel into which you gaze, the sum of all lands is inadequate as a seer's bowl."[20] This is metaphoric language, befitting hymnic texts, and so cannot be taken as a direct description of the shape of the world.

Certain constellations are found within the zodiacal belt; hence the zodiacal constellations. Some of these were identified by the fact that the moon will be seen to wend its way through them on its monthly course. In ancient Mesopotamia, the stars in "the path of the moon" (*harrān Sîn*) were recognized at least by the second quarter of the first millennium B.C.[21] These constellations are not of equal size, and therefore cannot be

[17] See L. Brack-Bernsen and H. Hunger, "The Babylonian Zodiac: Speculations on its Invention and Significance," *Centaurus* 41 (1999), pp. 280–92.

[18] In the meaning "circumference," *kippatu* is found most often in religious texts referring to the cosmic domains of deities. See *CAD* s.v. *kippatu*, meaning 3. See also W. Horowitz, *Mesopotamian Cosmic Geography*, pp. 226–7 and 264–5.

[19] See the Sumerian myth "Enmerkar and Enmushkeshdanna," in Kramer, *Sumerian Mythology*, p. 197.

[20] Lambert, *Babylonian Wisdom Literature*, p. 135:154–155. See also the prayer to Marduk in which the heaven of Anu is "the incense bowl of the gods," *KAR* 25 ii 16.

[21] A list enumerating them is included in the astronomical compendium MUL.APIN I iv 31–37 and gives the following eighteen zodiacal constellations: MUL.MUL (*Zappu*), "The Stars" = The Pleiades; MUL.GU₄.AN.NA (*Alu*), "The Bull of Heaven" = Taurus; MUL.SIPA.ZI.AN.NA (*Šidallu*), "The True Shepherd of Anu" = Orion; MUL.ŠU.GI (*Šibu*), The Old Man" = Perseus; MUL.GAM (*Gamlu*), "The Crook" = Auriga; MUL.MAŠ.TAB.BA.GAL.GAL (*Tū'amū rabbûtu*), "The Great Twins" = α and β Geminorum; MUL.AL.LUL (*Alluttu*), "The Crab" = Cancer; MUL.UR.GU.LA (*Urgulu*), "The Lion" = Leo; MUL.AB.SÍN (*Šer'u*), "The Furrow" = α + Virginis; MUL.zi-ba-ni-tu₄ (*Zibanītu*, later RÍN), "The Scales" = Libra; MUL.GÍR.TAB (*Zuqaqīpu*), "The Scorpion" = Scorpius; MUL.pa-bil-sag (*Pabilsag*), "Pabilsag" =

used as a standard of reference for the calculation of "distance," that is, in degrees of longitude, along "the path."

The zodiac consists of twelve 30° segments (1 sign = 30°), named for twelve ecliptical constellations, all of which belonged to the list of stars in the path of the moon found in MUL.APIN. Although the names of the zodiacal signs derived from an original relation to the zodiacal constellations, once the signs were defined by longitude rather than the constellation they ceased to have any real relation to the constellations and became a mathematical reference system, representing the 360° of the ecliptic, counted from some defined starting point.

The point on the modern ecliptic chosen as zero (normally the vernal point Aries 0°, where equator and ecliptic intersect) is not a fixed point in relation to the stars. The motion of the vernal point (and the autumnal equinoctial point) is retrograde, that is, westward, with respect to the stars. The effect of this motion is to increase the longitudes of stars by about 50.26 seconds of arc each year. Latitudes remain constant. The vernal point makes a complete revolution, returning to its original place with respect to the stars, in somewhat less than 26,000 years. This motion is known as precession. It is caused by the fact that the earth is not a perfect sphere but rather is an oblate ellipsoid, bulging at the equator. The oblateness of the earth, combined with the action of the sun and moon "pulling" on the earth's equatorial bulge, affects the motion of the earth's axial rotation such that the motion of the axis creates a cone in space, moving in reverse (retrograde) with respect to the direction of rotation. The effect of precession, however, was not recognized by the Babylonians as their zodiac was always sidereally fixed.[22]

The zodiacal signs provided the means for expressing longitude in Babylonian astronomical texts and are found precisely in texts that generally refer to a computed position of a planet or the moon. Unfortunately, however, use of the zodiac cannot serve as a marker for computed versus

Sagittarius (possibly with θ + Ophiuchi); MUL.SUHUR.MÁŠ, "The Goat-fish" = Capricorn; MUL.GU.LA (GU.LA), "The Great One" = Aquarius; KUN.MEŠ (*Zibbātu*), "Tails" = ω Piscium; MUL.SIM.MAH (*Sinunūtu*), "The Swallow" = western fish of Pisces; MUL.A-nu-ni-tu (*Anunītu*) = eastern fish of Pisces; MUL.LÚ.HUN.GÁ (*Agru*), "The Hired Man" = Aries. The list is defined (I iv 38–39) as follows: "All these are the gods who stand in the path of the Moon, through whose regions the Moon in the course of a month passes and whom he touches."

[22] For which, see O. Neugebauer, "The Alleged Babylonian Discovery of the Precession of the Equinoxes," *JAOS* 70 (1950), pp. 1–8.

observed phenomena, just as the use of Normal Stars cannot simply indicate observations. None of the ecliptical Normal Star references in horoscopes can be construed as observations, and similarly, references to zodiacal signs in the astronomical diaries need not reflect computed positions.

One can posit the following steps in the development of the zodiac, although it must be said that our knowledge of how the zodiac was first devised is provisional. The division of the schematic calendar into 12 months of 30 days each, such as was used in MUL.APIN, the Astrolabes, and *Enūma Anu Enlil*, could be correlated with twelve constellations through which the sun was found to travel in one ideal "year" of twelve 30-day months.[23] Because the spring equinox, which was always close to the beginning of the Babylonian year, was to occur in *Nisannu* (I.15 according to the tradition of MUL.APIN[24]), then *Nisannu*, or month I, was when the sun was in the constellation Aries (MUL.LÚ.HUN.GA = *Agru* "the hired man").[25] For each ideal month, the sun's position in the sky could be identified by the name of a constellation but schematized to correlate the sun's passage through the constellations with the twelve 30-day intervals. The result would be an association of twelve 30-day months and twelve constellations, later standardized to intervals of 30° along the ecliptic. L. Brack-Bernsen and H. Hunger have further argued for a connection among schematic months, zodiac, and intervals along the eastern horizon, which yields

[23] Zodiacal constellations were termed *lumāšu*, written logographically as MUL.LU.MAŠ (LU.MAŠ-*ši*) and sometimes shortened to MUL.LU, as in *TCL* 6 14:20. See *CAD* s.v. *lumāšu*, with other literature. See also Michael Roaf and Annette Zgoll, "Assyrian Astroglyphs," esp. pp. 266–7.

[24] See MUL.APIN II i 19–21: "On the 15th of *Nisannu* the Moon stands in the evening in Libra in the east, and the Sun in front of the Stars behind Aries in the west. 3 minas is a daytime watch, 3 minas is a nighttime watch." Note the tradition of *Enūma Anu Enlil* placed the equinox in *Addaru* (Month XII); see *Enūma Anu Enlil* 14, in F. N. H. Al-Rawi and A. R. George, "Enūma Anu Enlil XIV and Other Early Astronomical Tables," *AfO* 38/39 (1991/1992), pp. 52–73.

[25] P. Huber, *Astronomical Dating of Babylon I and Ur III*, Occasional Papers on the Near East 1/4 (Malibu, CA: Undena, 1982), pp. 8–9, has pointed out that in the Old Babylonian period the year began about two weeks after vernal equinox, on average, and that before the introduction of the 19-year cycle the irregular intercalations indicate "large fluctuations in the beginning of the year." In the period between 748 and 626 B.C. the beginnings of years, defined by the New Year syzygy (the new moon immediately preceding the first of *Nisannu*), occur on average at 346°. This too is consistent with the placing of the vernal equinox on *Nisannu* 15, as in MUL.APIN. After the institution of the 19-year cycle, the new year fell within the narrow range of 358° to 25° (with a median value of 12°).

the relation between longitude and time ($\Delta\lambda$ and $\Delta\tau$) characteristic of Babylonian mathematical astronomical theory.[26]

The earliest direct evidence for the existence of the zodiac comes from fifth-century astronomical diary texts (e.g., No. −453 iv 2 and upper edge 2–3, No. −440 rev. 3′, and No. −418:5, 10, rev. 8′ and 14′)[27] and horoscopes (*BH* 1 and 2, both dated 410 B.C.), in which positions of the planets are cited with terminology used with respect to zodiacal signs as opposed to zodiacal constellations. The existence of the zodiac in this period is also indirectly supported by Seleucid astronomical texts that deal with phenomena of the Achaemenid period. The oldest of these relates longitudes of conjunctions of the sun and moon, computed by a schematic method, with solar eclipses. The phenomena computed in these texts can be dated with relative certainty to 475 B.C., although the writing of the tablets was certainly much later.[28] Another text that uses the zodiac together with astronomical phenomena, dated to circa. 431 B.C.,[29] lists phenomena for Venus and Mars plus a column containing values of "column Φ," the purpose of which is to take into account the influence of the moon's variable velocity.[30]

Useful for tracing the evolution of the terminology connected to the various ecliptical reference systems are the astronomical diaries of the pre-Seleucid period, especially in the summary statements of the planets' location given at the end of a month section. The early diaries, those from the seventh to approximately the mid-fifth century, make reference to zodiacal constellations, denoting relative positions by the expressions IGI "in front of" (to the west) or further along in the sense of the daily rotation, and *ár* "behind" (to the east). After the mid-fifth century, one notes the gradual increase of another usage, namely, of *ina* "in," *ina* SAG "at the beginning of," or *ina* TIL "at the end," for reference to the equal 30° divisions of the ecliptic into zodiacal signs. In the very early texts, however, the terminology seems not to be fully differentiated, so that a

[26] Brack-Bernsen and Hunger, "The Babylonian Zodiac," pp. 281–9.

[27] Sachs-Hunger, *Diaries*, Vol. I. The references in diary No. −463:3′, 7′, and 12′ are not yet clearly distinguishable from zodiacal constellations, although they could already be zodiacal signs.

[28] A. Aaboe and A. J. Sachs, "Two Lunar Texts of the Achaemenid Period from Babylon," *Centaurus* 14 (1969), p. 17, Text B obv. col. v with heading lu-maš "zodiacal sign."

[29] O. Neugebauer and A. J. Sachs, "Some Atypical Astronomical Cuneiform Texts, I," *JCS* 21 (1967), pp. 193 and 197–8, Text C.

[30] J. P. Britton, "An Early Function for Eclipse Magnitudes in Babylonian Astronomy," *Centaurus* 32 (1989), pp. 1–52.

simple "*ina* star name" may refer to a zodiacal constellation rather than to a sign.[31] In Seleucid period texts, such as the horoscopes (except *BH* 1 and 2), the terminology "at the beginning/the end" followed by a star name always refers to a zodiacal sign. *BH* 12:3, 17:5, and 20:4 contain lunar positions "at the beginning of" (*ina* SAG) a zodiacal sign, and *BH* 15:5 has "at the end of" (*ina* TIL) zodiacal sign. *BH* 5:5 and 9:5 contain positions of Jupiter "at the beginning" of a zodiacal sign.

By the early fourth century, all the references in astronomical texts to positions of planets on the ecliptic were made either by the Normal Star system or the zodiac, and the zodiacal constellations, which originally constituted the "stars in the path of the moon," were no longer of any relevance.[32] As previously noted, the distinction between Normal Star and zodiacal references relates to the distinction between observation and prediction, but does not serve to indicate in all cases either one or the other. Although the system of degrees within the zodiac was useful for computation and prediction, but not for observations as the boundaries of the signs are not visible, the Normal Stars provided a series of visible reference points. Zodiacal signs (or constellations in the earlier diaries) were preferred for the summaries of planetary positions found at the end of monthly entries in astronomical diaries. There, following the phrase *inūšu* "at that time," the zodiacal signs in which the planets were located (sometimes with the additional datum "in the beginning/end" of the sign) are listed, for example, "Jupiter was in the beginning of Cancer, Venus was in Aries, Saturn, Mars and Mercury, which had set, were not visible."[33] The diaries also cite synodic phenomena of the planets with respect to zodiacal signs,[34] which when not observed are marked as such. Therefore, in the diaries, zodiacal references seem to appear both in observational as well as in predictive statements.

4.1.1.2 *Norming of the Zodiac*

Since Ptolemy's *Almagest*,[35] the beginning of the zodiac at 0° Aries was fixed in relation to the vernal equinox, which, however, moves westward

[31] For example, diary No. −453 up.edge 2.

[32] The last instance is the diary No. −380 in which Mars is in the nonzodiacal constellation "the Chariot" in Month XI; see Hunger–Pingree, *Astral Sciences*, p. 146.

[33] Diary No. −418 rev. 13′−14′. For many more examples, see Sachs–Hunger, *Diaries*.

[34] See Sachs–Hunger, *Diaries*, Vol. I, p. 25–6 sub 2.a and c.

[35] Almagest II, 7; see Toomer, *Ptolemy's Almagest*, p. 90 and note 70, and *HAMA*, p. 600.

at a constant rate ($1/72°$ per year). The Babylonian zodiac was not counted from the vernal point, but was generally normed by the end points of zodiacal constellations, each one counted from 0° to 30°. This implies an ecliptic of 360°, but Babylonian astronomy employed degrees within signs rather than a strictly numerical count of longitudes from 0 to 360. Also, the longitudes assigned to the fixed stars were done so arbitrarily, with the result that the zero point of the ecliptic did not coincide with the vernal equinox.[36] That the Babylonian zodiac was sidereally fixed implies that regardless of date the fixed stars do not change their positions (degree of longitude) with respect to the norming point of the ecliptic.

The zodiac and the year itself were defined sidereally, so that one year was the time in which the sun returned to the same position with respect to a fixed star. The year that was counted from vernal equinox to vernal equinox, known as the tropical year, was not yet distinguished by the Babylonians from the sidereal year. To have done so would have been to recognize the fact that the equinoxes move – the precession of the equinoxes – and this has been ruled out for Babylonian astronomy.[37]

In mathematical astronomical texts, the equinoxes and solstices were also normed sidereally, at 10° Aries in System A and 8° Aries in System B.[38] That the cardinal points of the year do not correspond to the zero points of the appropriate signs in the Babylonian zodiac is a result of the sidereal (rather than the tropical) construction of the zodiac. The two systems of Babylonian mathematical astronomy maintained the two norming points throughout the period of their use. As Neugebauer pointed out,[39] neither the chronological relation between Systems A and B norms nor the reason for their difference is understood. That both vernal-point longitudes remained sidereally fixed, however, proves precession was not recognized.

The counting of the zodiac signs from Aries is a consequence of the origins of the zodiacal signs in the association between zodiacal constellations and the twelve schematic months of the year. Although the original list of stars in the "path of the moon" began at the end of Aries, specifically, with the Pleiades (choosing an exemplary star with longitude[40]

[36] See P. Huber, "Ueber den Nullpunkt der babylonischen Ekliptik," *Centaurus* 5 (1958), p. 192.

[37] Neugebauer, "Alleged Babylonian Discovery," and idem, *HAMA*, p. 594.

[38] Neugebauer, *HAMA* II Intr. 4, 1, "Oblique Ascensions," pp. 368–9. A discussion of Systems A and B may be found under Subsections 4.2.4 and 7.4.2.

[39] Neugebauer, *HAMA*, p. 368–9.

[40] Longitude given by Hunger–Pingree, MUL.APIN, p. 144; see Table VII.

33;40°),[41] the zodiac, when it is enumerated in texts, begins with Aries.[42] More precisely, however, we still cannot establish the star that originally served as norming point for the ecliptic.[43] Even were we to assume the vernal point was determined correctly when it was assigned to 10° then 8° Aries, the corresponding dates for these zodiacal norming points cannot be pinpointed, as we do not sufficiently understand the ancient methods used to obtain those values. Comparison against modern values for the longitudes of equinoxes is therefore uninformative for this purpose.[44]

4.1.2 The Sun

The sun's annual motion with respect to the zodiac in combination with the diurnal rotation around the poles produces effects such as the seasons and the variation in the length of day and night throughout the year. Solar phenomena incorporated within horoscopes are the longitude of the sun at the time of birth, the date of either solstice or equinox within a month or two of the birth date, and the occurrence of a solar eclipse within the year of the birth. The eclipses mentioned in the horoscopes occur seemingly within five months of the birth, although our evidence is too fragmentary to determine with any greater definition the relation between birth date and eclipse date. In the extant texts, ten out of the thirteen horoscopes that contain eclipses cite both a solar and a lunar eclipse.[45]

Solar data entered into horoscope texts are the results of computation, although the methods used to obtain them are not clear in every case. Before the introduction of the 19-year cycle, two calendric cycles attest to the schematization of certain aspects of the motion of the sun, in one case in relation to the fixed stars and in the other in relation to the moon.

[41] The star of the Pleiades called MUL.MUL represents η Tauri of the Normal Stars. In the Normal Star almanacs, conjunctions with this star seem to occur, on average, 4 days following the entry of the planet within the zodiacal sign Taurus, on the basis of comparison with almanacs. Huber worked this relationship out in "Ueber den Nullpunkt der babylonischen Ekliptik," pp. 198–9.

[42] For example, *TCL* 6 14:10–22; see Sachs, "Babylonian Horoscopes," pp. 65–8.

[43] See the attempt by van der Waerden, "Zur babylonischen Planetenrechnung." *Eudemus* I (1941), pp. 46–7, in which it is suggested that ν Piscium served as 0°Aries, then χ Tauri for 30° Taurus, and finally α Virginis for 30° Virgo. See Sach's refutation in "A Late Babylonian Star Catalogue," *JCS* 6 (1952), pp. 149–50.

[44] See Neugebauer's discussion of these problems in "Alleged Babylonian Discovery," esp. pp. 5–6.

[45] *BH* Texts 3:5 (in broken context), 4 rev. 3–4 and 24:6–7 mention only lunar eclipses.

The first of these refers to a solstice–equinox scheme (with last settings and first risings of Sirius), which antedates the Uruk scheme.[46] The dates for the cardinal points in this text refer to the years 616–588 B.C. Besides the month and day numbers, the actual moments of the solstices and equinoxes are given, expressed in time degrees (uš).[47] Probably because of the chronology of the extant horoscopes, according to which all belong to the period after the introduction of the 19-year cycle, the dates of solstices and equinoxes entered there are most certainly derived by the later Uruk scheme, which is equivalent to the 19-year cycle.[48]

The second of the two calendric cycles is the famous Saros, the 18-year eclipse cycle of 223 lunar months. Solar eclipses recorded in horoscopes reflect data predicted by means of the 18-year period. Whether such data were obtained for the purpose of a horoscope directly or whether they were excerpted from other texts is difficult to demonstrate, but are considered more fully in subsequent subsections.

4.1.3 The Moon

The moon is preeminent in Babylonian astronomy because of its importance for the calendar. Before the construction of methods to predict first visibility, the close watch of the moon's synodic progress was essential for declaring the first day of a month. The celestial omen corpus attests to the preeminence of the moon for astrology as well. In that literature, many aspects of the moon's behavior come under scrutiny as omens of future happenings in the world. Among the lunar phenomena taken as omens were the moon's position in the heavens, expressed in *Enūma Anu Enlil* in terms of conjunctions with fixed stars. A Babylonian horoscope includes several lunar data, reflecting the astrological importance of both the moon's daily motion and its synodic behavior.

4.1.3.1 *Daily Motion*

The daily observation of the moon's position with respect to the fixed stars, specifically the Normal Stars, becomes systematic in the diaries.[49]

[46] Published by O. Neugebauer and A. J. Sachs, "Some Atypical Astronomical Cuneiform Texts, I" *JCS* 21 (1967), pp. 183–190; see also Neugebauer, *HAMA*, p. 542–543.

[47] O. Neugebauer and A. J. Sachs, "Atypical Astronomical Cuneiform Texts, I" p. 185.

[48] See Neugebauer, *HAMA*, p. 362.

[49] For discussion of this genre, see Subsection 4.2.1.

The first datum provided in a horoscope is the position of the moon on the date of birth. As a rule the position is given with respect to the zodiac, but in some cases, the position of the moon with respect to a Normal Star is given in addition to the zodiacal longitude. Normal Stars were used to cite the observed, as opposed to computed, positions of the moon. The moon moves eastward with respect to the stars approximately 13° per day, returning to the same fixed star in about 27 days. Its sidereal period (the sidereal month) is 27; 19, 17, 58, 45 days (the modern value is 27.32166 days or 27 days, 7 hours, 43 minutes 11.5 seconds).

When one considers how fast the moon moves, the observation of it in relation to the Normal Stars seems a practical method. However, because all evidence points to the horoscopes as being written some indeterminate time after a birth, the observational statements of Normal Star positions noted in horoscopes must have been copied from some other written source, and the horoscopes' statements citing Normal Star positions of the moon therefore do not constitute "observations." The diaries, which tracked the moon each night through the ecliptic by means of the Normal Stars and whose statements represent true observations, were used as a reference work by horoscope casters, as demonstrated by the recording of Normal Star approaches by the moon in horoscope texts.[50] In a number of horoscopes citing Normal Star positions of the moon, the moon was not above the horizon and observable at the time of the birth, although in most examples in which a diary has been quoted, the diary offered a lunar position fairly close to the time of birth.

4.1.3.2 *Synodic Motion*

The moon can also be viewed from the point of view of its positions with respect to the sun. Because the sun travels the ecliptic in the same direction as the moon, but slower, only about 1° per day, the moon moves eastward approximately 12° per day with respect to the sun and therefore rises (or culminates, or sets) about 50 minutes later on successive days. The time interval between any lunar position with respect to the sun, for example, new moon to new moon, or full moon to full moon, is a synodic month. One synodic month is 29; 31, 50, 8, 20 days (the modern value is 29.53059 days or 29 days, 12 hours, 44 minutes 2.8 seconds).

[50] See *BH*, pp. 31–3.

Several key lunar visibility intervals observed at the beginning, middle, and end of the month, therefore around conjunction and opposition of the sun and moon, are defined and systematically recorded in nonmathematical astronomical texts. Sachs termed them the Lunar Three and the Lunar Six,[51] depending on which of these data were referred to in a given text. Briefly, the Lunar Three are (1) month name followed by the number 1 or 30 to designate whether the previous month was full (30 days) or hollow (29 days), respectively; (2) the date around the middle of the month, just after true opposition, of the interval of lunar visibility between sunrise and moonset termed *na*. The day on which *na* occurs is the day the moon sets for the first time after sunrise. The longitude of the moon at *na* is greater than $\lambda_{sun} + 180°$; (3) the date around the end of the month of the interval termed KUR, which measured the duration of visibility of the last lunar crescent in the morning before sunrise, hence the interval between moonrise and sunrise. The Lunar Six are (1) the time interval termed *na* between sunset and moonset on the day of the moon's first visibility following conjunction. This marks the beginning of the first day of the lunar month; (2) ŠÚ occurs when the moon is on the western horizon in the morning, and refers to the time between moonset and sunrise when the moon sets for the last time before sunrise. The longitude of the moon is less than $\lambda_{sun} + 180°$; (3) *na* occurs when the moon in on the western horizon in the evening and is the time between sunrise and moonset when the moon set for the first time after sunrise; (4) ME occurs when the moon is on the eastern horizon in the evening and is the time between the rising of the moon and sunset, when the moon rises for the last time before sunset. It is the last day the moon has positive altitude at sunset and the longitude of the moon is less than $\lambda_{sun} + 180°$. Hunger has taken the term to be an abbreviation of the time designation ME *ana šú šamaš* "daylight (remaining) to sunset," which refers to the part of the day between noon and sunset[52]; (5) GE6 occurs when the moon is on the eastern horizon in the evening. It is the time between sunset and the rising of the moon, when the moon rises for the first time after sunset. The moon's longitude is greater than $\lambda_{sun} + 180°$. In the same way as for the term ME, Hunger suggests reading GE6 as an abbreviated form of the time designation GE6 GIN "the night went," or the part of the day between sunset and midnight[53]; (6) KUR is the date and time interval

[51] A. J. Sachs, "A Classification of the Babylonian Astronomical Tablets," pp. 273 and 281.
[52] See Sachs–Hunger, *Diaries*, Vol. I, p. 21.
[53] Ibid.

between moonrise and sunrise on the day of the moon's last visibility (the same as the third interval of the Lunar Three).

The four intervals, šú (from moonset to sunrise), na (from sunrise to moonset), ME (from moonrise to sunset), and GE$_6$ (from sunset to moonrise), show, by the delay or advance of either sun or moon crossing the horizon relative to the other, the distance (either less than or greater than) of the moon from true opposition when $\lambda_{moon} = \lambda_{sun} + 180°$. The observation of these intervals surely came about as a result of the fact that opposition does not generally occur exactly at sunrise or sunset. Determining the moment of opposition was important for predicting eclipses as well as for determining whether one would be visible locally. The study of these phenomena, according to L. Brack-Bernsen,[54] led to the important recognition of the very small difference between the sidereal month (return of the moon to a fixed star) and the anomalistic month (return in lunar velocity), important because identification of the anomalistic period is prerequisite to determining the Saros, or 18-year eclipse period, that relates synodic to anomalistic months (223 synodic months = 239 anomalistic months). How early these lunar intervals were determined is uncertain, but a sixth-century diary (No. −567:4) already refers to the mid-month na. The earliest extant diaries, for 652 and 568 B.C., continue to refer to opposition by the terminology of the omen texts, that is, "one god was seen with the other," but this expression seems to be quickly replaced by the use of the Lunar Six.

The six intervals given in time degrees (UŠ) appear in nearly all the Babylonian astronomical texts (diaries, Normal Star almanacs, goal-year texts). Normal Star almanacs not only include the dates but also the times of the Lunar Six data. The only genre that has only the Lunar Three is the almanacs. The horoscopes seem to follow the almanacs in this, as (with the exception of the fifth-century horoscope *BH* 2[55]) only month name followed by 30 or 1 and the dates of the mid-month na and the end-of-the-month KUR are given. Such is the case, however, only in the horoscopes from Babylon. Those from Uruk (*BH* 9, 10, 11, and 16) do not include any lunar data.

[54] On the derivation of the lunar anomaly parameter ϕ, see Lis Brack-Bernsen, "Babylonische Mondtexte: Beobachtung und Theorie," in Hannes D. Galter ed., *Die Rolle der Astronomie in den Kulturen Mesopotamiens*, Grazer Morgenländische Studien 3 (Graz: GrazKult, 1993), pp. 331–58, and idem, "Goal-Year Tablets," in N. M. Swerdlow ed., *Ancient Astronomy and Celestial Divination* (Cambridge, MA/London: MIT Press, 1999), pp. 149–77.

[55] See *BH*, Text 2:7–8 and commentary.

4.1.3.3 *Eclipses*

Because the moon does not travel along the ecliptic, but on its own path inclined about 5° to the ecliptic, lunar eclipses do not occur every synodic month at opposition of sun and moon, but only when the moon's latitude, or distance from the ecliptic, is small enough for it to be eclipsed by the earth's shadow. The paths of the sun and moon are both great circles in the heavens, so they intersect at two points or "nodes." The moon's path crosses the ecliptic from the south to the north at the ascending node and 180° from this point is the descending node where the moon crosses the ecliptic to the south. The nodes are important because at new or full moon if the moon is on the ecliptic, that is, at or near a node, an eclipse is possible. Like the equinoxes, the nodes are not fixed, but move steadily westward, slipping in retrograde motion, according to Babylonian mathematical astronomy, by 1; 33, 55, 30° per month,[56] or about 19° per year. To bring both sun and moon back to the same position with respect to the nodes, the moon's nodes make 19 revolutions relative to the sun in which time the moon has made 223 revolutions relative to the sun. Hence 19 synodic revolutions of the node take 223 synodic months, which is equal to 18 years + 11⅓ days. Because the 18-year Saros period returns sun and moon to almost the same position relative to the nodes, eclipses of the same description recur in this period.[57]

As early as the Neo-Assyrian period, the prediction and exclusion of lunar eclipses is an already established practice in letters and reports from court astrologers: "(I wrote to the king, my lord) '[The moon] will make an eclipse.' [Now] it will not pass by, it will occur."[58] The context for such interest in eclipses was celestial divination, and lunar eclipses held

[56] This constant does not appear in cuneiform texts, but was derived from analysis of column E of the lunar ephemerides. The cruder value 1;40° per month is attested in an atypical astronomical text (Text E of Neugebauer and Sachs, "Some Atypical Astronomical Cuneiform Texts, I," *JCS* 21 (1968), pp. 183–218). See A. Aaboe and J. Henderson, "The Babylonian Theory of Lunar Latitude and Eclipses According to System A," *Archives internationales d'histoire des sciences* 25 (1975), p. 200.

[57] For the history of the term "Saros," see O. Neugebauer, *Exact Sciences* (New York: Dover, 1957), pp. 141–3, and idem, *HAMA*, p. 497 note 2. See also A. Aaboe, J. P. Britton, J. Henderson, O. Neugebauer, and A. J. Sachs, *Saros Cycle Dates and Related Babylonian Astronomical Texts*, Transactions 81/6 (Philadelphia: American Philosophical Society, 1991).

[58] Hunger, *Astrological Reports* 487:2–3. A list of texts containing predictions (including predictions of nonoccurrences) elsewhere in the corpus of these reports may be found in the Introduction to Hunger, *Astrological Reports*, p. xix. See also Hunger–Pingree, *Astral Sciences*, pp. 116–17 and 119–22.

particular significance, usually of misfortune, for the king. The precise na-
ture of the methods underlying the seventh-century evidence of not only
prediction and exclusion of lunar eclipses, but of recognition of solar-
eclipse possibilities, and prediction of synodic appearances of the planets
as well, remains unclear beyond the inference that some rough period
relations for the moon and planets must have been known in this early
period. The regular and systematic observation of the heavens, exempli-
fied by the astronomical diaries archive, and the focus on lunar eclipses,
represented by the eclipse reports and their compilations reaching back to
the Nabonassar era,[59] are testimony to the results, in purely astronomical
terms, of the interest in astronomical prediction generated by celestial
divination.

For the eclipse period, or "Saros," there is only indirect indication
during the period of the Sargonids. Both Britton[60] and Parpola[61] have
concluded that knowledge of the Saros underlies the eclipse predictions
in the Neo-Assyrian scholars' celestial reports and correspondence with the
kings, although no direct evidence of the Saros, such as is found in texts
as the "Saros Canon,"[62] predates the fifth century. Hunger and Pingree
have drawn attention to some unusual means by which eclipses are some-
times predicted in the Neo-Assyrian reports, such as by conditions of the
moon (and) sun on the day of disappearance of the moon,[63] a practice
that may be associated with the instructions repeatedly given in *Enūma
Anu Enlil* Tablet 20 to "observe his (the moon's) last visibility . . . and you
will predict an eclipse."[64] The degree to which such statements constitute
methods of prediction, however, is poorly understood. In the reconstruc-
tion of Britton,[65] work to solve the problems of the variable velocity of
the moon (lunar anomaly), the anomaly of solar and lunar longitude at
syzygy (zodiacal anomaly), and the theory of eclipse magnitude (later to
manifest as values measuring expected eclipse magnitude in the so-called

[59] See texts *LBAT* 1413 (beginning in the accession year of Nabonassar with an eclipse of 747
B.C. Feb. 6) to *LBAT* 1457. On the Nabonassar Era, cf. note 84.

[60] J. P. Britton, "Scientific Astronomy in Pre-Seleucid Babylon," p. 64.

[61] Parpola, *LAS* Part II xxv and letters 41, 42, 53, 62, and 66.

[62] J. N. Strassmaier, "Der Saros-Canon Sp II, 71," *ZA* 10 (1895), pp. 64–9, also published in
cuneiform copy in *LBAT* 1428, and republication with commentary by Aaboe, et al., *Saros
Cycle Dates.*

[63] See Hunger–Pingree, *Astral Sciences*, p. 120, in reference to Hunger, *Astrological Reports*,
p. 219 (Report 382).

[64] *ABCD* p. 180 and passim, *Enūma Anu Enlil* Tablet 20.

[65] J. P. Britton, "Scientific Astronomy in Pre-Seleucid Babylon," p. 62.

column Ψ of System A ephemerides), and hence to produce a full-fledged method of eclipse prediction, culminated in the lunar theory of System A by 316 B.C. These achievements in astronomical understanding were the fruits of the much earlier focus on lunar eclipses.

4.1.3.4 *Latitude*

Lunar latitude was obtained in Babylonian mathematical astronomy by the finding of nodal elongation, or how far in longitude the moon moved from the node (Akkadian *kiṣru* "knot" or *riksu* "bond," or "link"). In the lunar ephemerides, column E is a function of the moon's elongation from the ascending node, and it is measured in še (1 še = 0;0,50° or 1° = 72 še). The function is piecewise linear and continuous with a maximum value of 7,12 še (= 6°) when elongation is 90° and a minimum of −7,12 še (= −6°) at elongation 270°. When the moon is close to the nodes, the values in column E range between ±2,24 še and the slope of the function becomes steeper, ±8 še per degree (near ascending and descending nodes respectively), but otherwise, the slope of column E is ±4 še per degree.[66] The longitude of the ascending node is derived from lunar longitudes at conjunction or opposition,[67] and the moon can be in relation to the nodes in four possible ways: (1) approaching the ascending node, going with negative latitude, increasing toward 0; (2) passing the node, going with increasing positive latitude; (3) approaching the descending node, going with decreasing positive latitude; or (4) passing the descending node, going with negative latitude, decreasing toward the maximum negative of −5°. In Babylonian lunar ephemerides, these four possibilities are expressed with the terms LAL and U, designated (1) LAL LAL "positive increasing", (2) LAL U "positive decreasing," (3) U U "negative decreasing," and (4) U LAL "negative increasing." The expression "positive and negative (latitude)" (NIM *u* SIG) is also found in lunar procedure texts.[68] In the so-called atypical astronomical Text E (BM 41004) Sections 1 and 4,[69] the yearly regression of the place where the moon crosses the ecliptic is given as 20° (1;40° per month), and the period of return of the node to a particular

[66] See Aaboe and Henderson, "The Babylonian Theory of Lunar Latitude," pp. 196–200.

[67] The procedure is explicated in A. Aaboe and J. Henderson, "The Babylonian Theory of Lunar Latitude," p. 198.

[68] *ACT* 200 Section 6, 200b Section 4, 200c, 200d Section 3, 200e, 200i Section 1, and 204 Section 1; see Hunger–Pingree, *Astral Sciences*, pp. 230–1.

[69] Neugebauer and Sachs, "Atypical Astronomical Cuneiform Texts, I," *JCS* 21 (1967), pp. 200–5, and Hunger–Pingree, *Astral Sciences*, pp. 198–9.

longitude is 18 years. The width of the moon's band of latitude is given variously as $\pm 5°$ and $\pm 6°$ in this text, but the idea seems to be that in 9-years time from an initial lunar position with respect to a Normal Star (not a zodiacal longitude) the moon will attain its extremal latitude, either maximum (NIM) or minimum (*šaplu* = SIG). Although many aspects of "atypical" Text E remain puzzling, the concern with return in longitude of the lunar node, even with respect to stars rather than to degrees of the zodiac, reflects an interest in eclipse prediction.

The concepts of lunar latitude and the lunar nodes are indicative of an eclipse prediction method in which the goal was to determine those syzygies on which the moon would be near enough to a node for an eclipse to occur. Obviously the omen protases of *Enūma Anu Enlil* have no interest in and so do not reflect such details of lunar theory. Statements about lunar latitude using the terms LAL, SIG, and NIM, consistent with the mathematical lunar latitude texts, occur in two horoscopes from Uruk. *BH* 10 includes a latitude statement with an omen protasis obviously cited because of its parallel construction with that statement. *BH* 10:4–6 reads thus:

The moon goes with increasing positive latitude (lit. "sets its face from the middle (node) toward positive latitude"). If (the moon) sets its face from the middle toward positive latitude, prosperity and greatness.

In the case of *BH* 16, the latitude remark is tacked onto the end of the enumeration of planetary positions. *BH* 16 rev. 9–10 reads thus:

If the progress of the moon. . . . (text was erased by the scribe) – favorable. The moon goes with (decreasing) positive latitude toward the node.

In another horoscope on the same tablet (obverse line 9), is the statement "The moon goes from (the point of extreme) negative latitude toward the node," that is, "with decreasing negative latitude," followed by a line referring to "good fortune" (lit. "propitious days").

What the presence of latitude statements in horoscopes signifies, especially in terms of method of derivation, is most uncertain. As an element of eclipse theory, the longitude of the node and the moon's relation to it is attested in the astronomical literature. Attempts to derive the moon's latitude from the lunar longitude are represented in System A ephemerides and in the "atypical" text just mentioned. Although it cannot be determined how the latitudes noted in the horoscopes were derived, these texts demonstrate that such data were utilized in an astrological context. Given

the inclusion of latitude in the two preserved horoscopes, it may also be
that Late Babylonian omens for the planets standing in the DUR (*riksu*)
may indeed be understood as referring to the "node," that is, to the case
when the planet stands on the ecliptic.[70] In these omens, the terminology
(DUR) would be consistent not with that of "atypical" lunar Text E, but
with that of "atypical" Text F, a planetary procedure text dealing with
latitude.[71]

4.1.4 The Planets

The series MUL.APIN refers to the planets as "[the gods(?) who] keep chang-
ing their positions."[72] What differentiates planets from fixed stars is the
fact that, in addition to the diurnal rotation they share with all the ce-
lestial bodies, the planets also travel in an eastward direction, as do the
sun and moon, through the zodiacal belt and exhibit characteristic pe-
riods of visibility and invisibility because of their positions relative to
the sun (the planetary synodic phenomena). Intervals of visibility and
invisibility are focused on in the early traditions both of MUL.APIN and
Enūma Anu Enlil.[73] Ultimately, the prediction of the dates and positions
(longitudes) of the characteristic synodic appearances of the planets, the
risings, settings, and stations, became the goal of the later mathematical
astronomy.

The planets are of great interest in the horoscopes, but on the whole,
not for the dates or longitudes of their synodic appearances, but rather for
their positions at times between synodic phenomena, that is, on arbitrary
birth dates. As pointed out by Neugebauer already in *ACT*,[74] the prob-
lem of determining positions in the ecliptic on arbitrary dates between

[70] *TCL* 6 14, see Sachs, "Babylonian Horoscopes," pp. 65ff., and see my discussion in "*TCL*
6 13: Mixed Traditions in Late Babylonian Astrology," *ZA* 77 (1987), esp. pp. 222–4. There
I did not consider whether *riksu* in *TCL* 6 13 rev. ii meant "node," as it does in astronom-
ical contexts, but tried to understand the term to mean a configuration of two or more
planets.

[71] Neugebauer and Sachs, "Atypical Astronomical Cuneiform Texts," p. 208. For further
discussion of planetary latitude, see Steele, "Planetary Latitudes."

[72] MUL.APIN II i 40; also individually, a planet is defined as "changing its position and crossing
the sky"; see Venus, Mars, and Saturn in MUL.APIN I ii 13, 14, and 15, respectively. Mercury
is described as one that "rises or sets in the east or in the west within a month," MUL.APIN
I ii 16–17. See Hunger–Pingree, MUL.APIN, pp. 33–4.

[73] Hunger–Pingree, MUL.APIN, pp. 148–9.

[74] *ACT* Vol. II, p. 279.

synodic appearances is secondary in the Babylonian planetary astronomy. However, he said, "if these phenomena are known," the planet's position can "be determined for intermediate moments by means of complicated interpolations."[75] For the purposes of the horoscopes, then, it would appear that the predictive schemes that enabled first the computation of synodic phenomena and second the interpolated positions in between could certainly have become vitally important.

4.1.4.1 *Synodic Phenomena*

On the analogy with the ecliptical stars, the appearances of the planets (Saturn, Jupiter, Mars, Venus, Mercury) make a cycle of visibilities and invisibilities, depending on the relation between the planet and the sun. The term synodic denotes the special connection between the planet, or a star, with the sun. In the case of a star, the synodic cycle has a period of one year. In the case of the planets, however, each has its own synodic cycle, the periods of which may be recognized in goal-year texts.[76]

For the outer planets (Jupiter, Saturn, Mars), the dates and positions of the following phenomena were observed and predicted by Babylonian astronomers:

Phenomenon	*Babylonian Term*[77]
Heliacal rising = first appearance in the morning (east) (Γ)	IGI
First (morning) station (Φ)	UŠ, UŠ *mahrītu* (IGI-*tû*),
Opposition = acronychal (evening) rising, or rising of planet at sunset) (Θ)[78]	E, E-ME, ME, *ana* ME-a
Second (evening) station (Ψ)	UŠ, UŠ *arkītu* (ÁR-*tû*)
Heliacal setting = last appearance in the evening/west (Ω)	ŠÚ

[75] Ibid.

[76] See Subsection 4.2.2.

[77] These terms occur in Seleucid astronomical texts and in horoscopes.

[78] On the basis of procedure texts (see *ACT* Vol. II, p. 312) and ephemerides that concern all the Greek-letter phenomena, such as *ACT* 611 covering consecutive Γ, Φ, Θ, Ψ, Ω for Jupiter for the period S.E. 180 to 252, Neugebauer pointed out that Θ cannot be "opposition" in the strict sense ($\lambda_{sun} + 180°$) because it is asymmetrical with respect to the stationary points, and is actually closer to the first than the second station. See Neugebauer, *ACT* Vol. II, pp. 280–1 with Fig. 55b, and *HAMA* pp. 398–9.

For the inner planets (Mercury and Venus):

Phenomenon	Babylonian Term
Evening rising = first appearance in the evening/west (Ξ)	IGI, IGI *ša* ŠÚ, ina ŠÚ IGI
Evening (first) station in west (Ψ) (superior conjunction)	UŠ, UŠ *ša* ŠÚ, ina ŠÚ UŠ
Evening setting = last appearance in evening/west (Ω)	ŠÚ, ŠÚ *ša* ŠÚ, ina ŠÚ ŠÚ
Morning rising = first appearance in the morning/east (Γ)	IGI, IGI *ša* KUR, ina KUR IGI
Morning (second) station in east (Φ)	UŠ *ša* KUR
Morning setting = last appearance in the morning/east (Σ) (inferior conjunction)	ŠÚ, ŠÚ *ša* KUR, ina KUR ŠÚ ŠÚ

The horoscopes make reference only to first and last visibilities, with the single exception of the fifth-century horoscope *BH* 1, which records the dates of the stationary points as well as opposition (actually the rising at sunset, or acronychal rising) for the planet Saturn:

(Obv.) The 24th of *Ṭebētu*, last part of the night of the 25th, year 13 of Darius, the child was born. *Kislīmu*, around the 15th, Mercury's morning rising east of Gemini. *Ṭebētu*: Solstice (winter) on the 9th; last lunar visibility on the 26th. *Šabaṭu*: *Šabaṭu*, dense clouds, around the 2nd, Mercury's morning setting in Capricorn. The 14th of *Šabaṭu*, Venus's morning setting west of Aquarius. Intercalary *Addaru*. (Rev.) The 22nd of *Tasrītu*, Jupiter's second station in Aquarius. Around the 2nd of *Addaru*, heliacal setting in Pisces. The 30th of *Du'ūzu*, Saturn's heliacal rising in Cancer, high and faint; around the 26th, (ideal) heliacal rising. The 7th of *Kislīmu*, first station; the 17th of *Ṭebētu*, acronychal rising. Intercalary *Addaru*.

Otherwise, attestations of synodic phenomena are limited to first and last visibility as evening star and first and last visibility as morning star for Mercury, and only last visibility for Venus, Mars, and Saturn.

4.1.4.2 *Daily Motion*

The Babylonian mathematical astronomical texts take the characteristic form of ephemerides constructed to generate longitudes and dates of planetary synodic phenomena by means of a variety of mathematical functions. Although these present the data in tabular form, the entries do

not correspond to consecutive days of the month, as they deal with phenomena separated by intervals of time that differ according to the planet. Within this corpus there are a very few texts (two from Uruk, one from Babylon[79]) that can be described as ephemerides in the literal sense. These tables give day-by-day positions of a planet and are extant only for Jupiter and Mercury.[80]

The following section surveys the astronomical texts contemporaneous with the horoscope corpus and draws out a number of textual relationships between the Babylonian horoscopes and the various astronomical text genres.

4.2 ASTRONOMICAL SOURCES FOR HOROSCOPES

Sachs's 1948 study of a select number of Late Babylonian astronomical texts had a great impact on our understanding of the nature of this corpus of scientific literature.[81] As a matter of historiographical interest as well as a tribute to the erudition of Sachs, his analysis, based on a total of 41 texts, was confirmed some years later by his cataloging of an additional 1,400 texts, which now constitute the known corpus of astronomical cuneiform texts from the late period of Mesopotamian history, or roughly between 600 B.C. and the beginning of the Common Era. The latest dated document is from A.D. 75.[82] His classification differentiated for the first time two branches, or methods, of ancient astronomy that correspond to different approaches to celestial phenomena. The two branches were represented by (1) numerical table texts (ephemerides) and their related procedure texts,[83] which are now termed mathematical astronomy, and (2) nontabular astronomical texts of various types, which comprise the nonmathematical astronomy. The terms mathematical and nonmathematical are not native Babylonian terms, as the scribes did not differentiate

[79] *ACT* 654 + 655.

[80] See *ACT* 654–655 for Jupiter, and *ACT* 310 for Mercury.

[81] Sachs, "A Classification of the Babylonian Astronomical Tablets," pp. 271–90. See also, Hermann Hunger, "Non-Mathematical Astronomical Texts and Their Relationships," in N. M. Swerdlow, ed., *Ancient Astronomy and Celestial Divination* (Cambridge, MA/London: MIT Press, 1999), pp. 77–96.

[82] *LBAT* *1201, an "almanac," dated 385 S.E. See A. J. Sachs, "The Latest Datable Cuneiform Texts," in Barry L. Eichler, ed., *Kramer Anniversary Volume. Studies in Honor of Samuel Noah Kramer*, AOAT 25 (Neukirchen-Vluyn: Verlag Butzon & Bercker Kevelaer, 1976), pp. 379–98 and pls. XV–XIX.

[83] Neugebauer, *ACT* (1955).

between general classes of texts in the same way we do. There was, however, a clearly defined nomenclature for the various text types: Each had a special name, given in the subscript (a line of identification of the text's content, written at the end of a text following a horizontal ruling) to a text, as well as a unique and regularized form.

The earliest datable example of an nonmathematical text is a diary from the seventh century (652 B.C.). It is now generally accepted that astronomical diarywriting, hence the activity of nonmathematical astronomy, began a full century earlier, that is, in the middle of the eighth century with the reign of Nabonassar (747–734 B.C.). This historical claim originally stemmed from Ptolemy's unique use of this reign as an era, the Era Nabonassar, by which to reckon dates, and his supporting statement (*Almagest* III,7) that he had access to astronomical records beginning in the reign of Nabonassar.[84] Astronomical diaries and contemporary eclipse reports are no longer extant from the eighth century, but late compilations of lunar-eclipse reports indicate that such records were made in that period. Most of the surviving astronomical texts, however, date from the mid-fifth century, a period in which Babylonian astronomy again underwent significant growth. The nonmathematical astronomical texts therefore belong to the latter part of the span of the history of Babylonian astronomy.

The nontabular texts, which are preserved in greater number than are the mathematical ephemerides, comprise at least five separate genres. Our modern terminology (after Sachs) denotes these as almanacs, Normal Star almanacs, goal-year texts, diaries, and their excerpts. As already mentioned, the difference between mathematical and nonmathematical texts is not only formal, that is, whether the text was tabular or not, but is also a matter of method. The tabular form of the ephemerides is a consequence of its underlying mathematical structure, which is not found in the diaries or in any of the other nonmathematical genres. At the same time, it should also be clear that nonmathematical is not synonymous with observational. Virtually all the nonmathematical text genres record predicted phenomena; predictions, however, that were not obtained by the methods of the mathematical tables. The only nonmathematical genre that is noted for its recording of contemporary astronomical observations is the diaries, and even these regularly include predicted data.

[84] The Nabonassar Era was not a dating device in contemporary Babylonia, as discussed in F. Rochberg-Halton, "Between Observation and Theory in Babylonian Astronomical Texts," *JNES* 50 (1991), pp. 109–11.

4.2.1 Astronomical Diaries

A standard diary collected lunar, planetary, meteorological, economic, and occasionally political (or otherwise peculiar) events night by night, for six (or seven) months of a Babylonian year.[85] Of primary importance was the progress of the moon each month through the ecliptic. This daily progress was charted by means of distances between the moon and the Normal Stars. The term "diary" was first coined by Sachs in his "Classification" as a concise way of rendering the Babylonian title "regular (celestial) observation which (extends) from the xth month of the yth year to the end of the yth year" (*naṣāru* (EN.NUN) *ša ginê ša ištu x* MU.y.KAM *adi qīt* MU.y.KAM). The term "diary" is apt because the texts record daily positions of the moon and planets visible above the local horizon. These texts are not exclusively observational. Predicted phenomena also regularly appear and are marked by the scribes with a variety of comments, such as "clouds, I did not make an observation," or, "dense mist, when I observed, I did not see it," or a numerical value such as the duration of visibility of first lunar crescent on the evening of the first day of the month (given in time degrees) can be qualified by a term meaning computed or measured. Included in addition to charting the progress of the moon and planets against the Normal Stars were the dates and time degrees of the Lunar Six, the characteristic lunar visibility intervals at the beginning, middle, and end of the month, that is, around conjunction and opposition of moon and sun, and these could either be observed or predicted.[86]

The interest here was in calendar dates of first and last visibilities, as well as syzygies, which occur at intervals of not less than 29 and not more than 30 days. Predictive control of these dates belongs to the most sophisticated level of Babylonian lunar theory because visibility considerations are of the highest complexity.[87] It is still not known what predictive methods were applied for the diaries, which provide dates or values for the duration of the desired phenomena with the added statement "not observed."[88] When one of these lunar phenomena could not be observed because of adverse weather conditions, a predicted value was given, as in the following from

[85] For texts, see Sachs–Hunger, *Diaries*.

[86] *ACT* 201 predicts the intervals surrounding full moon, viz., šú, *na*, ME, and GE$_6$. See *HAMA*, pp. 535–9.

[87] See discussion of the factors influencing visibility of the first lunar crescent in Neugebauer, *Exact Sciences*, pp. 107–9, and the discussion of the lunar ephemerides' columns M through P in *ACT* I, pp. 63–8 (System A) and pp. 80–5 (System B).

[88] Sachs–Hunger, *Diaries*, p. 21.

diary No. −567 obv. 8': "(interval from) sunrise to moonset (was) 17°; I did not keep watch; the sun was surrounded by a halo."

In addition to the Lunar Six, the astronomical data systematically observed throughout the entire period covered by the diary texts include eclipses, both solar and lunar, proximity of the moon and planets to the Normal Stars throughout the month ("conjunctions"), synodic phenomena of the planets (first and last visibilities, and oppositions of the outer planets), meteors and comets, and a wide variety of cloud conditions and (bad) weather.[89] The meteorological phenomena may have been recorded not only because they obscure the observation of lunar and planetary appearances, but also because they are phenomena of interest in their own right. If such interest in the weather phenomena was for their potential as signs, then the numerous weather omens (*Enūma Anu Enlil*'s "Adad" section) would stand in a significant relation to the weather reports in the diaries. Such a relation, although suggestive, remains entirely a matter of speculation, as does the divinatory value of any of the phenomena observed in the diaries.[90]

Sachs identified diaries as the ultimate observational source for several of the other nonmathematical astronomical text categories. The interrelations among the genres of the nonmathematical class of astronomical texts, however, is complex. Hunger has noted that the extensive corpus of these text types did not necessarily stem from one archive, nor is it certain "that all these texts formed a coherent and meaningfully correlated whole."[91] The relationship between diaries and the mathematical astronomical texts is also still not perfectly understood. At least some of the observational material recorded in diaries must have provided a foundation for the development of mathematical astronomy, although just how that was accomplished is still a matter of debate. According to Swerdlow, "they are as close as we can come to the observations underlying the

[89] See Hunger's discussion and glossary of weather words in Sachs–Hunger, *Diaries*, Vol. I, pp. 27–34.

[90] For the suggestion that astronomical diaries provided observations from which celestial omens could be interpreted, see A. Aaboe, "Babylonian Mathematics, Astrology, and Astronomy," in *The Cambridge Ancient History*, 2nd ed. (Cambridge/New York/Port Chester/Melbourne/Sydney: Cambridge University Press, 1992), III/2, p. 278, and William W. Hallo, "The Nabonassar Era and Other Epochs in Mesopotamian Chronology," in E. Leichty, M. deJ. Ellis, and P. Gerardi, eds., *A Scientific Humanist: Studies in Memory of Abraham Sachs*, Occasional Publications of the Samuel Noah Kramer Fund 9 (Philadelphia: Babylonian Section, University Museum, 1988), p. 188.

[91] Hunger, "Non-Mathematical Astronomical Texts," pp. 81–2.

mathematical astronomy of the ephemerides."[92] The question here is whether the data collected in diaries, either observational or predictive, or both, could constitute sources for horoscopes.

There is no doubt that the diaries archive functioned as a reference bank for scribes who constructed horoscopes. First, the inclusion in several horoscopes of the Normal Star position for the moon preceding the enumeration of planetary positions in the normal sequence (moon–sun–Jupiter–Venus–Mercury–Saturn–Mars) is readily retrievable from a diary, particularly as this datum appears at the beginning of the month section. Moreover, a comparison of the lines in the horoscopes referring to the Normal Star positions of the moon with the corresponding statements in diaries shows that, on the basis of the phraseology and terminology used, the horoscopes made use of the diaries archive. Actual quotations from diaries, however, cannot be shown as the diaries from corresponding dates to the horoscopes are no longer extant. The surviving material is more than sufficient, though, to support the connection. Finally, with reference to lunar data, it has been previously noted that the horoscopes regularly included the Lunar Three for the month of the birth. These too are to be found in the diaries.

Further evidence that the diaries provided a source for horoscope construction appears in an interesting parallel between one of the two fifth-century horoscopes (*BH* 1) and a notation in a number of diaries giving a date for a first visibility, qualified as "high (NIM)," and followed by an earlier date for the phenomenon, apparently the ideal date when the phenomenon should have occurred. In *BH* 1 rev. 3 is this statement:

The 30th of Month IV, Saturn's heliacal rising in Cancer, high and faint; around the 26th, (ideal) heliacal rising.

This compares strikingly with a number of similar statements in the diaries, although extant parallels are all in diaries later than *BH* 1, as in

No. −382 III [the 21st . . . Saturn's] first appearance [. . .] β Geminorum; it was bright and high, (ideal) first appearance on the 15th.

Eclipses are other phenomena incorporated within horoscopes that could have been taken from the diaries. A fragmentary diary from 81 B.C.,[93] with part of the paragraph for Month I, contains the same eclipse found in a horoscope of the same year and month. This total lunar eclipse

[92] Swerdlow, *The Babylonian Theory of the Planets*, p. 16.
[93] Sachs–Hunger, *Diaries* −80: 6′–8′, Vol. III, pp. 482–3.

occurred about 4 hours after sunset when the moon was in the beginning of Scorpius. The location of the eclipse in Scorpius is recorded in both texts, but clearly, the horoscope does not quote from the diary:

Diary No. −80: 6′−8′ [...] of night all of it was covered; 22° of night maximal phase; when [it began] to clear, [....] blew; in its eclipse, there was; it was surrounded by a halo which was not closed [.... δ/β]Scorpii it became eclipsed; at 1,0° after sunset.

BH 25: [Year 2]31 (s.e.) Month I, 30; [night of the 15/16th(?)] the child was born. In his hour [the moon was in Sc]orpius, Venus in Aries, Sat[urn in Vi]rgo, Mars in G[emini, Mercury which had se]t was not visible. [That mo]nth [night of the 14th, a lun]ar eclipse; [totality occurred] in Scorpius.

[The 14th] moonset after sunrise, 27th last lunar visibility before sunrise.

[That year] (summer) solstice was the 21st of [*Simanu*].

When it comes to the planetary positions in the zodiac found in horoscopes, much of the data provided by the diaries are not ideally suited to horoscopes. Horoscopes never record when a planet passes so many cubits above or below a Normal Star, although, as just mentioned, lunar positions with respect to Normal Stars are occasionally given. Even though both positional systems operate with reference to the ecliptic, no simple conversion from Normal Star to zodiacal positions has been reconstructed.[94] The evidence is not at all in favor of assuming that such a method existed in antiquity, as attempts to reconstruct such a method have run aground over the conversion of distances in cubits "above and below" Normal Stars to degrees of longitude, and modern conjectures about what these terms meant have been unable to reproduce the ancient data. The date of a planetary phase given in diaries together with the zodiacal sign in which the planet was located at the time would be useful for a horoscope only if the date of the phenomenon should coincide with a birth date.[95] But at the end of the day-by-day entries, a summary of the zodiacal signs in which the planets were found throughout the month would certainly have been of great utility for the construction of horoscopes. Such summaries are introduced with the adverbial phrase "at that time," paralleled in the enumeration of the planetary positions in the third-century horoscope *BH*

[94] See Neugebauer, *HAMA* I, pp. 545–7, and Sachs, "A Late Babylonian Star Catalog."

[95] For the form of a diary entry, see Sachs, "A Classification of the Babylonian Astronomical Tablets," pp. 285–6, and idem, "Babylonian Observational Astronomy," in F. Hodson, ed., *The Place of Astronomy in the Ancient World* (London: Philosophical Transactions of the Royal Society 276, 1974), pp. 43–50. For texts, see Sachs–Hunger, *Diaries*, Vols. I and II.

7, and, for the most part, the enumeration of the planets follows the same sequence as in the horoscopes (Jupiter–Venus–Mercury–Saturn–Mars). A single example will suffice, although many such zodiacal summaries are preserved:

Diary No. −140: 31–32 At that time, around the 5th, Jupiter's first appearance in Sagittarius; [until the end of the mo]nth, (it was) in Sagittarius; Venus and Mercury until the middle of the month, were in Scorpius, at the end of the month, in Sagittarius; Saturn was in Virgo; Mars, in the beginning of the month, was in Scorpius, until the end of the month, in Sagittarius.

BH 7 upper edge At that time, Jupiter was in Capricorn, Venus in Scorpius, on the 9th, Mercury's morning setting was in Sagittarius, Saturn and Mars were in Libra.

In sum, then, what is required for horoscopes is access to the location of planets in the zodiac on an arbitrary date. If these data were not obtained directly by means of computation, then the scribes must have had reference works in which to find the data, and it is clear that some, if not all, of the data would have been obtainable from astronomical diaries. These data could have been drawn from a variety of elements collected in a diary, namely, the lunar conjunctions with Normal Stars, the Lunar Three, the occasional date and position of a planetary synodic appearance, eclipses, but mostly the zodiacal signs in which the planets were located during the month as tallied at the end in the planetary summary section.

4.2.2 Goal-Year Texts

The diaries provided raw data for a variety of projects carried out by the astronomer–scribes. Another of the nonmathematical text genre, termed by Sachs the "goal-year text," illustrates a particular use of the data compiled in diaries. Goal-year texts focus on a year date and secondarily derive planetary appearances for the target date (from the observations recorded in the diaries) based on the appropriate synodic periods. In this way, the data collected in goal-year texts, like that in the diaries, is not readily usable for horoscopy.

A goal-year text presents a variety of astronomical phenomena whose dates and positions were culled from diaries a particular number of years before the "goal year." The number of years was determined by the synodic period appropriate to the given planet (or moon). That the data in the goal-year texts derive from diaries is clear both from the contents of the goal-year texts and from the colophon title given in the subscripts by the scribes.

Thus, "goal-year text" is not a translation but rather a representation of the text whose rubric is UD.I.KAM IGI.DU$_8$.A.MEŠ DIB.MEŠ *u* AN.KU$_{10}$.MEŠ *ša ana* MU *x kunnu* "The first day, synodic appearances, passings, and eclipses which have been established for (goal-)year *x*." The term "first day" corresponds to the length of the lunar synodic month, whether it was full (30 days) or hollow (29 days), *tāmarātu* "appearances" to the planetary synodic appearances, DIB.MEŠ "passings" to the distances between planets and Normal Stars, and finally, *antalû* "eclipses," to both lunar and solar eclipses.

The number of years preceding the goal year corresponds to the period that governs the reappearance of the desired phenomenon. A goal-year text collects dates and positions of planetary and lunar appearances in accordance with the following periods: For Jupiter, data such as Jupiter's conjunctions with Normal Stars or appearances in synodic phases are extracted from diaries 71 and 83 years[96] before the target or goal year; for Venus, 8 years before; Mercury, 46 years; Saturn, 59 years; Mars, 47 and 79 years; and finally, for the moon, the data are collected for 18 years before the goal year (the "Saros" cycle). The data are organized in ruled sections, one section devoted to one planet. Each ruled section contains astronomical data derived from a diary dated to a year appropriate to the period for that planet. Consequently, the data in each section come from a different year date, but the goal date for each section is the same. Normally the lunar data are placed at the end and arranged by columns. The planetary sections follow the standard Seleucid sequence, Jupiter–Venus–Mercury–Saturn–Mars. Within each section, the data simply follow in the order of dates (month and day), as can be seen from the following excerpt from the Venus section of the goal-year text *LBAT* 1251:5–11 (goal year = S.E. 140; Venus data from S.E. 132 [8-year period])[97]:

[96] The 83-year period restores the planet to a position with respect to a Normal Star. See B. L.van der Waerden, with contributions by Peter Huber, *Science Awakening II. The Birth of Astronomy* (Leiden: Noordhoff International Publishing and New York: Oxford University Press, 1974), p. 109, for P. Huber's explanation of the derivation of the two periods, one for fixed-star conjunctions and the other for synodic appearances.

[97] *LBAT 1251 obv. 5–11 Transliteration*

5 [MU.13]2.KAM $^{\text{I}}$*Si* LUGAL BAR 15 ŠÚ šá dele-bat ina NIM ina HUN TA 14 KI PAP NU IGI *x* [. . .]

6 [ITI.NE] in 1 IGI KIN GE$_6$ 7 USAN dele-bat e SA$_4$ šá ABSIN 1 KÙŠ GE$_6$ 25 USA[N . . .]

7 [KIN 2]9 USAN dele-bat SIG RÍN šá SI 3 $^1/_2$ KÙŠ KIN 2.KAM GE$_6$ 10 USAN dele-bat e MÚL.MU[RUB$_4$ šá SAG GÍR.TAB . . .]

8 4 SI! ana NIM DIB GE$_6$ 16 USAN dele-bat e SI$_4$ 2 KÙŠ GE$_6$ 25 USAN dele-bat e MÚL.KUR [šá KIR$_4$ šil PA . . .]

5 [Year 13]2 s.e., Seleucus was king. Month I, 15 heliacal setting of Venus in the east in Aries from the 14th; when watched for was not seen.[. . .]

6 [Month V] on the first heliacal rising; Month VI night of the 7th evening Venus above α Virginis 1°, night of the 25th, even[ing . . .]

7 [Month VI, 2]9, evening Venus below β Librae 3½°; Month VI₂ night of the 10th evening Venus above δ Scorpii . . . Venus] [passed]

8 4 fingers to the east; Night 16 evening Venus above α Scorpii 2°; night of the 25th evening Venus above [θ Ophiuchi . . .]

9 Month VIII, night of the first, evening Venus below β Capricorni 2½°; night of the 15th, evening Venus above γ Capricorni [. . .]

10 night of the 18th, evening Venus above δ Capricorni 1 finger; Venus passed 6 fingers to the east; Month XI, 23 [. . .]

11 Venus in the west in the end of Pisces sets heliacally; 30th Venus in the east in Pisces rises heliacally; is bright until sunrise; 8° is its visibility; visible on the 29th.

Because of the nature of the data collected in goal-year texts, no parallels between these texts and horoscopes are expected. In the extant material, indeed, no parallels have been found.

4.2.3 Almanacs and Normal Star Almanacs

Whereas the diaries and goal-year texts fit together well as source and derivative, two other types of non-mathematical astronomical texts present data in quite a different manner. These are the almanacs and Normal Star almanacs. An almanac presents in 12- (or 13-)month sections the location of each planet in the zodiac through the year. The tablet is organized by the month, and the first line of each month section contains the zodiacal sign in which each planet is found on the first day of the month. Degrees within signs are never given. These positions are registered in the standard order of the planets found also in goal-year texts and horoscopes, that is, Jupiter, Venus, Mercury, Saturn, and Mars. Thereafter, the dates of predicted entries of the planets into the next sign are given and expressed with the verb *kašādu* "to reach." The prediction of these dates would be of importance because it is precisely the boundaries between signs that are

9 APIN.GE₆ I USAN dele-bat SIG SI MÁŠ 2 ½ KÙŠ GE₆ 15 USAN dele-bat e MÚL IGI ŠÁ SUHUR.MÁŠ[. . .]

10 GE₆ 18 USAN dele-bat e MÚL ár ŠÁ SUHUR.MÀŠ. I SI dele-bat 6 SI ana NIM DIB ZÍZ 23 I[GI? . . .]

11 dele-bat ina ŠÚ ina TIL ZIB.ME ŠÚ 30 dele-bat ina NIM ina ZIB.ME IGI KUR NIM A 8 NA-su in 29 IGI [. . .]

impossible to observe, and the crossing from one zodiacal sign to another is very likely an astrologically important event.

In addition to predicting the positions in the zodiac of the planets month by month for one Babylonian year, dates of synodic phenomena are included in the appropriate order, as are the lunar phenomena *na* (the mid-month *na* for the moonset after sunrise) and KUR, and the dates of equinoxes or solstices. Occasionally also the heliacal appearances of Sirius are predicted, and so too are eclipses.[98] The chronological range for the almanacs, taken from the datable texts, is 262 B.C. to A.D. 75.[99]

The almanac *LBAT* 1174[100] dates from 236 S.E. = 76/5 B.C., the same year as *BH* 26. The relevant portions of this almanac are from months III–V:

Month III, the first of which will follow the 30th of the previous month. Jupiter in Gemini, Venus in Cancer, Saturn in Virgo, Mars in Aries. On the 9th Mars will reach Taurus; 15th moonset after sunrise; 16th solstice; on the 15th Mercury will be visible for the first time in the west in Cancer; 21st Venus will reach Leo; 22nd Mercury will reach Leo; 27th last lunar visibility before sunrise; night of the 29th eclipse of the sun which will pass by.

Month IV, the first of which will follow the 30th of the previous month. Jupiter in Gemini, Venus and Mercury in Leo, Saturn in Scorpius, Mars in Taurus. On the 1st Saturn will reach its stationary point in Scorpius; on the 7th Sirius will be visible for the first time, night of the 13th 8° before sunrise eclipse of the moon. It made 4 1/3 fingers. It set eclipsed. On the 13th moonset after sunrise. On the 15th Venus will reach Virgo; 13th (expect 23rd) Mercury will be visible for the last time in the west at the end of Leo. On the 25th Mars will reach Gemini; the 27th last lunar visibility before sunrise.

Month V, the first of which will follow the 30th of the previous month. Jupiter and Mars in Gemini, Venus in Virgo, Saturn in Scorpius. On the 11th Venus will reach Libra; 13th moonset after sunrise; 21st Mercury will be visible for the first time in the east in Leo; 26th last lunar visibility before sunrise.

In almanacs the planetary data are presented in the same order in which they are enumerated in a horoscope. Because almanacs are structured in 12 or 13 monthly sections, one almanac covering one Babylonian year, the data are easily extracted if one starts with a date.

[98] See A. J. Sachs, "A Classification of the Babylonian Astronomical Tablets, pp. 277–80.

[99] See *LBAT* catalog sub Almanacs.

[100] Publication: Kugler, *SSB* II 472–480 (transliteration, translation and textual commentary), *SSB* Erg.III Tf.II (copy); dupls.81-7-6,492 (*SSB* II 471) and Sp II 212 (*SSB* II 471–472).

A comparison between the data in *BH* 26 and the almanac of the same date shows the data of the two texts to be in excellent agreement with one another:

BH 26: Year 236 (s.e.), Arsaces was king. Month V 1, the 25th day, in the 12th hour the child was born; in his hour, the moon was in Leo, Sun in Virgo, Jupiter [and Mars] in Gemini, Venus in Libra, [Mercury] in Leo, Saturn in Scorpius; That month [moonset after sunrise was on the 13th] on the 21st, Mercury's [first appearance] in the east [in Leo], last lunar visibility before sunrise was on the 26th. [That year] (summer) solstice was on the 16th of Month III. On the 29th [day (of Month III)] a solar eclipse [i]n Cancer which passed by. Month IV, night of the 13th, a lunar eclipse in Aquarius made 1 finger. On the 25th in the last part of night, (the moon was) 8° in Leo. It was

Good agreement is found in the Lunar Three and the planetary longitudes in the zodiac. The almanac also predicted the entrance of Venus into Libra on the 11th. Because the birth occurred on the 25th day, the scribe correctly registered Libra as the position of Venus. The statement that Mercury is to rise heliacally in the East in Leo on the 21st was also transferred to the horoscope. The dates of *na* and KUR also agree. Data from the almanac's paragraphs three and four (i.e., months III and IV) also concur with those in the horoscope, specifically the date of the solstice closest to the birthdate and the lunar and solar eclipses, although the eclipse data were not entered verbatim.

Another example of a horoscope–almanac pair dated to the same year is available for comparison: *BH* 14 and almanac *BM* 40101 + 55536, both from the year 220 B.C. Here, too, the data in the almanac for the month of the birth (month VII) are in very good agreement with those in the horoscope, and the lunar eclipse that occurred in month XII is also found in the almanac:

BH 14 r. 2–3: Month XII night of the 1[5th lunar eclipse,] in Libra totality occurr[ed].

Almanac BM 40101 + r. 10: (Month XII) in the morning a lunar eclipse made totality.

Other eclipses found in horoscopes, having occurred in the year, or sometimes even the month, of the birth, correspond to those in diaries or eclipse reports. For example, the following solar eclipse appears in a horoscope as well as in a diary:

BH 21 rev. 4–5, dated 125 B.C. Oct. 1, eclipse occurred Aug. 24 125 B.C.: On the 28th an eclipse of the sun in Virgo. When watched for it was not observed.

LBAT 448:7′ (diary — 124: 7′): On the 28th an eclipse of the sun, cloudy, not obs[erved].

The available examples of horoscopes and almanacs indicate that, in general, almanacs provided a very good source of astronomical data for Babylonian horoscopes. A comparison of the general content of the almanacs with that of horoscopes shows that horoscopes contain most or all the available data in an almanac, derived from the appropriate month of the birth, or any other month paragraph containing astronomical data of importance to horoscopes, such as lunar and solar eclipses or solstice and equinox dates. But other nonmathematical astronomical texts in addition to almanacs were no doubt also consulted, as is clear in *BH* 25, in which eclipse data not available in the almanac are recorded, or in the horoscopes that provide the position of the moon with respect to a Normal Star.

The Normal Star almanacs were organized much like the almanacs, but the astronomical content, rather than being predicted, is tied directly to the observations contained in the diaries. For each monthly section in a Normal Star almanac, data are given for planetary synodic phenomena, Normal Star conjunctions, that is, how many cubits a planet passed in front of, behind, above, or below a Normal Star, and the dates of either of the Lunar Three or Lunar Six phenomena. The following example of a Normal Star almanac (*LBAT* 1038) is dated to the same year as horoscope *BH* 19, for S.E. 172 = 140 B.C. The paragraph containing data for month VI is given here as it was possible, by means of the astronomical data, to restore month VI as the month of the birth in the horoscope. Note the correspondence between the Lunar Three data and the location of Mars in Gemini. Concurrence of data between the Normal Star almanac and the horoscope may not prove that this document was used as a source for the preparation of the horoscope, but it is not inconceivable that the Normal Star positions could be registered as zodiacal signs, and suffice without any more precision than that. The almanac not only confirms the dating of BH 19, but resolves some broken passages as well[101]:

[101] *LBAT* 1038 obv.24–29 Transliteration:

24 KIN 30 13,20 2 GENNA ina TIL ABSIN ŠÚ GE₆ 4 US[AN . . .]
25 13 7 ME GE₆ 15 ina ZALÁG AN e MUL IGI [ša še-pit MAŠ.MAŠ . . .]
26 [1]3 13 ŠÚ SIG RÍN ša SI 3 ¹⁄₂ KÙŠ GE₆ 20+[. . .]
27 [] 35 GE₆ 28 USAN dele-bat e M[UL . . .]
28 [14] 2,20 NA GE₆ 30 ina ZALÁG AN e MAŠ.MAŠ ša [SIPA(?) . . .]
29 [2]8 KUR [remainder of line uninscribed]

LBAT 1038

24 Month VI 30. (sunset to moonset) 13,20. On the 2nd, Saturn sets in the end of Virgo. Night of the 4th, even[ing . . .]

25 On the 13th, moonrise to sunset 7°. On the 15th in the morning, Mars above η Gemi[norum ("the front star of the Twins' feet") . . . cubits . . .]

26 [On the 1]3th, moonset to sunrise 13°. Below β Librae ("the northern part of the scales") 3½ cubits. Night of the 2[0 + . . .]

27 [On the . . . th] sunset to moonrise 35°. Night of the 28th, evening, Venus above . . . [. . .]

28 [On the 14th] sunrise to moonset 2,20°. Night of the 30th, in the morning, Mars above γ Gemi[norum ("the Twins' star near the True Shepherd of Anu") . . .]

29 [On the 2]8th, moonrise to sunrise occurred (i.e., last lunar visibility)

BH 19:

[Year 17]2 (s.e.), Arsaces was king. [Month VI] 30, night of the 13th . . . evening watch; In his hour (of birth), the moon was in [Pisces(?)], sun in Virgo, Jupiter in Sagittarius, Venus in Libra, Mars in Gemini, Mercury and Saturn which had set were not visible. They were with the sun. That month, moonset after sunrise on the 14th, last lunar visibility on the 28th. That year, (autumnal) equinox was on the 2nd of Month IX.

4.2.4 Ephemerides

The growth of Babylonian astronomical theory after 600 B.C. culminates in the fully mathematical and predictive table texts or "ephemerides."[102] The bulk of the mathematical astronomical texts comprises lunar or planetary tables, which are supplemented by a smaller group of procedure texts outlining the steps necessary to generate the tables. The ephemerides contain parallel columns of numbers that represent dates or positions of the characteristic lunar and planetary appearances or other data relevant to the control of the desired synodic phenomena (e.g., lunar latitude tabulated in column E or lunar velocity in column F in a lunar ephemeris). Some columns do not themselves represent astronomical phenomena at all, but rather are mathematical entities relating to the computation of the phenomena (for example, planetary table *ACT* 600 col. ii containing the monthly differences in *tithis*, a unit equivalent to $1/_{30}$ of a mean synodic month). In the main, columns represent dates or positions of various periodic phenomena, for example, new moons, eclipses, planetary first

[102] Neugebauer, *ACT*, and *HAMA*, Book II.

visibilities, or stationary points, the dates or positions of which are generated by means of mathematical functions, such as $\Delta\lambda = f(\lambda)$.[103]

Planetary tables for the planets Jupiter, Venus, Saturn, Mercury, and Mars generate the dates and positions in the zodiac of such phenomena as first visibilities, oppositions (for the outer planets), stationary points, and last visibilities. The fact that each phenomenon had its own period enabled the Babylonians to compute them independently. Although no general physical or dynamical theory, in our modern sense, of planetary and lunar motion was articulated by Babylonian astronomers, their underlying mathematical methods denote "models" or representations of the occurrence of celestial phenomena that in turn are structured on the recognition of certain period relations. These period relations are of the following sort: x synodic phenomena $= y$ revolutions of the ecliptic (of the celestial body in question). For example, 391 synodic phenomena of Jupiter (first visibilities, last visibilities, first or second stations) will occur in thirty-six traversals of the 360° of the ecliptic by the planet. A Babylonian lunar table deals with the determination of conjunctions and oppositions of sun and moon, first and last visibilities, and eclipses, all of which are cyclic phenomena. The tabulation of the positions in the zodiac of such phenomena in sequence yields values, in degrees of the ecliptic, for the interval, or "synodic arc," between consecutive phenomena. The strictly arithmetical methods of this astronomy were sufficient to compute all the individual appearances of the visible heavenly bodies, whether forward as predictions or backward as retrojections. The goal of Babylonian mathematical astronomy may be said therefore to be the prediction (or retrojection) of the synodic appearances of moon and planets.

The ephemerides employed two models, or "systems," for computation, referred to as Systems A and B. System A in effect proposed that a planetary body moves through the ecliptic at varying rates of progress, fast or slow, its progress in longitude being a function of its longitude [$\Delta\lambda = f(\lambda)$]. System B was not tied in the same way to the ecliptic, but derived longitudes of synodic phenomena as a function of the number of the synodic occurrence in the sequence of such occurrences in the lines of the table [$\Delta\lambda = f(n)$]. The progress of the body therefore described a zigzag line bounded by a maximum and a minimum value, carefully chosen with respect to the mean value of the function. The resulting period referred then to line numbers between same values, not to the number of synodic occurrences

[103] See Section I.I.

per revolutions of the ecliptic, as in System A. It is, however, the case that the arithmetical mean value of the System B function bears relation to the ideal mean synodic arc in System A. For example, in System B for Jupiter, the mean value of the function $\mu = (M + m)/2$ is 33; 8, 45. In System A, the mean synodic arc $(\overline{\Delta\lambda})$ is 33; 8, 44, 48°.

Because positions of all the celestial bodies must be noted in a horoscope whether they are above the horizon or not, computational astronomy would obviously be of great advantage for horoscopy. The ability to compute the planetary position for dates in the past also has practical value for horoscopes, as these were generally constructed long after the birth date. Demonstrating the use of mathematical ephemerides for horoscopes is another matter. The longitudes of all seven planets are the principal data collected in horoscopes, but because the date of birth is of primary concern, the planets are for the most part between synodic appearances. When, however, a planet happens to be in the same sign as the sun on the date of birth and is near a synodic phase, sometimes the date of the synodic phenomenon will be mentioned in the text. On the whole, longitudes are given with respect to the names of the zodiacal signs. Degrees of longitude are not common, but do occur in eight horoscopes, five of which are from Uruk. No other source but the ephemerides provides longitudes in degrees within a zodiacal sign. But the relationship between the horoscopes' longitudes and those of the table texts is complicated by the fact that ephemerides, with rare exception, generate longitudes of consecutive synodic phenomena, not positions on arbitrary dates. Rules for subdividing the synodic arc, for example, from heliacal rising to first station or first station to heliacal setting, are given in a number of procedure texts of System A[104] and can be uncovered in some table texts as well.[105] Some procedure texts, such as *ACT* 810 and the similar *ACT* 813 for Jupiter, state the daily progress of the planet in degrees per day. Finally, there are a very few ephemerides, in the true sense of tabulating daily positions of the planets, such as *ACT* 310 for Mercury, *ACT* 654 and *ACT* 655 for Jupiter. These employ refined nonlinear interpolation schemes to obtain positions between the synodic phases. I do not find the excellence of the horoscopes' longitudes to be a compelling argument that daily motion schemes of the type represented by *ACT* 654 and *ACT* 655 were employed by the horoscope casters, at least it is not possible to demonstrate such an application. The horoscopes may well contain rounded values obtained

[104] See *ACT* 801 for Mercury and Saturn, 812 for Jupiter, 811a Section 10 for Mars.
[105] See *ACT* 611 for Jupiter System A'.

from *ACT* schemes. Even if that were the case, it leaves open the question of the motivation for those schemes, if all that was needed was a rounded value. The evidence is simply lacking for a firm decision on the question of the use of ephemerides, or their computational schemes, in horoscopes, and the related question of the motivation for producing the tables themselves.

The demonstrable connection between astronomical texts and horoscopes raises the question of the motivation for production of such astronomical records. A related question is this: To what degree was astrology an important impetus for the development of the mathematical astronomy that functioned independently of observation? To draw up a horoscope, the scribes needed a method, or methods, for the determination of planetary positions on arbitrary dates. This required control over the correspondence between dates and positions of all seven planets (moon, sun, Jupiter, Venus, Mercury, Saturn, and Mars). The body of sources in which this kind of control was most theoretically refined is the mathematical astronomy of the ephemerides. From the point of view of the horoscopes, however, these tables are not practical because they generate the dates and positions of synodic appearances. The position of a planet on other dates could of course be derived by interpolation from the ephemerides' longitude schemes, and perhaps indeed this was done.

The zodiac provided the basic and primary reference point for astronomical data recorded in horoscopes. In the case of the moon, however, we have noted the use of Normal Stars instead of and in addition to the lunar position with respect to a zodiacal sign. We do not yet understand if or how the two celestial "coordinate" systems (if indeed the Normal Star system may be regarded as such) may have been made compatible by systematic numerical conversion,[106] but this does not appear to have been at stake in the horoscope texts in which both systems are used. The evidence shows the use of nearly the full range of nonmathematical texts as sources for horoscopes. Sachs suggested that the few horoscopes quoting planetary positions in degrees of zodiacal signs derived data from ephemerides, but emphasized that the sources from which the greater number of horoscopes derived their data were more likely the astronomical diaries.[107]

[106] An attempt to do so was made by Sachs in "A Late Babylonian Star Catalog," JCS 6 (1952), pp. 146ff., and the problem was discussed further by Huber, "Ueber den Nullpunkt der babylonischen Ekliptik."

[107] Sachs, "Babylonian Horoscopes," pp. 64–5.

Ephemerides certainly could have been drawn on for the horoscope if interpolations between the synodic events, such as are attested to in a few ephemerides, were made.[108]

It is clear that the broad category of texts providing the source for the majority of horoscopes is the nonmathematical astronomical texts rather than the ephemerides. Whereas the bulk of the data offered by the diaries is not geared to the construction of horoscopes, sufficient and ready reference material is included in these texts and in a manner that would facilitate their use. Diaries regularly cite positions in between synodic appearances with respect to Normal Stars, not the zodiac, and give zodiacal signs primarily in connection only with synodic phenomena as is the standard Babylonian astronomical practice. By the middle of the fifth century, however (the earliest attestation is found in diary No. −463), a summary of the zodiacal locations of the planets was included at the end of a month section, which would obviously be of immediate utility for constructing a horoscope. The comparison between the contents of horoscopes and other nonmathematical astronomical texts, however, shows that other genres, particularly almanacs, provided sources for horoscopes, but these too, in part, derive data from the diaries.

This relationship undermines the historical reconstruction that sees horoscopic astrology giving rise to astronomy. Identifying the cultural impetus for the development of the mathematical astronomy of the fifth century and its relation to the forms of celestial inquiry that existed before it, that is, celestial observation and divination, has been of interest to assyriologists for many years. At the 14th Rencontre Assyriologique Internationale in Strasbourg in July of 1965, Oppenheim raised the issue of the role of celestial divination in the history of Babylonian astronomy:

Any serious investigation of the history of Mesopotamian civilization has to face the problem of the sudden emergence of mathematical astronomy about 400 B.C. To put it somewhat bluntly, the question is whether there exists a direct relationship between this development and the evolution within Mesopotamian divination, to be exact, within astrology, or whether the genesis of Mesopotamian science, that is, of mathematical astronomy, was released by other still unknown factors.[109]

[108] *ACT* 654 and 655, and see the discussion in Steele, "A 3405: An Unusual Astronomical Text from Uruk," pp. 103–35.

[109] A. L. Oppenheim, "Perspectives on Mesopotamian Divination," in *La divination en Mésopotamie ancienne et dans les régions voisines, CRRAI 14* (Paris: Presses Universitaires de France, 1966), pp. 40–1.

The phenomena on which the divination series *Enūma Anu Enlil* focused had a connection with those of mathematical astronomy in their interest in the horizon phenomena of the moon and planets, although many more celestial appearances, including nonperiodic ones, were regarded as ominous. As reasons for observing the heavens from a very early period, celestial omens provide a plausible motive. But whether astral omens constituted sufficient impetus for the eventual development of the kind of positional astronomy that emerged around 500 B.C. is unanswerable. Certainly, however, the virtually synchronous developments of personal astrology and mathematical astronomy in the period beginning roughly 500 B.C. makes any argument for horoscopes as the basis for the "sudden" advance in astronomy impossible to maintain.

The computational systems of Babylonian astronomy, which emerged at about the same time as did horoscopic astrology, cannot be accounted for solely by reason of their serving astrological purposes. The astronomical schemes known to us from Babylonian ephemerides and procedure texts are of a complexity beyond anything required by horoscope texts, which give planetary positions with respect only to zodiacal signs, less often to degrees within a zodiacal sign, and only rarely to $1/2°$. Such a discrepancy between the schemes available in mathematical ephemerides on the one hand and astrological texts on the other is matched by later Hellenistic astrology. Neugebauer and van Hoesen point out that, in the *Anthology* of Vettius Valens and the *Tetrabiblos* of Ptolemy, simple arithmetical schemes are used "which belong to a period of astronomical theory which had been long surpassed at that time."[110] They go on to say,

the cliché which is so popular in histories of astronomy about the stimulating influence of astrology on exact astronomy is nowhere borne out where we are able to control the details.[111]

The cuneiform evidence appears consistent with the picture derived from the Hellenistic sources. Babylonian mathematical astronomy produced far more data, and more puzzling, a different set of data (i.e., synodic phenomena rather than daily positions), than is needed by horoscopes. Even if some of the data were computed for horoscopes according to *ACT* schemes, using only the rounded values to the zodiacal sign, still the argument for horoscopic astrology as a catalyst for mathematical astronomy rests more on the expectation that ancient astronomy was limited by

[110] Neugebauer and van Hoesen, *Greek Horoscopes*, p. 185.
[111] Ibid.

pragmatic application and so needed astrology, rather than any convincing demonstration from the textual evidence.

Although the methods of Systems A or B are not in direct evidence in the data recorded in the horoscopes, the astronomical terminology and certain subjects, such as lunar latitude, which are not found in other astronomical texts, can perhaps be taken as indirect evidence of their use. Overall, despite the genre boundaries from one text type to the next, many aspects within the range of astronomical interests and methods typical of the nonmathematical and mathematical astronomical texts contribute to the construction of a horoscope. At the same time, the raison d'etre for these astronomical texts cannot be argued as simply or solely astrological. We can hardly assume that every recorded phenomenon had astrological or ominous import, as clearly the many phenomena in the prodigious observational diaries do not refer directly to omens, nor does the computation of synodic phenomena have anything to do directly with either omens or horoscopes.

Although astrology (omens and horoscopes) and astronomy (mathematical and nonmathematical) each represented well-defined scholarly activities in terms of their own respective goals and methods, the dependence on astronomical text genres revealed when one looks closely at the horoscopes points to some coherence in the celestial sciences of late Babylonia. Of course this is a matter of interpretation and of what one chooses to emphasize as an overriding characteristic of the material. The clear differences in method, if viewed as primary, suggest a lack of cohesion between astronomical and astrological texts. However, because a disavowal of celestial divination is nowhere in evidence in cuneiform texts and *Enūma Anu Enlil* continued to be preserved within the intellectual culture of the scribes who practiced the celestial sciences in the Late Babylonian period, the principle that the phenomena bore meaning as signs may indeed have provided a cohesive element. If indeed this is the case, a mutual dependence between horoscopy and omens and from horoscopy to astronomy can be argued. Whether the notion of "the heavenly writing," that is, that celestial phenomena could be read as signs and thereby revealed the divine in physical form, can be identified as that common bond between otherwise divergent branches of celestial science is again a matter of conjecture, but one that is considered further in subsequent chapters.

5

SOURCES FOR HOROSCOPES IN THE EARLY ASTROLOGICAL TRADITION

5.1 THE IDEOLOGICAL BACKGROUND

In the preceding chapter, parallels found within the contents of horoscopes and a variety of astronomical sources establish links between the modern categories of astronomical and astrological classes of texts in the scribes' repertoire. The horoscopes therefore uncover interrelations among celestial scientific texts and raise the question of the integrated nature of Babylonian celestial science in general. The place of horoscopy in the context of other Late Babylonian astronomical texts is secured by comparison with the content of those astronomical texts, but what of the relationship of horoscopes to other "astrological" genres, particularly celestial omens? An account of the data presented in horoscopes in light of traditional celestial omens has been undertaken in Chapter 3. But the historical question, whence the foundations for Babylonian horoscopy, cannot be answered solely by the identification of textual antecedents, either astronomical or astrological, but must also consider the ideological dimension as well.

We turn our attention then to the relation of the new genethlialogy to earlier celestial omens, from the perspectives of the meaning and authority of celestial signs, and the relation between the individual and the divine cosmos. Always a matter of translation and inference, we are sharply limited by our ability to penetrate to the underlying ideologies of our texts concerning the physical universe, why and how the phenomena constituted "signs," and the relationship between humankind and the gods. To entertain the question of whether the genre of horoscopes signaled a change in such ideologies about the world that permitted belief in the traditional celestial divination, or whether that same traditional worldview accommodated the kind of special relation between the individual and the cosmos implied by personal astrology, some grasp of the beliefs

about ominous signs and the role of the divine in the realm of physical phenomena is desirable.

I have no intention of making what some would call "essentialist" claims about "Babylonian thought," or a "Babylonian mentality," meant to represent a stage of thought or a type of thinking of any general status. I am here interested only in the ideas concerning the phenomena, the rationale for the efficacy of divination and astrology, and the relation between, on the one hand, the texts in which such ideas are found, and the astronomical texts on the other. The following discussion is limited to those ideas that can be extracted from and supported by the literature of the Babylonian scholar–scribes who specialized in divination and took part in its related activities, such as prayer, incantation, or, indeed, the mathematical prediction of lunar eclipses. Where assumptions regarding an ancient Near Eastern "mode of thought" have been made in the history of speculation on matters relevant to the texts under consideration, especially the once widely accepted presumption of a mythopoeic thought in ancient Mesopotamia, my discussion necessarily deals with this question.

The cultural background for the emergence of horoscopy in Babylonia is unquestionably the traditional Mesopotamian practice of divination in general and prognostication from celestial signs in particular. The scholarly literature of celestial divination, especially the celestial omen series *Enūma Anu Enlil,* is foundational for the horoscopes, in that a shared terminology and in some cases apodoses are found in both corpora. Reference to the historical development of the celestial omen series as well as a basic description of its contents may be found in Chapter 2. This chapter takes a more inferential turn and attempts to draw out some of the ideological underpinnings of celestial divination, such as the conceptualization of physical phenomena or the role of the gods in the realm of human perception and experience. My purpose is to consider the class of horoscope texts in the light of these methods and goals in order to determine how consistent with celestial divination this new kind of prognostication from the heavens might have been.

5.2 CONCEPTUALIZATION OF THE PHENOMENA AS SIGNS

The diviners regarded the physical world of phenomena as an interpretable system of signs or symbolic language, by means of which humankind could obtain knowledge of future events. Such a view is implicit in the omens themselves, and in the fact that extensive compilations of signs, both celestial and terrestrial, were collected into general reference works,

such as *Enūma Anu Enlil* and *Šumma ālu*. More explicit is the statement in the Babylonian "diviner's manual," that

> the signs on earth as well as of the sky bear signals for us; heaven and earth bring us omens; they are not separate from one another; heaven and earth are interconnected.[1]

This statement seems to articulate a basic premise about the scholar's view of the universe, that is, that the entire world order was thought to be pervaded by signs, and these signs consisted of every perceptible and imaginable phenomenon occurring in the world, not only above, but also below. A further cosmological implication may be drawn from this statement, namely that the cosmos was characterized by a complementary rather than a dualistic relationship between its two primary parts, heaven and earth.

The correlation between a sign and its predicted event in the cuneiform divination texts functioned as an omen, in the sense of the Latin for "warning." The "if–then" statements warned of what could occur for mankind, given certain situations, the "ifs" being potential occurrences associated with certain events, not documented antecedents of those events, certainly not causes of the events in the apodoses. On the basis of the organization of omens within the divination series themselves, it appears that the signs were rendered decipherable by means of schematic correlations of celestial sign (omen protasis) and terrestrial event (omen apodosis). Further determination of whether a sign was favorable or unfavorable was also a common practice.[2] But why these omens were deemed authoritative, and why the *Enūma Anu Enlil* compendium was copied and transmitted for centuries, may be indicated both in the scribes' claim to the divine authority of that text and perhaps also in the apparent perception of the celestial phenomena as manifestations of gods or, at least, as products of their agency.

The laconic nature of omen texts places limitations on the use of the divination literature as evidence for how the Babylonians perceived the celestial bodies, that is, how they understood the gods to relate to the celestial

[1] *JNES* 33, p. 200, lines 38–40; see A. L. Oppenheim, "A Babylonian Diviner's Manual," *JNES* 33 (1974), pp. 197–220.

[2] See again, Oppenheim, "Diviner's Manual," pp. 200–1, lines 72–83, as well as commentaries on extispicy, as in *CAD* s.v. *šalāmu/lapātu* "favorable/unfavorable" and, in more detail, I. Starr, *The Rituals of the Diviner*, Bibliotheca Mesopotamica 12 (Malibu, CA: Undena 1983), pp. 8–24.

omens, and by extension, to the physical world. Of course, our only way of knowing what Babylonian perceptions might be is by means of their descriptions of things, and so the following discussion focuses not so much on the kinds of phenomena observed in the celestial omen texts, but on the way in which some of these are described.

The bulk of the omen protases in the series *Enūma Anu Enlil* describe celestial phenomena directly, for example, "(if) the moon's appearance is red,"[3] or "Venus was seen in the East in the morning" or "Jupiter was bright," "or dim," or "the Bristle (Pleiades) rises heliacally in the month of Ajaru." Such statements refer to the physical world in a straightforward way. As a compendium of observation predicates, *Enūma Anu Enlil* organized the known elements of heavenly phenomena deemed meaningful for reading the heavens as signs from the gods concerning affairs on earth. Whereas most celestial omens betray no explicit conception of the involvement of the deities in the phenomena, some expressions found in omen protases refer to actions or appearances appropriate not to inanimate objects, such as we believe the planets and stars to be, but to anthropomorphic beings with agency and feeling.

The anthropomorphizing of deities, although not the exclusive conception of divine form in ancient Mesopotamia, is a feature of Mesopotamian religion attested from the earliest periods,[4] and it is quite clear that in the celestial omens the anthropomorphic references are to gods. If these expressions are metaphoric tropes, and not statements about anthropomorphic deities, they should imply two conceptual domains: one, the divine, serving as a vehicle for the description of the other, the phenomenal. For example, instead of simply stating there was a lunar eclipse, normally expressed by the term *attalû* "eclipse," we sometimes find that the moon, in anthropomorphic guise "mourns" or "feels distress." Such anthropomorphic expressions are attested already in the Old Babylonian lunar omens, in which, moreover, the moon is referred to explicitly as "the god." One protasis, for example, reads "The god disappeared in distress." But because context demands that we understand this to refer to an astronomical phenomenon, we translate thus: "The moon set while eclipsed."

[3] *ACh* Sin IX:1.

[4] See M. Stol, "The Moon as Seen by the Babylonians," in D. J. W. Meijer, ed., *Natural Phenomena: Their Meaning, Depiction and Description in the Ancient Near East* (North-Holland, Amsterdam, Oxford, New York and Tokyo: Koninklijke Nederlandse Akademie van Wetenschappen Verhandelingen, Afd. Letterkunde, Nieuwe Reeks, deel 152, 1992), pp. 245–77.

We therefore understand the expression to be metaphoric, that is, a lunar eclipse conceived of in terms of the distress of the moon god.

The anthropomorphic trope of psychological distress for the state of being eclipsed is expressed by the phrase *lumun libbi* "grief," which is said in the Akkadian lexical literature to be synonymous with the nouns *adirtu* "mourning" and *maruštu* "distress."[5] In astrological contexts, *lumun libbi* often occurs with the verb *adāru*, which primarily means "to be worried or distressed." By extension, *adāru* can mean "to become darkened." Although the noun *libbu* "heart" is constructed in compounds to describe states of mind and feeling, the derivation of the synonymns of *lumun libbi*, namely, *adirtu* from *adāru* "to be darkened" and *maruštu* from *(m)aršu* "dirty," also obviously suggests darkness of color. Hence *lumun libbi* too has a purely descriptive sense, that is, "darkened," when said of the moon in eclipse.

The Old Babylonian omen was explicit in its reference to the moon as "the god" experiencing distress, and similarly in a bilingual account, the eclipse is "explained" as the work of demons causing (with the causative Š stem of *adāru* "to be worried," hence "to cause to be worried") the moon god to be disturbed, that is, eclipsed: "They (the evil demons) caused the disturbance of the god Sin (=eclipse of the moon) in the sky."[6] These passages make reference to the moon god, but particularly within the context of the omens, in which we know the heavenly body is the object of discourse, the referent here must also be the moon observable in the sky. Because the name of the moon is indistinguishable from the name of the moon god, only context can disentangle the two possible interpretations this language presents to us, the first being the moon god in a psychologically disturbed state, and the second being a physical description, that is, the lunar disk darkened in eclipse.

Figurative language seems to be applied more often with respect to the moon. In other lunar omens we can see the moon set "with unwashed feet,"[7] "wear a crown" at first visibility,[8] or "ride a chariot."[9] The anthropomorphic image of Sin is also manifest in the reference to the moon

[5] *CAD* s.v. *lumun libbi* lexical section.

[6] *CT* 16 22:238f., see *CAD* s.v. *adāru* lexical section. For a translation of portions of this myth, see A. D. Kilmer, "A Note on the Babylonian Mythological Explanation of the Lunar Eclipse," *JAOS* 98 (1978), pp. 372–4.

[7] Hunger, *Astrological Reports*, 103:7.

[8] Ibid., 57:1; 105:1; 331:1.

[9] Ibid., 112 rev. 3; 298:1; 364:6.

occasionally as "the god" (*ilu*), in the manner of the Old Babylonian ex-
ample.[10] This designation, of course, is fully interchangeable with that
of the name ᵈSin or ᵈ30. The relation between the god and the heavenly
body called by the same name is never given to us directly in the omens,
but we may be in a better position to decide this question by further exam-
ining the nature of the figurative language of the omens that is, whether
its use is indeed metaphorical or merely substitutive.

If the heavenly bodies were thought of as gods – not manifestations of
gods, but identical to and synonymous with gods – we ought not regard
the anthropomorphic descriptions of their movements and appearances
as metaphorical. To say, in a mythological context, that a god mourns,
or rides a chariot,[11] is not metaphorical. We see, for example, in literary
texts or in Assyrian and Babylonian royal inscriptions, that gods such
as Marduk and Aššur ride chariots, and we do not consider these to be
figurative expressions. But what of the omen "the moon rides a chariot"?
This particular protasis is so far attested only in the astrologers' reports,
that is, not in the *Enūma Anu Enlil* text as currently reconstructed, but
it is included in more than one report in which all the protases refer to
lunar halos. The following report makes it clear that the phenomenon in
question was indeed the moon surrounded by a halo:

[To]night the moon was surrounded by a halo, and the Ol[d Man] Star (=Perseus)
and The Great Twins (=Gemini) sto[od] in it.

[If] the moon rid[es] a chariot in the month of Sililiti: the dominion of the
king of Akkad will prosper, and he w[ill capture] his enemies.... If the moon is
surrounded by a halo and the Old Man Star stands in it: a reign of long duration.

[If The Great Tw]ins (Gemini) stand [in the halo of the m]oon and [....] (one line
destroyed) May [the kin]g, [my lord], and [the peo]ple with him live fo[rever!]
[From] Akkullānu.[12]

The astrological report consists of an observation, followed by the citation
of a number of omens, all relevant to that observed phenomenon, and by
means of which a prediction, favorable or unfavorable, may be determined

[10] Texts using *ilu* "god" for the moon may be found in *Enūma Anu Enlil* Tablet 20; see
 ABCD, pp. 179–226.
[11] For example, "he (Marduk) mounted the chariot, the storm which has no equal," EnEl IV
 50, "(Aššur) who rides in a chariot," D. D. Luckenbill, *The Annals of Sennacherib*, OIP 2
 (Chicago/London: University of Chicago Press, 1924), p. 140:7, and the god Bunene is the
 rākib narkabti [charioteer] in VAB 4 260 ii 33.
[12] Hunger, *Astrological Reports*, 112 rev. 1–11.

for what was observed. Because the omens cited in a report are thematically related, the inclusion of the moon (god) riding the chariot in the context of halos points to an interpretation of this trope as some sort of halo.

A possibility for interpreting this protasis in a nonmetaphorical way is to read the chariot here as the constellation "The Chariot (MUL.GIGIR/ *narkabtu*)," representing the stars ζ, o+ Persei with the northern stars of Taurus[13]. The determinative MUL "star" before GIGIR "chariot" seems invariably to be written where the star name is intended, and this does not appear in the omen "the moon rides a chariot." Elsewhere in *Enūma Anu Enlil*, the verb *rakābu* means "(celestial bodies) conjoin," that is, one star may "ride" or "mount" another,[14] but without indication that this reference to GIGIR is a star name, we are left with an image of the moon, expressed figuratively by reference to the moon god riding a chariot. Whether indeed the phenomenon so described is some kind of halo must await further evidence. The more important point in the present context is whether the expression is metaphorical or not.

In the context of the omen protases, the ominous phenomena, described in the first example as a god in mourning and in the second as a god riding a chariot, refer not to imagined mythological events, but to observable objects, and thus, I would argue, the use of the language is metaphorical. These tropes functioned to describe particular visible effects, the former a lunar eclipse represented by the mournful darkened face of the moon, the latter perhaps some type of halo, represented by the chariot. Of course, an expression functions metaphorically, as E. Feder Kittay said, "always relative to a set of beliefs and to linguistic usage."[15] Thus she questioned the metaphorical force, for example, of the Homeric phrase "the rosy-fingered dawn" for the ancient Greeks who conceived of the dawn anthropomorphically. I would prefer to understand the anthropomorphic conception as the source for a metaphor for the pink morning sky, just as the Mesopotamian conception of an anthropomorphic god can be seen to give rise to the metaphor of the psychological distress of the moon god to represent an eclipse.

It should further be clear that, in the case of the moon's chariot, the metaphor refers not to the moon, but to the halo, as in the protasis "if

[13] According to Reiner–Pingree, *BPO* 2, pp. 11–12 s.v. GIŠ.GIGIR and EN.ME.ŠÁR.RA.

[14] Reiner–Pingree, *BPO* 2 XII 12(-13) [DIŠ MUL.MEŠ-*šú* AN.TA *r*]*it-ku-su* KI.MIN U₅.ME "If its upper stars are conjoined," variant: "ride one on the other."

[15] Eva Feder Kittay, *Metaphor: Its Cognitive Force and Linguistic Structure* (Oxford: Clarendon, 1987), p. 20.

the moon is surrounded by a river,"[16] in which, again, a halo is described as having the appearance of a river. Similarly, extispicy abounds with metaphoric language, whose referents stem from the appearance of the exta, for example, the "finger," the "palace," or the "weapon," which denote certain features of the liver.[17] In the example of the eclipse, however, the celestial body itself is anthropomorphized by the language used to describe its appearance.

Even in the cases in which the celestial bodies' names duplicate the names of gods, such as is the case with the moon and sun, the celestial bodies cannot themselves be one and the same with the gods their namesakes. Were this the case, the personifications in the omen protases would be tautological and the figurative references merely substitutive. Saying the moon rides a chariot is of no help in describing the appearance of the moon if indeed no distinction were made between the moon and the moon god. There is still no clear confirmation of this interpretation. The fact that other names besides those of the gods are used to designate the planets, for example, d30 instead of Sin for the moon, or dSAG.ME.GAR instead of Marduk for Jupiter, might throw some weight as supporting evidence, underscoring the conceptual distinction between the deity and the physical object in the sky that in some way represented or manifested the deity. It must be admitted, however, that such names can simply represent alternative names for the same divinity.

In the omens, the use of metaphor seems in every case to be an attempt to convey the appearance of something observed, likening the appearance of one thing to another that has visual associations. Some common understanding of the image of the moon god riding a chariot must underlie the use of that image to convey some feature of the moon's appearance. At least this is the limited extent to which we can determine the meaning of these metaphors. Any semantic extension beyond the merely descriptive depends on recognition of culturally dependent elements to which we have limited access. In the case of the chariot, for example, the only aspect that connects god with chariot seems to be an association to the special

[16] Hunger, *Astrological Reports* 93:5.

[17] The metaphoric language in extispicy has its own special usage, however, in that the features of the liver designated by reference to objects in the physical world (palace, weapon, path, foot, etc.) seem to be so designated in order to correlate these features with certain forecasts, e.g., the success of the king on campaign (based on the correlation "path" = troops on campaign). See Larsen, "The Mesopotamian Lukewarm Mind," pp. 213–15 with literature given in the notes.

status of the royal chariot, ornamented and equipped with fine horses. Therefore the appropriateness of the metaphor is clear, but just what the metaphor refers to is not.

In another example, a commentary to the protasis the planet Venus "sports a beard" (*ziqnu zaqnat*) explains that su$_6$ (*ziqnu*) is also readable as *nabāṭu* "to become radiant." In this case, the scribes sought to explain the anthropomorphic image of a bearded goddess in terms of an optical description, that is, as the planet radiating brightness as though with a "beard" of light.[18] By the scribes' own testimony, the figurative language of the omen text is interpreted descriptively. The effectiveness of these tropes in descriptive usage depends on a shared conceptualization of what is being described, and therefore they function for us as indicators of an underlying conception of – or set of associations with – what is being observed. In each case in which there is a personification, we can see that an appeal to the image of a deity can act as a means to a physical description of a heavenly body. An attribute of a god, such as the beard of Ištar, can be said of the celestial body associated with the god, namely Venus. The beard of Venus is therefore a figurative description for a radiance of the planet.

One final argument for the metaphorical rather than literal interpretation of the examples presented is based on the late occurrence of the metaphor of the moon god in mourning for a lunar eclipse. This time, the context is the Seleucid eclipse reports that are strictly astronomical and have no overt connection with omens. In the eclipse reports alongside the term *attalû* (AN.KU$_{10}$) "eclipse," the darkening of the moon is not infrequently expressed with the verb *bakû* "to mourn." The expression occurs sometimes in the form *bakû u namāru* (ír u ZALÁG-*ru*), translatable as "darkening (lit. mourning), and clearing (lit. becoming light)."[19] A parallel to this use of *bakû* is found in the solar section of *Enūma Anu Enlil*, in which Šamaš is said to "mourn," that is, to be in eclipse, at the end of the month.[20] The relation of *bakû* to *lumun libbi* and the

[18] The context for the "beard" of light in the Šamaš Hymn is problematic. W. G. Lambert, *Babylonian Wisdom Literature* (Oxford: Clarendon, 1960), 126:18, reads *mu- šah-miṭ ziq-nat ur-ri* as "who sets aglow the beard of light," the interpretation also recorded in *CAD* Z s.v. *ziqnu*. E. Reiner, however, in *Your Thwarts in Pieces Your Mooring Rope Cut: Poetry from Babylon and Assyria*, Michigan Studies in the Humanities 5 (Ann Arbor, MI: University of Michigan Press, 1985), p. 70, translates "Hastener of dawn's [. . .]", reading *mušahmiṭ* as the Š participle of *hamāṭu* A "to hasten, be quick," therefore not from *hamāṭu* B "to burn, to set aglow."

[19] See *LBAT* 1416 rev. 7′.

[20] *ACh* Supp. 2 Šamaš 40:6 and ibid. 1 written ír.

complex of words associated with psychological or emotional disturbance, for example, *adāru* and *dalāhu*,[21] used in the context of eclipse omens are unmistakable. Whether the mental image of the mourning of the moon or sun gods in terms of which eclipses were understood persisted as far as the Seleucid period in the context of Babylonian astronomy, or whether "mourning" had become a dead metaphor, one cannot say. The image of the moon god in mourning need not have survived for the metaphoric language, in this case the term *bakû* (ír) to continue as an idiomatic, yet literal, expression for the darkening of the moon. Idioms have traditionally been regarded as dead or frozen metaphors, and perhaps this is how we should understand this isolated term in the vocabulary of the Late Babylonian astronomy, which no longer had anything overtly to do with gods.[22] If the expression for lunar or solar eclipses using terms linked with anthropomorphic feeling had not been metaphorical in the omen texts, that is, did not refer to the phenomena, but rather literally to the gods, I fail to see how such an expression would have had a meaningful survival in astronomical technical terminology.

The interpretation of the nature of the tropes found in omen protases has further importance because it provides an effective argument for the existence of relational, analogical, even "abstract" thinking in the divination texts. In the once-influential *Before Philosophy: The Intellectual Adventure of Ancient Man*,[23] H. Frankfort et al. alleged an incapacity (or an unwillingness[24]) in the "ancient mind" for just such analogical or metaphorical thought. Their thesis erased any distinction between subjective perception and objective conception in this ancient mode of thought, and, regarding signs or omens, Frankfort et al. argued that the ancient observer

can no more conceive them as signifying, yet separate from, the gods or powers than he can consider a relationship established in his mind – such as resemblance – as connecting, and yet separate from, the objects compared. Hence there is coalescence of the symbol and what it signifies, as there is coalescence of two objects compared so that one may stand for the other.[25]

[21] Again in the bilingual in which demons cause the lunar eclipse, see "his (Sin's) bright light became disturbed and he became mute," *CT* 16 20:96–97, cited in *CAD* s.v. *dalāhu* mng.5.

[22] See Raymond W. Gibbs, Jr., "Process and Products in Making Sense of Tropes," in A. Ortony, ed., *Metaphor and Thought*, 2nd ed. (Cambridge: Cambridge University Press, 1993), p. 272.

[23] Frankfort, et al.

[24] In *Before Philosophy*, p. 19, Frankfort et al. did not claim that ancient Near Eastern thought was illogical, or even prelogical. Their view on this is expressed rather in the statement, "They could reason logically; but they did not often care to do it."

[25] Frankfort et al., *Before Philosophy*, p. 21.

Before Philosophy declared the inability to separate the realms of "the symbol and what it signified" (Saussure's signifier and signified) to be characteristic of a mode of mythical thought opposed to theoretical logical thought,[26] in which the alleged mythopoeic mind conceived an animistic world of physical phenomena that were, in the term of Frankfort et al., "Thou's." Despite Kramer's cogent critique of such animism in his review of *Before Philosophy*,[27] the interpretation by Frankfort et al. of the conceptual apparatus of "ancient man," in which natural phenomena, such as the storms, the rivers, the heavenly bodies, were conceived of as animate beings, became highly influential outside the field of assyriology and remains so even today.[28] From a contemporary assyriological perspective, however, the "mythopoeic thought" thesis has been replaced with

[26] Although published somewhat later, see also E. Cassirer, *Language and Myth*, trans. Susanne K. Langer (New York: Dover, 1953) for the evolutionary scheme of thought from the mythical to the theoretical.

[27] Kramer's review of Frankfort et al. in *JCS* 2 (1948), pp. 39–70, especially pp. 40–4, reprinted in Robert A. Segal, ed., *Theories of Myth: From Ancient Israel and Greece to Freud, Jung, Campbell and Lévi-Strauss* (New York/London: Garland, 1996), Vol. 3, pp. 213–44. See also T. H. Gaster's review, "Mythic Thought in the Ancient Near East," in the same volume, pp. 168–172, in which he too charges Frankfort et al. with reconstruction of a mode of thought for the ancients of Mesopotamia and Egypt from a body of poetic expressions of the nature of the world.

[28] In the history of science, for example, it is surprising to see how much reliance on this work still exists. See for example David C. Lindberg, *The Beginnings of Western Science: The European Scientific Tradition in Philosophical, Religious, and Institutional Context, 600 B.C. to A.D. 1450* (Chicago/London: University of Chicago Press, 1992), Chapter 1, "Science and Its Origins," in which assertions about traditions concerning nature characteristic of "prehistoric cultures and contemporary preliterate societies" are made (pp. 6–13). The influence of Frankfort et al. is even specifically adduced (p. 7) to define the kind of causality allegedly reflected in these cultures' thinking, i.e., one devoid of generality or abstraction from particular instances. Similarly, in a work designed for university students of western civilization, *Science and Culture in the Western Tradition: Sources and Interpretations* (Scottsdate, AZ: Gorsuch Scarisbrick, 1987), edited by John G. Burke, the first chapter approaches the question "was there *really* something new, different, and important about the ways in which the Greeks approached questions about the natural world (p. 1)," as compared with Mesopotamia and Egypt. The material offered for Mesopotamia, by means of which this complex question involving the comparison between Mesopotamian and Greek evidence is to be discussed, is a four-page passage from Frankfort et al., *Before Philosophy*, prefaced with the note that "we need to have some feeling for what the prescientific universe of early Mediterranean cultures was like (p. 6)." The "essence of prescientific cultures in the personal and particular character of human interactions with the natural world (p. 6)" as articulated by Frankfort et al. is accepted there without question as the foundation for the analysis of science in the ancient Mediterranean cultural sphere.

an effort to demonstrate the capacity of the ancient Mesopotamians to think abstractly and theoretically, which clearly bears on the issue of the ancient conceptualization of the ominous phenomena and the modern classification of celestial and other divination as science.[29]

Even according to the so-called "comparison theory" of metaphor, the theory traceable to Aristotelian rhetoric and poetics,[30] metaphor implies principles of analogy at work in the establishment of a metaphorical connection between two things. Metaphorical statements, even if they merely "involve a *comparison* or *similarity* between two or more *objects*,"[31] still presuppose a conceptual distinction between a perceived phenomenon and any other imagined or real phenomenon in terms of which it might be compared, described, and understood. Kittay, who argues forcibly for the cognitive efficacy of metaphor, said metaphor "is the paradigmatic device for pointing out analogies and making comparisons which cross the bounds of our usual categories and concepts."[32]

Analysis on this basis indicates that the expressions found in the omen protases are not statements about gods that substitute for statements about celestial phenomena, based on some putative interchangeable nature of the gods and the phenomena. The metaphorical expressions are better interpreted as referring to the phenomena in terms of the gods. Implied also is the necessary conceptual distinction between the phenomena and the gods, without which there can be no possibility of analogical relationships underlying the attested metaphorical references, such as the crown of Sin and the first visibility of the moon, Sin riding a chariot and the lunar halo, or the beard of Ištar and the radiance of Venus.

The omens of *Enūma Anu Enlil* attest to the fact that the domain of natural phenomena was the subject of systematic empirical consideration, and usually without overt reference to gods. The descriptions of phenomena

[29] See Larsen, "The Mesopotamian Lukewarm Mind, pp. 203–25, citing previous literature. See also the remarks of S. J. Tambiah, *Culture, Thought, and Social Action: An Anthropological Perspective* (Cambridge, MA: Harvard University Press, 1985), pp. 30–5, from a paper originally published as "The Magical Power of Words," *Man* n.s. 3 (1968), pp. 175–208.

[30] Aristotle, *Rhetoric*, trans. W. R. Roberts in W. D. Ross, ed., *The Works of Aristotle*, Vol. 11: *Rhetorica, de rhetorica ad Alexandrum, poetica* (Oxford: Clarendon, 1952) and *Poetics*, trans. I. Bywater in W. D. Ross, ed. *The Works of Aristotle*, Vol. 11: *Rhetorica, de rhetorica ad Alexandrum, poetica* (Oxford: Clarendon, 1952).

[31] John R. Searle, "Metaphor," in A. Ortony, ed., *Metaphor and Thought*, 2nd ed. (Cambridge/New York: Cambridge University Press, 1993) p. 90, citing P. Henle ed., *Language, Thought, and Culture* (Ann Arbor, MI: University of Michigan Press, 1958).

[32] Kittay, *Metaphor*, p. 19.

in the celestial divination corpus that make metaphorical references to deities suggest, however, that the heavenly bodies also had identities within the divine realm. Metaphors referring to Sin, Šamaš, or Ištar to describe the appearance of the moon, sun, and Venus, respectively, evidence a view of the heavenly bodies as physical manifestations of gods, but evidence outside of the divination corpus attests to the fact that the conception of these Babylonians gods was not limited to those astral manifestations alone. Epithets referring, for example, to Sin as an astral manifestation, such as "great star (ᵈ*kakkabu rabû*)" or "one who dwells in the pure heavens (*āšib šamê ellūti*)," constitute but a small fraction of the range of epithets attested for this deity.[33]

The appearance of a celestial body could be described by an appeal to an anthropomorphic image of the god with which it was associated without implying a kind of isomorphic identity between celestial body and the god manifested by it. In the fact that the personifications and metaphors show a distinction between celestial bodies with their appearances as discrete phenomena on the one hand, and gods on the other, we find a persuasive argument for the idea that natural phenomena in omen protases were not viewed as agents but as indicators of the change predicted by the omen apodoses.[34] This claim may be explained in terms of the attribution of agency only to the gods, who were therefore not viewed as constituting the signs, but as producing the signs.

On the basis of the evidence of the use of metaphors in celestial omens to describe physical phenomena, the possibility was previously raised of our gaining some insight into the nature of Babylonian thought about physical phenomena and the gods and, by extension, into the conception of the world within which celestial divination provided the principal context for intellectual inquiry about phenomena, that is, what we term science. The consideration of what the use of metaphor may mean for science and the history of scientific thought is not new. Thus Ortony states in his introduction to *Metaphor and Thought*:

A central presupposition of our culture is that the description and explanation of physical reality is a respectable and worthwhile enterprise – an enterprise that we

[33] See K. Tallqvist, *Akkadische Götterepitheta* (Helsinki: Studia Orientalia edidit Societas Orientalis Fennica VII, 1938, reprinted Hildesheim: Georg Olms Verlag, 1974), pp. 442–8.

[34] This claim can also be made on the basis that if apotropaic rituals (*namburbis*) can undo the misfortune predicted by omens, the omens should not be thought of as bound by causality to their predicted events, but merely as indicators of the predicted events. Implied here too is that the appeal to change "fate" is made directly to the gods.

call "science." Science is supposed to be characterized by precision and the absence of ambiguity, and the language of science is assumed to be correspondingly precise and unambiguous – in short, literal.[35]

By such a criterion of language use, Babylonian celestial divination with its metaphorical descriptions of phenomena in terms of gods and the conception of nature implied by such use of language will not qualify as science. But such a claim about science, in particular that it should have a special language, derives from the extreme position regarding language and science held by logical positivists, which even while it rapidly passed out of fashion continued to influence modern philosophy of science. Today, however, the extremely limited notion that nonliteral uses of language are inappropriate to science because they are not clear, objective, or empirical and that consequently metaphor has no place in science is no longer maintained by philosophers of science; but the discussion of the nature and function of metaphor in the creation of scientific models and theories continues.[36] This discussion bears on the history of science in terms of the fact that if metaphor functions in certain ways within science, then its use becomes significant in historical contexts wherein the presence or absence of science is still being adjudicated.

Study of the relation between language and thought in ancient science took shape with reference to Greek sources and was aimed at defining where science diverged from magic.[37] And just as the extreme position on the function of metaphor in (modern) scientific discourse was modified over the course of the history of its discussion within the philosophy of science, G. E. R. Lloyd commented on the danger of exaggerated

[35] A. Ortony, "Metaphor, Language, and Thought," in A. Ortony, ed., *Metaphor and Thought*, 2nd ed. (Cambridge/New York: Cambridge University Press, 1993), p. 1.

[36] See Mary Hesse, *Models and Analogies in Science* (Notre Dame, IN: University of Notre Dame Press, 1966); D. Gentner, "Are Scientific Analogies Metaphors?" in D. Miall, ed., *Metaphor: Problems and Perspectives* (Brighton, England: Harvester, 1982), pp. 106–32; J. Martin and R. Harré, "Metaphor in Science," in ibid., pp. 89–105; N. Nersessian, *Faraday to Einstein: Constructing Meaning in Scientific Theories* (Dordrecht, Holland: Kluwer, 1984); and D. Gentner and M. Jeziorski, "Historical Shifts in the Use of Analogy in Science," in B. Gholson, A. Houts, R. A. Neimeyer, and W. R. Shadish, eds., *The Psychology of Science and Metascience* (Cambridge/New York: Cambridge University Press, 1989), pp. 296–325.

[37] G. E. R. Lloyd, *Magic, Reason and Experience: Studies in the Origins and Development of Greek Science* (Cambridge: Cambridge University Press, 1979); idem, *Demystifying Mentalities* (Cambridge/New York: Cambridge University Press, 1990), especially Chap. 1, "Mentalities, Metaphors and the Foundations of Science," and Chap. 2, "Magic and Science, Ancient and Modern."

distinctions as absolute criteria applied in the analysis of historical texts as well, especially on the basis of modern categories such as magic, myth, and science, as well as the distinctions in the mentalities that supposedly correspond to them. He pointed out that

the Greek concepts [science, magic, myth, and the opposition between the literal and the metaphorical] in question were often, even generally, made to play a distinct and explicit polemical role. Once that is taken into account we can appreciate that the contrasts drawn for the purposes of polemic were often *over-drawn*. This is true of the opposition between the literal and the metaphorical, for instance, and again of the contrast between myth and magic on the one hand, and science and philosophy on the other. Certainly what, in practice, emerging Greek science and philosophy continued to have in common with the traditional forms of knowledge that they were aiming to replace is often quite as striking as the points where they diverged from previous modes of thought, even though in one respect, the degree of explicitness and self-consciousness of the inquiries concerned, those differences were considerable.[38]

Such radical distinctions and the criteria that depend on them have been employed in a study of analogy in Renaissance magic, in which B. Vickers claimed, that in the "scientific," as opposed to the "magical" tradition, "a clear distinction is made between words and things and between literal and metaphorical language."[39] In Vicker's terms, "the occult sciences' double process of reification and substitution, formulating ideas as essences, then making them identical and exchangeable, inevitably broke down the distinction between metaphorical and literal."[40] Vickers juxtaposed a "modern" ability to distinguish "mental activities" and "material things"[41] and a consequent ability to relate the two, on the one hand, with "traditional thought" on the other, in which "'everything in the universe is underpinned by spiritual forces,' words and things 'are both part of a single reality, neither material nor immaterial,'"[42] and within which no analogies but only concrete (literal) identities are possible. On this basis, an extrapolation from forms of intellectual culture to modes of thought was made such that practitioners of magic were seen as not recognizing

[38] G. E. R. Lloyd, *Demystifying Mentalities*, pp. 7–8.

[39] Brian Vickers, "Analogy versus Identity: The Rejection of Occult Symbolism, 1580–1680," in Brian Vickers, ed., *Occult and Scientific Mentalities in the Renaissance* (Cambridge/New York: Cambridge University Press, 1984, repr. 1986), p. 95.

[40] Ibid., p. 127.

[41] Ibid., p. 96.

[42] Ibid., in which he is quoting from R. Horton, "African Traditional Thought and Western Science," *Africa* 37 (1967), Nos. 1 and 2, repr. in B. R. Wilson, *Rationality* (Oxford: Basil Blackwell, 1970), p. 157.

the discrete entities basic to relational metaphorical thought, but as merging the ingredients of metaphors into literal identities. He illustrated this claim with reference to Paracelsus, explaining,

it is generally recognized that the whole of Paracelsus' system is based on the distinction between macrocosm and microcosm. Yet where many thinkers treated the relationship analogically, Paracelsus collapsed the two poles into one. Man does not merely resemble the macrocosm, he *is* the macrocosm *sic*. The move from analogy to identity is total."[43]

The dichotomous and often evolutionary scheme of magical versus scientific modes of thought underlying Vickers's argument parallels the speculation of Frankfort et al. in *Before Philosophy*, both of which turn on the question of whether or not there is evidence for relational thought in myths and magic. The dichotomy of "mentalities," with its long intellectual patrimony, from J. G. Frazer, L. Lévy-Bruhl, and B. Malinowski to E. Cassirer,[44] has been criticized from an anthropological perspective precisely on the grounds that it is a mistake to view traditional (magical) thought as incapable of making analogies or of expressing relations by the use of metaphors. This criticism has been best articulated, and correctly so, by Tambiah, who said,

insofar as Lévi-Strauss has demonstrated the logical and relational character of mythic thought, Cassirer's basic dichotomy of modes of thought disappears. And if it can be demonstrated that primitive magic is based on true relational metaphorical thinking, we shall explode the classical theory which postulates that magic is based on the belief in a real identity between word and thing. The basic fallacy of linguists and philosophers who search for the origins of the magical attitude to words is their prior assumption and acceptance that the primitive has in fact such an attitude. This axiom they have derived principally from Frazer, and indeed from Malinowski, who had affirmed the truth of this classical assertion on the basis of his fieldwork. It would perhaps have been safer for the linguists to have held fast to their knowledge of how language works and to have questioned whether anthropologists had correctly reported primitive thought.[45]

[43] Ibid., p. 126.

[44] J. G. Frazer, *The Golden Bough: A Study in Magic and Religion*, Vol. I, Part I: *The Magic Art and the Evolution of Kings*, 3rd ed. (London: Macmillan, 1911); L. Lévy-Bruhl, *La mentalité primitive* (Oxford: Clarendon, 1922), trans. Lilian Clare as *Primitive Mentality* (Oxford: Clarendon, 1923); B. Malinowski, *Magic, Science and Religion and Other Essays* (New York: Doubleday Anchor, 1954); E. Cassirer, *Language and Myth* (New York: Dover, 1953).

[45] Tambiah, *Culture, Thought, and Social Action*, Chap. I, "The Magical Power of Words," p. 34.

The use of metaphorical language, and the implications of that use for abstract analogical thinking, has been argued here for the Babylonian celestial omens. The recognition of the use of tropic language in Mesopotamian divination, however, is not meant to characterize the nature of this divinatory language altogether or to derive from it an equivalent mode of thought. In this I concur with the cautionary view of Lloyd previously quoted, that such differing modes of discourse do not necessarily provide us with absolute criteria for analyzing "mentalities." The anthropomorphic character of the Babylonian metaphors bears relation to elements of Greco–Roman and later astrology. In my view, however, the way in which the metaphors are constituted in the Babylonian omens is not consistent with Vickers's description of metaphors in the Renaissance material in which, according to his reading, their true metaphorical status is diminished by literal identifications between the referents within the metaphors.[46] Were the Babylonian metaphors consistent with this interpretation, the distinction between the elements in the metaphors referring, for example, to lunar phenomena, would be lost. Sin, the moon god, as the divine force associated with the moon, would be regarded as identical and indistinguishable from Sin the moon, that is, the visible lunar disk in the sky. Interpreted this way, the omen protasis in which the first visibility of the moon is referred to as the moon god Sin wearing a crown (*Sin agâ apir*) cannot be speaking (or thinking) metaphorically, but only literally, and consequently, the protasis would no longer refer to the phenomenon of first visibility but only to the anthropomorphic image of the moon god with his crown. This is precisely the position regarding metaphor and relational thought held by Frankfort et al. in *Before Philosophy*, which is contravened by the requirements of celestial omens to describe in the protases those physical phenomena considered ominous. The function of

[46] Vickers loosened his position on metaphor in magic, at least insofar as he takes as given for the occult sciences (astrology, alchemy, numerology, iatromathematics, and natural magic) the "use of analogies, correspondences, and relations among apparently discrete elements in man and the universe"; Brian Vickers, "On the Function of Analogy in the Occult," in Ingrid Menkel and Allen G. Debus, eds., *Hermeticism and the Renaissance: Intellectual History and the Occult in Early Modern Europe* (Washington: Folger Shakespeare Library and London/Toronto: Associated University Presses, 1988), p. 265. Here he focuses on the nature and function of these metaphors, but his analysis of their function reflects the positivistic tendency, emerging in contemporary (the period between 1580 and 1680) critics of the practitioners of the occult, to view the language of magic as misguided and confused and the form of thought reflected in the magical tradition as irrational and inferior to that of empirical science.

the attested metaphors, which was to describe observed realities in the physical world, effectively rules out the extrapolation from a belief system that accepts divine agency to a mode of thought or "mentality" incapable of separating such metaphysical beliefs about the world from an interest in the physical dimension of phenomena.

5.3 THE AUTHORITATIVE CHARACTER OF THE CELESTIAL SIGNS

A belief in omens seems to have stemmed, in one way, from the conception of the phenomena as signs from the divine realm and as well, in some cases, from the perception of phenomena as manifestations of deities. But apart from this aspect, another argument for the authoritative status of omens and the reason why the scribes continued to consult the compendium may be found in the claim to the divine authority of the compendium itself. Ascription of divine authority for the series *Enūma Anu Enlil* appears, together with other omen, incantation, and ritual texts, in a catalog of texts. There the following texts and titles are found:

[The Exorcists'] Series (*āšipûtu*), The Lamentation Priests' Series (*kalûtu*), The Celestial Omen Series (*Enūma Anu Enlil*), [(If) a] Form (*alamdimmû*), Not Completing the Months, Diseased Sinews; [(If)] the Utterance [of the Mouth], The King, The Storm(?), Whose Aura is Heroic, Fashioned like An: These (works) are from the mouth of Ea.[47]

The selection of Ea as the ultimate source for the collections about exorcism, incantations, and celestial divination, is fitting, because he was the god associated chiefly with magic and *arcana mundi*. He was considered, as the creator of humankind, to be the divine figure with special sympathy for human beings, and therefore would be the likely candidate to make messages or warnings available for the benefit of the human race.[48]

[47] W. G. Lambert, "A Catalogue of Texts and Authors," *JCS* 16 (1962), pp. 59–77; for the text see p. 64 I (K.2248):1–4.

[48] The physiognomic omen series SA.GIG is also attributed to Ea with Asalluhi: "(The series) Alamdimmû (referring to) the external form and appearance (relevant to) the fate of man, which Ea and Asalluhi(?) ordained in heaven," see I. Finkel, "Adad-apla-iddina, Esagil-kīn-apli, and the Series SA.GIG," in E. Leichty, M. DeJ. Ellis, and P. Gerardi, eds., *A Scientific Humanist: Studies in Memory of Abraham Sachs*, Occasional Publications of the Samuel Noah Kramer Fund 9 (Philadelphia: Babylonian Section, University Museum, 1988), p. 149, lines 29–30. Note too the reference to divination by the exta (*bārûtu*) as a "secret" transmitted by Ea: *niṣirti bārûti ša* ᵈ*Ea imbû* "the secret art of extispicy, which Ea

In this same catalog of texts, Ea is followed by Umanna-Adapa,[49] literally "Umanna, the Wise," who is there assigned two series. The legendary figure of Adapa is seen elsewhere as a recipient and transmitter of texts of divine origin.[50] In the late literary text "The Verse Account of Nabonidus," Adapa is the "compiler" (or "collector") of a series titled "the lunar crescent of Anu and Enlil," the same series attributed to him in the catalog of texts previously cited.[51] Umanna-Adapa is also known as the first antediluvian sage, the Oannes of Berossus. And Adapa, the *išippu*[52] or purification priest of Eridu, who ascended to heaven, is also one of the famous sages, and is frequently associated with the mythic time before the Flood. In an oft-quoted passage, King Aššurbanipal claims to have learned "the craft of Adapa, the sage, the hidden esoteric knowledge of the whole of the scribal art,"[53] and refers to "stone inscriptions from before the Flood."[54]

According to the texts referring to the "seven sages,"[55] the sages (*apkallu*) were mythological entities, only partly human, and had a magical apotropaic function. Like Ea, they were identified with special wisdom, wisdom of crafts and of magic. And like Ea, Anu, and Enlil, in the introduction to *Enūma Anu Enlil*, the *apkallus* were considered to play a role in the maintenance of the "designs of heaven and earth" (*uṣurāti šamê*

transmitted," in H. Zimmern, *Beiträge zur Kenntnis der Babylonischen Religion* (Leipzig: J. C. Hinrichs, 1901), pp. 96–7, Nr. 1–21: 11–12. See R. Borger, "*Nisirti bārûti*, Geheimlehre der Haruspizin," *BiOr* 14 (1957), esp. p. 191. Also Hunger, *Kolophone*, p. 76, No. 221.

49 ᵐuma(UD)-an-na a-da-p[a], line 6; see note 48.

50 Erra Tablet V:42–44.

51 Sidney Smith, *Babylonian Historical Texts* (London: Methuen, 1924), pl. 9, v 12; see B. Landsberger and T. Bauer, "Zu neuveröffentlichten Geschichtsquellen der Zeit von Asarhaddon bis Nabonid," *ZA* 37 (1927); p. 92. P. Machinist and H. Tadmor, "Heavenly Wisdom," in Mark E. Cohen, Daniel C. Snell, and David B. Weisberg, eds., *The Tablet and the Scroll: Near Eastern Studies in Honor of William W. Hallo* (Bethesda, MD: CDL, 1993), pp. 146–51.

52 Note that the title *išippu* "purification priest" is a loan word into Sumerian IŠIB from Akkadian *āšipu* "exorcist," the professional whose field included medical diagnosis, exorcism against disease and apotropaic rites; see *CAD* s.v. *išippu*.

53 K. M. Streck, *Assurbanipal und die letzten assyrische Könige bis zum untergange Nineveh's* (Leipzig: J. C. Hinrichs, 1916), Vol.2, p. 254, i 13.

54 Streck, *Assurbanipal*, Vol. 2, p. 256:18. See also J. A. van Dijk, "Die Tontafeln aus dem reš-Heiligtum," *Vorlufiger Bericht über die in Uruk-Warka unternommenen Ausgrabungen* 18 (1962), pp. 44–5, for a Seleucid tradition about the antediluvian sage ᵐU₄-AN ABGAL, and further, W. W. Hallo, "On the Antiquity of Sumerian Literature," *JAOS* 83 (1963), pp. 174–6.

55 *LKA* 76 and parallels, see E. Reiner, "The Etiological Myth of the 'Seven Sages,'" *Orientalia* N.S. 30 (1961), pp. 1–12.

u erṣeti).[56] According to another tradition, the *apkallu*'s function was to transmit special knowledge from the divine realm to the world, as in the case of the revelation of oil, liver, and celestial divination by Šamaš and Adad to the sage Enmeduranki[57]:

Šamaš in Ebabbarra [appointed] Enmeduranki, king of Sippar, the beloved of Anu, Enlil, [and Ea]. Šamaš and Adad [brought him in] to their assembly, Šamaš and Adad honored him, Šamaš and Adad [set him] on a large throne of gold, they showed him how to observe oil on water, a mystery of Anu, [Enlil and Ea], they gave him the tablet of the gods, the liver, a secret of heaven and [underworld], they put in his hand the cedar-(rod), beloved of the great gods."[58]

After the gods initiated Enmeduranki, he passed on the gifts of knowledge to the "men of Nippur, Sippar, and Babylon," honored them, placed them on thrones, and showed them lecanomancy and extispicy. The text then adds (line 18), "that (text) with commentary, 'When Anu, Enlil'; and how to make mathematical calculations." Clearly there were variant traditions on the line of authority behind the celestial divination corpus.

The linking of literary, magical, and divinatory traditions either to gods or to some mythic time before the Flood recurs in other passages of Akkadian literature, for example, in Gilgamesh, who "brought knowledge from before the Flood,"[59] and in Aššurbanipal's reference to difficult stone inscriptions from prediluvian times.[60] This theme finds expression elsewhere in Mesopotamian culture, for example in the Sumerian King List's view of the divine origin of the institution of kingship. According to the Sumerian King List, kingship had been "lowered" from above, that is, from the cosmic heavenly domain. In addition, and perhaps more importantly, a connection to the distant past of antediluvian times was achieved in the Sumerian King List with the addition of the section of antediluvian kings. The Late Babylonian Dynastic Chronicle preserves the tradition of listing kings of cities inhabited before the Deluge.[61] Another list of kings and their wise men from the late period (second century B.C.) similarly begins with mythical antediluvian kings and their sages (*apkallu*), followed

[56] K 5119 rev. 5, see Reiner, "The 'Seven Sages,'" p. 4.

[57] W. G. Lambert, "Enmeduranki and Related Matters," *JCS* 21 (1967), pp. 132–3.

[58] Ibid. (K 2486+ ii 1–9.).

[59] R. C. Thompson, *The Epic of Gilgamesh: Text, Transliteration, and Notes* (Oxford: Clarendon, 1930), p. 9, Tablet I i 6.

[60] See note 54 of this chapter.

[61] A. K. Grayson, *Assyrian and Babylonian Chronicles,* Texts from Cuneiform Sources 5 (Locust Valley, NY: J. J. Augustin, 1975), Chronicle 18, pp. 139–44.

by historical kings and their scholars (*ummânu*), and shows linear descent from the time "before the Flood" to history.[62] The connection between divine and human in the political realm thereby parallels that between god and scholar in the realm of magic and divination.

The etiological function of Anu, Enlil, and Ea is found in the opening lines of *Enūma Anu Enlil,* although what is of central interest there is not political order and kingship, but cosmic order and regularity in the heavens. The divine authority of the text *Enūma Anu Enlil* (as of the others mentioned as originating with Ea) is consistent with the notion of the divine establishment of order and regularity in the world. The Babylonian understanding of the divine origin and hence divine authority of the *Enūma Anu Enlil* text seems to be a scholarly derivation from the role of the gods in the system of Mesopotamian divination as of their place in the cosmos in general. A connection may therefore be made between the practical understanding of omens, that is, that they were messages from gods containing clues to change in the future, and the claim that the written omen had validity because it was divine in origin. That is, the divine origin, and therefore the revealed character of its knowledge, made the text valid and fundamentally unalterable as evidenced by the continuous copying of omens from Neo-Assyrian to Seleucid times. This does not mean that the omen corpus circulated in only a fixed and standardized form. As already mentioned, a number of different recensions may be identified, as well as supplementary collections of omens containing material not repeated in the series *Enūma Anu Enlil* as cataloged by the scribes. Whereas the standardized nature of the *Enūma Anu Enlil* text, as of other scholarly corpora, surely served practical needs of the scribal community, providing a common ground for scholars, the traditional force of the text does not seem to be a function merely of outward textual stability; rather the traditionalist attitude toward the text and its contents may have stemmed from the belief in its underlying divine authority. If this is the case, then the impact of the "religious" foundation on omen texts, *Enūma Anu Enlil* or any other standardized divination series, was profound.

A divine authority attributed to the omen collections would not only account for the importance attached to these texts in terms of the necessity

[62] W. R. Mayer and J. J. van Dijk, *Texte aus der Rēš-Heiligtum in Uruk-Warka* (Berlin: Gebr. Mann Verlag, Baghdader Mitteilungen, Beiheft 2, 1980), No. 89; edition in J. J. van Dijk, "Die Tontafeln aus dem Rēš-Heiligtum," *Vorläufiger Bericht über die in Uruk-Warka unternommenen Ausgrabungen* 18 (1962), pp. 44–52.

of their preservation, but also points to a reason for the interest in the omen phenomena as "targets of epistemic activity," to borrow a phrase from H.-J. Rheinberger.[63] The scribes' claim to the divine transmission of the techniques of oil divination and extispicy, and of the god Ea's being the source for celestial, physiognomic and medical diagnostic omens, suggests the notion of omen compendia as bodies of revealed knowledge. Yet the Neo-Assyrian scholars' correspondence with Kings Esarhaddon and Aššurbanipal, which gives us sources for the practice of scholarly divination, in particular celestial divination, reflects something more. The omens may have been accepted as a matter of belief, but the ominous nature of phenomena required that they be studied, understood, and interpreted as objects of empirical inquiry. The Neo-Assyrian scholars' letters and reports focused on what had been observed, and their writers sought to interpret their observations by consulting *Enūma Anu Enlil.* Scholarly commentaries also sought to understand the meaning of some of the nonoccurring phenomena of the omen protases by means of some scheme or schemes of interpretation, for example, with respect to the omens for fixed stars "approaching" or "reaching" other fixed stars.[64] As a result of this "epistemic activity," divination elevated many elements of daily experience to a higher level of integration and understanding within a world system.

5.4 DIVINE–HUMAN RELATIONS

The behavior of the moon, sun, planets, fixed stars, and weather was of primary interest to celestial diviners in terms of the significance those phenomena carried for the world of human beings. This significance in turn seems to have been perceived as a function of the gods' vested interest in humanity. The tradition of Mesopotamian celestial divination thereby resolved a complex of relationships involving the heavens, the gods, the world of the royal court, and of humankind as a whole. To take account of celestial divination and its related texts as a cultural product requires consideration of the subject of divine–human relations, but it is

[63] H.-J. Rheinberger, "Cytoplasmic Particles: The Trajectory of a Scientific Object," in L. Daston, ed., *Biographies of Scientific Objects* (Chicago/London: University of Chicago Press, 2000), p. 274.

[64] For discussion and examples, see Koch-Westenholz, *Mesopotamian Astrology,* pp. 130–1, and Reiner, "Constellation into Planet."

one that generally lies beyond even the furthest boundaries of the history of science. Within what domain this subject properly falls is indeed not a simple matter of choosing between science and religion (or magic), as these terms are applied to the sources of interest here only with great difficulty, particularly when used in a highly contrastive sense.

Although the cuneiform scholastic tradition produced texts of distinct form, purpose, and subject matter, for example, divination texts, magical texts, mythological texts, such genre designations are also modern conveniences not found in the texts themselves. The scribes had a system of designating texts by title (incipit) or by type of tablet (IM.GÍD.DA "long tablet, ÉŠ.GÀR "series"). Certainly the differences in subject matter do not correspond to differences in attitude about the world, as, for example, between a mythological and an astronomical text. On the contrary, a consistent worldview resolving the relationships between divine and human as of the divine and nature seems to be shared among the various genres of texts that deal with celestial signs, astral magic, cosmological mythology, prayers to deities associated with heavenly bodies, or even astronomy. Not surprisingly, the evidence shows the absolute and primary position of the divine in this worldview. The cosmological implication of the position of the divine in the tradition of the scholar–scribes not only bears on our understanding of the Babylonian rationale for celestial divination, but has further significance in placing the Babylonian intellectual tradition in contrastive relation to later Greco–Roman divination and astrology.

The Mesopotamian idea that divination was a product of the gods' beneficence and care for their creation is only one aspect of a complex relation between human and divine. Humanity's need for the protection and love of the gods, as expressed in prayers, hymns of praise, and invocations, was complemented by the need on the part of the divine for humanity as its servants, to build and maintain their temples, feed and clothe their statues. In their royal inscriptions, Babylonian and Assyrian kings bragged of how splendidly they served the divine meal, consisting of foods, such as meat and birds, not generally consumed by ordinary people, and served on shining silver and gold bowls.[65] Cultic ritual instructions describe in detail the proper times and manner of preparing and serving the divine meal, which, as van Driel notes, "was an everyday occurrence in the Assyrian and Babylonian temples."[66]

[65] see *CAD* s.v. *naptanu* mng. 1a 9′ b′, b and c.

[66] G. van Driel, *The Cult of Aššur* (Assen: Van Gorcum and Comp. N.V., 1969), p. 159. For the clothing of divine statuary, see *CAD* s.v. *labāšu*, mng. 4 (*nalbušu*) a and b.

Mesopotamian scholarly divination texts do not reflect directly on this divine–human relation, but rather indirectly in the form of lists of omens. Just as in extispicy, in which the gods were thought to "write upon the liver" a forecast encoded in the cracks and coloration of the liver,[67] the gods were also believed to act on (we might say "cause") the signs observed in the natural world. We depend, however, on nondivinatory texts for evidence of the gods' direct connection to natural phenomena, as illustrated in the following passage from a prayer to the moon god Sin and the sun god Šamaš[68]:

The lands rejoice at your appearance.
Day and night they entrust (to you) their ability to see.
You stand by to let loose the omens of heaven and earth.
I, your servant, who keep watch for you,
who look upon your faces each day,
who am attentive to your appearance,
make my evil omens pass away from me.
Set for me propitious and favorable omens.

In this prayer, the celestial deities Šamaš and Sin are addressed as though they were the celestial bodies. The speaker seems to believe that to watch for the sun and moon in the sky is to await the appearance of the gods Šamaš and Sin. Other prayers to the luminaries allude to the astral nature of these gods, as in one of the best known prayers to Sin, which makes mention of special days of lunar visibility and invisibility[69]:

[67] The notion of the god (often Šamaš) "writing" the signs on the exta of sheep is well known; see, e.g., *ina libbi immeri tašaṭṭar šere tašakkan dīnu*, "you (Šamaš) write upon the flesh inside the sheep (i.e., the entrails), you establish (there) an oracular decision" OECT 6 pl. 30 K.2824:12. See also Werner Mayer, *Untersuchungen zur Formensprache der Babylonischen 'Gebetsbeschwörungen,'* Studia Pohl, Series Maior 5 (Rome: Biblical Institute Press, 1976), p. 505:III, and in the Sargon inscription *TCL* 3 319. For references to the gods of extispicy, Šamaš and Adad, making a propitious omen visible in the liver for Esarhaddon, see R. Borger, *Die Inschriften Asarhaddons, Königs von Assyrien, AfO* Supplement 9 (Graz: Im Selbtverlage der Herausgebers, 1956), p. 3 iii 45, 3 iv 6, and 19 Episode 17:16. The idea that the divine scribe Nabû decreed a long life and on his "reliable writing board (GIŠ.LI.U₅.UM) which establishes the borders of heaven and earth" inscribed (*šuṭur*) old age for the king is stated in a royal inscription of Nebuchadnezzar; see Langdon, *Neubabylonischen Königsinschriften, VAB* 4 100 ii 25.

[68] Lutz, PBS 1/2 106 r.13–21, edition by E. Ebeling, "Beschwörungen gegen den Feind," *ArOr* 17 (1949), pp. 179 and 181. Quoted here is the translation of Benjamin R. Foster, *Before the Muses: An Anthology of Akkadian Literature* (Bethesda, MD: CDL, 1993), Vol. 2, p. 684.

[69] The ŠU.ÍL.LÁ prayer, *BMS* 1:17–18 and see Werner Mayer, *Untersuchungen zur Formensprache der babylonischen "Gebetsbeschwörungen"* (Rome: Biblical Institute Press, 1976), pp. 490–4.

Your day of disappearance is your day of splendor,[70] a secret of the great gods.
The thirtieth day is your festival, the day of your divinity's splendor.

The association of deities with celestial bodies is explicitly attested to
in a late scholastic list, in which explanatory identifications are made
between stars and deities, such as Venus as the goddess Ištar (MUL. *Dilbat*:
^d*Ištar bēlit mātāti*, "Venus = Ištar, lady of the lands"[71]) or Centaurus
as the god Ningirsu (MUL. *Habaṣirānu*: ^dNin.gír.su "The Mouse-like =
Ningirsu"[72]). It is these associations of gods with heavenly phenomena
that underlie the personifications in the celestial omen protases describing
certain phenomena in terms of gods, as discussed in Section 5.2.

Such associations between heavenly bodies and certain deities go back
to the beginnings of Mesopotamian civilization and persist as well to the
end. Astral emblems, such as the lunar crescent (*uškaru*) for Sin,[73] the
eight-pointed star for Ištar,[74] and the solar disk (*šamšatu*) for Šamaš,[75] are
a regular feature of Mesopotamian iconography throughout its history.
These divine symbols can be traced on cylinder seals as early as the Early
Dynastic period[76] and as late as the Neo-Babylonian. On a stele of the

[70] According to *CAD* s.v. *bubbulu*, reading *ta-šil* (text: BE)-*ti-ka* for *tašīltika* "your splendor,"
as opposed to *ta-mit-ti-ka*, for which, see Mayer, *"Gebetsbeschwörungen,"* p. 493:17.

[71] K. 250+ (*CT* 26 40–41) i 5; see Koch-Westenholz, *Mesopotamian Astrology*, Appendix B,
p. 188:30.

[72] Ibid. p. 194:157. Perhaps the equations "Jupiter is the star of Sin and Sin is Aššur," attested
in the Assyrian cultic text BM 121206 viii 55–60, represent a similar practice, although the
meaning of this particular passage in its broken context is not very clear. See van Driel,
The Cult of Aššur, pp. 96–7.

[73] According to J. Black and A. Green, the *uškaru*, or recumbent crescent moon, is found
as a motif from prehistoric periods, although associated with the god Sin (Nanna-Suen)
from the Old Babylonian period onward. See their *Gods, Demons, and Symbols of Ancient
Mesopotamia: An Illustrated Dictionary* (Austin, TX: University of Texas Press, 1992), p. 54.

[74] The eight-pointed star is associated with Ištar (Inanna) from the Old Babylonian period
(probably even earlier, in Early Dynastic) and persists to the Neo-Babylonian period. See
Black and Green, *Gods, Demons, and Symbols*, pp. 169–70.

[75] For textual references to the solar disk as the emblem of Šamaš, see the *CAD* s.v. *šamšatu*,
šamšu meaning 4, and cf. *šaššāru*, the saw as an emblem of Šamaš, the one who "decides
("lit. cuts") decisions (*purussâ parāsu*)," in Old Babylonian texts. The saw associated with
the sun god is attested already in Akkadian period glyptic, see B. Teissier, *Ancient Near
Eastern Cylinder Seals from the Marcopoli Collection* (Berkeley, CA/Los Angeles/London:
University of California Press, 1984), p. 15 (seal no. 81).

[76] B. Teissier, *Ancient Near Eastern Cylinder Seals*, pp. 126–7. Early Dynastic seals no. 62 and
64 have star, star disk, and crescent elements. Whether these are firmly associated with the
astral gods, however, is uncertain. Briggs Buchanan, *Early Near Eastern Seals in the Yale
Babylonian Collection* (New Haven, CT: Yale University Press, 1981), p. 61, notes that, "the

Akkadian period, Narām-Sin's (2254–2218 B.C.) victory over the Lullubi is commemorated in a depiction of the victorious king standing upon a mountain above which hover clear astral symbols.[77] The Middle Babylonian *kudurru*, or boundary stones, are well known for representations of many divine symbols, some clearly astral, such as in the first register of the *kudurru* of Nebuchadnezzar I (1124–1104 B.C.), which shows the eight-pointed star, the lunar crescent, and the solar emblem.[78] Some of these same symbols are to be seen embellishing the royal wardrobe of Assyrian kings, as on the reliefs of the palace of Aššurnaṣirpal II (883–859 B.C.) at Nimrud,[79] or on the stela of Šamši-Adad V (823–811 B.C.), also from Nimrud, where the Assyrian king appears wearing the solar cross symbol.[80] Even earlier, a necklace from Dilbat, dated to the nineteenth or eighteenth century B.C., is adorned with the lunar crescent, the lightning bolt, the solar "cross" commonly known from the Kassite period, and the eight-pointed star.[81] Perhaps the most remarkable depiction of the solar disk emblem is that found on the upper portion of a stone tablet of the post-Kassite Babylonian King Nabû-apla-iddina of the ninth century B.C.[82] The scene depicts the king being presented to the god Šamaš, who holds the symbols of divine justice (the rod and ring[83]) beneath astral symbols (lunar crescent, solar disk, and eight-pointed star), while two minor

crescent, as in [seals no.] 175–76, does not seem to be attested in Uruk period designs. Nor was it part of the usual Jamdat Nasr repertory. When it does occur in Jamdat Nasr or post Jamdat-Nasr seals, it looks more like an added filler than an object of heavenly significance; see, for example, OIP 72, 455, 257 (reversed), 467 (both ways). It is therefore possible that the convention of depicting the moon as a crescent grew out of what was originally an aesthetic device. Compare, however, A. Falkenstein, *Archaische Texte aus Uruk* (Berlin: Deutsche Forschungsgemeinschaft 1936), sign 305, of Warka IV, which looks like a crescent standard, though Falkenstein (p. 60, n. 4) relates it to a sun disk group."

77 Dominique Collon, *Ancient Near Eastern Art* (Berkeley, CA/Los Angeles: University of California Press, 1995), p. 75, pl. 58.

78 Collon, *Ancient Near Eastern Art*, p. 121, pl. 98.

79 R. D. Barnett and A. Lorenzini, *Assyrian Sculpture* (Toronto: McClelland and Stewart, 1975), pl. 2.

80 Julian Reade, *Assyrian Sculpture* (Cambridge, MA: Harvard University Press, 1983), p. 32, pl. 42. Cf. The stela of Aššurnaṣirpal from Nimrud, in which the king again wears a necklace strung with amulets in the shapes of similar symbols; see Black and Green, *Gods, Demons and Symbols*, p. 31, pl. 21.

81 Black and Green, *Gods, Demons and Symbols*, p. 31, pl. 21.

82 Collon, *Ancient Near Eastern Art*, p. 169, pl.135.

83 See E. Ascalone and L. Peyronel, "Two Weights from Temple N at Tell Mardikh-Ebla, Syria: A Link between Metrology and Cultic Activities in the Second Millennium BC?," *JCS* 53 (2001), p. 7 and especially note 20.

gods lower a huge solar symbol onto what appears to be a table.[84] The three primary astral deities, Sin (moon), Šamaš (sun), and Ištar (Venus), are represented with their traditional symbols during the Neo-Babylonian period as well, as in a stele of Nabonidus (?) (555–539 B.C.) depicting the king before the lunar crescent, the solar symbol as Kassite cross, and the eight-pointed star of Venus.[85]

Perhaps also relevant here are the so-called "presentation scenes" of cylinder seals, which depict the meeting of a human servant (usually a king) and a god, often through the intermediary of the personal god who leads the devotee before the enthroned cosmic deity.[86] Of course, the elaborate scene presented on the tablet of Nabû-apla-iddina is another example of this same iconographic *topos*. Such images of a human being approaching a god symbolized as a celestial body show us that the gods, even the remote gods associated with celestial bodies, were thought to be willing to communicate with humankind. That ominous phenomena in the heavens were viewed as messages from the divine was one such form of communication.[87] At least for the celestial signs, the identity of the deity and the celestial body makes even clearer the notion that the gods communicated their messages by means of their visible manifestations in the heavens, as seems to be explicit in the following passage from a prayer to Marduk: "(I praise your name, Marduk,...) your name is SAG.ME.GAR (=Jupiter), the foremost god,..., who shows a sign at his rising."[88] The planet Jupiter is again called "bearer of signs to the world" in a list of star names giving the equivalence MUL.SAG.ME.GAR = *nāš ṣaddu ana dadmu sic.*[89]

[84] See E. Reiner, "Suspendu entre ciel et terre...," in H. Gasche and B. Hrouda, eds. *Collectaneo Orientalia: Histoire, arts de l'espace et industrie de la terre, études offertes en hommage à Agnès Spycket,* Archéologie et environnement, 1 Civilisations du Proche-Orient Serie I. (Neuchâtel/Paris: Recherches et publications, 1996), pp. 311–13.

[85] Michael Roaf, *Cultural Atlas of Mesopotamia and the Ancient Near East* (New York: Facts on File Books, 1998), p. 201.

[86] Collon, *Ancient Near Eastern Art,* p. 81, pl. 60.

[87] See further in Oppenheim, *Ancient Mesopotamia,* pp. 206–227; Bottéro, *Mesopotamia: Writing, Reasoning, and the Gods,* Chaps. 8 and 9; H. W. F. Saggs, *The Encounter with the Divine in Mesopotamia and Israel* (London: Athlone, 1978), Chap. 5; and, most comprehensively, B. Pongratz-Leisten, *Herrschaftswissen in Mesopotamien,* State Archives of Assyria Studies 10 (Helsinki: University of Helsinki Press, 1999).

[88] (*adallal zikirka* ᵈ*Marduk*).... *šumka* ᵈSAG.ME.GAR *ilu rēštu....ša ina niphišu ukallamu ṣaddu;* Craig, *ABRT,* Vol. 1, 30:41–42.

[89] 5R 46 No. 1:39.

Celestial omens further instantiate the rather abstract idea of correspondence between the two cosmological domains, heaven and earth.[90] The protasis and the apodosis of a celestial omen are expressions of the reciprocal relationship between nature and society, and by extension, heaven and earth, where nature is not a separate domain, independent of divine agency, but a sphere within which the divine could have direct impact on human life. Again, nondivinatory literature affords a better insight into the belief in the gods' active role in the world, as in the following incantation[91]:

[Incantation: Ea, Ša]maš, Marduk (Asalluhi), the [great] gods,
you are the ones who judge the law of the land,
who determine the nature of things,
who draw the cosmic designs,
who assign the [lots] for heaven and earth;
it is in your hands to decree the destinies
and to draw the cosmic designs;
you determine the destinies of life,
you draw the designs of life,
you decide the decisions of life.

In this incantation, the gods are viewed as having the power to make decisions, give commands, and determine the fate of people, much like the power possessed by a king. The designation of the gods as determiners of the "nature of things," the "destinies of life," the ones who draw the "cosmic designs," and the "designs of life," evokes the conception of god as king, who orders and legislates existence and recalls the image of the deity enthroned in the presentation scenes of Mesopotamian glyptic. In reference to the sun god Šamaš, nondivinatory literature attests to epithets such as "king of heaven and earth," "judge (of the regions) above and below," "lord of the dead, guide of the living," "great leader of humankind," "averter of spells, signs, and portents. There is also the aspect of the god as promulgator of law, again on the analogy with the king as lawgiver.[92]

[90] Akkadian *erṣetu* (Sumerian ki), the most common word for earth, is also the term for netherworld, but in the cosmic duality an.ki (*šamê u erṣeti*), ki most likely refers to earth, not to the netherworld. For discussion, see Horowitz, *Mesopotamian Cosmic Geography*, p. 271.

[91] *LKA* 109:1–8.

[92] E. Ascalone and L. Peyronel discuss archaeological evidence for the association of Šamaš with justice and law in an early second millennium (Middle Bronze) temple at Ebla, in "Two Weights from Temple N at Tell Mardikh-Ebla, Syria: A Link between Metrology and Cultic Activities in the Second Millennium B.C.?," *JCS* 53 (2001), pp. 7–10.

Šamaš, often associated with divination by extispicy, is called DI.KU₅/*ṣēru* "supreme judge" and *pāris purussê ilāni rabûti* "decider of decisions of the great gods." In a prayer to this deity, he is addressed as "lofty judge," "creator of the above and below," the god "who never wearies of divination," and who renders "daily verdicts for heaven and earth." This conception of the sun god (Utu) and the moon god (Nanna) as divine legislators can be traced in Sumerian literary contexts as well, such as we have in an Old Babylonian reference to "Utu the great lord of Arali who turns the dark places to day" as the god who "will decide your case" and Nanna, who on the day of the disappearance of the moon will "determine your fate."[93] The connection between judgments and divine oracles, particularly in the extispicy literature, is clear in the use of the words *dīnu* "verdict" and *dajānu* "judge" in legal contexts as well as in reference to gods and divination.[94]

The notion of god as king, according to Jacobsen, is already reflected in the Sumerian mythological assembly of the gods and in divine names composed with the Sumerian word "lord" (en) or "ruler of," as in Enlil "Lord Wind."[95] A third-millennium Sumerian liturgical poem addressed to Enlil expresses the metaphor of the god as king and his decision-making powers:

Enlil! His authority is far-reaching
His word is sublime and holy.
His decisions are unalterable
He decides fates forever!
His eyes scrutinize the entire world!
When the honorable Enlil sits down in majesty
on his sacred and sublime throne,
When he exercises with perfection
his power as Lord and King

[93] S. N. Kramer, *Two Elegies on a Pushkin Museum Tablet*, 88–89, apud A. Livingstone, *Mystical and Mythological Explanatory Works of Assyrian and Babylonian Scholars* (Oxford: Clarendon, 1986), p. 42.

[94] See *CAD* s.v. *dīnu* meaning 1 3'b and *dajānu* usage m.

[95] Thorkild Jacobsen, *The Treasures of Darkness: A History of Mesopotamian Religion* (New Haven, CT/London: Yale University Press, 1976), pp. 20, 78–81. Cf. Tallqvist, *Götterepitheta*, for divine names constructed with the element LUGAL "king." See also A. Wendell Bowes, "The Basilomorphic Conception of Deity in Israel and Mesopotamia," in K. Lawson Younger, Jr., William W. Hallo, and Bernard F. Batto, eds. *The Biblical Canon in Comparative Perspective: Scripture in Context IV, Ancient Near Eastern Texts and Studies* (Lewiston/Queenston/Lampeter: Edwin Mellen, 1991), Vol. II, pp. 235–75.

Spontaneously the other gods prostrate before him
and obey his orders without protest!
He is the great and powerful ruler
who dominates heaven and earth
who knows all and understands all![96]

Enlil in particular represented the divine ruler whose inscrutable verbal decree, his "word," executed the decisions of the divine assembly, producing the calamities often mentioned in omen apodoses, for example, pestilence and enemy attack:

His word which up above makes the heavens tremble
His word which down below rocks the earth
His word wherewith the Anunnaki gods destroy
His word has no seer (who can foresee it)
No diviner (who could divine it)
His word is a risen flood-storm
It has none who could oppose it.[97]

Prayers and incantations, as the one previously quoted in reference to Ea, Šamaš, and Marduk (Asalluhi), show that this idea of the divine royal judge could be fundamental to the conception of other gods in their celestial manifestations. The continuity of the conceptualization of god as ruler is evidenced as well in the Hellenistic Greek milieu, particularly of the eastern empire, in which gods such as Zeus and Helios were given the titles *kurios* "lord" (=Latin *dominus*), *despotēs* "master," and *tyrannos* "absolute ruler."[98]

But how, logically, are omens to be construed in light of this conception of gods as divine sovereigns decreeing destinies and assigning the lots of heaven and earth? As previously discussed, omen texts set the ominous phenomena and the events indicated by them in relation to one another in the manner of conditional probabilities, in which the occurrence of an event is expected if it is established that another event has occurred (or will occur), parallel to the standardized casuistic formula (if *x*, *y*) of Babylonian

[96] Bottéro, *Mesopotamia: Writing, Reasoning, and the Gods*, p. 209.

[97] G. A. Reisner, *Sumerisch-babylonische Hymnen nach Thontafeln griechischer Zeit*, Mittheilungen aus der orientalischen Sammlungen, Heft 10 (Berlin: W. Spemann, 1896) No. 4:11–15, translated in Thorkild Jacobsen, *Treasures of Darkness*, p. 103.

[98] See A. D. Nock, "Studies in the Graeco–Roman Beliefs of the Empire," reprinted in Z. Stewart, ed., *Essays on Religion and the Ancient World* (Oxford: Clarendon, 1972), p. 47 and notes 93–95.

law codes. The first case in the Code of Hammurabi, for example, is "If a man accuses a man of murder and does not prove it, his accuser shall be put to death."[99] The parallel between lists of omens and earlier collections of legal precedents and their "judgments" or "verdicts" is suggestive and compelling in light of prayers and incantations referring to the gods as "deciders of decisions" (*pārisū purussî*), often said of Sin, and of Sin and Šamaš together.[100] The late theological and "astrological" commentary series titled I.NAM.GIŠ.HUR.AN.KI.A states "Sin and Šamaš, the two gods, are present and decide the decisions of the land (*purussê māti iparrasū*) [. . .] they give signs to the land."[101]

The observation that omens "are analogous to judgements" has been made by R. Westbrook,[102] but with a different interpretation of the force of those judgments. He said, "an omen will remain valid forever, i.e. the same ominous sign will always have the same significance. Thus it has the potential for becoming independent of the god whose will it represents." My view differs on the understanding of the eternal quality of omens. As divine "case" judgments, the omens are subject to the gods' will to alter their verdict in any given case, provided the necessary appeal (the *namburbi* ritual) has been made. It does not seem to follow that the omen ever attains a status apart from or more enduring than the divine source of judgment.

That the diviners saw the omens as indications of divinely determined events is also supported by the use of the word *purussû* "legal decision" or "verdict" as a term for what we would call an "omen prediction." Inserted between the protasis and apodosis of the lunar-eclipse omens of *Enūma Anu Enlil* Tablet 20, for example in the omen for month *Du'ūzu*, is this

[99] Code of Hammurabi 1; see J. B. Pritchard, *Ancient Near Eastern Texts*, 3rd ed. (Princeton, NJ: Princeton University Press, 1969, 3rd ed.), p. 166.

[100] See F. Rochberg-Halton, "Fate and Divination in Mesopotamia," *AfO Beiheft* 19 (1982), p. 367, and see Subsection 7.3.2.

[101] A. Livingstone, *Mystical and Mythological Explanatory Works*, pp. 24–25. Cf. ᵈ*Sin* ᵈ*Sin ša purussê* "Sin is (the equivalent of) Sin of the decision," *CT* 24 39:15; for Sin and Šamaš, *KAR* 18 r. 44. The literary stylists of Aššurbanipal's royal inscriptions also made reference to the god Sin's making cosmic "decisions," as in *ukallimanni inbu purussēšu ša la inninnû* "the Fruit (i.e., the new moon) revealed to me his decisions which cannot be revoked," Streck, *Assurbanipal* 110 v 10. This seems to be a clear metaphor for the idea that only the appearances of the heavenly bodies, i.e., while they are above the horizon are capable of providing omens. See also E. Reiner, *Astral Magic*, pp. 66–7.

[102] R. Westbrook, "Codification and Canonization," in E. Lévy, ed., *La codification des lois dans l'antiquité*, Travaux du centre de recherche sur le Proche-Orient et la Grèce Antiques 16 (Université Marc Bloch de Strasbourg, 2000), p. 41.

instruction: "you observe his (Sin's) eclipse and keep the north wind in mind; thereby a decision (*purussû*) is given for Ur and the king of Ur."[103] In another lunar-eclipse text, similarly, we have the comment "region (of the heavens) for a decision concerning the king of Elam, region of (meaning: for the occurrence of) an eclipse."[104] A commentary shows that, when the moon is eclipsed in various ecliptical stars, decisions are given for a variety of subjects, including a decision "for the furrow," for the Tigris and Euphrates, and the cities of Akkad, Uruk, and Kullaba.[105] The term *purussû* in this usage is also found in the reports of the diviners to the Neo-Assyrian kings, in which *Enūma Anu Enlil* is quoted, such as "[If] a star is darkened in the region of Sagittarius: a decision (*purussû*) for Muttabal and Babylon,"[106] or "*Simanu* means the Westland and a decision (*purussû*) is given for Ur."[107]

The *purussû*s in these examples can be identified with the divine decisions referred to in the epithets of gods. Such divine decisions are also attested to in the names of temples constructed with EŠ.BAR (=*purussû*), for example, É.EŠ.BAR.AN.KI "House of Decisions of Heaven and Earth," EŠ.BAR.ME.SI.SÁ "(House) which keeps in Order Decisions and me's," and É.EŠ.BAR.ZI.DA "House of True Decisions."[108] The use of the phrase *purussâ nadānu* "to give a decision (or judgment)" in connection with celestial omens further appears to parallel the phrase *dīna dânu* "to render a judgment in the form of an oracle." The Old Babylonian prayer to the gods of the night, that is, the stars, expresses the notion that only the appearances of the heavenly bodies while they are above the horizon are capable of providing omens, as the heavenly bodies Šamaš, Sin, Adad, and Ištar are said not to give judgment (*ul idinnū dīnam*) because they have set (*iterbû*).[109] In another prayer to the stars, before the making of a ritual offering, the stars are addressed as "divine judges," and asked to provide their "true judgment" and "divine verdict" in order that the extispicy to

[103] See *ABCD*, Chap. 10 *passim*. Cf. ⌈ù⌉-da ù EŠ.BAR "sign and decision," CT 13 31:7'.

[104] *TCL* 6 12 ii 4ff.

[105] *ACh* Suppl. I 1:1–8.

[106] Hunger, *Astrological Reports*, 4:8, also line 4, and 300 r. 11, also line 7; cf. 336 r. 4 and *LBAT*, 1599 obv. I 5', 13', 17' and 18'.

[107] ITI.SIG₄ KUR.MAR.TU.KI *ù pu-ru-us-su-ú a-na* ŠEŠ.UNUG.KI *na-din*; see Hunger, *Astrological Reports*, 316:6.

[108] A. R. George, *House Most High: The Temples of Ancient Mesopotamia* (Winona Lake, IN: Eisenbrauns, 1993), pp. 82–83.

[109] W. Von Soden, "Schwer zugängliche russische Veröffentlichungen altbabylonischer Texten," *ZA* 43 (1936), p. 306:7–8.

be performed will provide an answer.[110] Finally, the idea of the omen apo-
doses as divine decisions is made explicit in an apodosis attested in *Enūma
Anu Enlil, Šumma ālu*, and extispicy, namely, that "the gods will make a
favorable/unfavorable decision about the land."[111]

If this divine decision-making is legitimately connected to the mytho-
logical "decreeing of destinies" by the gods, then fate (*šīmtu*), meaning
"that which is determined by (divine) decree," and divination are interre-
lated in Mesopotamian thought. In this sense, the predictions from omens
could have been understood as things ordained by the gods to occur. Even
more fundamentally, the gods decreed a "nature," expressed also with the
term *šīmtu* for every person, animal, plant, and stone. In the Sumerian
myth of Enki and Ninhursag, Enki endows the plants with their charac-
teristic properties, conferring a NAM (*šīmtu*) on each one by means of a
command,[112] and in Tablet X of the bilingual (Sumerian and Akkadian)
mythological work *Lugale*, Ninurta determines the natures of stones by
pronouncing a verdict for each one.[113] We may understand the "nature"
of a person in terms of something such as an individual's lot in life.[114]
The nature of a person and how that correlated with an individual's fate
and fortune is an idea reflected in the series *Alamdimmû* and some parts
of *Šumma ālu*, in which omens from physiognomic features of the body
as well as speech habits and behaviors are correlated with events to take
place in that person's life. Just as the nature of things was subject to deci-
sions by the gods, so a person's lot, or *šīmtu*, seems to have been viewed
as susceptible to change as well. Curse formulas reflect such a notion, as
imprecations to a number of gods attest, for example, "may Ea, fashioner
of mankind, make his an unfortunate fate (*šīmtašu lilammin*)."[115] The first
in a list of imprecations that make up the curse clause of the Code of
Hammurabi directed against anyone who does not heed the laws reads

[110] O. R. Gurney and J. J. Finkelstein, *The Sultantepe Tablets* I (London: The British School
of Archaeology at Ankara, 1957), No. 73:110–117; see E. Reiner, "Fortune-Telling in
Mesopotamia," *JNES* 19 (1960), esp. p. 35, and also Reiner, *Astral Magic*, p. 73.

[111] Hunger, *Astrological Reports* 506:3; cf. YOS 10 13:15, and *CAD* s.v. *malāku* meaning 2.

[112] Kramer, *Sumerian Mythology*, p. 201.

[113] J. van Dijk, *Lugal ud me-lam-bi nir-gál*, (Leiden: Brill, 1983).

[114] Whether this is more than only superficially parallel to the Greek sense of *moira*, person-
ified in Homer as a goddess who determined the lifespan of man, is unclear. Referring
more generally to a portion of land or a division of something, *moira* bears a similar
connotation as one's portion in life, or lot; see Liddell and Scott, *A Greek-English Lexicon*,
s.v. moira.

[115] *BBSt.* No. 4 iii 11, and other examples cited in *CAD* s.v. *arāru* "to curse," meaning 1b.

"may mighty Anu, the father of the gods, who proclaimed my reign, . . . curse his fate."[116] Related to this is the statement in a prayer to Ištar that it was in her power "to transform an unfortunate *šīmtu* into a fortunate one."[117]

Why the gods were viewed as the producers of signs in the natural world is further clarified by Mesopotamian cosmology. In one sense, the cosmic deities (Anu, Enlil, and Ea) are the divine essence of the physical cosmos, and so their very existence presupposes the existence of the physical parts of the universe identified with them, that is, the great above is An-Anu, and the great below is Enki-Ea.[118] The other sense, which we have already seen in the evidence from prayers and incantations to celestial deities, derives from a conception of the cosmos as a polity ruled by those gods: An ruled remote heaven, Enki the waters around and below the earth, and Enlil the space between the great above and the great below containing the earth and winds. The opening line of the celestial divination series makes the notion of divine rule over the entire cosmic domain clear, in seeing the establishment of the cosmic "designs" as a divine act of creation[119]: In the Babylonian creation poem, *Enūma eliš*, a hierarchical structure of divine authority is described, placing Marduk in the position of leadership (*EnEl* Tablet IV), the seven gods of the "destinies," the Anunnaki and Igigi being delegated to various cosmic domains (*EnEl* Tablet VI 80–81). This divine society was part of a fixed order that came into existence with creation and became a permanent characteristic of the cosmos. The phenomena through which divine messages were relayed to "the land" were a consequence of this fixed order. As stated in *Enūma eliš*, "the norms had been fixed (and) all [their] portents" (*EnEl* Tablet VI 78). If the physical phenomena that functioned as signs portending the future for humankind were established as part of creation, the channel of communication between divine and human in the form of divination would be seen as part of the original structure of the world. In the concluding paragraph of a source for *Enūma Anu Enlil* Tablet 22,[120] a similar notion is expressed:

116 CH xlii 52; see Pritchard, *Ancient Near Eastern Texts*, pp. 178–9.

117 Erich Ebeling, *Die Akkadische Gebetsserie "Handerhebung"* (Berlin: Akademie-Verlag, 1953), p. 128:12 (K.3447).

118 See further on the association between deities and parts of the cosmos, A. Livingstone, *Mystical and Mythological Explanatory Works*, pp. 71–91.

119 See Chap. 2 note 78.

120 The translation given here is tentative because of the many breaks and the resulting difficulty of the syntax. See Weidner, *AfO* 17 89:5 and pl. IV (VAT 9805+), also *ABCD*, pp. 270–1 (=Source E), and W. Horowitz, "Mesopotamian Accounts of Creation," in

When Anu, Enlil, and Ea, the great gods, created heaven and earth and made manifest the celestial signs, [they fixed the stations and estab]lished the positions (of celestial bodies), [the gods of the night they . . . , they divided the co]urses, [(and with) stars as their (the gods') likenesses, they drew the constellations.]

Here it is specifically celestial signs that are conceived of as coming into being simultaneously with the creation of heaven itself.

The orderliness of the Mesopotamian cosmos was manifest in the reciprocity of heaven and earth and further conceived of in terms of the rule of regions by designated deities. The chief mythological image of the body of the cosmos according to *Enūma eliš* was that of Tiāmat, the personified feminine salt waters. Marduk secured bolts on either side of the gates, or "doors" of heaven (*EnEl* Tablet V 9–10), that is, for the upper part of the cosmos formed from the cosmic saltwater Mother. Also encoded in this metaphor, no doubt, is the original watery state before the generation of the gods in the form of Apsû and Tiāmat. After splitting the monster in half, Marduk ultimately placed the celestial bodies in the upper half of Tiāmat, forming the "roof" of the sky. In addition, a motif of the "bonds of heaven and earth" implies the physical unity of the two parts. This cosmological feature was sometimes called *durmahu*, a word for some kind of strong rope made of reeds (see *EnEl* Tablets V 59 and VII 95). The cosmic bonds, imagined as ropes or cables, therefore tied down and controlled, particularly the flow of waters (in the form of dew, rain, or clouds) from the heavens, and recall the image of the gates which locked in the waters of Tiāmat. A symbolic anchoring of the heavens by means of a rope may go back to a Sumerian image preserved in an Early Dynastic hymn, which has the phrase "the twisted rope to which heaven is secured."[121] The cosmic cable was used in cosmological mythology as a linking device which could be held by a deity as a symbol of power. Ištar, for example, is described as the goddess "who holds the connecting link of all heaven and earth." In a marvelous compounding of metaphors, the lead-rope passed through the nose of an animal became synonymous with this cosmological feature because it too could be held by a deity as a symbol of control or authority: "I (Ištar) am in possession of the (symbols of) the divine offices, in my hands I hold the lead-rope of heaven," or, "Marduk made firm and took

N. S. Hetherington, ed., *Encyclopedia of Cosmology: Historical, Philosophical, and Scientific Foundations of Modern Cosmology* (New York/London: Garland, 1993), p. 396.

[121] A. Westenholz, *Old Sumerian and Old Akkadian Texts in Philadelphia* 1, No. 4 (=UM 29-16-273 + N 99 iv 7), apud B. Alster, "On the Earliest Sumerian Literary Tradition," *JCS* 28 (1976), p. 122.

into his hands the lead-rope of the Igigi and Anunnaki, the connecting link between heaven and earth."[122]

The symmetrical bipartite cosmos persisted in later Babylonian thought, where, in religious and scholarly texts of the first millennium, reference is made to cosmic designs (GIŠ.HUR.AN.KI / *uṣurāt šamê u erṣeti*), literally "plans of the above and below." These cosmic designs, perhaps the image of universality and regularity, are frequently associated with the "destinies," literally "(divine) decrees" (NAM.MEŠ = *šīmâtu*), as for example in the divine epithet "lord of cosmic destinies and designs" (*bēl šīmâti u uṣurāti*). Given the meaning of *šīmâtu* "the decreed things," or "destinies," the association of destinies and designs on the cosmological level connotes an order of things as a result of divine agency.[123] With such a conceptualization of the order of things in the world, underlying "causes" or reasons for the "designlike" regularities in the cosmos could not be expressed in terms of "natural law."[124] Accordingly, we cannot presume that the patterns observed in nature were taken by the ancient Mesopotamians as outward signs of a lawlike behavior of physical phenomena, unless by "lawlike" we mean subject to the judgments and rulings of the gods, as expressed in terms of *purussû* (or *dīnu*). In accordance with such a conception, the natural order could just as easily be disrupted as maintained by divine will, as in the following line from *Enūma eliš*, which attests to

[122] Further to the *ṣerretu*, see A. R. George, "Sennacherib and the Tablet of Destinies," *Iraq* 48 (1986), esp. pp. 138–9.

[123] All such claims about the relations among physical phenomena, the gods, and what we would call "fate" are of course highly interpretative. Other interpretations have been offered, for example, that suppose a Babylonian belief in a notion of overarching fate to which even the gods are bound, for example J. N. Lawson, *The Concept of Fate in Ancient Mesopotamia of the First Millennium: Toward an Understanding of Šimtu* (Wiesbaden: Harrassowitz, 1994), and G. Buccellati, "Mesopotamian Magic as a Mythology and Ritual of Fate: Structural Correlations with Biblical Religion," in S. J. Denning-Bolle and E. Gerow, eds., *The Persistence of Religions: Essays in Honor of Kees W. Bolle* (Malibu, CA: Undena, 1995), pp. 185–95. This view bears a resemblance to the classical Greek conception of fate, as evidenced in the tragedies and developed philosophically in the Hellenistic period (e.g., by the Stoic Chrysippus).

[124] Ronald N. Giere, *Science Without Laws* (Chicago/London: University of Chicago Press, 1999), pp. 23–4, argues that the concept of universal laws of nature is at the same time an artifact of history, imported from (seventeenth-century) theology, and "theoretically suspect as well," noting that "as general claims about the world, most purported laws of nature are in fact false." Accordingly, he recommends that we not view science as in the business of discovering laws of nature, but rather as principles, meaning "rules devised by humans to be used in building models to represent specific aspects of the natural world" (page 94).

this very power of the god Marduk to create as to destroy order in the heavens:

By your utterance let the star be destroyed, command again and let the star be restored.[125]

Less clear, but related in essence is the statement from an angry Marduk, found in the Erra Epic:

When I left my dwelling, the regulation of heaven and earth disintegrated; the shaking of heaven meant the positions of the heavenly bodies changed, nor did I restore them.[126]

The divinely regulated order reflected in this passage admits of cosmological order and regularity, but not universal determinism and necessity. Again, the prayer literature provides us with another parallel, this time with specific reference to an omen:

You (Nabû) are able to turn an untoward physiognomic omen into (one that is) propitious.[127]

The instrumental role of the gods manifested in natural phenomena reflects the nonmechanistic character of the Mesopotamian cosmos. Even in the context of the mythological "designs of heaven and earth," which suggest a fixed world structure, the "designs" were drawn by gods who were never conceived of as simply setting things in motion only to step away and leave the machinery running, but as active participants in the world. The idea that the gods had the ability to change "destinies" is already attested in Sumerian literature, for example, in the "Death of Ur-Nammu," in which An "changed his holy word" and Enlil "altered his decree of fate deceitfully(?)."[128] In later Akkadian literature, a prayer to the sky god Anu calls that god "dispeller of evil, wicked and terrifying dreams,

[125] *EnEl* IV 23f.

[126] Erra Epic Tablet I 133–134, translation of Foster, *Before the Muses*, Vol. II, p. 778; see also L. Cagni, *The Poem of Erra*, Sources and Monographs, Sources from the Ancient Near East I/3 (Malibu, CA: Undena, 1977), p. 32.

[127] Gurney and Finkelstein, *The Sultantepe Tablets* I No. 71:20, and see W. G. Lambert, "The Sultantepe Tablets: A Review Article," *RA* 53 (1959), p. 135.

[128] S. N. Kramer, "The Death of Ur-Nammu and his Descent to the Netherworld," *JCS* 21 (1967), p. 112:8f.

evil signs and portents."[129] Within such a cosmology, signs in nature, produced by gods, cannot be viewed as occurring out of deterministic necessity. But the most compelling evidence against determinism (or necessity) in Babylonian divination and cosmology was the viability of apotropaic ritual action for dispelling bad omens. This further dimension of Mesopotamian divination, the human response to an omen's meaning, seems wholly consistent with a system conceived of as fundamentally one of communication between divine and human.

Rituals termed NAM.BÚR.BI (Akkadian *namburbû*), meaning its undo-ing, could be performed by priests, or even by gods, to ward off the evil portended by an omen.[130] The gods Ea, Šamaš, and Marduk (Asalluhi) are said to "perform apotropaic rituals wherever there are portentous hap-penings and signs,"[131] and the sun god is extolled as the one "who averts the (bad) signs and portents by means of *namburbi* rituals."[132] The reports from the scholars to Kings Esarhaddon and Aššurbanipal reveal the use of such rituals, as in the following selected lines: "Let them perform a *namburbi* ritual; the halo was not a closed one"[133]; "This is a bad sign for all lands. Let the king my lord perform a *namburbi* ritual and so make its evil pass by."[134]; "Mars remained four fingers distant from Saturn, it did not come close. It did not reach it. I have copied (the omen from *Enūma Anu Enlil*). What is the harm in it? Let the pertinent *namburbi* ritual be performed."[135] The protection of the king was paramount, because the celestial omens (especially the lunar) most directly affected him as the rep-resentative of the state. Therefore we find the scholar Munnabitu warning that

the [ki]ng must not become negligent about these observations of the mo[on]; let the king perform either a *namburbi* or [so]me ritual which is pertinent to it.[136]

When, however, the *namburbi* was not performed or the "cancellation" (*pissatu*) of the omen did not occur, the consequences of the sign were

[129] *LKA* 50:5–7, translation of Foster, *Before the Muses*, p. 549.
[130] Maul, *Zukunftsbewältigung*.
[131] *LKA* 109:16–17; see *CAD* s.v. *namburbû* usage a.
[132] *LKA* 111:7–10; see *CAD* s.v. *namburbû* usage a.
[133] Hunger, *Astrological Reports* 71:4.
[134] Ibid., 288 rev. 7–9.
[135] Ibid., 82:8–10.
[136] Ibid., 320 rev. 6–9.

indeed thought to be inevitable. A diviner's instruction manual says, "should no sign counteracting the sign have occurred, or it had no cancellation, or no one could make it pass by, (or) its evil consequences could not be removed, (then) it will happen."[137] This is as close as we will come to a Babylonian argument for the truth of divination. This truth, however, stems from the belief in the deities' active role in the universe, that is, above and below. It is not derived from the logical necessity of conditional probability statements. The reliance on incantation and apotropaic ritual acts, which effectively asked the gods to undo the connection between the omen and its "prediction," might seem (to some) to undermine the entire logical structure of omen statements (if x, y). At the very least, the resort to prayer and "magic" renders the omen statements something of the order of "if x then y (unless z)," where z is the *namburbi* ritual to avert the untoward event predicted by the omen. Implicit in each omen, then, is the possibility that some procedure will prevent the occurrence of the predicted event by persuading the gods to do so. Perhaps a better modern formulation of a Babylonian omen statement, then, would be "if x then y, if and only if not z."

5.5 PERSONAL CELESTIAL DIVINATION

The question remains of how one bridges the gap between the public nature of the celestial omens and the private nature of horoscopes. It seems that an individual's "fate" was expressed by the term *šīmtu*, which denoted "that which is determined by decree." In a sense parallel to the decreeing of the "fates" of plants and stones, that is to say their "natures," a human being's *šīmtu* is the course of life, portioned out by divine decree. This is indicated in an inscription of Nebuchadnezzar that says in the place of destinies at the shrine of destinies, Marduk's place during the New Year's festival on the eighth and eleventh days, the god decreed "the destiny of everlasting days, the destiny of my life."[138] Another inscription of Nebuchadnezzar testifies to the idea of human life being part of all that is divinely decreed in the universe and makes reference to the written form of such a decree:

[137] Oppenheim, "Diviner's Manual," p. 200: 45–6, and p. 204, note 30, for a parallel in a Neo-Assyrian letter, *LAS* 110 (not 10), rev. 9, which says, "if a sign occurs in the sky and has no cancellation *(piššatu la erši)*." See also Hunger, *Astrological Reports*, 469 rev. 1–5, in which the scribe states that the "evil" will not be "cut off" if the sign has no cancellation.

[138] Langdon, *Neubabylonischen Königsinschriften*, VAB 4, pp. 1267:63–4.

Decree for me long life upon your reliable writing board which establishes the borders of heaven and the nether world (and) write (on it) old age for me.[139]

As the fulfillment of one's decreed lot and share of life, the word *šīmtu* also meant "death" in the euphemism "he went to his fate" (*ana šīmtišu illik*) or "fate carried him away" (*šīmtu ūbilšu*). In the context of divination, the decree is a divine one and can be altered at the will of the deity, if necessary by the force of prayer and ritual magic. A personal *šīmtu* can be either propitious (*damqat*) or unpropitious (*lemnat*), the same adjectives attributed to "signs" in general. The personal "fate," was alterable, but not by the vagaries of "fortune," but rather by the determination of a god. These ideas about the relationship of the individual to the gods and so also to the cosmos appear perfectly consistent with the ideology of things decreed by the deities to occur, of physical phenomena as signs from the gods indicating future events, in short with the principles of celestial and other divination. Aspects of a person's life can be easily fitted into the "world structure" implied by the omen texts, and indeed, the physiognomic and some of the daily life omens already provided signs forecasting an individual's life and fortunes.

From a philological perspective, the background and foundation for personal prognostications from heavenly phenomena in horoscopes has been identified by means of parallels between these, albeit few, statements about the life of the native and the stock phraseology of omen apodoses.[140] The parallels to these apodoses, however, are also found in the form of nativity omens, a later development with respect to *Enūma Anu Enlil*, probably to be dated to the Achaemenid period, but one that follows from the kinds of personal omens already mentioned, such as those of *Alamdimmû, Šumma ālu*, and also SA.GIG. Another important link between divination and the horoscopes is the idea of the life of an individual indicated by the month of his birth, as attested to in the omens of the series *Iqqur īpuš*, such as "If a child is born in the month of *Ajaru*, he will die suddenly" and "If a child is born in the month of *Abu*, that child will be despondent."[141]

The evolution of "horoscopy" seems then to follow a new genre of omen, the nativity omen, which itself took two forms. According to Sachs's

[139] Ibid., p. 100–01 ii 23–25, cited in *CAD* s.v. *lē'u* usage b. Assyrian royal inscriptions attest to the same motif; see Shalom Paul, "Heavenly Tablets and the Book of Life," *Journal of the Near Eastern Society of Columbia University* 5 (1973), p. 345 and notes 9–11.

[140] *BH*, pp. 13 and 50, Subsection 4.2. See *BH* texts 2, 5, 9, 10, and 11.

[141] Labat, *Calendrier*, pp. 132–133, Section 64:2 and 5.

terminology, a "pseudo-horoscopic" form derived omens from celestial phenomena occurring on the date of birth[142]:

If a child is born when Venus comes forth and Jupiter set, his wife will be stronger than he.

If a child is born when Venus comes forth and Saturn set, his oldest son will die.

If a child is born when Mars comes forth and Jupiter set, the hand of his personal enemy will capture him.

These he differentiated from the "horoscopic" type, in which the omen was based on the zodiacal sign in which the sun was located on the child's birth date, as in "If a child is born in Taurus . . . that man will be distinguished, his sons and daughters will return and he will see gain."[143] Sachs viewed the two nativity omen types as indicative of an evolution of astrology, that is, from the pseudohoroscopic to the horoscopic,[144] yet both forms can occur together in the same text.[145] From the horoscopic nativity omen, only a short step would be needed to the horoscope itself, which combined the zodiacal sign of the sun on the date of birth together with the positions in the zodiac of the other planets, and the particular set of lunar and solar phenomena selected, presumably with respect to the date of birth as well. This hypothetical reconstruction, at any rate, is arguable from extant texts.

In this light it is interesting to consider the effect of the earliest horoscope (dated 410 B.C.), which does not conform to the format of the other horoscopes in that its interest was in the synodic appearances of the planets on the dates within two to three months of the date of the birth.[146] This horoscope relates well to the celestial and nativity omens that concern visibilities. The other horoscopes do not concern visibilities at all, strictly speaking. Their concern was with the positions in the zodiac of the planets at the arbitrary moment of birth, regardless of whether they were visible. It was no longer the visible "phenomena" that were considered ominous in a horoscope, but the entire arrangement of the seven heavenly bodies in the ecliptic, plus whether or not eclipses, solstices, or

[142] *TCL* 6 14 rev. 11, 12, and 19; see Sachs, "Babylonian Horoscopes," pp. 67 and 69.

[143] BM 32224 ii 13′–15′.

[144] Sachs, "Babylonian Horoscopes," p. 73. Cf. the discussion in *BH*, pp. 14–15.

[145] *LBAT* 1593; see E. Reiner, "Early Zodiologia and Related Matters," in A. R. George and I. L. Finkel, eds., *Wisdom, Gods and Literature: Studies in Assyriology in Honour of W. G. Lambert* (Winona Lake, IN: Eisenbrauns, 2000), pp. 421–7.

[146] For translation, see Subsection 4.1.4.1, and *BH* Text 1, pp. 51–5.

equinoxes had occurred within five months of the birth and on what dates certain significant lunar visibilities (the Lunar Three) had occurred. The following excerpt illustrates the change in content, but with its inclusion of personal "predictions," and even a quoted omen to explain the lunar latitude statement, it cannot be regarded as "typical"[147]:

Year 77 Seleucid Era, the 4th of Simanu in the morning of the 5th, Aristocrates was born. That day, the Moon was in Leo, the sun was in 12;30° Gemini. The moon goes with increasing positive latitude (lite. "sets its face from the middle (nodal zone) toward positive latitude"). (An omen says:) "If (the moon) sets its face from the middle toward positive latitude, prosperity and greatness."

Jupiter was in 18° Sagittarius. The place of Jupiter (means): (the native's life will be) prosperous; at peace(?); his wealth will be long-lasting; (he will have) long days.

Venus was in 4° Taurus. The place of Venus (means): he will find favor wherever he goes; he will have sons and daughters.

Mercury was in Gemini with the sun. The place of Mercury (means): the brave one will be first in rank; he will be more important than his brother; he will take over his father's house.

Saturn was in 6° Cancer.

Mars was in 24° Cancer. (Remainder too broken for translation.)

The personal forecasts according to the "place" of the planets are parallel to those of nativity omens.[148] This is by no means usual in the horoscopes, which more often confine themselves to the astronomical data on the date of birth. This last example will serve to represent a more or less "standard" horoscope, translated here without indication of restored passages[149]:

By the command of Bēl and Bēltīja, may it go well.
 Year 92 Seleucid Era, Antiochus III was king. *Tašrītu* 30, night of the 12th, first part of night, the moon was below the Rear Star of the Head of the Hired Man (=α Arietis). The moon passed $^1/_2$ cubit to the east (of α Arietis). . . . the child was born. In his hour of birth, the moon was in Aries, the sun was in Scorpius, Jupiter was in Aries, Venus and Saturn were in Sagittarius, Mercury and Mars which had set were not visible. They were with the sun. That month, moonset after sunrise was on the 14th, last lunar visibility before sunrise was on the 27th.

[147] *BH* Text 10, pp. 82–5.
[148] *LBAT* 1597: 1ff.; see also *TCL* 6 13 obv. ii 5–6 in F. Rochberg-Halton, "TCL 6 13: Mixed Traditions in Late Babylonian Astrology," *ZA* 77 (1987), pp. 213 and 215.
[149] *BH* Text 14, pp. 92–95.

Winter solstice was on the 20th of *Kislīmu. Addaru,* night of the 14th a lunar eclipse. Totality occurred in Libra. On the 28th day an eclipse of the sun in Aries, invisible[150] (and) omitted.

Another piece of evidence to support the idea that the horoscope summarizes ominous data for the date of a birth comes from a Late Babylonian astrological text of diverse content, but which contains a guide to the interpretation of the life of a person in some relation to the planets.[151] The text correlates the planets with kinds of signs, that is, favorable, ambiguous, good, and indications for the life of a person, as follows:

(If) Jupiter: favorable; . . . ; wealth, (he will have) long days. (If) Ve[nus: very calm; wherever he goes good fortune and long days.]

(If) Mercury: heroic, lordly; (he will have) great strength. (If) [Mars: ambiguous; (he will be) quick to anger.]

(If) Saturn: dark, disturbed; (he will be) sick and constrained.

(If) the moon: bright, good; (he will be) true and long(lived), (but) if the moon is eclipsed: dark, disturbed, not bright; [no true omen. If] the sun is eclipsed: divided, confused.[152]

The interpretation of this passage hinges on whether the attributes "favorable, heroic, dark, disturbed, bright, good" refer to the planets themselves or, as I have suggested, to the nature of signs. Because the attributes are given in the form of feminine stative verbs without expressing a subject, the implied subject could be the feminine substantive *ittu* "the ominous sign." As just seen, these statements about the nature of the signs were incorporated within a horoscope immediately following the positions in the zodiac given for the planets. The continuing role of the planets as signs is evident in another late astrological text, *LBAT* 1593,[153] in which the presence of one of the planets with the moon indicates whether a child born at that time will be male or female. Although the planetary signs in

[150] Translation of BAR DIB is difficult, but the best suggestion is that of John M. Steele, "The Meaning of BAR DIB in Late Babylonian Astronomical Texts," *AfO* 48/49 (2001/2002), pp. 107–12. His proposal to read BAR as Akkadian *ahû* "extraneous" becomes understandable when it is seen in relation to the method of predicting eclipses by the Saros scheme, a scheme that is not perfect, but whose implementation will result in periodic series of eclipses that are penumbral and therefore not visible. Instead of translating "extraneous" here, however, I have opted to say simply "invisible," as this is the effective meaning of such an eclipse from the scheme that falls into what Steele refers to as a "dead" row.

[151] See Rochberg-Halton, "Mixed Traditions," pp. 207–28.

[152] *TCL* 6, 13 obv. ii 1–4, see Rochberg-Halton, "Mixed Traditions," pp. 212 and 215.

[153] See note 145 of this chapter.

Late Babylonian astrology have evolved from those of the "Ištar" section of *Enūma Anu Enlil*, the perception of the planetary bodies as signs in Late Babylonian genethlialogy suggests an unbroken continuity with the principles of celestial divination.

In the absence of evidence that the planets come to be seen in the Babylonian context as deterministic agents of personal fate, I prefer to view the astrological principle of the horoscopes as consistent with that of the other cuneiform celestial divination traditions. The content of a celestial omen for the fate of the king may be outwardly quite different from that of a horoscope for the fate of an "ordinary" individual, but the horoscope provided the ultimate accommodation of the individual within the complex of relationships among divine, phenomenal, and human that defined the scope of Mesopotamian divination. The sphere of influence and interest of the personal predictions, both in the nativity omens and the few horoscopes that attest to them, are strictly "domestic," and run parallel to personal predictions found in other divination series, such as *Šumma ālu, Alamdimmû,* and *Šumma izbu.* Why such personal omens were created in the Late Babylonian period is unanswerable for a total lack of evidence for the practical use of such omens or horoscopes, or for what sort of individuals were in a position to avail themselves of such professional advice. One would only be guessing to propose that in the absence of support from the royal court, the diviners saw potential customers within a wider public. This idea may, however, appear plausible in light of the transmission, development and use of personal celestial divination in India already from the Achaemenid period onward and in Greece from the late third century B.C.[154]

To integrate cuneiform horoscopes within the "ideology" of Mesopotamian divination in general is to differentiate them from their later Greek parallels. Greek horoscopes represent a wholly different genethlialogical system, beginning with the fact that the *horoscopus,* a concept not evident in the cuneiform horoscopes, refers to the consideration of the rising point of the ecliptic at the moment of birth. More fundamentally, Greek horoscopy follows from Aristotelian cosmology and physics, as well as the conception of a mechanistic cosmos. It is not only Greek astrology, but also the Hellenistic philosophical discourse on divination

[154] For the explanation of the appearance of personal celestial divination as an "appeal to all members of society rather than just to kings," see D. Pingree, *From Astral Omens to Astrology,* p. 19, Chap. 3, "Babylonian Omens and Greek Astrology in India," pp. 31–8, and p. 23 on the origins of the Greek awareness of Babylonian birth omens.

that is to be differentiated from Mesopotamian counterparts. Some of the most basic elements of the theory and cosmological background of the Stoic philosophy of divination may be comparable, such as the idea of cosmic order and the possibility of prognostication by "signs." But more of their central concerns are absent from the Babylonian formulation, for example, causation, determinism, necessity, the truth of predictions, and the ideal of cosmic sympathy.[155]

[155] See Susanne Bobzien, *Determinism and Freedom in Stoic Philosophy* (Oxford: Clarendon, 1998).

6

THE SCRIBES AND SCHOLARS OF
MESOPOTAMIAN CELESTIAL SCIENCE

T HE RICH SOURCE MATERIAL FOR THE ACTIVITIES OF SCRIBES
in the Neo-Assyrian court makes it clear that the scribal personnel
of the palace, those involved in celestial and other divinatory sciences,
participated in a complex of relationships that were at once political and
religious. By the fourth century B.C., however, evidence for the intense
involvement of the king with the scholars appears to diminish. To say that
cultural and intellectual change is shaped by political and social change is
perhaps true, but in the present context, none too clear. At the end of the
Neo-Babylonian dynasty, the fall of Babylonia in 539 B.C. to Achaemenid
King Cyrus II certainly affected Mesopotamian politics and society, but
what the nature of these changes may have been for the intellectual elite is
difficult to identify. One determinable change in the environment of later
Babylonian scholarship was the shift of the locus of astronomical activity
from the palace to the temple. When exactly this occurred, however, is not
well documented. Only limited Achaemenid evidence is so far available for
the association of the scholars with the temple. Although the astronomical
diaries testify to the continuous activity of astronomy in Babylon from the
eighth century B.C., concrete support for identifying the temple Esagila
as the provenance of the diaries comes only in the Arsacid period. Only
a spotty picture of the transition from palace to temple therefore emerges
from the documentation, making a poor basis on which to generalize
about changes in the culture of science of the later first millennium.

Apart from the change in the scribal "workplace" from palace to tem-
ple, other changes invite explanation, such as the appearance of personal
astrology and mathematical astronomy. These innovations in cuneiform
intellectual traditions are difficult to account for by external pressures or
foreign influence, as each new strain of thought is traceable to earlier

Mesopotamian traditions. Yet these important developments seem to emerge simultaneously with the changes in Mesopotamian politics, resulting first from the Achaemenid, second from the Macedonian conquests. Qualitative changes in ideas, such as the evident growth in importance of the individual with respect to the stars, the gods, and the cosmos, and the rise of mathematical astronomy, in this case do not seem to be reducible to or explainable by political and social factors, however much the subculture of the Babylonian scholar may have been shaped by a changed milieu.

Despite limitations in the sociological evidence, the textual relationships evident in horoscopes and omen texts strongly suggest that the group of scholars who prepared horoscopes were the "scribes of *Enūma Anu Enlil*" (*ṭupšar Enūma Anu Enlil*). Although the professional title came about during the Neo-Assyrian period because of the specialization of those scribes in the texts of the celestial divination repertoire, later it designated any scribe involved in the various activities of celestial science, including mathematical astronomy in the Seleucid and Arsacid periods. In the following section, an exploration of the evidence for the *ṭupšar Enūma Anu Enlil* is offered, not as an attempt to "socially construct" Mesopotamian celestial science in the sense of its being a product of a particular social or institutional context, which it most certainly was, but rather to account for some of the values that characterize the activities of the Babylonian scribes whose occupation was celestial inquiry.

6.1 THE SCRIBES, SCHOLARSHIP, AND KNOWLEDGE

Before the focus is narrowed to the *ṭupšar Enūma Anu Enlil,* some further context about the cuneiform scribes and their scholarly program in general will be helpful. The textual repertoire consisting of technical handbooks of the various divination series, complementary magical texts, scholastic lists of words and commentaries, and liturgical and ritual prescriptions comprised the literature of what the Babylonian and Assyrian scribes termed *ṭupšarrūtu* "scholarship," an abstract nominal form from the word *ṭupšarru* "scribe," also having the meaning "scholar." The Akkadian word scribe is derived from *ṭuppu* "tablet," or "text," itself a loan word from Sumerian (dub). The term *ṭupšarrūtu* designated the learned repertoire of the scribes, which was not limited to but encompassed "natural" knowledge, and the term for the profession "scribe" (LÚA.BA = *ṭupšarru*) applied generally to specialists in scholarly divination and the other text

genres just mentioned.[1] One text provides the word *mūdû* "expert" (as an adjective) as a gloss for *ṭupšarru*.[2] A Late Assyrian catalog of scholarly works belonging to the library of Aššurbanipal gives us a sense for what the Assyro–Babylonian scribes included under the rubric of scholarship: lexical lists, lamentations, celestial omens, terrestrial omens, commentaries to a number of the omen series, as well as the cosmogonic poem *Enūma eliš*.[3] The nature of that library's holdings is paralleled by the contents of other Assyrian and Babylonian libraries, such as those of the temple of Nabû (Ezida) at Nimrud[4] and of the temple of Šamaš (Ebabbara) at Sippar.[5]

Given that the scribal repertoire of texts consisted in anonymous compendia of words, omens of all kinds, hemerologies and menologies, medical symptoms, and magical ritual prescriptions, the only place in such works where one obtains a glimpse of scribal identity and how the contents of the tablet are classified or conceptualized is in the tablet's colophon. Unlike the contents of standard texts of the omen series, which do not vary much from one copy to another, the colophons are unique and within certain parameters contain vastly different information, as the following examples illustrate. The first is from the terrestrial omen series *Šumma ālu*, the second from the celestial series *Enūma Anu Enlil*.

52nd Tablet (of the series) "If a city is situated on a height." According to [its original (it was) written an]d collated. Hand of Sillâ, son of Su[. . . the app]rentice scribe, the junior exorcist. Tablet of Nabû-mudammiq, the [. . .][6]

Tablet of Anu-aha-iddin, son of Nidinti-Ani, the son of Anu-bēl-šunu, the descendant of Ekur-zākir, the Exorcist of Anu and Antu, the high priest of the Rēš Temple [. . . Hand of Anu-aha-ušabši, son of Ina-qibīt-Ani, son of Anu-uballiṭ,

[1] It should be noted, however, that, strictly speaking, the series devoted to the physiognomy and behavior of human beings, i.e., *Alamdimmû, Kataduggû,* and *Nigdimdimmû,* the medical diagnostic series *Enūma ašipu ana būt marṣi illiku,* as well as the ritual instructional literature including the *Namburbi* series all belong to the professional *āšipu* "exorcist." See Chap. 2.

[2] Lambert, *Babylonian Wisdom Literature,* p. 70:6.

[3] W. G. Lambert, "A Late Assyrian Catalogue of Literary and Scholarly Texts," in B. Eichler, ed., *Cuneiform Studies in Honor of Samuel Noah Kramer,* AOAT 25 (Neukirchen-Vlyun: Verlag Butzon & Bercker Kevelaer, 1976), p. 314 (K.14067+).

[4] D. J. Wiseman and J. A. Black, *Literary Texts from the Temple of Nabû,* Cuneiform Texts from Nimrud IV (British School of Archaeology in Iraq, 1996).

[5] F. N. H. Al-Rawi and A. R. George, "Tablets from the Sippar Library, II. Tablet II of the Babylonian Creation Epic," *Iraq* 52 (1990), pp. 149–57.

[6] Hermann Hunger, *Babylonische und assyrische Kolophone,* AOAT 2 (Neukirchen-Vluyn: Verlag Butzon & Bercker Kevelaer, 1968), No. 77.

the descendant of Ekur-zākir, the Ex]orcist of Anu and Antu, the high priest of
the Rēš Temple, Scribe of *Enūma Anu Enlil.*

He wrote (the tablet) for his study, long days, good health, that he not become
sick, and for the reverence of his lordship, and placed it in Uruk. Whoever worships
Anu and Antu, may he not remove it (the tablet)! Uruk, Month XI, day 26, year
117 of Antio[chus, k]ing of kings.[7]

Some colophons designate the contents of scholarly texts as "secret" or
"exclusive" knowledge (Akkadian *pirištu,* from the root *prš,* meaning "to
cut off" or "to separate"), as in this colophon from a Middle Assyrian
scholarly commentary:

Exclusive knowledge: The one who knows may show it to another one who knows.
(The tablet was) completed and collated; old original.
Hand of Kidin-Sin, junior scribe, son of Sutu, scribe of the king.[8]

From the Neo-Assyrian period, the colophon from an incantation text of
the exorcist of the temple of Aššur is similar:

Exclusive knowledge of the great gods. The one who knows may show (it) to
another one who knows. The one who does not know may not see it. It (belongs)
to the forbidden things of the great gods. Written according to its original and
collated.[9]

And on a Late Babylonian tablet of omens concerning the opposition of
sun and moon is the following rubric: "secret scholarly knowledge, ex-
clusive knowledge of the heavens."[10] Whereas *pirištu* denoted exclusivity,
another term used in reference to the texts of the scribal repertoire even
more clearly connoted secrecy. This was the term *niṣirtu* "guarded," from
the root *nṣr* "to guard" or "to protect," which often referred to a "(hidden,
guarded) treasure," hence "secret knowledge." An astronomical text deal-
ing with the Lunar Six phenomena and possibly dating to the fifth century
bears the designation "tablet of the secrets of heaven, the exclusive things
of the great gods." This tablet proscribes the communication of its con-
tents to anyone not from Babylon or Borsippa, or who is not a scholar (lit.
"person possessing knowledge"), and warns anyone who offends the gods
in this way that they should be struck down with dropsy.[11] Concerning

[7] Ibid., No. 93
[8] Ibid., No. 50.
[9] Ibid., No. 206.
[10] *LBAT* 1526 rev.17.
[11] Unpublished tablet in the British Museum, BM 42282+42294 obv. 1–4, for which I thank
Christopher Walker and Irving Finkel.

the exorcist's domain (*āšipūtu*), another text tells the scribe to preserve the secret knowledge of *āšipūtu* so that no one else may see it.[12]

The implications of designations such as "secret," and "exclusive" when applied to cuneiform scholarly texts has been the subject of some ambivalence among assyriologists. The first study by R. Borger[13] pointed to a seeming inconsistency between the variety of these texts' contents and their classification as secret or "esoteric." A. Livingstone maintains that texts so designated are not "esoteric" in the sense of being abstruse or recondite, although he concedes that "one need not doubt that certain texts or doctrines were only understood or held by a select few."[14] Neugebauer too granted only that the secrecy referred to in the colophons of astronomical tablets "merely expresses the tendency of the scribe to keep the knowledge of their arts within their own circles."[15] This is precisely the sense in which I take the term "esoteric," and find it well within bounds of the evidence. In no way do I see esotericism as implying incomprehensibility, only exclusivity. Another viewpoint was taken by Beaulieu, who expressed an openness to the possibility that an esoteric tradition existed in the late antique and medieval sense of "an intellectual approach seeking to comprehend the hidden relationships between the constituent elements of knowledge and the cosmic order."[16] Such a notion, as he rightly acknowledged, is so far not easily attributed to the cuneiform texts. There seems to me to be no reason, at least in our present state of awareness, to retroject any such notion from Late Antiquity to ancient Mesopotamia.

A sense of exclusivity and control over what scribes in earlier periods knew seems already to have prevailed with reference to the community of cuneiform scribes of the Sumerian "tablet school (é.dub.ba)" or the scribal bureaucracy of Ur during the reign of Shulgi (2094–2047 B.C.). N. Veldhuis described the é.dub.ba curriculum as having created a community of scribes unified by a certain corpus of literature and scholarship. The texts learned by that scribal community formed a common background and experience, which, as he put it, "may have helped the scribes to locate their identity and loyalty with the other scribes and administrators rather

[12] F. Köcher, *Die babylonisch-assyrische Medizin in Texten und Untersuchungen*, 6 vols. (Berlin: de Gruyter, 1943–1980), No. 322:90 (*niṣirti āšipūti uṣurma mamma la immar*).

[13] R. Borger, "Geheimwissen," in E. Weidner and W. von Soden eds., *Reallexikon der Assyriologie*, Vol. 3 (Berlin/New York: de Gruyter, 1964), pp. 188–91.

[14] Livingstone, *Mystical and Mythological Explanatory Works*, p. 1.

[15] Neugebauer, *ACT*, Vol. I, p. 12. Cf. R. Borger, "Geheimwissen," pp. 188–91.

[16] P.-A. Beaulieu, "New Light on Secret Knowledge in Late Babylonian Culture," *ZA* 82 (1992), p. 108.

than with their own clan or family."[17] P. Michalowski observed that the scribes of the bureaucracy at Ur at the end of the second millennium B.C., by virtue of their é.dub.ba education, shared "a common stock of ideas and attitudes which bound them together as a class and in many ways separated them from their original backgrounds."[18] He saw the scribes' textual corpus, comprised largely of epics, myths, and hymns written in Sumerian, as having forged "an exclusive club" of scribes.

Even if there were a tendency for communities and subcommunities of scribes to regard themselves as separate and exclusive, the question remains of why the explicit attribution of secrecy to certain tablets. Summarizing the genres of texts designated as secret or exclusive knowledge, J. Goodnick-Westenholz found lists of gods, stars, cult symbols, incantations, rituals, omens, medical texts, and astronomical texts, all of which genres belong to *ṭupšarrūtu*.[19] Although the notion of secret knowledge has generally been assumed to be late, that is, first millennium, in origin, Goodnick-Westenholz's particular thesis was "that the earliest lexical compilations may have been more than a utilitarian convenience for the scribes who wrote them; that they contained a systematization of the world order; and that at least one was considered as containing 'secret lore.'"[20] In contrast to the view that lexical lists were the practical result of the need to store data and to preserve the scribal school curriculum, that is, the lists were simply inventories and teaching tools,[21] Goodnick-Westenholz saw already in the early third millennium the notion of privileged, exclusive knowledge within the community of scribes.

[17] Niek Veldhuis, "Elementary Education at Nippur: The Lists of Trees and Wooden Objects," Ph.D. dissertation (Groningen: Rijksuniversiteit Groningen, 1997), p. 143.

[18] Piotr Michalowski, "Charisma and Control: On Continuity and Change in Early Mesopotamian Bureauratic Systems," in McGuire Gibson and Robert D. Biggs eds., *The Organization of Power: Aspects of Bureaucracy in the Ancient Near East,* Studies in Ancient Oriental Civilization No. 46, (Chicago: The Oriental Institute of the University of Chicago, 1987), p. 63.

[19] Joan Goodnick-Westenholz, "Thoughts on Esoteric Knowledge and Secret Lore," in Jiří Prosecký, ed., *Intellectual Life of the Ancient Near East, CRRAI* 43 (Prague: Academy of Sciences of the Czech Republic Oriental Institute, 1998), p. 456 and note 28.

[20] Goodnick-Westenholz, "Thoughts on Esoteric Knowledge," p. 451. This position resonates with the remarks of R. D. Biggs on the existence of a Sumerian literary tradition as early as the twenty-seventh and twenty-sixth centuries B.C., demonstrating that writing in this early period was not used simply for "practical" purposes, in "An Archaic Sumerian Version of the Kesh Temple Hymn from Tell Abū Ṣalābīkh," *ZA* 61 (1971), esp. pp. 193–95.

[21] Oppenheim, *Ancient Mesopotamia,* p. 248.

Often, but not exclusively, associated with "knowledge" or "wisdom" (*nēmequ*) was the god Ea, who, as creator and ally of humankind, was willing to divulge his secrets in the form of magic and *arcana mundi* to human beings. Indeed, the scribes' view that the authority behind the series *Enūma Anu Enlil*, as well as other omen, incantation, and ritual texts was the god Ea, appears in a catalog of texts and "authors."[22] The claim that the contents of secret texts stem ultimately from the "mouth" of a god seems to imply divine revelation in the process of transmission of these traditions to the ranks of scholars. An explicit story of such revelation is told about the antediluvian sage Enmeduranki, who was shown oil, liver, and celestial divination by Šamaš and Adad, the gods of divination.[23] The sage Enmeduranki in turn shared with "the men of Nippur, Sippar, and Babylon" the knowledge he had obtained from the gods, and the text continues with the promise that

the scholar, the one who knows, who guards the secrets of the great gods, will bind his son whom he loves with an oath before Šamaš and Adad by tablet and stylus and will instruct him.[24]

Such oral transmission of knowledge from a mythological sage is also found in the colophon of a medical text, in which the efficacy of the "salves and poultices" is vouched for by their source, that is, the lists prepared in accordance with the oral tradition of the sages, as transmitted by a sage from Nippur.[25] But in the metaphorical language of Akkadian hymnography, the primacy of texts is expressed in a line from a hymn to Gula, the goddess of healing, in which she says in self-praise, "I am the physician, I can save life, I carry every herb, I banish illness... I carry the texts which make (one) well."[26] Objects of "natural" knowledge, comprising phenomena of heaven and earth for purposes of divination and medicine, are found as the contents of texts. Viewed in this way, what one knows is not nature, but texts, and "secret knowledge," "belonging to the forbidden things of the gods," refers to the sanctity of texts, not of nature.

[22] See Chap. 5, note 47.
[23] See Chap. 5, notes 57 and 58.
[24] W. G. Lambert, "Enmeduranki and Related Matters," *JCS* 21 (1967), pp. 126–138.
[25] R. C. Thompson, *Assyrian Medical Texts From the Originals in the British Museum* (London/New York: H. Milford, Oxford Univeristy Press, 1923), No. 105 colophon; see *CAD* s.v. *apkallu* meaning 2a.
[26] Foster, *Before the Muses*, p. 495, lines ix 79–82.

As seen in the several examples previously quoted, the colophons make it clear that access to the tablets containing secret, exclusive knowledge was limited to scholars, who were often termed *mūdû* "the one who knows" or "the initiated," as in the statement found at the end of many text colophons, "the initiated may show (the tablet) only to the initiated (but not to the uninitiated)."[27] The designation *mūdû* seems to denote a person having acquired the secret knowledge of the texts as a result of study, rather than as a function of special intimacy with the god. The reference to "secret scholarly knowledge" (*niṣirti ummâni*) would seem therefore to be of a different nature from that of the antediluvian sages of literary tradition, who received knowedge directly from the god.[28] Nonetheless, once the scholar was instructed in the *niṣirti ummâni* and had sworn an oath "on tablet and stylus before Šamaš and Adad,"[29] he was to be considered a descendant of Enmeduranki the sage, who did receive knowledge of the divination series by divine revelation (expressed with the verb *šubrû* "to reveal"). Similarly, in a list of sages and scholars *(apkallus* and *ummânus)* preserved from the Bīt Rēš temple at Uruk from the mid-second century B.C., the scholars appear to be conceived of in an analogous way to the antediluvian *apkallus*. In the style of the Sumerian King List, the mythological sages of antediluvian kings are listed there as predecessors of the historical kings and their *ummânus*.[30]

One who had not entered the privileged group of the knowledgeable was *la mūdû* "the one who does not know." An interdiction against the *la mūdû* is specified in some colophons with the statement that for the uninformed to see the tablet belonged to the "forbidden things" of one or more of the gods. This taboo seems to go back to Middle Babylonian times in a text giving a list of gods and their divine symbols.[31] The latest sources in which this interdiction is expressed are the Seleucid period astronomical texts. Consider the following colophon from a lunar ephemeris written about 190 B.C.:

[27] See *CAD* s.v. *kullumu* meaning 4b, and Hunger, *Kolophone*, index s.v. *kullumu*.

[28] Colophons also make frequent reference to "secret" scholarly knowledge (*niṣirti ummâni*); see *CAD* s.v. *niṣirtu* meaning 1 e 2' and 3'. See also B. Foster, "Wisdom and the Gods in Ancient Mesopotamia," *Orientalia* NS 43 (1974), pp. 344–54.

[29] *JCS* 21 132 K.2486+ ii 20–21, with parallel in H. Zimmern, *Beiträge zur Kenntnis der babylonischen Religion*, Assyriologische Bibliothek XII (Leipzig: J. C. Hinrichs, 1896–1901), No. 24:22.

[30] Cited in Chap. 5, note 62.

[31] Hunger, *Kolophone*, No. 40.

On eclipses of the moon.

Tablet of Anu-bēl-šunu, lamentation priest of Anu, son of Nidintu-Anu, descendant of Sin-leqi-unninnī of Uruk. Hand of Anu-[aba-utēr, his son, scri]be of *Enūma Anu Enlil* of Uruk. Uruk, month I, year 12[1?] Antiochus [. . .] Whoever reveres Anu and Antu [. . .] Computational table. The wisdom of Anu-ship, exclusive knowledge of the god [. . .] Secret knowledge of the masters. The one who knows may show (it) to an[other one who knows]. One who does not know may not [see it. It belongs to the forbidden things] of Anu, Enlil [and Ea, the great gods].[32]

The secrecy and exclusivity of the scholars' knowledge, not to be disclosed to the "one who does not know," mark the particular body of knowledge that included divination, magic, medicine, and astronomy, from other fields or skills. As no testimony to the necessity of divine revelation as the method of access to the "secrets" is extant for the Mesopotamian diviners and scholars themselves, study would seem to be the only route. From this point of view, the secrecy of the scholarly texts seems to be of the sort associated with trade knowledge. The scholars' knowledge was safeguarded and protected from the uninformed, and the integrity of the discipline was thereby maintained. The practice of celestial divination, as well as of observational and mathematical astronomy, as represented in the letters and reports of the scholars as well as the diaries and ephemerides, suggests that the knowledge of celestial phenomena was derived by textual hermeneutics, empiricism, theoretization, and prediction. When a celestial omen specialist interpreted the meaning of a phenomenon by reference to the omen compendium, the authority of the interpretation was grounded in the text, not on a claim to divine inspiration. This corresponds well to the apparent distinction between divination and prophecy found elsewhere in Mesopotamian culture.[33] The interdiction against persons outside the circle of "knowers" reflects the efforts of a particular scribal body to maintain control over its tradition and to protect a particular body of knowledge. The special status of the tradition in the view of the scribes, however, is expressed in the claim that the knowledge contained in the tablets was transmitted from a divine source. Before we conjure up too extreme a picture of an exclusive learned society, however, it is worth noting that,

[32] *ACT* 135, reading of the date is uncertain; see *ACT* p. 19 for discussion, see Neugebauer, *ACT*, p. 19 colophon U, also published in Hunger, *Kolophone*, No. 98.

[33] See Chap. 2, Section 2.1.

as M. Stolper showed in the case of Bēl-ittannu of the fourth century
B.C., one and the same scribe has been discovered to participate in both
learned scholarship and clerical record-keeping. Stolper observed that "the
same men sometimes wrote texts of both sorts and sometimes stored their
archives and their libraries together. Excavated and reconstructed groups
of late Achaemenid tablets from Ur, Uruk, and Nippur that included legal
and administrative as well as scholarly and practical texts foster the same
view."[34]

W. Eamon has described the "secrets of nature" as "one of the most
prominent and most powerful metaphors in the history of science."[35] In his
analysis, "secret" knowledge becomes a way of expressing not only a deeper
knowledge of the phenomena beyond our ordinary sense perceptions,
but also comments on the privileged status of the one who has come to
know the deeper meaning of nature. Such "secrets of nature," as referred
to during the sixteenth and seventeenth centuries, do not function as a
meaningful metaphor in the context of cuneiform texts. As shown by the
colophons, more than one kind of text could be designated as secret or
as containing exclusive knowledge. The particular aspect of the metaphor
"secrets of nature" that connoted unknown things of the natural world
and that could be divulged through methods of inquiry has no parallel
in Near Eastern antiquity. The scribes' inquiries were directed toward the
manifest observable parts of the world, regardless of the fact that their
ideas of what phenomena meant, referring here of course to divination,
were taken as a matter of belief from what were regarded as authoritative
texts.

How can astronomical texts belong together with the other "secret" texts
of the scholarly tradition? Why did the scribes designate the contents
of astronomical texts in the same way as they did the copies of omens
or of rituals? If the term secret here describes valued knowledge whose
exclusivity was to be guarded, then astronomy is not different from celestial
or other omens, or indeed any of the other genres of text included within

[34] Matthew W. Stolper, "Lurindu the Maiden, Bēl-ittannu the Dreamer, and Artaritassu the
King,"in Barbara Böck, Eva Cancik-Kirschbaum and Thomas Richter, eds., *Munuscula
Mesopotamica: Festschrift für Johannes Renger*, AOAT 267 (Münster: Ugarit-Verlag, 1999),
p. 595. See also on the Nippur scribes of the Achaemenid period, Francis Joannès, "Les
archives de Ninurta-ahhê-bulliṭ," in Maria deJong Ellis, ed., *Nippur at the Centennial*,
Occasional Publications of the Samuel Noah Kramer Fund 14 (Philadelphia: Babylonian
Section, University Museum, 1992), pp. 87–100.

[35] William Eamon, *Science and the Secrets of Nature: Books of Secrets in Medieval and Early
Modern Culture* (Princeton, NJ: Princeton University Press, 1994), p. 351.

ṭupšarrūtu, in terms of the desire of the scribes to maintain dominium over the contents of these texts.[36]

6.2 THE SCRIBES OF *ENŪMA ANU ENLIL*

The title "*ṭupšar Enūma Anu Enlil*," although easily yet only literally translated as "scribe of *Enūma Anu Enlil*," is difficult to define. The common translation, "astrologer," by focusing on only one aspect of the *Enūma Anu Enlil* scribe's activities, conveys an inadequate and one-sided picture. No one-word English translation of *ṭupšar Enūma Anu Enlil* adequately defines the field of expertise of the *Enūma Anu Enlil* scribe without implying an anachronistically sharp distinction between astrologer and astronomer, and an implied distinction between pseudoscientist and scientist. Even more important, however, is that it is not simply a matter of establishing the relationship between astrology and astronomy, but of acknowledging the integration of both together with other practices belonging to Mesopotamian scribal scholarship as a whole. Text genres hitherto considered to be either exclusively astronomical or astrological, from the point of view of their content alone, might rather be seen as intimately related, and this connection is underscored by the horoscope corpus. In view of this, a fresh look at "the scribe of *Enūma Anu Enlil*" is warranted.

Textual sources from which one can piece together the range of responsibilities and expertise of a scribe of *Enūma Anu Enlil* are fortunately not limited to those on which the title appears, as these are surprisingly rare. In the Neo-Assyrian period, the available texts include one letter mentioning the "reports of the *ṭupšar Enūma Anu Enlil*s,"[37] one Babylonian report in which the writer Šumāia is the "scribe of *Enūma Anu Enlil* from the new team,"[38] and one administrative document listing the employees of the court in which seven *ṭupšar Enūma Anu Enlil*s head the list, two of whom are well known from the court correspondence and the astrological reports, that is, Ištar-šuma-ēreš and Balasî.[39] Ištar-šuma-ēreš is also named

[36] For discussion of secrecy and esoteric knowledge from late antiquity to the Renaissance, see Pamela O. Long, *Openness, Secrecy, Authorship: Technical Arts and the Culture of Knowledge From Antiquity to the Renaissance* (Baltimore/London: Johns Hopkins University Press, 2001).

[37] Parpola, *LAS* 60:13.

[38] Hunger, *Astrological Reports* 499 rev.5, and see A. L. Oppenheim, "Divination and Celestial Observation in the Last Assyrian Empire," *Centaurus* 14 (1969), p. 99.

[39] C. H. W. Johns, *Assyrian Deeds and Documents* (hereafter *ADD*) (Cambridge/London: Deighton, Bell and Co., 1898–1923), No. 851.

as an *ummânu* during the reigns of both Esarhaddon and Aššurbanipal. He was dispatched to inspect cultic objects for a temple[40] and consulted on the timing of religious festivals and offerings.[41] Two others, Nādin-ahhē and Nergal-šumu-iddina, are known outside the list of *ṭupšar Enūma Anu Enlil* as well.[42] The dearth of references to the title *ṭupšar Enūma Anu Enlil* is ascribable in part to the fact that these scribes held other titles as well. The "chief scribe," (*rabi ṭupšarri*, written LÚ.GAL.DUB.SAR or GAL.A.BA), for example, was a title associated with celestial omen scribes from the time of Sargon II. One such chief scribe was Gabbi-ilāni-ēreš, ancestor of the famous scholar Nabû-zuqup-kēna.[43]

The canonical *Enūma Anu Enlil* texts and their scholia are not at all informative about the scribes themselves because of the infrequent presence of – or preservation of – colophons to identify their names, ancestors, kings, or cities. However, although the canonical series represents a basic part of the knowledge of this group of scribes, and mastery of that text was obviously the chief defining feature of the "*Enūma Anu Enlil* scribe," evidence spanning the Neo-Assyrian to Arsacid periods points to the fact that the capabilities of the *ṭupšar Enūma Anu Enlil* were certainly not limited to the practice of celestial divination.[44]

As evidenced principally from the Neo-Assyrian period, *Enūma Anu Enlil* was the comprehensive celestial omen series on the basis of which educated royal advisers counseled their kings. The royal correspondence

[40] Parpola, *LAS* Part II, App N No. 62.

[41] See Parpola, *LAS* 5, 72, and 170.

[42] See Nādin-ahhē in Parpola, *Letters from Assyrian and Babylonian Scholars*, No. 255 rev.5 and ABL 447, in which he is mentioned as "assisting" the *ummâni* and working on the series É LÚ.GIG (*bīt marṣi*), and *LAS* Part II p. 458, Appendix N No. 28. For Nergal-šumu-iddina, see *LAS* 82, 83, and 84; also *ADD* 640. In none of these texts are these scribes designated by the title *ṭupšar Enūma Anu Enlil*, although the contents of their letters point to their specialization in matters of celestial divination and astronomy.

[43] Oppenheim, "Divination and Celestial Observation," p. 99; for Nabû-zuqup-kēna colophons, see Craig *AAT* 29, *CT* 33 11, H. Hunger, "Neues von Nabû-zuqup-kēna," *ZA* 62 (1972), p. 100; idem, *Kolophone*, pp. 90–5, Nos. 293–311; D. J. Wiseman, "ND 3579 and 3557," *Iraq* 17 (1955), p. 9; K2164+ rev.33ff., in Livingstone, *Mystical and Mythological Explanatory Works*, pp. 28–9 (K.2164+) and pp. 32–3 (K.2670). The fullest discussion of Nabû-zuqup-kēna may be found in Stephen J. Lieberman, "A Mesopotamian Background for the So-Called Aggadic 'Measures' of Biblical Hermeneutics?" *HUCA* 58 (1987), pp. 204–17.

[44] Gilbert J. P. McEwan, *Priest and Temple in Hellenistic Babylonia*, Freiburger Altorientalische Studien 4 (Wiesbaden: Franz Steiner Verlag, 1981), p. 16 has already made this point, but I am not persuaded by his interpretation of astrology as "an additional activity of other professions," confirmed in his view by the fact that the *ṭupšar Enūma Anu Enlil* did not constitute a separate clan as did the *kalû* or *āšipu*.

between Neo-Assyrian scholars and Kings Esarhaddon and Aššurbanipal shows that a number of the celestial omen experts also dealt with the incantations, rituals, and sacrifices necessitated by ominous signs. During the reigns of Esarhaddon and Aššurbanipal, the scribe Akkullānu, who was also an "Enterer of the temple (*erēb bīti*)" of Aššur,[45] carried out celestial observation and "research" in the *Enūma Anu Enlil* series and personally supervised the sacrifices he recommended be performed. A letter from Balasî to Aššurbanipal, dated to 667 B.C., in which Balasî reassured the king about a lunar eclipse, says that Akkulānu "will read and explain the report on the lunar eclipse to the king."[46] In another letter the same scholar reported to the king on revenues of the Aššur temple,[47] and on affairs concerning a variety of priests (LÚ.SANGA= *šangû*) about whom the king had inquired.[48] Being a scribe of *Enūma Anu Enlil* during the seventh century B.C., as portrayed in the Neo-Assyrian royal correspondence, seems to have involved not only knowing what to watch for in the heavens and when, as well as where to find the corresponding prognostication in the compendium *Enūma Anu Enlil*, but also required knowing what to do in magical or cultic terms about one's findings in the text and to advise the king accordingly. Balasî, known from the previously mentioned list of scholars as a *ṭupšar Enūma Anu Enlil*, is deferred to in matters of ritual correctness in a letter from Nabû-nādin-šumi as follows:

To the king, my lord: your servant Nabû-nādin-šumi. Good health to the king, my lord! May Nabû and Marduk greatly bless the king, my lord! Concerning what the king, my lord, said to me: "Discuss it with Balasî," I did so and he said: "He should sit down on the 15th and get up on the 22nd; on the 24th day the king should go down to the river and perform his ritual."[49]

In addition to the scholars' correspondence, a cultic text of uncertain date, but referring to the cult of Aššur, attests to the intimate connection between the activity of the cult and of celestial science. G. van Driel argues for this text's connection to Sennacherib's reconstruction of the Aššur temple and consequent reorganization of the cult of Aššur.[50] Following

[45] *ABL* 539; see Parpola, *LAS* Part II App.N no. 56, p. 463.

[46] Parpola, *LAS* 40 rev. 3'ff.

[47] According to Parpola, *LAS* Part II, p. 317.

[48] Parpola, *LAS* 309, 310, 312, and 314.

[49] Parpola, *Letters from Assyrian and Babylonian Scholars*, No. 276:1–12.

[50] For BM 121206, see G. van Driel, *The Cult of Aššur* (Assen: Van Gorcum and Comp. N.V.-Dr. H. J. Prakke and H. M. G. Prakke, 1969), pp. 77–119. For an updated edition, see B. Menzel, *Assyrische Tempel* II, Studia Pohl, Series Maior 10 (Rome: Biblical Institute Press, 1981), No. 35.

a list of days for the kettledrum performance before certain deities is a section assigning specific times at night for a ritual involving the king. The specified times at night begin on the 4th of the month *Nisannu* and are expressed in terms of the culminations of *ziqpu* stars[51] whereupon the king enters the temple of Aššur, or the temple of Ninlil, or the palace. Such culminating stars are known from astronomical texts such as MUL.APIN and later Babylonian lists of *ziqpus*.[52] Further specification of these times at night seems to be made by means of the waterclock, as the text gives the portion of the "*qapūtu*"-container (of water?) to be placed when a certain star culminates. Another ritual text refers to blessings to be said on the 29th day "in the morning for Bau, at noon for DINGIR.MAH, in the afternoon for Adad, (and) at night for Ištar."[53] This comment is of interest in connection with a Late Babylonian copy of the Astrolabe, which includes a section dealing with the *ziqpu* stars.[54] In this and a series of similar texts, data on the *mešhus* of Astrolabe stars, and the distances measured in degrees between a *ziqpu* star and the meridian on the day of last visibility of the moon (28th, 29th, or 30th) are schematized in the morning, midday, or afternoon. No hint of ritual application is evident in the astronomical text, but the day and time of interest in these texts is not explainable in an astronomical context. The relevance of the late Babylonian *ziqpu* texts to the Neo-Assyrian cultic reference to specific times for ritual actions may well be that, albeit from a later period, ostensibly astronomical texts could have functioned to explicate and instruct on the knowledge necessary for scribes responsible for the determination of ritual times by means of *ziqpu* transits. Similarly, for the use of the waterclock, portions of the *qapūtu*-container were to be filled when a certain star culminated. This would be within the field of knowledge of a *tupšar Enūma Anu Enlil*, whose expertise would therefore have practical application in a cultic milieu.

Another striking example of the connection between celestial divination and cult was the necessity of performing a substitute king ritual in the event of certain lunar eclipses. This phenomenon too is made clear in

[51] G. van Driel, *The Cult of Aššur*, pp. 90–92 (BM 121206 vii 20'–31' and viii 4'–5').

[52] Hunger-Pingree, *Astral Sciences*, pp. 68–70 and 84–89.

[53] C. Virolleaud, *Fragments de textes divinatoires assyriens du Musée Britannique* (London: Harrison and Sons, 1903), p. 19:9, see also idem, *Babyloniaca* 4 (1910), p. 105:20.

[54] See F. Rochberg, "A Babylonian Rising Times Scheme in Non-Tabular Astronomical Texts," in Charles Burnett, Jan Hogendijk, Kim Plofker and M. Yano, eds., *Studies in the History of the Exact Sciences in Honour of David Pingree* (Leiden: Bill, 2004), pp. 59–64, 68–72, and 73–7.

the letters to the Neo-Assyrian kings from scholars, such as the following passages from two letters of Mār-Ištar, writing from his post in Babylonia:

The substitute king, who on the 14th sat on the throne in [Ninev]eh and spent the night of the 15th in the palace o[f the kin]g, and on account of whom the eclipse took place, entered the city of Akkad safely on the night of the 20th and sat upon the throne. I made him recite the omen litanies before Šamaš; he took all the celestial and terrestrial portents on himself, and ruled all the countries. The king my lord should kn[ow] (this).[55]

[Damqî], the son of the prelate of Akka[d], who had ru[led] Assyria, Babylon(ia), [and] all the countries, [di]ed with his queen on the night o[f the xth day as] a substitute for the king, my lord, [and for the sake of the li]fe of Šamaš-šumu-uki[n]. He went to his fate for their redemption. We prepared the burial chamber. He and his queen were decorated, treated, displayed, buried and wailed over. The burnt-offering was made, all portents were cancelled, and numerous apotropaic rituals, Bīt rimki and Bīt salā' mê ceremonies, exorcistic rites, penitential psalms and omen litanies were performed to perfection. The king, my lord, should know (this).[56]

What is notable about the Assyrian and Babylonian scholars who observed the heavens and consulted Enūma Anu Enlil is that they were not confined in their activities to astrological and other divinatory matters. They possessed a broad knowledge of astronomy, including lunar and planetary periods not attested in the canonical Enūma Anu Enlil literature, and in addition, the apotropaic rites and incantations were also their province. The scholars of what Parpola has called the Ninevite "inner circle"[57] held advisory positions, as attested to amply in their letters. The basis on which these men advised the king stemmed from knowledge of a textual repertoire that included divination, ritual apotropaism, astronomical works, and presumably the observational and predictive methods required by such texts. Just how influential the high-ranking court scribes were is a matter of interpretation. The sources show that much advice was requested and given. Whether or not it was taken is unclear.[58] The element

[55] Parpola, LAS 279; also idem, Letters from Assyrian and Babylonian Scholars, No. 351:5–14. The "omen litanies" (naqbiāte ša ṭupšarrūte) refer, according to CAD s.v. naqbītu, to blessings recited during the performance of a ritual. Parpola interprets naqbiāte, here specified as "of the scholars," to refer not to prayers, but to omens.

[56] Parpola, Letters from Assyrian and Babylonian Scholars, No. 352:5–21. Note the mention again of the recitation of omens.

[57] LAS Part II, pp. xv–xx.

[58] See Koch-Westenholz, Mesopotamian Astrology, pp. 56–73.

of secrecy attested to in the colophons further unifies all the texts so des-
ignated, bringing divination and astronomy within a single classification.
In view of this, the boundaries between what we would call religious
and scientific bodies of knowledge become blurred or vanish altogether
when we try to reconstruct the intellectual milieu of the Neo-Assyrian
scholar.

Oppenheim's study of the Neo-Assyrian *Enūma Anu Enlil* scribes was
the first to outline essential aspects of the celestial diviner of the Sargonid
period. This important study[59] was derived mainly from an analysis of
the so-called astrological reports (*u'ilāti ša ṭupšarru* UD AN ᵈEN.LÍL), the
succinct communications of astronomical observations accompanied by
a collection of relevant omens extracted from the series *Enūma Anu Enlil*
by scribes in various cities of Assyria and Babylonia for the benefit of the
king.[60] Oppenheim called attention to the fact that "the same experts re-
port on and 'interpret' celestial events as well as such ominous occurrences
as the birth of abnormal animals, or incidents which are typical of the sort
dealt with in the compendium called Šumma-ālu," and that this "should
prevent us from talking of them as 'astrologers.' They are simply experts
in all those fields of divination which are outside extispicy."[61] This point
should be extended even further to include expertise in astronomy and in
the magical and incantational literature that supported the practice of div-
ination. The solution to the translation problem, though, is not to negate
the *ṭupšar Enūma Anu Enlil*'s role as astrologer in favor of a culturally
neutral term like "expert," but rather to emphasize the interactive rela-
tionship between the study of astronomical phenomena, the management
of religious life and also, in the Sargonid period, the impact on politics
which was effected by these scholars.

Access to the careers of Neo-Babylonian scholars, those who flourished
during the sixth century B.C., is more restricted, as a correspondence be-
tween them and the Chaldean dynasts, comparable with that between
Sargonid kings and their scholars, does not survive. Five Neo-Babylonian
"letter orders," in this case from the temple archive at Sippar,[62] record

[59] Oppenheim, "Divination and Celestial Observation."

[60] For text editions, see H. Hunger, *Astrological Reports*.

[61] Oppenheim, "Divination and Celestial Observation," p. 99.

[62] From the Ebabbar temple, cited by Paul-Alain Beaulieu, *The Reign of Nabonidus King of Babylon 556–539* B.C., Yale Near Eastern Researches 10 (New Haven, CT London: Yale University Press, 1989), p. 8. Also Hallo, "The Neo-Sumerian Letter Orders," *BiOr* 26 (1969), pp. 171–6, and Oppenheim, review of Figulla, UET IV in *JCS* 4 (1949), p. 195.

royal orders (three from Nabonidus[63] and two from Cyrus[64]) to give food
and beer rations to Babylonian scholars (*ummânu*) who have been sent to
the temple Ebabbar in Sippar to find and excavate the old foundations. Al-
though titled solely "scribe" (DUB.SAR/*tupšarru*), one Nabû-zēr-lišir func-
tioned as a royal scribe–scholar through the reigns of Neriglissar to the
eighth year of Nabonidus.[65] Beaulieu, with Joannès, view this scholar as
an *ummânu*, whose training, evidenced in the orthography of the texts
written by him, selected him for work in old inscriptions found in the
excavations of the *bīt akītu* at Agade conducted by Nabonidus.[66] Further
evidence of Nabonidus' connection to his scholars shows him assembling
them before the restoration of sacred buildings to supervise excavation,
or to perform other tasks in accordance with tradition.[67] The impression
given in these inscriptions is that the Neo-Babylonian scholars' workplace
was not the palace but a separate scribal institution termed the *bīt mummu*,
sometimes denoting a workshop of some kind, but which Beaulieu has
translated as the "temple academy."[68] In one of Nabonidus' royal inscrip-
tions, the "wise scribes who dwell in the temple academy" are mentioned
as guarding "the secrets of the great gods."[69]

Although the connection of the Neo-Babylonian scribes to the temple
and the cult is evident, texts from the reign of Nabonidus are lacking
that attest to the scholars' dealings with celestial divination, and so the
title *tupšar Enūma Anu Enlil* is not found. The oft-quoted inscription
concerning the "request of Sin" in the form of a celestial omen protasis
("on the 13th day the moon was eclipsed and set while eclipsed") and
apodosis ("his decision") for consecration of an *entu*-priestess at Ur reflects
the desire of Nabonidus to verify a celestial sign by means of extispicy.[70]

[63] I. N. Strassmaier, *Inschriften von Nabonidus, König von Babylon* (Leipzig: Pfeiffer, 1889),
 Nos. 56 (second year of Nabonidus), 407, and 409 (both tenth year); see Beaulieu, *The
 Reign of Nabonidus*, pp. 7–11.

[64] J. N. Strassmaier, *Die Inschriften von Cyrus, König von Babylon*, Babylonische Texts 7
 (Leipzig: Pfeiffer, 1890), No. 103 and *CT* 55:321.

[65] Beaulieu, *The Reign of Nabonidus*, p. 142, and Francis Joannès, "Un lettre neo-babylonien,"
 NABU (1988), p. 55, apud Beaulieu.

[66] Beaulieu, *The Reign of Nabonidus*, p. 142.

[67] Ibid., pp. 7–12.

[68] Ibid. pp. 7–8. This translation seems reasonable given other references to the *bīt mummu*.
 that indicate its ties both to the work of scribes as well as to cultic ritual; see *CAD* s.v.
 mummu A in *bīt mummu*.

[69] Langdon, *Die neubabylonischen Königsinschriftem*, VAB 4, p. 256i 32–33.

[70] YOS 1 45; see the discussion in Reiner, *Astral Magic*, pp. 76–77.

But here no scholars are mentioned. The result of the evaluation of both celestial and liver divination was the consecration of Nabonidus' daughter En-nigaldi-Nanna as priestess at Ur, and a reorganization of the cult, suggesting the continuing intersection of the two domains of divinatory science and cultic matters in this period.[71] Beaulieu points to "an increased involvement of the monarchy in temple affairs" under Nabonidus, but for chiefly economic reasons, that is, to control the estates of the Eanna temple.[72]

The connection between the activity of astronomy and the ceremonial activities of the temple and its personnel continues after the fall of the Neo-Babylonians. From two administrative documents recording depositions made before an authoritative body of the Eanna temple at Uruk, it is known that the performance of a ritual against the effects of a lunar eclipse, perhaps similar to such a ritual referred to in the Neo-Assyrian correspondence,[73] took place on the 13th day of Month III in the eighth year of Cyrus, two days before the case was brought before the authorities.[74] In the testimony of the witnesses, is was stated that "after sunset, the *kalûs* of the Ebabbar played the copper kettledrum at the gate of the Ebabbar[75] and declared as follows: 'eclipse!'" The nature of the controversy over this ritual, necessitating a second deposition recorded three days later, is of less relevance here than is the fact of the ritual and its relation to other attested apotropaic eclipse rituals performed by the temple singers and percussionists, the *kalûs* who specialized in the ritual preparation and playing of the kettledrum that often accompanied the ritual singing of lamentations.[76]

After the fall of the Neo-Babylonian Empire, the progress of astronomy becomes abundantly clear in the sharp increase not only in the numbers but the quality of extant astronomical texts of the late Babylonian period, primarily from the Seleucid Era. The Bīt Rēš sanctuary at Uruk, from

[71] See Beaulieu, *The Reign of Nabonidus*, p. 131.

[72] See ibid., pp. 103–4 and 124–6.

[73] Parpola, *Letters from Assyrian and Babylonian Scholars*, No. 347:5–10.

[74] P.-A. Beaulieu and J. P. Britton, "Rituals for an Eclipse Possibility in the 8th Year of Cyrus," *JCS* 46 (1994), pp. 73–86.

[75] The second deposition text reports the scene of the ritual as the gate of the Eanna temple, see Beaulieu and Britton, "Rituals for an Eclipse Possibility," p. 76 line 19.

[76] For an ancient representation of the kettledrum (*lilissu*), see the drawing on *TCL* 6 47 with the caption ^dLIDXDÚB (=*lilissu*), and F. Thureau-Dangin, "Un Acte de Donation de Marduk-Zâkir-Šumi," *RA* 16 (1919), pp. 154–5. The text is republished in A. Livingstone, *Mystical and Mythological Explanatory Works*, pp. 194–5.

which many astronomical texts survive, was a prominent center for the cult of Anu, the sky god. A number of views on the dating of the inception of this cult have been offered. J. Oelsner conjectured that its beginnings are to be associated already with the building of the forerunner to the temples Bīt Rēš and the Irigal in the Late Achaemenid period.[77] Similarly, A. Kuhrt suggested that, contrary to the usual Seleucid period dating of the rise of the gods Anu and Antum within the Uruk pantheon, an earlier dating to the fifth or early fourth century be considered on the basis of many Achaemenid personal names containing the theophoric element Anu.[78] She sees this change, however, as a result of influence from the cult of the Iranian sky god Ahura-mazda.[79] The appearance of horoscopes and the transmission of celestial and terrestrial omens from Babylonia to India during the Achaemenid period were, in Kuhrt's view, related phenomena also in response to Iranian ideas. Certainly if the change in the cult can be dated to the Achaemenid period, then there would be coincidence with the change in the scholarly traditions of celestial science. The appearance of horoscopes, however, can be accounted for without appealing to outside influence.

Beaulieu presented evidence in the form of the name (AN.ŠÁR-*bēl-uṣur*) of the *qēpu* official of the Eanna temple at Uruk in the mid-seventh century B.C. as well as a number of references to the temple of Aššur at Uruk, to suggest that a cult of the Assyrian god AN.ŠÁR/Aššur, identified with Anu at Uruk, was already installed in that city during the period of Assyrian domination of Babylonia. Beaulieu construes this evidence to signal the renewal of the cult of the sky god Anu at Uruk before the Achaemenid conquest. He sees this Assyrian import as preliminary to the transformation of the Anu cult at Uruk during the Achaemenid period (latter part of fifth century B.C.), which brought about the building

77 Joachim Oelsner, *Materialien zur babylonischen Gesellschaft und Kultur in hellenistischer Zeit*, Assyriologia VII (Budapest: Eötvös University, 1986), p. 95.

78 A. Kuhrt, "Survey of Written Sources Available for the History of Babylonia under the Later Achaemenids," in H. Sancisi-Weerdenberg, ed., *Achaemenid History I: Sources, Structures and Synthesis* (Leiden: Nederlands Instituut voor het Nabije Oosten, Proceedings of the Groningen 1983 Achaemenid History Workshop, 1987), p. 151; R. J. van der Spek, "The Babylonian City," in A. Kuhrt and S. Sherwin-White, eds., *Hellenism in the East* (Berkeley, CA: Los Angeles: University of California Press, 1987), p. 70.

79 For the relationship between Aššur and Ahura-mazda, see W. Mayer, "Der Gott Assur und die Erben Assyriens," in R. Albertz ed., *Religion und Gesellschaft. Studien zu ihrer Wechselbeziehung in den Kulturen des Antiken Vorderen Orients*, AOAT 248 (Münster: Ugarit-Verlag, 1997), pp. 15–23.

of the new and enlarged temple É.SAG (*Bīt Rēš*). At this time, Anu is equated with the two previously supreme deities of Babylonia, Marduk and Enlil, taking on their epithets and their liturgy.[80] This thesis entertains the possibility of an Assyrian theological tradition's influencing the rise of Anu in Uruk after Anu had been eclipsed by Ištar, patron deity of Uruk, and would further provide a context within which the focus on the sky god and the increase in the activity of "astrology" in Mesopotamia can be seen as a wholly native tradition independent of influence from Persia.

The Achaemenid period saw the beginnings of the astronomical interests and methods that were to be more fully developed in the Seleucid period. Early Saros cycle texts from the Achaemenid period list dates of possible lunar and solar eclipses, arranged by 18-year (223-month) cycles.[81] Lunar longitudes at syzygy, as well as parameters of column Φ and column F of System A are attested, and also longitudes of Mercury at last visibility.[82] Such texts show that the mathematical astronomical methods characteristic of the late Babylonian ephemerides were being developed during the Achaemenid period, that is, by the end of the fifth or beginning of the fourth century B.C. Britton is convinced about this development, particularly of the invention of the lunar theory, which he places 200 years before the Seleucid Era.[83] This is coincident with the suggested dating of the transition in the Uruk cult, although a connection remains ill-defined.

In the Seleucid period, with the increase in extant astronomical and otherwise scholarly texts of the various divination series, the *ṭupšar Enūma Anu Enlil* reemerges. The picture remains consistent in some respects with what we have found earlier, with implications for an esoteric conception of knowledge and for a continued relationship rather than progressive separation of divination and magic from astronomy. In the late fourth

[80] Paul-Alain Beaulieu, "The Cult of AN.ŠÁR/Aššur in Babylonia after the Fall of the Assyrian Empire," *State Archives of Assyria Bulletin* 11 (1997), pp. 55–73.

[81] Aaboe, Britton, Henderson, Neugebauer, and Sachs, *Saros Cycle Dates and Related Babylonian Astronomical Texts.*

[82] Ibid., texts L, F, and M and S. See also J. P. Britton, "An Early Function for Eclipse Magnitudes in Babylonian Astronomy," *Centaurus* 32 (1989), pp. 1–52.

[83] J. P. Britton, "Scientific Astronomy in Pre-Seleucid Babylonia," pp. 61–76, and more recently, his "Treatments of Annual Phenomena in Cuneiform Sources,"in John M. Steele and Annette Imhausen, eds., *Under One Sky: Astronomy and Mathematics in the Ancient Near East*, AOAT 297 (Münster: Ugarit Verlag, Alter Orient und Altes Testament, 297, 2002), pp. 52–3.

century,[84] the Urukian scribe Iqīšâ, although not a *ṭupšar Enūma Anu Enlil* himself but rather an exorcist *(āšipu/*MAŠ.MAŠ)[85] and enterer of the temple *(ēreb bīti)* of Anu and Antu, provides a relevant case. He was a member of the clan of Ekur-zākir, an *āšipu*, chief priest of Anu and Antu, and *ṭupšar Enūma Anu Enlil* of Uruk.[86] The breadth of Iqīšâ's learning is represented by the tablets of which he was either "owner" *(ṭuppi* Iqīšâ, lit. "tablet of Iqīšâ") or copyist *(qāt* Iqīšâ, lit. "hand of Iqīšâ"). This collection of tablets was found in a private house at Uruk, evidently the remains of Iqīšâ's personal library. Among the works identified as belonging to Iqīšâ are omens, both celestial *(Enūma Anu Enlil)* and terrestrial *(Šumma ālu, Šumma izbu,* and medical diagnostic), commentaries, incantations, lexical tablets (vocabularies and synonym lists, for example, the lexical series HAR.RA = *hubullu* IX and the lexical series erimhuš = *anantu* V), and astronomical texts, including an ephemeris computed by the scheme of "System A."[87] Iqīšâ is also known to have prepared two tablets coordinating dates (months and days),[88] "regions" of zodiacal signs *(qaqqar* MUL. such-and-such), and magic.[89] Despite the fact that Iqīšâ himself was not a *ṭupšar Enūma Anu Enlil,* although his ancestry claimed Ekur-zākir who did hold that title, the integration of scribal learning and ritual with mathematical astronomy is similar to the profile of the Neo-Assyrian court intellectuals who held the title *ṭupšar Enūma Anu Enlil.*

In the second century, another scholar from Uruk, Anu-aba-utēr, a *ṭupšar Enūma Anu Enlil,* of the prestigious Sin-leqi-unninnī family, produced texts of astronomical content, such as the System A Jupiter

[84] Dated colophons place Iqīšâ during the reign of Philipp Arrhidaeus, between 323 and 316 B.C.

[85] W. Farber, "Neues aus Uruk: Zur Bibliothek des Iqīša," *WO* 18 (1987), p. 29, note 11 and McEwan, *Priest and Temple,* p. 73.

[86] See the colophon of K.3753, photo published in Weidner, *Gestirn-Darstellungen,* Tf. 11/12, and transcription in McEwan, *Priest and Temple,* pp. 174–76.

[87] Hermann Hunger, *Spätbabylonische Texte aus Uruk,* Teil I Ausgrabungen der Deutschen Forschungsgemeinschaft in Uruk-Warka, Band 9, (Berlin: Gebr. Mann Verlag, 1976), No. 98.

[88] See O. Neugebauer and A. J. Sachs, "The 'Dodekatemoria' in Babylonian Astrology," *AfO* 16 (1952–53), pp. 65–6.

[89] *BRM* 4 19 and 20, and note the more complete duplicate in O. R. Gurney and P. Hulin, *The Sultantepe Tablets,* Vol. 2 (London: The British School of Archaeology at Ankara, 1964), No. 300. Erica Reiner discusses one of the text's magical acts, associated with a love charm(?) "to make a woman talk," in "Nocturnal Talk," T. Abusch, J. Huehnergard, and P. Steinkeller, eds., *Lingering Over Words: Studies in Ancient Near Eastern Literature in Honor of William L. Moran* (Atlanta, GA: Scholars Press, 1990), pp. 421–4.

ephemeris for first stations (*ACT* 600), as well as those of astrological content, as for example the "illustrated" text containing lunar-eclipse omens, microzodiacal signs and associations with cities, temples, stones, and plants.[90] Some of the associations in the latter text relate to the "opening of the gate" (*pīt bābi*) ceremony performed at dawn in the temple, marking the end of the night vigil and so reveal a connection to the cult in addition to the more obvious astrological aspect of the text.[91] As shown in various mathematical astronomical text colophons, this scribe not only held the title *ṭupšar Enūma Anu Enlil*, but also that of *kalû Anu u Antu*. The *kalû*, as previously seen in the context of the eclipse ritual, was a specialist in the lamentation liturgy, and who, among other duties, sang and recited prayers and lamentations to the accompaniment of the drum and harp. Anu-aba-utēr's father, Anu-bēlšunu, mentioned already in the course of this study,[92] is similarly known to have copied and collected texts including omens, rituals, lamentation, and other religious matters (the measurement of the Esagila, the Marduk temple in Babylon[93]). In a manner reminiscent of the case of Bēl-ittannu in the fourth century,[94] Pearce and Doty have shown that Anu-bēlšunu too not only functioned as a scholar but also applied his skills as a scribe to the business end of real estate.[95]

In terms of the fields of knowledge and relevant literature comprising the *ṭupšar Enūma Anu Enlil*'s discipline, the nature of the *ṭupšar Enūma Anu Enlil* in the late Babylonian evidence seems not so very different from that of its Neo-Assyrian counterpart. Evidence for the advisory role of the scribes in the later periods, however, is not traceable. As to the employment of these later counterparts to the Neo-Assyrian scholars, from Achaemenid times onward, there is no evidence that they belonged to the palace administration. On the other hand, whether they were all in the service of the major temples is difficult to pin down. Some of the scribes producing ephemerides and procedure texts for which colophons remain

[90] VAT 7815; Weidner, *Gestirn-Darstellungen*, p. 47.

[91] Weidner, *Gestirn-Darstellungen*, p. 24f., McEwan, *Priest and Temple*, p. 165–6.

[92] See Subsection 1.2.2.

[93] See A. R. George, *Babylonian Topographical Texts* (Leuven: Uitgeverij Peeters, 1992), pp. 109–118, especially the colophon on p. 118:6–7.

[94] See Section 6.1.

[95] Laurie E. Pearce and L. Timothy Doty, "The Activities of Anu-belšunu, Seleucid Scribe," in J. Marzahn and H. Neumann, eds., *Assyriologica et Semitica, Festschrift für Joachim Oelsner anläßich seines 65. Geburtstages am 18. Februar 1997*, AOAT 252 (Münster: Ugarit-Verlag, 2000), pp. 337–40.

appear to be working within the temple institution during the Seleucid period. But, as Brinkman has pointed out, there were private scribes in the first millennium (not, however, *ṭupšar Enūma Anu Enlil*) producing Babylonian chronicles who were not connected to the temple and who held no official titles.[96]

During the Seleucid period, as shown by S. Sherwin-White and A. Kuhrt, the Marduk temple in Babylon, the Esagila, and its administration were still indispensable to the Seleucid government in providing a venue for the demonstration of the king's power and piety achieved by the performance of ceremonies and rituals there.[97] As attested in late astronomical diaries, offerings and dedications "for the life of" the king and his family were also provided by the administrator of Esagila, as in the following diary from the second century:

> The 5th, the commander of the troops of Babylonia who was against? the 4 presidents entered Babylon. The 6th, at the.... gate [....] Kasikila, the administrator of Esangil and the Babylonians provided an ox and 5 (sheep) sacrifices to [the commander of the troops of Babylo]nia; he performed offerings to Bēl, Bēltija, the great gods, and for the life [of] king Seleucus, his wife, and his sons. That? day, [....] went out from Babylon to Seleucia which is on the Tigris and the royal canal [....][98]

The king is also noted as making sacrifices at Esagila:

> [....] the king entered Babylon from Borsippa [....] went up to Esangil. Cattle and sheep [he sacrificed] to Bēl, Bēltija, and the great gods [....][99]

Scholarly opinion varies over whether Seleucid kings rebuilt the temple Esagila,[100] but explicit comment to this effect appears in an astronomical diary that notes, "That month, work on the terrace and the building

96 J. A. Brinkman, "The Babylonian Chronicle Revisited," in T. Abusch, J. Huehnergard, and P. Steinkeller, eds., *Lingering Over Words: Studies in Ancient Near Eastern Literature in Honor of William L. Moran*, Harvard Semitic Studies 37 (Atlanta, GA: Scholars Press, 1990), p. 75 with note 13.

97 See the discussion of the royal state cult of Antiochus III in Susan Sherwin-White and Amélie Kuhrt, *From Samarkhand to Sardis: A New Approach to the Seleucid Empire* (Berkeley, CA/Los Angeles: University of California Press, 1993), pp. 202–3 and 216.

98 Sachs–Hunger, *Diaries*, No. −178 rev. 18′–22′, and cf. No. −204 rev. 14–18, No. −171 rev. 1′–7′, No. −137 rev.23, No. −136 rev. 13′, No. −132 D₂ rev. 13′–14′, No. −129 A₁ 13′–15′, A₂ 18′–24′, No. −126 A: 9′, No. −126 B rev.6′–11′

99 Sachs–Hunger, *Diaries*, No. −187 rev. 17′–18′.

100 For discussion and bibliography, see Susan B. Downey, *Mesopotamian Religious Architecture: Alexander Through the Parthians* (Princeton, NJ: Princeton University Press, 1988), p. 10.

of... of Esangil was done."[101] A few other documents make mention of activities at that temple, suggesting that it was indeed maintained. One such text details a seasonal (solstitial?) festival performed there in concert with the Nabû temple Ezida in Borsippa, in which "the daughters of Esagila" go to Ezida in Month IV and the "daughters of Ezida" go to Esagila in Month IX, because Esagila is the "House of Day," or "day temple," and Ezida is the "House of Night," or "night temple."[102]

The other site from which Seleucid period astronomical texts have come is the Bīt Rēš temple complex of Anu and Antum at Uruk. An inscription dated to 244 B.C. (S.E. 68), in the reign of Antiochus II, attests to building activity at this temple and the vitality of the Uruk sanctuary:

In *Nisan* of Year 68 of King Seleucus, Anu-uballiṭ, the son of Anu-ikṣur, of the Ah'utu family, *šaknu* (governor) of Uruk, on whom Antiochus, King of Lands, bestowed the other name Nikarchos, completely built the Rēš(-sanctuary), the temple of Anu and Antum; the 'Exalted Gate', the great door, the socket of Papsukkal, the entrance to the Rēš(-sanctuary), the great door, the socket of Nusku, the entry door, – two doors that open towards the north-east – ; the 'Gate of Abundance'; the Gate that admits the produce of the mountains, – in all three gates, which open outwards; – seven courts, around the courtyard in which the 'Shrine of Destinies' is; the enclosure wall of the Rēš(-santuary); the work rooms; the cellae of the great gods and their courts. (He) constructed doors of sweet- smelling woods, fastened them to their posts, surrounded the temple with battlements, a gold bolt, a gold door-post he made and fixed to the outside of the 'Exalted Gate', for the life of Kings Antiochus and Seleucus he built (all this) in its entirety. On 8 *Nisan* he made Anu and Antum enter and caused them to dwell for ever in the cella Enamenna in their shrines; *ginû*- and *satukku*-offerings he established in there as earlier.[103]

In 201 B.C. this shrine was rebuilt and enlarged by Anu-uballiṭ-Kephalon.[104] S. Downey remarked that "the Anu-Antum temple with its

[101] Sachs–Hunger, *Diaries*, No. – 182 rev. 11–12.

[102] E. Unger, *Babylon: Die heilige Stadt nach der Beschreibung der Babylonier* (Berlin: de Gruyter, 1931, reprinted 1970), p. 271 no. 14, and F. Wetzel, *Das Babylon der Spätzeit*, Wissenschaftliche Veröffentlichung der Orient-Gesellschaft 62 (Berlin: Gebr. Mann Verlag, 1957), p. 73, no. 32. See also A. Livingstone, *Mystical and Mythological Explanatory Works*, p. 255.

[103] YOS I 52; see A. Falkenstein, *Topographie von Uruk I: Uruk zur Seleukidenzeit*, Ausgrabungen der Deutschen Forschungsgemeinschaft in Uruk-Warka 3 (Leipzig: Harrassowitz, 1941), pp. 4–5, and cited in Sherwin-White and Kuhrt, *From Samarkhand to Sardis*, p. 150.

[104] See Falkenstein, *Topographie*, pp. 6–9 and 45–9, and the description of the temple remains in Downey, *Mesopotamian Religious Architecture*, pp. 22–8.

associated ziggurat was the most important religious structure in Uruk during the Seleucid period, although in earlier times Eanna, the shrine of the goddess Inanna, had greatly overshadowed it in importance. The sky god Anu thus replaced Inanna as the most important deity of Uruk."[105] According to Downey, the Anu ziggurat, located beside the Bīt Rēš complex, was not only the largest in Mesopotamia, but the only one dedicated to the god of the heavens. She argues for a brief "renaissance of Babylonian religion in Uruk" during the Seleucid period, citing the hymn to Anu and the text concerning the Akītu festival, both dated to s.e. 61.[106] This revival was to terminate in the Parthian conquest of 141 B.C., in which these buildings were destroyed by fire and replaced at least in part with residential quarters. Other evidence suggests the end came somewhat later, even as late as the reign of Mithridates II (123–88 B.C.)[107]

From 208/7 to 151/0 B.C., however, according to the dates preserved in colophons of the astronomical table texts, the astronomers worked within the Rēš sanctuary of the Anu temple.[108] Given the institutional context for astronomy in this period, the invocations to Bēl and Bēltīja in the Babylonian astronomical texts and horoscopes, and to Anu and Antu in those from Uruk,[109] become understandable. Why the āšipus or kalûs who also held the title ṭupšar Enūma Anu Enlil were part of the temple organization is very possibly tied to their authority in matters of ritual. In view of the advisory role of some of the Neo-Assyrian ṭupšar Enūma Anu Enlils on celestial science and cultic ritual, some of which involved specified times at night or the making of offerings in concert with particular phenomena, the astronomical activities of Late Babylonian scribes are easier to understand in the context of temple life. The ability to make the observations and computations of select astronomical moments could have been an important component of the daily activities of the temple scribes when the performance of religious rites or festivals were associated with such times. An example of just such a use of astronomy in

[105] Downey, *Mesopotamian Religious Architecture*, p. 17.

[106] Ibid. note 77. See Falkenstein, *Topographie*, pp. 45–9 and F. Thureau-Dangin, *Rituels accadiens* (Paris: Leroux, 1921).

[107] See Downey, *Mesopotamian Religious Architecture*, p. 17.

[108] An ephemeris dated 273/2 B.C. from Uruk is also known; see Hunger, *Spätbabylonische Texte aus Uruk*, pp. 100–101 (No. 98). É.SAG in *ACT* Colophon H:4 and É.ZAG ibid. Colophon V:9.

[109] The invocation is also (anomalously ?) attested in an administrative text from Seleucid Uruk, NBC 8456; see Paul-Alain Beaulieu, "The Impact of Month-Lengths on the Neo-Babylonian Cultic Calendars," *ZA* 83 (1993), p. 79, Text 5:1.

the cultic functioning of the temple is evidenced in the ritual performed to dispel evil in the event of a lunar eclipse. As Steele surmised in his study of the prediction of eclipse times, references to the time of the beginning of an eclipse relative to sunrise or sunset could have had nonastronomical motivation. This conjecture was confirmed by the text of a Seleucid period ritual from Uruk to ward off the dire portents of an eclipse, indicating what parts of the ritual were to take place in accordance with significant times of the eclipse, that is, the beginning of the eclipse, when the eclipse "is as two-thirds disk," and when the eclipse clears.[110] Preparation for this elaborate ritual, involving the playing of percussion instruments, singing, ritual mourning, pouring out a circle of flour, and the purification of gates and buildings, could well have benefitted from the prediction of eclipses. The practical application of predictive astronomical methods appears in this instance to be plausibly integrated not only with cultic activities but also with the practice of divination, as the necessity to avert the forebodings of this celestial sign was not obviated by prediction of eclipses.

For those scribes under the patronage of the temple in Arsacid Babylon, evidence of the employment of astronomers comes from an administrative text from the Esagila. This tablet was written roughly fifty years before the last extant astronomical diary (61 B.C.) and represents a protocol from a session of the temple assembly and its administrator, the *šatammu*, in which the decision to transfer silver and arable land as payment from one scribe of *Enūma Anu Enlil* to another. It is of great interest for its stipulation of the duties of these scribes, particularly in the correspondence between the terms for these duties used in the temple protocol and those derived from rubrics of astronomical texts[111]:

On the 15th of *Ṭebētu*, year 129 A.E., which is year 193 S.E., we had drawn up a memorandum concerning our comon property, (namely) that one mina of silver in the rate of exchange of Babylon, as well as the arable land of Bēl-aba-uṣur, the scribe of *Enūma Anu Enlil*, son of Bēl-rīmannu, the scribe of *Enūma Anu Enlil*, which he enjoyed for carrying out celestial observation, we had assigned to Nabû-apla-uṣur, *kalû* priest and scribe of *Enūma Anu Enlil*, son of Nabû-mušētiq-ūdi.

[110] See J. M. Steele, "Eclipse Prediction in Mesopotamia," *Archive for History of Exact Sciences* 54 (2000), p. 431, and David Brown and Marc Linssen, "BM 134701=1965–10–14–1 and the Hellenistic Period Eclipse Ritual from Uruk," *RA* 91 (1997), pp. 147–65.

[111] See R. van der Spek, "The Babylonian Temple during the Macedonian and Parthian Domination," *BiOr* 42 (1985), p. 555, and F. Rochberg, "Scribes and Scholars: The *ṭupsar Enūma Anu Enlil*," in J. Marzahn und H. Neumann, eds., *Assyriologica et Semitica: Festschrift für Joachim Oelsner*, AOAT 252 (Munster: Ugarit-Verlag, 2000), Appendix pp. 373–75.

Now, however, Bēl-uṣuršu, the scribe of *Enūma Anu Enlil*, son of Bēl-aba-uṣur who was mentioned before, having appeared in court before us all, persuaded(?) us that he is able to make all the astronomical observations. We have seen that he is capable of carrying out the activity of keeping watch to its fullest extent, and we have approached Nabû-apla-uṣur who was mentioned before, (to the effect) that the arable land and the one mina of silver, the support ration of the said Bēl-aba-uṣur, father of this Bēl-uṣuršu, he (Nabû-apla-uṣur) will release before us and will clear of any claim. Regarding this, Bēl-uṣuršu, who brought the claim before us concerning the one mina of silver in the rate of exchange of Babylon and the arable land which was mentioned before, from this year on, every year from the current one, from the silver of our supplies we shall give him (Bēl-uṣuršu). He will carry out the celestial observation. He will provide *tersētu*-tablets and almanacs with Lābâši, Mūrānu and Marduk-šāpik-zēri, sons of Bēl-bullissu, Bēl-ahhē-uṣur, Nabû-mušētiq-ūdi, descendants of Itti-Marduk-balāṭu and with the other scribes of *Enūma Anu Enlil.*

Of particular interest are the tasks for which the astronomers are being paid, that is, to carry out regular celestial observation and to provide specific types of astronomical records, the *tersētu* tablets and almanacs. Each of these corresponds to text titles found in the rubrics of extant astronomical texts: the *naṣāru* "observation" corresponds to the rubric of the diaries, *tersētu* "computed tables," might be the ephemerides, and *mešhi*.MEŠ "measurements" is a term found in the rubric of almanacs. These texts represent the full range of astronomy in the late period, that is, from the observational to the predictive.

Regardless of the way astronomy functioned within the temple institution, association with the temple was without doubt the key to the survival of Babylonian astronomy for so many centuries after it had become seemingly defunct in the political sphere. We do not have information on the relationship between the Hellenistic monarchs and the cuneiform scribes who specialized in this branch of esoteric learning. At Babylon, at least, the occupation of the scribes with celestial observation and the preparation of ephemerides and other astronomical texts reminds us of the artificial separation made by our notions of religion and science when transposed to ancient Mesopotamia. At the same time, the relation between celestial divination and astronomy is not definable solely in terms of the institutional context for these practices, or the use of astronomy in matters of cult. It is undoubtedly the case that the study of ominous celestial phenomena provided the foundation for the development of astronomical methodologies, but the purpose of the study of the heavens for divination was certainly not the development of "astronomy." Nor can the use of

astronomy be limited to the production of practical knowledge for ritual and cult. Celestial divination, we could say, raised questions about what the gods communicated to humankind through ominous phenomena; that is, what earthly phenomena are predictable, and how do the signs predict these things? Astronomy's questions were perhaps more methodological: By what means were the positions of synodic appearances and the dates of their occurrences known, that is, what celestial phenomena are predictable, and how do the mathematical models predict them? These specific questions raised by astronomy were thereby independent of the premise of divination (or horoscopy) that the world embodied divine agency and will. It was an intellectual pursuit that owed nothing to the assumptions of Mesopotamian religion, despite the fact that its practitioners were the scribes and scholars who also practiced divination, produced horoscopes, or determined the times for certain rites, and who evidently were employed in the Babylonian temples of late Uruk or Babylon.

7

THE CLASSIFICATION OF
MESOPOTAMIAN CELESTIAL
INQUIRY AS SCIENCE

7.1 THE EVIDENCE OF TRANSMISSION

Second only to the invention of writing, science, in the forms of astronomy and astrology, ranks as the cultural phenomenon through which Mesopotamian civilization had its broadest impact on other cultures. This impact is measured by the nature of the evidence for the transmission of the Mesopotamian celestial sciences both to the west and east, in antiquity and even later. During the Hellenistic period the transmission of astronomical knowledge from Mesopotamia to Greece was to be influential in the early development of western astronomy. The preservation of Babylonian astronomy in Medieval European, Indian, and Arabic traditions is in turn a consequence of the influence of Hellenistic astronomy and astrology, in which parts of the Babylonian tradition came to be embedded. Whereas the Indian reception of western astronomy and astrology occurred as early as the mid-second century of the Common Era, the impact of Indian astronomy on Arabic astronomy took place during the ninth century of our era, by which time Indian astronomy represented a hybrid of Babylonian and Greek traditions. In addition to the Babylonian contribution to Arabic science via India, the Greek *Almagest* became another significant vehicle for the transmission of Babylonian astronomy to the Islamic world and all the places where the *Almagest* became known. Babylonian astronomical units (the sexagesimal system, the measure of time and arc, units of length and magnitude in cubits and fingers, *tithis*, and ecliptical coordinates), parameters (such as period relations for lunar, solar, planetary phenomena, and values for the length of daylight), and methods (Systems A and B of Babylonian mathematical astronomy and methods for computing the rising times of the zodiac) were incorporated within the astronomy of these later antique and mediaeval sciences. A brief

accounting of some of the evidence for the Babylonian contribution to later western astronomy is given here, although the details are available in the works particularly of Neugebauer and Pingree.

Calculations of astronomical phenomena in Greek, Arabic, and Indian astronomy are carried out in the Babylonian sexagesimal (base-60) system, the origins of which may be traced to Sumerian bookkeeping of the third millennium, preserved in the archaic texts of Uruk.[1] Units of measure for time and arc in the Babylonian system give us the 360° circle, as the day was measured as 12 DANNA units, each subdivided into 30 UŠ: 12 × 30 = 360 UŠ. Because the day is the equivalent of one rotation of the heavens from sunrise to sunrise (or sunset to sunset), the circle was thereby divided into 360 UŠ units, or "degrees."[2] This convention, along with the use of sexagesimal notation, is attested in Greek astronomy by the mid-second century B.C., associated with Hipparchus[3] and Hypsicles (ca. 200 B.C.).[4] The cubit (KÙŠ = *ammatu*), with its subdivision the finger or digit (ŠU.SI = *ubānu*), was a unit of distance in Babylonian metrology with an astronomical application for measuring distances in the heavens between, for example, fixed stars and the meridian, or between planets and ecliptical stars, and also for measuring eclipse magnitude. The equivalence 1 cubit = 30 fingers = $2^1/_2$ uš, gives us 1 finger = 0; 5° and 1° = 12 fingers. The cubit is used in two of the earliest observations (of the planet Mercury) recorded in the *Almagest*, from 245 and 237 B.C. (*Almagest* IX, 7). Ptolemy cites Babylonian eclipse reports, giving the time the eclipse begins, statement of totality, time of mid-eclipse, and direction and magnitude of greatest obscuration in digits, in the manner of cuneiform eclipse reports.[5] Ptolemy (*Almagest* IX, 7) also cites distance in cubits from ecliptical norming stars (Normal Stars) at dawn for Mercury, the dates for which are given in the Babylonian calendric system of lunar months (translated into Macedonian

[1] Hans J. Nissen, Peter Damerow, and Robert Englund, *Archaic Bookkeeping: Early Writing and Techniques of Economic Administration in the Ancient Near East*, trans. Paul Larsen (Chicago/London: University of Chicago Press, 1993), pp. 25–7.

[2] O. Neugebauer, *Astronomy and History: Selected Essays* (New York/Berlin/Heidelberg/Tokyo: Springer-Verlag, 1983), pp. 16–17.

[3] G. J. Toomer, "Hipparchus and Babylonian Astronomy," in E. Leichty M. de J. Ellis, and P. Gerardi, eds., *A Scientific Humanist: Studies in Memory of Abraham Sachs*, Occasional Publications of the Samuel Noah Kramer Fund 9, (Philadelphia: Babylonian Section, University Museum, 1988), pp. 353–62.

[4] Hyspicles, *Anaphorikos*, ed. and trans. V. de Falco and M. Krause with O. Neugebauer, (Göttingen: Vandenhoeck and Ruprecht, 1966).

[5] For these texts, see Pinches–Sachs, *LBAT*, 1413–*1432, and Peter J. Huber and Salvo de Meis, *Babylonian Eclipse Observations from 750 B.C. to 1 B.C.* (Milan: Mimesis, 2004).

month names) and Seleucid Era years, and he also cites the distance of Saturn in digits from a Normal Star in the evening (*Almagest* XI, 7). These observational reports attest to Greek awareness of the Babylonian astronomical diaries and related observational and predictive texts.[6] The Babylonian cubit is also used by Strabo in his *Geography* (2, 1, 18).

The lunar day or *tithi*, the equivalent of $^1/_{30}$ (Sanskrit *tithi*) of a mean synodic month, is fundamental to Babylonian mathematical astronomy. The difference sequences between dates of the ephemerides are computed in *tithi*s (τ) because one mean synodic month of 30^τ enables computation of dates without reference to civil days, the number of which in any given true lunar month varied month by month. For planetary phenomena, *tithi*s substituted well enough for calendar dates and enabled the coordination between progress in longitude (number of degrees between consecutive phenomena) and time (number of *tithi*s between consecutive phenomena). Later Indian astronomy applied the unit to $^1/_{30}$ of true lunar months, thereby reintroducing the complex variation in month length precluded by the Babylonian *tithi*.

By the middle of the first millennium, cuneiform texts attest to the standardization of the ecliptic as a circular band in the heavens, consisting of twelve parts, or "signs," of 30° each. The travel of the sun and planets was then reckoned by means of such degrees (celestial longitude), counted from a sidereally normed point (Aries 8° or Aries 10°). The dating of the Greek reception of the Babylonian zodiac is uncertain before the Hellenistic period, although the treatises of Autolycus and Euclid (ca. 300 B.C.) already assume the ecliptic and the zodiac. Pliny's claim (*Natural History* II, 31) that "Cleostratus" was responsible for introducing the concept to the Greeks around 500 B.C. is suspect given the date of the introduction of the zodiac in Mesopotamia at just the same time. By the second century of the Common Era, in the *Almagest*, the zodiac was no longer sidereally normed as in Babylonia, but at the vernal equinox point Aries 0°. The assimilation of the Babylonian ecliptical coordinate system is also found in the astrological devices of the Egyptian *decans* and Indian *nakshatras*. Indeed, the medium of transmission of Western astronomy to India by mid-second century was Greek astrology, which by the first century of the Common Era attests to the use of the zodiac in Greek and demotic papyri.

Perhaps most well known of the Babylonian legacies to western astronomy are the parameters, particularly the Babylonian period relations: The earliest example is the luni–solar period of 19 years = 235 synodic

months, sometimes called the Metonic cycle. This relation begins to be employed for the Babylonian calendar around 500 B.C., somewhat earlier than the date for Meton of Athens (432 B.C.), thereby giving chronological priority to the relation as an originally Babylonian calendar cycle.[7] Ptolemy refers to an earlier estimate of the 18-year eclipse period known as the Saros, which he defined as $6585\frac{1}{3}$ days = 223 synodic months = 239 anomalistic months = 242 draconitic months = 241 sidereal months $+10\frac{2}{3}° = 18$ sidereal years $+10\frac{2}{3}°$. The Babylonian formulation did not give the length of the period in days, nor did it correct for longitude, but cycles of 223 months (18 years) were employed in the computation of eclipse possibilities, both lunar and solar.[8] Although Ptolemy does not identify Hipparchus' essential lunar parameters as "Babylonian" in origin, Kugler discovered that they indeed were.[9] Hipparchus seems to be responsible for introducing Babylonian numerical parameters into Greek astronomy and in so doing established a quantitative basis for cinematic models of the moon and planets. The period relations for the planets given by Ptolemy as Hipparchan are based on the so-called Babylonian goal-year periods. Planetary period relations from the Babylonian ephemerides also turn up in much later astronomy, in particular the Indian astronomy of Varāhamihira's *Pañca-Siddhāntikā*, Chapter XVII, from the sixth century of the Common Era.[10] The daylight length ratio ($M{:}m$) was another important parameter in the later inheritance of Babylonian astronomy. Because the longest day increases in duration with an increase in geographical latitude, the ratio of longest to shortest day will be an indication of local latitude. The ratio 3:2 for Babylon was the value accepted in Babylonian computations of length of daylight, although the ratio does not correspond to the actual geographical latitude of Babylon. This conventional, albeit incorrect, Babylonian value was adopted by Greek geographers, resulting in their misidentification of the latitude of Babylon by several degrees, and a consequent distortion of the eastern part of the world on early maps.

Evidence for Babylonian arithmetical methods in Greek astronomy after Hipparchus, as well as in Indian and demotic texts, attests to the

[7] Bowen and Goldstein, "Meton of Athens and Astronomy in the Late Fifth Century B.C.," pp. 39–82.

[8] Aaboe, Britton, Henderson, Neugebauer, and Sachs, *Saros Cycle Dates and Related Babylonian Astronomical Texts*.

[9] F. X. Kugler, *Die Babylonische Mondrechnung. Zwei Systeme der Chaldäer über den Lauf des Mondes und der Sonne* (Freiburg im Breisgau: Herder, 1900), pp. 20–1.

[10] O. Neugebauer and D. Pingree, *The Pañcasiddhāntikā of Varāhamihira*. (Copenhagen: Danske Vidensk. Selskab, Histor.-Filos. Skrifter 6, 1 and 6, 2, 1970–1).

widespread nature of the Babylonian transmission. For example, a diagnostic scheme of System A, in which the synodic motion of Mars is divided into six zones of the ecliptic, appears in the "Stobart Tables" of Roman Egypt. Although these are based on Babylonian methods, they were adapted to an entirely different set of requirements for Hellenistic astrology, tabulating the dates of planetary entries into zodiacal signs, rather than dates of synodic phenomena as in the Babylonian tables.[11] A six-zone scheme for the synodic motion of Mars, the treatment of the retrograde arc of Mars, and a System A-type scheme for Mercury are also attested in the *Pañca-Siddhāntikā*.[12] Kugler was the first to recognize that underlying the eclipse period attributed to Hipparchus (126,007 days) is the Babylonian value for the mean synodic month of System B (29; 31, 50, 8, 20 days).[13] He also identified the reduction of Hipparchus' relation to 251 synodic months = 269 anomalistic months as the relation at the basis of column F (lunar velocity in degrees) and column G (first approximation of the variable length of the synodic month assuming constant solar velocity of 30° per month) of System B. Hipparchus' use of these lunar parameters as well as the period relation for the moon's motion in latitude (5458 synodic months = 5923 draconitic months) further imply Greek knowledge of the Babylonian relation 1 year = 12; 22, 8 synodic months. Neugebauer published a Greek papyrus fragment from Roman Egypt containing a sequence of sexagesimal numbers forming a zigzag function with parameters familiar as column G of the System B lunar ephemerides. This text showed that, by this period, Babylonian ephemerides had been reproduced in Greek, and that the knowledge of Babylonian lunar theory in this period went beyond isolated period relations or observations of eclipses.[14] Jones has provided even more evidence of the full integration of Babylonian predictive methods in Greco–Roman astronomy until the fifth century of the Common Era.[15] Greek awareness of the Babylonian inheritance is indicated, albeit in fragmentary context, in a papyrus

[11] Neugebauer, *HAMA*, p. 456.

[12] Ibid., pp. 456 and 473.

[13] Kugler, *Die Babylonische Mondrechnung*, pp. 23–4, and A. Aaboe, "On the Babylonian Origins of Some Hipparchan Parameters," *Centaurus* 4 (1955), pp. 122–25.

[14] O. Neugebauer, "A Babylonian Lunar Ephemeris from Roman Egypt," in E. Leichty, M. de J. Ellis, and P. Gerardi, eds., *A Scientific Humanist: Studies in Memory of Abraham Sachs*, Occasional Publications of the Samuel Noah Kramer Fund 9 (Philadelphia: Babylonian Section, University Museum 1988), pp. 301–304.

[15] Jones, *Astronomical Papyri from Oxyrhynchus*, Vols. 1 and 2, and idem, "Babylonian Lunar Theory in Roman Egypt: Two New Texts," in John M. Steele and Annette Imhausen, eds.,

concerning lunar periods (P. Oxy. 4139), which not only contains the earli-
est reference to a lunar parameter of the Babylonian System A lunar theory
(6695 anomalistic months in the period relation for lunar anomaly) in a
Greek text, but also mentions *Orchenoi* (P. Oxy. 4139 line 8, again in bro-
ken context) or "people of Uruk," the same group identified by Strabo
as "astronomical Chaldeans" (Strabo XVI 1.6). Uruk is indeed one of the
two principal Mesopotamian cities from which archives of mathematical
cuneiform texts have come.

Finally, a method for computing the rising times of the zodiac found
its way into later Greek astronomy. In Babylonia, a scheme for computing
the length of daylight was based on the notion that the length of daylight
equals the rising time of the half of the ecliptic to rise and set with the sun
on a given day of the year at the geographical latitude of Babylon (32.5°
North), i.e., from λ_{sun} to $\lambda_{sun}+180°$. Two sets of rising times (Systems A
and B) were chosen for the twelve zodiacal signs so as to form arithmetical
progressions such that the extremal values in both would obey the conven-
tional ratio 3:2 for longest to shortest day at Babylon. These rising times
were adopted by the Greeks to accommodate other geographical latitudes
(ten different latitudes are given in the table in Ptolemy's *Almagest.* II.8).
The originally Babylonian method of computing rising times can also be
traced in Vettius Valens (ca. A.D. 150), Papyrus Mighigan 149 (ca. second
century of the Common Era), and Manilius. As Neugebauer observed,

The historical significance of the Babylonian scheme for the rising times reaches far
beyond their applications in the solar and lunar theory. Since Greek mathematical
geography characterized the latitude of a locality by its maximum daylight *M* the
Babylonian method of finding the function $C(\lambda)$ of daylight depending on the
solar longitude was properly modified, but under preservation of the arithmetical
types A or B for the rising times. The geographical system of the "seven climata"
preserved vestiges of the Babylonian oblique ascensions until deep into the Middle
Ages. On the other hand one finds the unaltered set of Babylonian rising times of
System A in Indian astronomy of the sixth century A.D. without any consideration
for India's far more southern position. Rising times and related patterns have
thus become an excellent indicator of cultural contacts, ultimately originating in
Mesopotamia.[16]

All this evidence makes clear the depth of the astronomical achievement
of Babylonia and the fact that Babylonian science was well known to

Under One Sky: Astronomy and Mathematics in the Ancient Near East, AOAT 297 (Münster:
Ugarit-Verlag, 2002), pp. 167–74.
[16] Neugebauer, *HAMA*, p. 371,

Hellenistic Greek intellectuals. Greek adaptation and incorporation of certain Babylonian astronomical concepts, parameters, and computational schemes would ensure a position for Babylonian civilization in the intellectual history of the West. But the influence of Babylonian traditions of celestial divination and astrology can be shown to have been just as penetrating.

Already during the third and second millennia, ancient Near Eastern states beyond the borders of Mesopotamia not only adopted cuneiform script for the writing of their native languages, but foreign scribes copied Akkadian texts from the scribal curriculum, resulting in the preservation from the second millennium B.C. of a selection of Babylonian celestial and other (*Šumma ālu*, and *Iqqur īpuš*) omens, some in Akkadian and some in the languages of Hittite, Hurrian, Elamite, and Ugaritic. Akkadian omen texts are extant from the Hittite capital of Hattušaš (Boghazköy), the Elamite city of Susa, and a number of cities in Syria (Emar, Alalakh, Qatna, and Nuzi).[17] Presumably these texts reflect the spread, not simply of the curriculum of the scribal school, but of the practice of divination to Iran, Syria, and Anatolia. More widespread even than celestial divination, however, was extispicy, as traced not only by inscribed clay models of livers and other exta west to Syro-Palestine, Anatolia, and Cyprus, but also by models of the liver, one produced in bronze, from Etruria.[18] If we consider the many parallels to Mesopotamian forms of divination traceable in Greek sources as early as the Homeric tradition, it would seem that an early transmission of divinatory tradition occurred throughout much of the Mediterranean world.[19]

The practice of celestial prognostication was naturalized throughout the ancient Near East, but in its further evolution within Greek astrology, the principle of heavenly influence on earthly events became, during Late Antiquity, the Middle Ages, and Renaissance, one of the chief unchallenged western assumptions about the cosmos. Already in Greco–Roman

[17] Sources are enumerated in Koch-Westenholz, *Mesopotamian Astrology*, pp. 44–51. The peripheral texts from the lunar eclipse section of *Enūma Anu Enlil* are discussed in *ABCD*, pp. 30–35.

[18] For liver models from Syro-Palestine, see the bibliographical references in Oppenheim, *Ancient Mesopotamia*, p. 372, note 45, and West, *The East Face of Helicon*, p. 48. For the second-century B.C. bronze Piacenza liver, see Massimo Pallottino, *Testimonia Linguae Etruscae*, Biblioteca di studi superiori 24 (Florence: Nuova Italia, 1968), No. 719.

[19] West, *The East Face of Helicon*, pp. 46–51. An equally extensive transmission to the east is documented in Sanskrit texts of the first millennium B.C.; see Pingree, *From Astral Omens to Astrology*, pp. 31–8.

antiquity, astrology was associated with the culture of Babylonia and specifically with the tradition of celestial divination, which only became known to the Greeks and Romans in the latter part of the first millennium B.C.[20] The longevity of Babylonian astronomy (the observation and prediction of astronomical phenomena) and astrology (prognosticating from such phenomena), continuing to the end of the cuneiform writing tradition itself in the first century of the Common Era, meant that cultural contact and the possibility of transmission of Babylonian celestial sciences to the West and East continued into later antiquity; the omen compilation *Enūma Anu Enlil* was copied well into the Seleucid period; the last horoscope is dated to 69 B.C. and the last astronomical text to A.D. 75.

7.2 A CONSIDERATION OF CRITERIA

From a modern standpoint, the astrological part of the legacy of the ancient Near East has not been viewed with the same reverence as was Babylonia's claim to the origin of mathematical astronomical science, a result of the gradual relegation of astrology since the seventeenth century to a place outside of the boundary of science. And because celestial as well as the other systems of Mesopotamian divination all stemmed from a belief in the gods' involvement in the physical natural as well as the human social worlds, and because of the close relationship this practice had to apotropaic ritual magic, some historians of science once preferred to see in this material a form of prescience- or protoscience.[21] Recent studies in the history of science have shown the coexistence of empirical sciences with beliefs in deities (or a deity), the occult, and magic to be central rather than peripheral to the study of premodern and early modern science.[22]

[20] Rochberg-Halton, "New Evidence for the History of Astrology," pp. 127–44, and idem, "Elements of the Babylonian Contribution to Hellenistic Astrology," pp. 51–62.

[21] A. Aaboe, "Scientific Astronomy in Antiquity," in F. R. Hodson, ed., *The Place of Astronomy in the Ancient World*, (London: Philosophical Transactions of the Royal Society A 276, 1974), pp. 21–42; O. Pedersen, *Early Physics and Astronomy: A Historical Introduction*, rev. ed. (Cambridge/New York: Cambridge University Press, 1993), see Chap. 1, "Science Before the Greeks," under the subheading, "The Mythological Explanation of Nature"; David Lindberg, *The Beginnings of Western Science: The European Scientific Tradition in Philosophical, Religious, and Institutional Context, 600 B.C. to A.D. 1450* (Chicago /London: University of Chicago Press, 1992).

[22] The following citations are merely a suggestion of what is now an enormous literature. See Ron Millen, "The Manifestation of Occult Qualities in the Scientific Revolution," in

The concession, as J. H. Brooke said, "that aesthetic and religious beliefs *have* played a selective role in the past, giving priority to one theoretical model rather than another,"[23] is by now firmly embedded within the mainstream narrative of the history of science. Equally mainstream in the historiography of science of the premodern world is the view that science encompassed a wide range and variety of activities and beliefs, some of which were fully integrated within theological, metaphysical, or other speculative, or indeed "mythic," forms of thought.[24] Former demarcations between science and nonscience, based on a criterion of science and of scientific truth established, for example, by Sir Robert Boyle and the Royal Society of London in the seventeenth century, have been repudiated, as B. Barnes, D. Bloor, and J. Henry put it, "not least because philosophers and historians have now demonstrated repeatedly that the contents of the accepted, authentic history of science are not capable of being demarcated by this criterion, or indeed by any other."[25] L. Laudan has argued on purely epistemological grounds, that "the quest for a specifically scientific form of knowledge, or for a demarcation criterion between science and nonscience, has been an unqualified failure. There is apparently no epistemic feature or set of such features which all and only the 'sciences' exhibit."[26] This is not to say that on other grounds, such as with respect to practice, that science cannot be defined as a cultural phenomenon.

Without the former exclusionary notions of what "scientific knowledge" is to be in an absolute sense, local historical particulars can move into the foreground of our reconstructions of ancient science. However, an extreme "contextualist" position, which claims that none of the interpreter's assumptions will affect the study or interpretation of a local past

M. J. Osler and P. L. Farber, eds., *Religion, Science and Worldview: Essays in Honor of Richard S. Westfall* (Cambridge/New York: Cambridge University Press, 1985), pp. 185–216; the collection of papers edited by David C. Lindberg and Robert S. Westman, *Reappraisals of the Scientific Revolution* (Cambridge: Cambridge University Press, 1990); also the papers of Keith Hutchinson, "What Happended to Occult Qualities in the Scientific Revolution," B. J. T. Dobbs, "Newton's Alchemy and His Theory of Matter," and others collected in Peter Dear, ed., *The Scientific Enterprise in Early Modern Europe: Readings from Isis* (Chicago/London: University of Chicago Press, 1997).

[23] Brooke, *Science and Religion: Some Historical Perspectives*, p. 327.

[24] See the *Osiris* issue devoted to this theme, *Science in Theistic Contexts: Cognitive Dimensions*, ed. John Hedley Brooke, Margaret J. Osler, and Jitse M. Van der Meer, *Osiris*, Vol. 16 (2001).

[25] Barry Barnes, David Bloor, and John Henry, *Scientific Knowledge: A Sociological Analysis* (Chicago: University of Chicago Press, 1996), p. 149.

[26] L. Laudan, *Beyond Positivism and Relativism: Theory, Method, and Evidence* (Oxford/Boulder, CO: Westview, 1996), pp. 85–6.

reclaimed solely "in its own terms," is as unattainable and untenable as
the belief in a reified science transcendent of historical–cultural context.
More importantly, to define science as a Babylonian would is an idea I
find unintelligible, as no such concept is expressed in Akkadian. If, there-
fore, science is neither definable by necessary and sufficient conditions,
nor is it a meaningful *Kulturwort* in ancient Mesopotamia, why enter
into a justification of that designation for any corpus of cuneiform texts?
I believe the answer lies in the features shared between the activities of
the Mesopotamian celestial inquirers and those of other inquiries into
celestial phenomena attested both in and outside of the western tradition
of science. Some of the standard criteria associated with science, such as
the systematization of knowledge,[27] the explanation of phenomena, the
use of an empirical method, and the goal to make predictions of other-
wise observed phenomena, are indeed useful for assessing the character
of the Mesopotamian sources for science. It seems to me highly worth-
while to employ such criteria, not as a measure of "how scientific" ancient
Mesopotamian celestial inquiry was, but as an aid to our understanding of
their methods and goals. Recognition of family resemblances among the
many historical celestial sciences then becomes possible without exacting
too much of a "definition" of science. It is enough to establish the context
within which it makes sense to speak of "science" in the ancient Near East.
Also to be taken into account are the relations among the various parts
of the Mesopotamian celestial sciences, which necessitates our considera-
tion, for example, of omens, in the same context as that of astronomical
texts. The remainder of this chapter, then, undertakes a discussion of
these sources, starting with the omen texts, in terms of selected criteria for
science, both epistemological and pragmatic. Empiricism and prediction
seem particularly apt in the present context.

7.3 THE FOUNDATIONS OF MESOPOTAMIAN SCIENTIFIC
KNOWLEDGE: THE EPISTEMOLOGICAL CRITERION

A continuous thread in the history of western science has been the inti-
mate connection between beliefs about the physical world and scientific
knowledge. If science encapsulates knowledge about physical phenom-
ena, the nature of that knowledge is necessarily empirical. This, at any
rate, is a foundational notion whose articulation traces back to Aristotle's

[27] D. Pingree, "Hellenophilia v. History of Science," *Isis* (1992), p. 559, reprinted in Michael
H. Shank, ed., *The Scientific Enterprise in Antiquity and the Middle Ages* (Chicago/London:
University of Chicago Press, 2000), esp. p. 35.

Posterior Analytics, in which the discussion of scientific knowledge takes empiricism, specifically connoting sense perception, as one, yet only one fundamental component of science:

[I]t is impossible to get an induction without perception – for of particulars there is perception; for it is not possible to get understanding of them; for it can be got neither from universals without induction nor through induction without perception.[28]

Empiricism here takes on special significance, through the inductive process, as a key to the attainment of scientific knowledge. In Aristotle's analysis, it followed that the empirical content of science formed the basis for generalizations about the natural world. Of course the principle that empirical sciences are built exclusively on inductive inferences has become philosophically controversial. Although the project associated with the logical empiricists and aimed at the demarcation between science and nonscience has become largely an issue for the history of philosophy, questions about the relation of observation to knowledge remain. From the evidence of the history of science, Kuhn showed that not only are worldviews, or epistemic frameworks, within which observations are made, subject to change, but also the ways in which observations are stated, and that such changes are indexical of changes in scientific cultures. In the following subsection, I raise the question of whether a consideration of the empirical content of the cuneiform sources for celestial science serves to indicate something of the particular epistemic frameworks that developed within Mesopotamian science.

7.3.1 The Empirical Character of Objects of Mesopotamian Scientific Knowledge

Omens and the principles of their organization have been analyzed as the product both of empirical study of phenomena and of the creation of schemata in the compilation and redaction of scholarly collections of words or omens. I. Starr notes that "it is not unlikely that the two practices, the empirical and the theoretical, continued side by side for some time, with the former providing the basis for the latter."[29] Starr refers here to the relationship between protasis and apodosis in which first,

[28] Aristotle, *Posterior Analytics*, I. 16, see J. Barnes, *The Complete Works of Aristotle*, Vol. 1 (Princeton: Bollingen, 1984), p. 132.

[29] I. Starr, *The Rituals of the Diviner* (Malibu, CA: Undena Publications, 1983), p. 12. See also Larsen, "The Mesopotamian Lukewarm Mind, pp. 213–14 and p. 222.

in his analysis, the omens represented "empirical" correlations between events, followed in a later development by the extension of the omen list to include schematic (theoretical) as opposed to empirical correlations. I subsequently address the protasis–apodosis relation below. Here, the empirical character of phenomena comprising omen protases is my concern. Although my primary interest is in the celestial omens, these should first be viewed in the wider context of divination in general. At the outset my discussion addresses the protases as found in the unprovoked omen series and secondarily considers the evidence from Neo-Assyrian scholarly commentaries to *Enūma Anu Enlil,* which presents a somewhat different picture.

The following description of omen texts as essentially observational in character was given by Oppenheim:

Because of the belief that whatever happens within perception occurs not only due to specific if unknown causes, but also for the benefit of the observer to whom a supernatural agency is thereby revealing its intentions, the Akkadians of the Old Babylonian period began rather early to record such happenings. They first made reports on specific events, then assembled observations of each kind in small collections. The purpose was clearly to record experiences for future reference and for the benefit of coming generations. Thus, written records were made of unusual acts of animals, unusual happenings in the sky, and similar occurrences, and divination moved from the realm of folklore to the level of a scientific activity. The subsequent systematization of such collections represents high scholarly achievement.[30]

The willingness on the part of assyriologists to consider omen texts a form of science in Mesopotamia has been due to the fact that many of the phenomena of interest in these texts are of the physical natural world.[31]

[30] Oppenheim, *Ancient Mesopotamia,* p. 210. Opposing the view that Babylonian divination is fundamentally empirical, Koch-Westenholz, in the Introduction to *Mesopotamian Astrology,* pp. 13–19, questions the primacy of observation in the practice of Babylonian divination from the point of view of a Babylonian diviner. Within the diviners' cultural frame of reference, observation, she argues, was a technique supplemental to the direct(?) acquisition of divinely revealed knowledge transmitted by the initiated from time immemorial. In the present discussion, however, the empirical character of the texts is not being measured by Babylonian standards, but necessarily by our own, just as the whole question of the classification of Mesopotamian divination as science refers not to Babylonian ideas, as they had no notion of science, but to the character of other historical sciences with which they may be implicitly compared.

[31] Note the discussion of omens under the rubric "science" in the general overview of Mesopotamian culture by W. von Soden, *The Ancient Orient: An Introduction to the Study*

Thus many of the omen protases of the celestial omen series *Enūma Anu Enlil*, parts of *Šumma ālu* dealing with fauna, *Šumma izbu* focusing on anomalous animal and human births, *Alamdimmû*, the variable forms of the human anatomy, and even parts of *Ziqīqu* the dreambook, have come to be interpreted as a source for the Mesopotamian attempt to grasp the workings of nature. In the previously quoted passage, Oppenheim gives an intuitive account of the genesis of omen lists. Regardless of how the lists came into being, speaking solely of the omen protases, once formulated, the arrangement of subjects into categorical groups within the various lists of signs points toward an empirical foundation for the lists in general, as any sort of classification of subjects would be difficult to imagine without such a foundation. The range of signs collected in the omen series, however, does not exhibit the same empirical constraints as are found in the study of some natural phenomena, particularly the periodic astronomical phenomena that behave in accordance with certain limited parameters. The organization of tablets in the series *Šumma ālu*, for example, exhibits an interest in assembling and classifying phenomena of widely disparate subjects. The omens that deal with human phenomena would seem to be endlessly and unsystematically variable, as in the series *Šumma ālu*, which defines its interests rather broadly, *Alamdimmû*, which focuses on the physiognomic characteristics of people, and SA. GIG, which studies the symptoms of the sick. Clearly there is some overlap between what is of interest from series to series, but each series of unprovoked omens establishes a field of phenomena deemed appropriate for empirical study within its particular confines. The scope of the series *Šumma ālu* encompasses things of "real life," relating to cities and houses, flora, fauna, water, fire, lights, or describing an individual's thoughts, prayers, actions of daily life (sex, sleep, family quarrels), even the perception of phantasms, such as demons[32] and ghosts.[33]

This last subject raises a question about the empirical, or perceptual, nature of Babylonian ominous phenomena. Whether a demon was seen in a house, or the cries of a ghost were heard, appear categorically different

of the Ancient Near East, trans. Donald G. Schley (Grand Rapids, MI: Eerdmans, 1994), pp. 153–7; celestial omens under the heading "Astronomy in Mesopotamia," in H. W. F. Saggs, *Civilization Before Greece and Rome* (New Haven, CT/London: Yale University Press, 1989), pp. 236–8; and the chapter titled "Divination and the Scientific Spirit" in Bottéro, *Mesopotamia: Writing, Reasoning, and the Gods*, pp. 125–37.

[32] For example, "If a goatlike demon appears in a man's house, that house will be dispersed," see Freedman, *If a City*, p. 277.

[33] *Šumma ālu* Tablet 19: 44′–68′ see Freedman, *If a City*, pp. 278–82.

from the omens from physical phenomena, whose empirical character we do not immediately question. But the omens from phantasmic entities are constructed in precisely the same way as are other physical appearances in omen protases, that is, as subjects of the verb *amāru* (the basic meaning of which is "to see") in the passive N stem (*nanmuru*). In translations of omen protases, the passive forms of *amāru*, meaning to be seen, are often rendered as though active, "to appear," as in the example: "if a black demon appears (lit. "is seen") in a man's house."[34] When phenomena we do not regard as "observable" in the usual sense, that is, by ordinary sensory perception, are included in the list of omen protases, such protases invite reexamination of the criteria underlying observables, or at least potential observables, in Mesopotamian science. As suggested by L. Daston's work on preternatural philosophy, this is perhaps not only a matter of epistemology but also ontology, in which the kinds of phenomena deemed ominous might be understood to constitute a historical ontology that accords with these special objects of scientific investigation.[35]

Another kind of omen protasis seems problematic if indeed omens, at least those included in the written compilations, have an empirical basis. These contain not phantasmic but purportedly natural phenomena that cannot occur in nature. The following omens may serve to illustrate such nonoccurring or unobservable phenomena:

If the sun comes out in the night and the country sees its light everywhere: there will be disorder in the country everywhere. (*Enūma Anu Enlil* 25 i 1[36])

If the sun comes out in the night and lasts until the morning: Enlil [...] the rumor of [...] if Erra speaks the people of the land will be diminished, the entire country will not [...] rain. (*Enūma Anu Enlil* 25 i 2)

If the sun comes out during the evening watch: an uprising in the land [...]" followed by omens for the sun coming out in the middle and morning watches, as well as the sun rising during various watches with other astral bodies "standing in front of it." (*Enūma Anu Enlil* 25 i 5–10)

How are we to understand such "phenomena" if we require that omens be established by observation? Exegetical methods can be employed, by means of which what is stated in the text can be otherwise translated, as in

[34] *CT* 38 25b:6 = Šumma ālu 19:6, also lines 1–9; see Freedman, *If a City*, pp. 276–7.
[35] Lorraine Daston, "Preternatural Philosophy," in L. Daston, ed., *Biographies of Scientific Objects* (Chicago/London: University of Chicago Press, 2000), pp. 15–41.
[36] Wilfred H. van Soldt, *Solar Omens of Enuma Anu Enlil*, p. 32.

the preceding case of the solar omens, in which, with good reason, W. van Soldt has translated "If a 'sun'" in each case, implying that *Šamaš* here, written with the normal logogram 20, does not refer to *the* sun, but perhaps some other heavenly body. But, recognizing the dilemma, he notes that these omens continue the topic of the previous tablet in which the protases of the final section deal with the unexpected appearance of *the* sun.[37]

Another example may be found in the omens for lunar eclipses "occurring" on days 17, 18, 19, 20, 21, and even *ištu* UD.I. KAM *adi* UD.30.KAM "(on any day) from the first to the thirtieth (of the month)."[38] These omen protases form a schema for eclipses on days of the month beginning with possible days of opposition, 14, 15, and 16, and continue until conjunction at the end of the month. If we think the omens refer only to what we take to be empirically true phenomena, such a schema, setting out days 14–30 for "observing" a lunar-eclipse, does not make empirical sense. If, on the other hand, we assume it was not yet known that in the lunar calendar, days 17–30 (as well as days 1–11) are excluded as possible lunar-eclipse days, then nonsense becomes simply error.

The question of empirical veracity was raised by Leichty in his treatment of the series *Šumma izbu*. His determination was that indeed most of the birth anomalies described in the protases could be identified with attested birth abnormalities, but that some could not. He said,

from this we do not wish to argue that all the omens in the series were actually observed. This is simply not true. In addition to the cases where omens were obviously added in an attempt to make the series all-inclusive, there are also occasional omens where the anomaly is naturally impossible.[39]

Leichty also makes the point, with which I fully agree, that in the expansion and redaction of omen collections, additional omens were introduced, not on an empirical basis, but on the basis of the requirements of formal schemata into which phenomena were arranged.[40] What the implications of the creation of schemata may be in terms of the empirical character of the omen texts in general is difficult to judge. We can easily see schematic expansions as the combined result of good empiricism and imaginative excess, but this does not address the preservation of unobservable "phenomena" within omen series, and even seems a particularly

[37] Ibid., p. 32.
[38] See *ABCD*, Chaps. 7–9, 11–12 passim (in *Enūma Anu Enlil* Tablets 17–18, 19, 21–22).
[39] Leichty, *Izbu*, p. 20.
[40] See also Bottéro, *Mesopotamia*, pp. 134–5, and Hunger–Pingree, *Astral Sciences*, pp. 5–6.

modern approach to the problem, betraying, to quote Marshall Sahlins, "a common or garden variety of the classic Western sensory epistemology: the mind as mirror of nature."[41] The physiology of perception may not have changed since Mesopotamian antiquity but, at least on the basis of the evidence from omen texts, conceptualization of the phenomenal world has. The problem is that, although we view some omens as absurdities, we are not quite sure whether the scribes did as well. We may not be able to comprehend fully such conceptualizations that underpin Mesopotamian divination, but when it comes to our analysis of the material in terms of "science" and the empirical, it seems worthwhile to explore what was at stake for the diviners in having omens from nonoccurring phenomena, celestial and otherwise, in their compilations.

The discussion of Mesopotamian divination, with respect to the question of empirical foundations, has paralleled the investigation of divination more broadly by anthropologists. Robin Horton pointed out that modern social anthropologists (he names Lévy-Bruhl, Malinowski, Evans-Pritchard, Gluckman, Firth, Leach, and Beattie) assume a positivistic tone when it comes to defining scientific as against nonscientific thought. These anthropologists, he said,

have made it plain that they regard science as an extension of common sense; as based on induction from observables [defined as "occurrences in the visible, tangible world"(p. 98)] and as limiting itself to questions of *how* these observables behave. Once such a position has been taken up with respect to science, it is inevitable that the magico–religious thinking of the traditional cultures should be seen as radically contrasted with it.[42]

The problem for an analysis of Mesopotamian divination stems from the seeming irreconcilability of our classification of these texts as part of science on one hand and, on the other, our view of the omen series as comprising empirically valid ("scientific") phenomena, interrupted, as it were, by nonsensical phenomena fabricated merely for the sake of schematic symmetries. Can we presume that a distinction between fact and fiction, "real" knowledge and fantasy, existed for the compilers, redacters, and copyists of these series? Without evidence from the series themselves on which to base such distinctions between omens as to their empirical status,

[41] Marshall Sahlins, *How "Natives" Think: About Captain Cook, For Example* (Chicago/London: The University of Chicago Press, 1995), p. 6.

[42] Horton, *Patterns of Thought in Africa and the West: Essays on Magic, Religion and Science,* p. 99.

we can only view all the omens, as presented to us in the omen collections, as somehow equally valid.

Something of this approach was taken by M. Geller in his discussion of the *izbu* omens from human fetuses in the shapes of various animals. In light of the Babylonian Talmud, Geller considered the possible similarity between these malformed fetuses and the lists in the Talmud of miscarriages, or gynecological discharges, of different shapes for the purpose of determining whether the mother is unclean. He commented that

One usually considers such omens to be the product of a fertile Mesopotamian imagination or a fantasy which has no basis in reality... the Akkadian omens probably do not represent fantastic events or miraculous occurrences, but the example of a woman giving birth to an elephant probably describes some shape of an ordinary discharge or miscarriage.[43]

This compares favorably with the report of a human *izbu* in an astronomical diary for 78 B.C., although the report does not include an omen cited from the series:

That month, a woman gave birth, and (the baby's) head and hands were like (those) of a lion, his hips and feet were like a frog's.[44]

In many other cases, however, we are stretched to the limit to provide a rational explanation on a par with Geller's interpretation of the *izbus*. Particularly where the fantastic phenomena are the result of some schematic symmetry, such as the eclipse shadow moving across the moon from each of the four directions, no such possibility exists unless we redefine the phenomenon altogether, as on occasion a seventh-century scribe would, such as to reinterpret an astronomically eclipsed moon as a moon covered by a cloud. If such limits on eclipse occurrences were not known when *Enūma Anu Enlil* was first compiled, certainly by the Neo-Assyrian period the scribes knew well what the possible days were for the occurrence of a lunar eclipse. Nevertheless, *Enūma Anu Enlil* continued to be copied during this period, and even later, the impossible phenomena were not redacted out of the series. Commentaries, however, sometimes explained such impossibilities in other terms. The eclipses occurring on days when the moon is not full, for example, become atmospheric darkenings of

[43] M. J. Geller, "The Survival of Babylonian Wissenschaft in Later Tradition," in A. Aro and R. M. Whiting, *The Heirs of Assyria, Melammu Symposia* Vol. 1 (Helsinki: The Neo-Assyrian Text Corpus Project, 2000), pp. 4–5.

[44] Sachs–Hunger, *Diaries*, Vol. III, p. 491 No. −77: 30′–31′.

the moon.[45] It is tempting to take such seventh-century commentaries that explain impossible phenomena in terms of possible phenomena as sufficient evidence that the Neo-Assyrian scribes were engaged in rationalizations for traditional omens they, in light of greater knowledge, no longer accepted. The question of the empirical character of the phenomena originally collected in the series, however, remains open.

Seventh-century commentaries aside, to maintain that phenomena in some protases were considered possible and others not seems difficult in light of the identical formulation of the omens "if x, then y," and the fact that, as a result, all the protases appear to be signs of equal mantic validity. That the omen texts make no distinctions between empirically true signs and signs that are patently impossible is indeed puzzling. As previously pointed out, even phantasmic entities are formulated as "if x is observed (*innamir*)." Can this suggest that the distinction between empirically true on the one hand, and "absurd" or "impossible" on the other, was not valid in the omen compendia? Perhaps all one can say is that all the signs entered in the omen lists seem to be presented not only as mantically valid, but (potentially) empirically valid as well.

The interest in phenomena for what they indicated about future events in the world of human enterprise created a context in which a range of nonoccurring, hence unobserved, phenomena were included. Some examples may stem from an incorrect understanding of the physical behavior of phenomena, for example, a lunar eclipse in which the shadow travels across the moon the wrong way, that is, from west to east. But all the items of the omen protases refer to "observables," not in our sense of being subject to sense perception, but in the sense of being objects of empirical interest to the diviners. This interest would of course have been in the potentiality of such signs. Because clearly these ominous phenomena had never occurred, the fact that they were conceivable required that their mantic meaning be known. Phenomena formulated as "observed" in omen protases depended on a conceptual framework, and reciprocally, the organizational schemata used to arrange the phenomena as omens depended on observations. A

[45] For example, the eclipse commentary in *ABCD* Appendix 2.4, possibly, obv. 9–14, 22–30, rev. 2–5. Other apparent rationalizations are attested to in the context of omens for fixed stars and planets, as discussed in Brown, *Mesopotamian Planetary Astronomy-Astrology*, Section 2.1 and in E. Reiner, "Constellation into Planet," in Charles Burnett, Jan Hogendijk, Kim Plofker, and Michio Yano, eds., *Studies in the History of the Exact Sciences in Honour of David Pingree* (Leiden: Brill, 2004), pp. 3–15.

category of scientific objects therefore is posited here that is not limited to material things seen in the world, but includes unobserved entities that nonetheless could be imagined by extension or extrapolation from physically observed phenomena (such as the sun shining at night or eclipses on days of the month other than the days of syzygy). What counted as mantically valid and therefore of empirical interest in the omen series, that is, what could or could not be an event that presaged, stemmed from the presuppositions of divination.

The system of divination itself seems to have determined what the diviner should attend to in the world of phenomena, natural and otherwise. The mere inclusion of phenomena within omen series, and the regular use of the verb "to observe" (*amāru*) in the protases, defines the items of the protases as potentially observable objects, and objects of knowledge, regardless of their physical ontological status. The use of an ancient divinatory observation language, whose meaning reflects accepted notions of what was potentially observable, parallels other scientific observation languages attested in various periods and pertaining to different "conceptual frameworks."[46] "The *observable*," as M. Wartofsky put it, is

the index of the whole framework of science, or of the standard beliefs of the scientific community... if the sense of *observable* shifts from one to another framework, it may also be seen that the frameworks of science also shift, historically, so that the standard "observables" of one period are either augmented or replaced by those of another.[47]

It follows from this that understanding what it was that Babylonian diviners considered observable is key to understanding something of the conceptual framework for their system of divination. The evidence is in the omen protases, which either state plainly that something was "observed," or which are formulated as observation predicates, that is, protases in the form "if *x* is red" or "if *x* is like a goat" or "if *x* stands in front of Jupiter."

[46] On the nature of conceptual schemes, see Michael P. Lynch, *Truth in Context: An Essay on Pluralism and Objectivity* (Cambridge, MA/London: MIT Press, 2001), pp. 31–54, and objections to the notion in Donald Davidson, "On the Very Idea of a Conceptual Scheme," *Proceedings and Addresses of the American Philosophical Association* 47 (1974), pp. 5–20. See also the discussion in Ian Hacking, *Why Does Language Matter to Philosophy?* (Cambridge: Cambridge University Press, 1975), Chap. 12, as well as his "Language Truth and Reason," in M. Hollis and S. Lukes, eds., *Rationality and Relativism* (Cambridge, MA: MIT Press, 1982), pp. 48–66.

[47] Wartofsky, *Conceptual Foundations of Scientific Thought*, p. 120.

7.3.2 Omens are Not "Observation Statements"

Although formulated frequently as observation predicates, phenomena recorded in omen protases were necessarily only potentially observable because in no case do the omens function as a record of observations of identifiable (i.e., datable) instances.[48] They represent abstractions from experience and cognition, (mere) eventualities, "ifs."[49] The diviner watched for occurrences of phenomena, but the written omens in his handbook stood for general cases of such phenomena whenever such may occur.

The difference between phenomena recorded in omen protases and observations of phenomena is made clear in the reports of the Babylonian and Assyrian diviners to the Neo-Assyrian kings. This corpus spans the period from 709 to 649 B.C., although most are dated between 678 and 666 B.C. These texts document the systematic observation and reporting of heavenly phenomena together with the appropriate omens for the observed phenomena.[50] In the following report, dated to April 15, 657 B.C., a solar eclipse was observed and reported, and "its interpretation (*pišeršu*)," was included, that is, what such an eclipse portended according to omens of the *Enūma Anu Enlil* series:

On the 28th day, at two and one-half "double-hou[rs" of the day. . . .] in the west [. . . .] it also cover[ed. . . .] 2 fingers towards [. . . .] it made [an eclipse], the east wind [. . . .] the north wind ble[w. This is its interpretation]: If the day [becomes covered] with clouds on the north side: [famine for the king of Elam]. If the day be[comes covered] with clouds on the south side: [famine for the king of Akkad]. If the day is dark and r[ides] the north wind: [devouring by Nergal (=plague); herds will diminish]. If [there is an eclip]se in *Nisan* (I) on the 28th day: [the king of that land will fall ill but recover]; in his stead, a daughter of the king, [an *entu*-priestess, will die]; in that land, variant: in [that] ye[ar, there will be an attack of the enemy, and] the land will panic [. . . .].[51]

As is clear in this report, an entry in an omen text records an event which, if or when such was observed, warned of another event. Even in the rather unusual case in which another celestial phenomenon is "predicted" in the apodosis, as in "if the moon at its appearance is very large: there

[48] See, however, P. Huber, "Dating by Lunar Eclipse Omina with Speculations on the Birth of Omen Astrology" in J. L. Berggren and B. R. Goldstein, eds., *From Ancient Omens to Statistical Mechanics: Essays on the Exact Sciences Presented to Asger Aaboe* (Copenhagen: University Library, 1987), pp. 3–13, discussed in Subsection 7.4.1.

[49] See Chap. 2, note 20.

[50] See Hunger, *Astrological Reports*.

[51] Ibid., 104:1-rev. 1.

will be an eclipse,"[52] the laconic "prediction" of a lunar eclipse cannot be differentiated from other forecasts of dreaded events. By the same token, the phenomenon of the protasis does not in any way constitute empirical grounds for making such a prediction in the apodosis. In the astrological reports, the phenomena are observations in the familiar sense; they are stated declaratively, and followed up with quoted omens from *Enūma Anu Enlil*, as in the following:

This night, the moon was surrounded by a halo, [and] Jupiter and Scorpius [stood] in [it].

If the moon is surrounded by a halo, and Jupiter stands in it: the king of Akkad will be shut up.

If the moon is surrounded by a halo, and *Nēberu*
stands in it: fall of cattle and wild animals.[53]

However the connections came to be made, once recorded as an omen, the sign and the associated event related to one another as invariant correlations,[54] in which the expression "if (or, "whenever") *x* then *y*," referred to an association of those two things considered valid "whenever." Whether the omens reflect a conception of invariant sequence, "if *x* occurs first then *y* occurs next," or, alternatively, a conception of invariant coincidence, "whenever *x* occurs *y* also occurs simultaneously," is impossible to determine. Regardless of whether *x* and *y* were sequential or coincident, the important element is their potential recurrence, that is, the particular instances are assumed to occur whenever the indicating phenomenon occurs. This must be the case because the essence of the omens is in their capacity to warn of or forecast other events. In other words, *x* indicates (predicts) *y* because, by virtue of being entered into the omen list, the two have been designated as invariantly associated.

General formulations "if/whenever *x* then *y*" are a species of causal statements. In the case of the omens, I view this causal connection between protasis and apodosis as a function merely of the relationship created by their association. There is no empirical, or experiential, connection, such as in statements like "if/whenever the teapot whistles, the water is boiling," or "if/whenever there is lightning, there will be thunder." But these statements are related to the omens in that neither entertains the question

[52] Ibid., 251:8–9.

[53] Ibid., 147:1–6.

[54] My discussion and its terminology here is influenced by Wartofsky, *Conceptual Foundations of Scientific Thought*, Chap. 11 on causality, pp. 291–315, especially sub (*a*) pp. 293–5.

of what causes *y* to happen whenever *x*. This formulation gives the omens a lawlike appearance, especially when it is further evident that predictions derivable from the relation of *x* to *y* are the goal of the inquiry into the set of *x*s that bear predictive possibilities. If we regard the omens as lawlike abstract statements, however, it must be said that any actual instances of such "laws" are limited to the unique, and as such trivial, co-occurrence of just that particular *x* and *y* stated in the omen. Although a formal similarity may be seen between the omen statements and so-called scientific statements of empirical generalization, both of which enable prediction, albeit of very different sorts, there is something fundamentally different in the extreme limitation of the domain of the omens as predictive statements. Perhaps the more apt parallel to the formulation of omens are the case law (casuistic) statements of the Babylonian law codes, in which the apodosis has been affixed to the protasis by cultural tradition, not nature. The relationship of protasis to apodosis in the omens is something like the statements in Mesopotamian "laws" formulated as "if someone does *x*, the consequence will be *y*," for instance, "If a man committed robbery and has been caught, that man shall be put to death."[55] The similarity rests on the relationship between protasis and apodosis, in which, in the codes, the apodosis represents the decision, or judgment, assigned to the case. The lawlike nature of omens can similarly be understood in terms of divinely decided cases, although we should not press this point too far into the morality of case judgments.

In the main, however, the relationship of protasis to apodosis is one of "cultural" as opposed to "natural" association. This is confirmed when we take into account the methods whereby a sign (omen protasis) was paired up with an event (omen apodosis). The hypothesis that the link between the sign and its prediction necessarily involved an observation of the simultaneous or sequential occurrence of those two elements is undermined by many omens.[56] It seems that associations between the sign and the predicted event could be purely linguistic or conceptual and independent of any observation. I have already noted (Section 2.1) the use of paronomasia, playing on the sound of a word from the protasis to

[55] Code of Hammurabi 22; see James B. Pritchard, ed., *Ancient Near Eastern Texts*, 3rd ed. (Princeton, NJ: Princeton University Press, 1969), p. 167.
[56] This has been discussed by Starr, *The Rituals of the Diviner*, pp. 8–12, in which he juxtaposes "theoretical" methods of relating protasis to apodosis against "empirical." In Starr's analysis, the empirical method of divination is equivalent to Speiser's "circumstantial association," for which, see Subsection 7.4.1.

a word in the apodosis (*arbu:irbu*, raven:income), and analogy, in which the apodosis is an analog of some element of the protasis (Venus enters, i.e., is occulted by the moon: crown prince enters, or usurps, the throne, or, the Fish star stands close to the Raven star: fish (and) birds become abundant[57]). Examples of such linguistic manipulations indicate rather persuasively that although empiricism was a factor in the formation of omen protases, it did not always come into play in the decision to associate certain apodoses with certain protases. Association by analogy could also determine whether the sign was propitious or unpropitious, for example, on the basis of common polarities such as right and left. Other schematic symmetries functioned in the same way, and are found in all the divination series, celestial, terrestrial, physiognomic, medical diagnostic, dream, and anomalous birth omens.[58]

7.3.3 Observables in Mesopotamian Divination

It has become commonplace to admit that theory and inference are embedded in observations and that in fact one observes a field of phenomena, not blindly, but for the purpose of discovering evidence *for* something. The conceptual context of an inquiry as a whole defines the interests and the problems for inquiry, including defining what is taken to be empirical for a particular inquiry. The history of science is rife with examples of empirical entities that turned out not to refer to anything true about the world, from crystalline celestial spheres to phlogiston to spontaneous generation. The most basic of all premises of Mesopotamian divination, namely, that "signs" in nature are produced by deities for the purpose of communicating with human beings, suggests that ominous phenomena belonged to a conceptual framework representing the world as created and manipulated by deities. The expectations of what kinds of "signs" would occur resulted from this very inclusive concept of all possible divinely produced phenomena of the world. Therefore dreams, lunar eclipses, puddles, disease symptoms, and malformed fetuses could all and equivalently be "signs." No category of phenomena had greater or lesser epistemological status, as all of the signs yielded forecasts of what was in store for humankind. The periodic nature of astronomical phenomena rendered this category of signs amenable to prediction, which, from our point of view, distinguishes celestial divination from other forms of scholarly

[57] Hunger, *Astrological Reports* 73 rev. 1–2.
[58] See Chapter 2.

divination. It seems likely that the predictability of the signs themselves would be advantageous to the practice of divination, giving the diviner advance knowledge of the occurrence of signs and accordingly more time to prepare for their anticipated consequences.

In the absence of sources that make explicit what the Babylonian scribes' criteria for empirical entities were, the schemata themselves indicate what was deemed "observable," or potentially so. The schemata typically exhibit symmetries of direction (right and left, high and low, up and down, or north, south, east, and west), temporal relationships (beginning, middle, end), or other descriptive features and their opposites (bright and dull, light and dark, thick and thin), all, in principle, observable features of phenomena. One such scheme is found in the omens referring to the color of the object of interest, for example, the color of ants crossing the threshold of a house, the color of a lunar eclipse, the color of a sick person's throat, or the color of a dog that urinates on a man. These items from the series Šumma ālu, Enūma Anu Enlil, SA.GIG, and Šumma izbu, respectively, are all organized similarly, that is, white, black, red, green–yellow, and variegated. Simple numerical expansions are also characteristic, for example, the multiple births running from two to ten,[59] or parhelia (mock suns) numbering from one to four,[60] some of which seem to be beyond the range of the empirically veridical. Such patterns are also characteristically found in impetrated omens, such as lecanomancy (oil divination), for example, "If (the oil) becomes dark to the right/left," or "If it dissolves to the right/left"; libanomancy, for example, "If the smoke, when you scatter it, rises to its right but does not rise to its left," or "If the smoke, when you scatter it, rises to its left but does not rise to its right." The formal patterns into which phenomena could be organized in omen lists indicate that what was observed was observed for the purpose of determining whether a given phenomenon appeared in a particular configuration (e.g., up, down, to the right, left, etc.) in accordance with such patterns. One may argue that it would only have been in terms of established ideas about the behavior of phenomena that any phenomena would have been interpretable. Or, put another way, the kinds of phenomena under observation were shaped by the scribes' traditional ideas of what was deemed ominous. The phenomena collected as omens in the series include both those potentially accessible to the senses and those that were not, but both

[59] Leichty, Izbu, VI, 46–58.
[60] See the šamšatu omens in ACh Suppl. 2 32.

were apparently considered (potentially) meaningful in conjunction with apodoses.

We can imagine that, in the process of compiling the omen series and out of the scribes' consideration of empirical symmetries, logical possibilities were raised of "phenomena" that had not been observed, but yet were conceivable and could be rationally included within the omen series. The status of such phenomena as potential "observables" may indicate the lack of a distinction between phenomena we would classify as empirically veridical and those we would not. Because the omen series do not seem to recognize such a categorical distinction, either ontological or epistemological, between what to us are observable and unobservable phenomena, both appear to belong to the category of potential "observables" in that the diviners watched for them all in order to predict the future. That some diviners in the Neo-Assyrian period saw the need to convert the meaning of some protases in accordance with physical "reality," as in the conversion of a lunar eclipse to a moon obscured by a cloud, further demonstrates the centrality of ominous phenomena to the practitioners of this ancient science.

7.3.4 A Brief Look at Babylonian Astronomical Observations

Legitimate "observation statements" are abundantly attested in astronomical texts.[61] Here, we are concerned with the relationship between this observational program (or programs) and celestial divination (including horoscopes). There is no doubt that the earliest astronomical texts, such as MUL.APIN, the Astrolabes, or other "official" compilations, that is, those that were copied and distributed, rest upon a substantial empirical foundation. But the contents of these early astronomical texts do not represent observations; rather they present schematic resolutions to astronomical problems, such as in the seasonal appearances of fixed stars, the return of the planets to their synodic phases, or the length of daylight. On the other hand, in close association with celestial divination are the (mostly undated) letters and reports from the Assyrian and Babylonian scholars to the Neo-Assyrian monarchs, which provide contemporary observations with a mind to their interpretation as omens. With reference then to this material, the observational program may be said to have encompassed lunar, planetary, meteorological, and stellar phenomena. The moon was of

[61] An account of the observational content of the various astronomical source groups may be found in Hunger–Pingree, *Astral Sciences.*

interest mainly on the days of synodic appearances, that is, new moon on the 30th or the 1st day and full moon on the 12th, 13th, 14th, 15th, or 16th days, as well as lunar eclipses. The planets and their conjunctions with fixed stars were also regularly observed, as were meteors, comets, halos around the moon, sun, or planets, and a variety of weather phenomena, such as rainbows, thunder, lightning, rain, and fog. These phenomena correspond to those of the omen protases in *Enūma Anu Enlil*. As discussed in Subsection 7.3.2, in the letters and reports, the scholars recorded their observations of such phenomena that occurred on a given night, followed by an enumeration of related omens to aid in their determination of appropriate action to take in the face of the observed portent.

The most extensive of observational records are the astronomical diaries (see also under Subsection 4.2.1). As Hunger and Pingree put it, "a diary is a record of observed phenomena carefully chosen from the realms of the celestial, the atmospheric, and the terrestrial."[62] The astronomical data systematically observed throughout the period covered by the diaries (seventh to first centuries B.C.) can be summarized as follows: (1) The date of the first crescent moon appearing either on the "30th day" or the "1st day," the former indicating that the previous month had 29 days, the latter that it had 30 days. (2) On the first day of the month, the duration of visibility of the first lunar crescent, in terms of the observable interval between sunset and the first visible moonset after conjunction (termed *na*). This interval was sometimes predicted rather than observed. (3) The two pairs of mid-month lunar visibility intervals, šú and *na*, ME and GE₆, also sometimes predicted. (4) The last visible lunar crescent (KUR), also predicted when weather obscured visibility. It is clear that the moon figures prominently in the diaries; its progress through the month is denoted by means of the ecliptical stars it is seen to pass by each night, and its synodic moments are observed in terms of the intervals of visibility between sunrise or sunset and moonset or moonrise in the beginning, middle, and end of each month, that is, around conjunction (*na* and KUR) and opposition (šú, *na*, ME, and GE₆). (5) Eclipses, both solar and lunar. (6) Conjunctions of the moon and planets to the Normal Stars throughout the month. (7) Planetary synodic phenomena. (8) Meteors and comets. (9) A wide variety of cloud conditions and bad weather. In fact, weather reports are a dominant feature of the diaries. The meteorological phenomena were perhaps not recorded merely because they obscure the observation of more significant astronomical events, but as phenomena of interest in

[62] Hunger-Pingree, *Astral Sciences*, p. 141.

their own right. The numerous weather omens of the "Adad" section of *Enūma Anu Enlil*, the tablets of which are still not identified with any certainty (Tablets 37–49), bear some relation to the weather phenomena observed in the diaries. They concern winds and storms, lightning, and earthquakes, the very same subjects we see in the Neo-Assyrian reports from the scholars. Whether indeed these were of interest as signs is not ascertainable from the diary texts.

Hunger and Pingree have commented on the stability of the diaries' contents throughout the centuries long duration of this archive. They remark:

Particularly stable seem to have been the astronomical data recorded in the Diaries. This is remarkable in several respects: only phenomena which are periodic and therefore capable of being described mathematically are included, and almost all of the phenomena regarded as ominous in *Enūma Anu Enlil* (exceptional are halos around either luminary enclosing planets or constellations) and constantly observed, recorded, and interpreted for the court at Nineveh were assiduously ignored.[63]

Diametrically opposed to this point of view on the nature of the diaries' astronomical content is that of Swerdlow, who said, "the fundamental purpose of the Diaries was surely to record ominous phenomena in the heavens for divination and perhaps also for ritual and magic."[64] It is indeed the case that a wide variety of subjects of celestial omens that are not periodic (e.g., "the appearance of the moon was very large" or "Venus in the month of *Nisannu* at her appearance is dimmed") are no longer attended to in the diaries. Yet some phenomena that are observed and recorded in diaries still bear close association to many ominous phenomena of *Enūma Anu Enlil*. Hunger and Pingree admit that "the scribes of the Diaries certainly continued to believe in omens since they report some,"[65] but do not wish to see the recorded phenomena as ominous. This is an important clarification, because although the phenomena compiled in the diaries are surely not omens, the diaries must be situated within a cultural context wholly accepting of the significance of signs.

The mere fact that some phenomena become predictable does not necessarily detract from their effect as portents. Indeed, the compilation of astronomical data in a horoscope was made so as to determine the life

[63] Ibid., p. 144.

[64] Swerdlow, *The Babylonian Theory of the Planets*, p. 16. Brown, *Mesopotamian Planetary Astronomy-Astrology*, pp. 97–103, concurs.

[65] Hunger–Pingree, *Astral Sciences*, p. 140.

of the individual in a manner similar to a nativity omen. Because the horoscope was composed after the birth, the question of whether anything was observed becomes moot. A connection between the diaries' contents and celestial divination/horoscopy cannot be ruled out, and may be important for our understanding of the no doubt several purposes served by that extensive archive. Particularly good evidence of such a connection is to be found in reference to lunar eclipses.

Observations of lunar eclipses are included in diaries, goal-year texts, and some of the Late Babylonan astronomical texts that were devoted solely to the recording of eclipses.[66] J. Steele has shown that the content of the observed eclipses bears close relation to that of the eclipse omens of *Enūma Anu Enlil*. These reports include the elements of eclipse phenomena familiar from omen protases, that is, the time, duration, magnitude, color, direction of movement of the eclipse shadow during the eclipse, the visibility of stars and planets during the eclipse, and the direction of the wind.[67] Despite a marked difference in the accounts of predicted eclipses, Steele further notes that "we seem to have a direct link between the factors that affected the interpretation of an eclipse in the *Enūma Anu Enlil* omens and the details of the observations that were recorded in the Diaries."[68] This can be illustrated by the following examples, the first from a diary, the second from *Enūma Anu Enlil* Tablet 20.

Night of the 14th, moonrise to sunset: 4°, measured (despite) mist; at 52° after sunset, when α Cygni culminated, lunar eclipse; when it began on the east side in 17° nighttime it covered it completely; 10° nighttime maximum phase; when it began to clear, it cleared in 15° nighttime from south to north; in (its) onset it was slow, in (its) clearing it was fast; 42° onset, maximum phase, and clearing; its eclipse was red; (in) its eclipse, a gusty north wind blew; (in) its eclipse, all the planets did not stand there; 5 cubits behind δ Capricorni it became eclipsed.[69]

[If an eclipse occurs on the 14th day of *Du'ūzu*, a]nd the god, in his eclipse, becomes dark [on the sid]e east above, and clears [on the side s]outh below; [the north wind (blows) and] in the first watch (the eclipse) is half, and [in his *šurinnu* the stars abo]ve come out. [Observe his eclipse], (that of) the god who in his

[66] Steele, *Observations and Predictions of Eclipse Times*, Appendix A, pp. 244–7, lists all lunar eclipses available in these eclipse texts.

[67] *ABCD*, pp. 44–63, discusses these elements in relation to the lunar eclipse omens of *Enūma Anu Enlil* Tablets 15–22.

[68] Steele, *Observations and Predictions of Eclipse Times*, p. 55.

[69] Sachs–Hunger, *Diaries*, Vol. II (1989) No. −225 rev. 4–8.

eclipse bec[ame dark] on the side east above, [and] cleared [on the side south be]low, and [bear in min]d the [nor]th wind.[70]

The diaries do not indicate that the observed eclipse was to be interpreted as an omen, but if only data useful for prediction or amenable to mathematical description were included in diaries, it would become difficult to account for the attention to the color of the eclipse or to the prevailing wind at the time of its occurrence. If the observed eclipses described in the diaries were thought to be ominous, it of course does not follow that all phenomena recorded in diaries were ominous. However, the possibility that a relation between celestial divination and the production of diary texts goes beyond the obvious and trivial relation that they shared an interest in heavenly phenomena must be given serious consideration.

7.4 THE AIM OF PREDICTION: THE PRAGMATIC CRITERION

If the domain of "observables" indexes the framework of a science, then the criteria for theory, in which are embedded all sorts of culturally determined goals, index the nature of a science. The domain of the observable sets the agenda, so to speak, for what a particular science is looking for, and the determining criteria for scientific theory create a context in which the results of science are valued. In view of the relativity of scientific criteria, Mary Hesse has singled out as the "one overriding value for natural science, namely the criterion of increasingly successful prediction and control of the environment."[71] For this she used the term "pragmatic criterion," which I adopt here, although, as will become clear, there are significant differences between the modern "pragmatic criterion" and what I have identified as a Mesopotamian counterpart. For one thing, we must be satisfied simply with prediction as an aim. A desire for "increasingly successful prediction" is difficult if not impossible to demonstrate in the Babylonian material.

7.4.1 The Case of Celestial Divination

In speaking of the interpretation of ominous phenomena and the science of calculating ominous phenomena, Swerdlow characterized both as

[70] *Enūma Anu Enlil* Tablet 20 IV Recension A: 1–6; see *ABCD*, pp. 192–3.

[71] Mary Hesse, "Theory and Value in the Social Sciences," in C. Hookway and P. Pettit, eds., *Action and Interpretation in the Philosophy of the Social Sciences* (Cambridge/New York: Cambridge University Press, 1978), p. 2.

sciences, even empirical sciences, of great complexity, requiring classification and
analysis of observational records, distinction between correct and erroneous obser-
vation, correction of the erroneous, and the development of systematic methods
by which predictions of the future may be based upon regularities of the past.[72]

He further commented that

although the development of mathematical astronomy followed the collection of
celestial omens and systematic observation of phenomena by hundreds of years,
the relation between the omen series, Diaries, and ephemerides is very close . . .
and divination, observation, and calculation must be regarded as parts of a single
descriptive and interpretive science of the heavens.[73]

Swerdlow sees a continuity and consistency of omen prediction and the
prediction of ominous phenomena on the basis of their each employing
"systematic methods by which predictions of the future may be based
upon regularities of the past." But in the case of divination, it is most
difficult to show that the method of prediction stems from an under-
standing of regularities in the past. To support the claim that divination
and astronomical calculation are consistent and continuous beyond the
mere functional similarity of their shared goal to predict, we must attempt
to establish a clearer understanding of what sort of predictions omen apo-
doses represent.

As already discussed, the ominous phenomena and the events indicated
by them were set in relation to one another in the manner of conditional
probabilities, where the occurrence of an event is expected if it is estab-
lished that another event has occurred (or will occur). The formulary "if
x, y" parallels that of Sumerian and Akkadian law collections, which listed
the verdicts for specific cases. The interpretation of omens as collections
of divine "judgments" or "verdicts" was argued in Section 5.4 in the light
of prayers and incantations that refer to the gods as "deciders of decisions"
and "renderers of judgments" in the form of oracles and omens. The use
of the word *purussû*, "decision" or "verdict" as a term for "omen predic-
tion" seems to confirm this interpretation. This terminology shows where
agency is placed in the Mesopotamian system of divination, that is, not in
the phenomena regarded as ominous, but in the gods, who not only make
celestial phenomena appear the way they do, but decide what events will
happen on earth in association with the celestial omens. Outside of *Enūma
Anu Enlil* and its direct citations, R. D. Biggs noted the same terminology

[72] Swerdlow, *The Babylonian Theory of the Planets*, p. 33.
[73] Ibid.

in prophecy texts,[74] for example, "its decision concerns Elam: Elam will lie waste, its shrines will be destroyed, the regular offerings of the major gods will cease, and so on."[75] In reviewing the evidence for this usage of *purussû*, Biggs concluded that the term refers primarily to predictions derived from celestial divination, although he cited a number of rubrics in which the term applies to other categories of omens, as in "divine decisions (*purussû*) concerning celestial bodies, birds, and oxen"[76] and "divine decisions (*purussû*) concerning all the birds."[77] In light of the expression "such is his sign and its decision (*kīam ittašu u purussūšu*)," attested in an inscription of Nabonidus as well as in both lunar and planetary omens of *Enūma Anu Enlil, purussû* refers specifically to the apodosis, not to the omen as a whole. In light of this evidence, our designation of omen apodoses as "predictions" does not render the Babylonian conception very well. Of course the apodoses contain forecasts of future events, and so are "predictive" in a general sense, but the term "prediction" implies the result of something very different from a "judgment" or "verdict."

It is one thing to allow Babylonian terminology to suggest what the scribes thought omens were, and another thing to infer from the formulary and function of the omens to a thesis about their logical meaning and derivation. J. Bottéro states the problem this way:

What is most important for an understanding of divination as an intellectual activity, as a way of knowing, is contained much less in the protases or apodoses themselves than in the transition from the first to the second. How could someone decide to base the conclusion that a man would become a slave on the fact that his chest-hair curled upwards?[78]

Bottéro sees the mechanism by which protasis leads to apodosis as "at first entirely empirical, i.e. based on simple a-posteriori observation."[79] In this way his interpretation is influenced by E. A. Speiser's principle of "circumstantial association," which was defined as follows: event *y* was

[74] R. D. Biggs, "More Babylonian Prophecies," *Iraq* 29 (1967), p. 122:28.

[75] Ibid. p. 124:35–38.

[76] *KAR* 44 rev. 2.

[77] A. Boissier, *Documents assyriens: Relatifs aux présages* (Paris: Librairie E. Bouillon, 1894), p. 35:3.

[78] Bottéro, *Mesopotamia*, p. 130. The omen referred to here is "If the hair on a man's chest is turned (upward) and points towards his chin: he will become a slave"; see VAT 7525 col.i 19–20, edited by Köcher and Oppenheim, "The Old-Babylonian Omen Text VAT 7525," p. 63.

[79] Ibid.

originally observed under certain circumstances represented by event x. Because chance occurrence was not possible in the Mesopotamian understanding of the occurrence of the two events, whenever x would be observed again, y was anticipated. Thus x became a warning, or omen, of y. Hunger and Pingree see the omens in a similarly empirical way, explaining that "once it was observed that a certain sign had been followed by a specific event, it is considered known that this sign, whenever it is observed again, will indicate the same future event."[80] Recurrent associations expressed by "if/whenever x then y" can and often do represent inductive generalizations (as in "if the sun sets, then the birds stop singing"). The question is this: Is there reason to view Babylonian omens this way?

Whereas the circumstantial association theory does not view the recurrence of the phenomena x and y, and therefore the inductive element, as essential in the original formation of an omen, as soon as the association is made between the two events, recurrence must be presumed for x to function as an omen of y. Thus the claim is made that omens represent generalized statements to future occurrences on the basis of one past instance. Speiser's "circumstantial association" not only underlies the discussion of Bottéro[81] and Hunger–Pingree, but also that of Saggs,[82] Oppenheim, and M. T. Larsen as well.[83] We must also note its relation to Swerdlow's view that prediction in omens relied upon a knowledge of past regularities. Swerdlow's claim, however, follows from an interpretation of the omen statements (if x then y) as products of induction, that is, generalizations or abstractions from observations which established the recurrence of y whenever x. This seems to me somewhat different from "circumstantial association," which accepts and establishes a connection between x and y on the basis of a one-time empirical association. Either way, the appeal to induction at any point in the analysis could be taken as a rationalization of the belief in divination.

[80] Hunger–Pingree, *Astral Sciences*, p. 5.

[81] J. Bottéro, "Symptômes, signes, écritures en Mésopotamia ancienne," in J.-P. Vernant, ed., *Divination et rationalité* (Paris: Éditions du Seuil, 1974), pp. 144–68. See, however, Koch-Westenholz, who explicitly counters the empiricism argument in *Mesopotamian Astrology*, pp. 13–19.

[82] H. W. F. Saggs, *The Encounter with the Divine in Mesopotamia and Israel* (London: Athlone, 1978), p. 132, states, "That the omens were basically non-deistic is further a conclusion from the fact that it is usual for a particular circumstance always to presage the same particular area of ill or good fortune. The omen thus represented not a god's decision upon a situation but rather a recognized correlation between past and future phenomena."

[83] Larsen, The Babylonian Luke-Warm Mind," p. 212.

An argument in support of omens as originally empirically ascertained has been made by appeal to the earliest extant divination texts, the liver models from Mari.[84] Some of the models refer to persons and events of Mesopotamian history datable between the Akkadian (ca. 2300–2230 B.C.) and Isin (ca. 2000–1900 B.C.) periods, stating that the liver was "this way" when a particular event occurred: For example, when the king of Ur, Ibbi-Sin's land rebelled against him, *anni'um kīam iššakin* "this (liver) was like this."[85] Because the appearance of a liver is paired with specific events, the liver omen collections that later replace the models are said to preserve the empirical relationship, or, in Larsen's words, "the compilations are built on this principle of precedence which places an absolute meaning on the relationships that have been – in theory – empirically established."[86] U. Koch-Westenholz has, I think rightly, pointed to a number of flaws in the argument for the liver models as evidence of an empirical foundation for divination. The most significant is that, given the schematic character of the configuration of the models, she, following J. Nougayrol,[87] suggests the models are not forerunners to omens, but rather are teaching aids for extispicy at Mari that trace back to already systematic omen prototypes. This would mean that, far from representing a posteriori observations, the models may in fact duplicate a priori inventions about what correlates with what. That associations between the sign and the predicted event in omens were based on nonempirical relationships is far easier to show, such as the paronomastic association of the sound of a word from the protasis to a word in the apodosis, or other linguistic and semantic connections, as discussed by Jeyes and Starr in reference to extispicy. Examples of such linguistic or semantic connections indicate that, although empiricism was certainly a factor in the formation of omen protases, it did not necessarily come into play in the decision to associate certain apodoses with certain protases.

[84] M. Rutten, "Trente-deux modèles de foie en argile inscrits provenant de Tell-Hariri (Mari)," *RA* 35 (1938), pp. 36–70; for this example, see no. 7, cited by Larsen in "The Babylonian Luke-Warm Mind," p. 212 and Bottéro, *Mesopotamia*, p. 131. See also, Daniel C. Snell, "The Mari Livers and the Omen Tradition," *Journal of the Ancient Near Eastern Society of Columbia University* 6 (1974), pp. 117–23.

[85] Rutten, "Trente-deux modèles," p. 47, No. 19:5, cited by Larsen, ibid., p. 213. Other models state "if *x* occurs: this (liver) will be like this" (*anni'um kīam iššakkan*).

[86] Larsen, "The Babylonian Luke-Warm Mind," p. 213.

[87] J. Nougayrol, "Note sur la place des 'présages historiques' dans l'extispicine babylonienne," *École pratique des hautes études, Annuaire* (1944–45), p. 37, and Koch-Westenholz, *Mesopotamian Astrology*, p. 16.

Because of the elusive nature of the evidence that empiricism was much
a part of the process that paired protasis and apodosis, mention should
be made of the bold hypothesis of P. Huber on the origins of celestial
divination in precisely such empirical connections between celestial and
historical events.[88] Basing the dating of the Akkadian dynasty on a chronol-
ogy combining his 1982 *Astronomical Dating of Babylon I and Ur III* with
Sollberger's relative chronology for the Dynasty of Akkad (therefore from
2381 to 2200 B.C.), Huber found "an almost unbelievable coincidence,"
namely, "no fewer than three (!) transitions of reign in this dynasty are
immediately preceded by an eclipse that matches the description of the
ominous Nisan eclipse presaging the death of the king of Akkad."[89] The
omen referred to is the first lunar-eclipse omen of *Enūma Anu Enlil* Tablet
20. The protasis describes an eclipse of the 14th day of the first month
of the year, specifying time (the eclipse ends during the last watch of
the night) and the direction of travel of the eclipse shadow (the shadow
begins to cross the moon "on the side south above" and clears "on the
side north below," presumably a total eclipse). The apodosis refers to the
death of "the king of Akkad," as follows: [The prediction is given] for
Agade. [The king] of Agade will die, but his people will be well. The
reign of Agade will fall into anarchy, (but) its future is propitious.[90] Hu-
ber argues that a hypothesis that the omen eclipses are not "real" (i.e.,
they are fabricated as to date, time, and direction of eclipsing shadow),
implying also that protasis and apodosis have no empirical connection,
must be rejected "if the agreement between text and calculation is implau-
sibly good."[91] After computing the dates of eclipses fitting the description
provided in the omen protasis and finding that reign transitions occurred
in the year immediately following three of these dated eclipses, Huber
indeed rejects the initial hypothesis (that the eclipses in the omen text do
not represent observations) and accepts the omens as referring to actual
observations. From this determination of the actuality of the eclipses, he
concludes that they must have been identified after the fact to anticipate
the end of a reign. "Who would not become superstitious," he asked,
"if two very similar total eclipses occur shortly before the deaths of two

[88] Huber, "Dating by Lunar Eclipse Omina, pp. 3–13.
[89] Huber, "Dating by Lunar Eclipse Omina," p. 3.
[90] *Enūma Anu Enlil* Tablet 20 Recension A I: 7; see *ABCD*, p. 179.
[91] Ibid. p. 7.

consecutive kings," meaning Manishtushu and Narām-Sin.[92] From the alleged empirical connections between datable eclipses and documented political events, he derives the origins of celestial divination in the third millennium. A historiographical dilemma is created in that the allegedly historical eclipses dating to the third millennium (2302, 2265, and 2237 B.C.), long before any extant textual evidence of celestial divination or astronomy in Mesopotamia, become the evidentiary basis for a historical thesis about the third millennium origins of celestial divination. It remains difficult, if not impossible, to equate any protasis with a real occurrence as we cannot be sure that omens were meant to, or did, record observed phenomena. The nature of the apodoses is equally vague, naming no historical persons, nor specifying anything in particular beyond the province of the reign, such as "Akkad" or "Ur," which is typical of the content of these "political" apodoses. The problematic nature of omens as sources for datable historical astronomical phenonena as well as political historical events undermines Huber's thesis. However, his suggestion that associations between phenomena and events were identified after the fact may be a reasonable alternative approach to reconstructing, in some cases, how the ominous events were paired with significant moments in the historical experience of the Babylonians.

In conclusion, to show even a methodological sympathy between astronomical predictions and those of celestial divination would require that protases and apodoses have some inherent empirical connection to one another. If that were the case, omens might then provide evidence for a hypothetical reconstruction of the origins of science suggested by W.v.O. Quine, who placed the origin of scientific laws in what he called "observation categoricals." Quine's "observation categoricals" are nothing more than statements in the form "if/when *x* then *y*." This is, as he put it,

what I picture as the first step beyond ordinary observation sentences; namely a generalized expression of expectation. It is a way of joining two observation sentences to express the general expectation that whenever the one observation sentence holds, the other will be fulfilled as well.[93]

But despite the attempts, previously discussed, to construe Old Babylonian liver models and Akkadian period lunar eclipse omens in this way, I do

[92] Ibid., p. 11.
[93] W. v. O. Quine, *From Stimulus to Science* (Cambridge, MA/London: Harvard University Press, 1995), p. 25.

not see the evidence in support of such an analysis of Babylonian omens. Omens merely share the if–then formulation of so-called observation cat-egoricals, such as "if the sun sets then the birds will stop singing"; Babylonian omens consist of signs and their divine decisions whose connections are highly variable and not dependent upon the regular or even one-time observation of their co-occurrence. The formulation "if *x* then *y*" in the context of Babylonian omens expresses only the belief that the gods de-termined *y* whenever *x*, unless of course the performance of an apotropaic *namburbi* ritual persuaded them to change their determination.

The question of prediction as it pertains to the ominous phenomena themselves is, however, a different matter. The historical relation between divination and astronomy does not require our establishing an empirical connection between protasis and apodosis in the omen texts. Evidence for observing and predicting ominous phenomena is already embedded in celestial divination: *Enūma Anu Enlil* Tablet 63 attests to an early scheme for the periods of visibility and invisibility of Venus; *Enūma Anu Enlil* Tablet 14 predicts the duration of the visibility of the moon each night over the course of a year by means of a tidy mathematical scheme, and for predicting eclipses, *Enūma Anu Enlil* Tablet 20 instructs the diviner to observe the last visible moonrise on the 28th day, expressly stating "you observe and you predict," literally, "you say (*taqabbi*) 'eclipse'" and further states that "the day of last visibility will show you the eclipse."[94] This method of short-term eclipse prediction, however, remains obscure, although it may relate to the evidence from the reports to the Neo-Assyrian kings that state that an eclipse will "pass by" if the moon and sun are "seen together" on the day of opposition, as suggested by Steele.[95] Although the term for an apodosis "prediction" is *purussû* "(divine) decision," prediction when said of the phenomenon itself is expressed by the verb "to say" (*qabû*). Astronomical procedure texts in which we have such constructions as "predict the dates" (ME.MEŠ *qibi*) or "predict it as *x*" (*ana x qibi*), echo the language of *Enūma Anu Enlil* in their use of the verb *qabû* "to say" in the meaning "to predict."

Finally, the connection among divination, observation, and calculation of phenomena spoken of by Swerdlow is beyond doubt, but rests solely in the independent study of celestial phenomena, whereas the connection

[94] See *Enūma Anu Enlil* Tablet 20 I 9, and similarly for each month section of this tablet, *ABCD*, p. 180ff.

[95] Steele, *Observations and Predictions of Eclipse Times*, p. 78.

between ominous phenomena and their anticipated consequences remains a matter of arbitrary connections, seen by the scribes as divine judgements. Where we can discern such connections, they seem to have been derived by means of a variety of associations. As confirmed by the evidence of predicting ominous phenomena in the letters and reports, as well as the few indications in *Enūma Anu Enlil* itself that prediction of such phenomena was desirable, it does not seem to me to follow that the predictability of a phenomenon precluded its status as an omen. The instructions in *Enūma Anu Enlil* Tablet 20 to observe the last visibility of the moon so that the eclipse will be predicted seems to constitute particularly strong evidence that even a predicted eclipse was still an ominous sign. The development of predictive methods seems only natural given the periodic nature of many ominous celestial phenomena.

7.4.2 The Case of Astronomy

The regular and systematic observation of the heavens, exemplified by the astronomical diaries and the focus on lunar eclipses, represented by the eclipse reports and their compilations reaching back to the Nabonassar era, beginning 747 B.C.,[96] are testimony to the results, in purely astronomical terms, of the interest in astronomical prediction, whether or not it was generated or justified by celestial divination. And whether the diaries were, as Hunger and Pingree maintain, a "scientific program" aimed specifically at the development of a mathematical astronomy, is an open question, but, in Hunger and Pingree's words, they were indeed "explicit expression of the Babylonian's belief that celestial motions are periodic, that they represent the order imparted to the heavens by Marduk according to *Enūma eliš*."[97]

With a firm empirical footing, the Babylonian astronomer–scribes approached the prediction of synodic phenomena theoretically and created a general method for the solution of a range of particular problems. That solution was achieved by the creation of mathematical models applicable to the synodic phenomena of all the planets. These quantitative models, the two principal ones now conventionally referred to as System A and System B (see Subsection 4.2.4), accommodated the differences between inner and outer planets as well as the different periods for

[96] For discussion of such eclipse records, from the corpus *LBAT* 1413–1457, see Steele, *Observations and Predictions of Eclipse Times*, pp. 52–7.

[97] Hunger–Pingree, *Astral Sciences*, p. 140.

each planet. The systems schematized and quantified such aspects of celestial motion as the movement in latitude of the moon and the regression of the lunar nodes, and embedded within them are the concepts of mean synodic arc and mean synodic time.[98] As a result either one of the two systems in combination with excellent parameters and the convenience of the Seleucid Era enabled the computation of tables of dates (month and *tithis*) and positions (zodiacal longitudes) of the synodic phenomena.

To answer the question of how the Babylonian astronomers achieved all this requires that we reconstruct the method, or a method, by which we can reproduce their results. Neugebauer discussed a development from short-range predictions made by means of linear extrapolation from crude period relations such as are preserved in goal-year texts. As he put it, "Such methods are frequently sufficient to *exclude* certain phenomena (such as eclipses) in the near future and, under favorable conditions, even to predict the date of the next phenomenon in question."[99] Neugebauer saw systematic long-range prediction, exemplified by the calculated phenomena listed in ephemerides, as an outgrowth of these parameters achieved through the application of the notion of perturbations. Thus the long and excellent periods underlying the ephemerides can be shown to derive from shorter more approximate goal-year periods by a process of linear combination in which error is progressively factored out.[100] The goal-year periods themselves find their ancestors in the earlier planetary periods of visibility and invisibility attested in MUL.APIN and celestial omens such as the Venus Tablet, *Enūma Anu Enlil* Tablet 63.[101] For the period of approximately the fifth century and later, a method of predicting the durations of lunar visibility around the dates of syzygy, that is, the Lunar Four phenomena šù, *na*, ME, and GE₆, by means of the observations recorded in goal-year texts one eclipse cycle earlier has been successfully demonstrated by L. Brack-Bernsen. She has also shown the derivation of the lunar anomaly parameter (Φ) from the sum of observations of the Lunar Four, corresponding to arcs of elongation of the moon on the days on

[98] This has been frequently discussed; see A. Aaboe, "On Period Relations in Babylonian Astronomy," *Centaurus* 10 (1964), esp. pp. 221–2, Neugebauer, *HAMA*, pp. 373, 382, and 394–7, and Swerdlow, *The Babylonian Theory of the Planets*, pp. 64–72.

[99] O. Neugebauer, "The History of Ancient Astronomy: Problems and Methods," in *Astronomy and History: Selected Essays* (New York/Berlin/Heidelberg/Tokyo: Springer-Verlag, 1983), p. 47.

[100] Neugebauer, *HAMA*, p. 391.

[101] See Hunger–Pingree, *MUL.APIN*, pp. 148–9.

either side of opposition.[102] Eclipse prediction also goes back to the early, pre-fifth-century, period. Steele remarked that "more or less as soon as the Mesopotamian astronomers began to observe solar and lunar eclipses, they also attempted to predict these events in advance." By 600 B.C., at least, the Saros period (223 synodic months or 18 years) was used to predict the eclipses recorded in the texts such as diaries and eclipse reports, and Steele has discussed how this period relation may have been derived from the observational record and how the method of its application in the non-mathematical astronomical texts differs from that of the ephemerides.[103] In another study Swerdlow tackled the problem of the relationship between observational and predictive texts by looking at the derivation of the synodic times ($\Delta\tau$) used in the ephemerides. On the premise that the synodic arc ($\Delta\lambda$) cannot be found with any precision by observation, he worked from the position of primacy of synodic time rather than arc for the derivation of the parameters used in the ephemerides. He hypothesized that the dates of observed heliacal phenomena and the locations in the zodiac such as are available in the observational diary texts could serve to determine synodic time, that is, the time between successive occurrences of a synodic phenomenon. From the synodic times the synodic arc is derivable by means of a numerical constant that relates synodic time and synodic arc, this being possible because the synodic phenomena occur by definition with respect to the sun, here assumed to move uniformly (i.e., the mean sun).[104]

The predictive aspect of Babylonian astronomical science is no doubt its most important legacy as well as the most important evidence for the theoretical basis of the program. I have already referred to the inheritance of the Babylonian science in Hellenistic and Indian tradition. The Greek inheritance is evident in both the *Almagest*, in which elements of the Babylonian astronomy are preserved, and in the astronomical papyri, in which the quantitative methods themselves (Systems A and B) remain

[102] Lis Brack-Bernsen, "Goal-Year Tablets: Lunar Data and Predictions," in N. M. Swerdlow, ed., *Ancient Astronomy and Celestial Divination* (Cambridge, MA/London: MIT Press, 1999), pp. 149–77.

[103] Steele, *Observations and Predictions of Eclipse Times*, pp. 75–83, and idem, "Eclipse Prediction in Mesopotamia," *Archive for History of Exact Sciences* 54 (2000), pp. 421–54.

[104] N. M. Swerdlow, "The Derivation of the Parameters of Babylonian Planetary Theory with Time as the Principal Independent Variable," in N. M. Swerdlow, ed., *Ancient Astronomy and Celestial Divination* (Cambridge, MA/London: MIT Press, 1999), pp. 255–98, with a fuller treatment in N. M. Swerdlow, *The Babylonian Theory of the Planets* (Princeton, NJ: Princeton University Press, 1998).

a fundamental predictive tool. The results of these predictive methods testify to the control over the effects of periods and visibility conditions, which are themselves highly variable. That these elements were identified and then integrated within a mathematical system that could be applied to the moon and planets in any one of their synodic phenomena, constitutes unequivocally an example of the development and refinement of theory.

7.4.3 Questions About Theory

Formerly, in the historiography of science of the mid-twentieth century, the theoretical dimension of Babylonian astronomy was not generally recognized outside of the circle of scholars who read and analyzed the cuneiform texts. Neugebauer, for example, used "the lunar theory in general" and "the planetary theory in general" as headings in his *Astronomical Cuneiform Texts* of 1955. The sense in which he meant the term was carried over by A. Aaboe, "On Babylonian Planetary Theories" of 1958,[105] and is preserved in Swerdlow's *The Babylonian Theory of the Planets*, which appeared in 1998. The use of the word "theory" to refer to the underpinnings of the Babylonian ephemerides is worth exploring, particularly given that philosophical expectations for what "theory" is have changed and grown considerably since the days of Babylonian astronomy's early reception within the wider field of history of science.

Behind the reluctance to characterize the cuneiform astronomical texts as theoretical was the continuing influence of logical positivism, even though by 1960 it had come under attack, especially from philosophers sensitive to history. But by the 1990s, as R. E. Grandy said in the opening sentence of his "Theories of Theories: A View from Cognitive Science,"

Logical positivism is interred. And with it a conception of scientific theories that once dominated the philosophy of science scene.[106]

That conception, which played such a significant role in how modern philosophers of science approached the very question of the nature of science, can be defined, in R. Giere's words, "as interpreted, formal, axiomatic

[105] In A. Aaboe, "On Babylonian Planetary Theories," *Centaurus* 5 (1958), pp. 209–77; see also A. "Aaboe, "Scientific Astronomy in Antiquity," in F. R. Hodson, ed., *The Place of Astronomy in the Ancient World* (London: Philosophical Transactions of the Royal Society A 276), pp. 21–42.

[106] Richard E. Grandy, "Theories of Theories: A View from Cognitive Science," in John Earman, ed., *Inference, Explanation, and Other Frustrations: Essays in the Philosophy of Science* (Berkeley, CA/Los Angeles/Oxford: University of California Press, 1992), p. 216.

systems...typically taken to have the form of laws, understood as universal generalizations."[107] The history of the application of the concept of natural law is well beyond the present scope, but relatively speaking, the idea is late, appearing in the Middle Ages, but associated most readily with Kepler and Descartes. Ironically, if we think of the Babylonian celestial diviners' "divine verdicts," "the nineteenth- and twentieth-century scholars who have offered explanations of modern scientific 'law,'" as J. E. Ruby points out, "have all found its origin in the metaphor of divine legislation, with the prescriptive connotations subsequently disappearing."[108]

Lawlike regularities discerned in nature were seen not only as the basis for making reliable predictions, but as having an explanatory capacity as well. Systems, or theories, for the prediction and explanation of phenomena were rooted in the "'soil' of observation (experience),"[109] but were not themselves necessarily representative of the real world. Cuneiform astronomical tables had no use for axiomatic expressions of lawlike regularities or causal explanations of the synodic phenomena of the moon and planets, but their systems, referring here to the Systems A and B (and their variants), were constructed on an empirical foundation. And although these systems did not purport to represent the real world, their aim was to reproduce, in the form of dates and longitudes, the appearance of celestial phenomena in the real world.

Modern expositors of these texts retain the use of the term theory in reference to the Babylonian astronomical systems. What do they mean by theory in this context, and further, can their assessment find a place on today's topographical map of the philosophies of science? Is the appellation "theory" to Babylonian ephemerides so self-contained that it bears no meaningful relation to any philosophical discourse on scientific theory? Or is it more a matter of ancient Near Eastern science not conforming to modern views on scientific theory when they are couched in logical positivist terms, but can perhaps be found to have some affinity for "theory" in some other recognizable sense?

[107] Ronald N. Giere, *Science Without Laws* (Chicago/London: University of Chicago Press, 1999), p. 97.

[108] Jane E. Ruby, "Origins of Scientific 'Law,'" in Friedel Weinert, ed., *Laws of Nature: Essays on the Philosophical, Scientific and Historical Dimensions* (Berlin/New York: de Gruyter, 1995), pp. 289–90.

[109] See H. Feigl, "The 'Orthodox' View of Theories: Remarks in Defense as Well as Critique," in M. Radner and S. Winokur, eds., *Analyses of Theories and Methods of Physics and Psychology*, Minnesota Studies in the Philosophy of Science, Vol. 4 (Minneapolis, MN: University of Minnesota Press, 1970), *apud* Giere, *Explaining Science*, p. 25, Fig. 2.1.

First, it should be noted that Neugebauer's classification of Babylonian mathematical astronomical texts as "theoretical" was partly intended to separate that corpus from other cuneiform astronomical texts whose methods are not predictive, computational, or schematic in the same way, that is, by means of the particular methods of Systems A and B employed in the ephemeris tables. This practice continues today, with the result that modern characterizations of the corpus of ephemerides use the adjectives theoretical, mathematical, predictive, computational, and schematic rather interchangeably. Theoretical astronomy, in this usage, denotes that part of the discipline of the ancient scribes that developed and applied specific mathematical models. The astronomical theories shed no light whatever on Babylonian thought about the lawlike behavior of celestial bodies, certainly not the idea that the heavens operated on the basis of laws of "nature." The conception of the schematic behavior of the celestial phenomena underlying and defined by Systems A or B served the purpose of computing the phenomena. Whether observation was possible or not, the dates and positions of synodic phenomena could be obtained by means of the theory and its procedures. Phenomena could just as easily be predicted as retrojected, as they would have to have been for horoscopes, if indeed Systems A or B were used in any such cases.

Beyond reconstruction of the schemes, it is difficult to even tender a suggestion about any general Babylonian assumptions regarding the behavior of heavenly phenomena. To push much of an exegesis on the tables of numbers, for example, that the schemes attest to a Babylonian conception of how heavenly motion was constituted physically or materially in the cosmos, would not be supported by the texts. No cosmological model corresponding physically to the models that generate the dates and positions of lunar and planetary phenomena may be reconstructed. Neither System A, which imposed a mathematical structure on the phenomena by means of step functions, nor System B, which made use of linear zigzag functions, can be argued to constitute an image of the world. Nor is there a hint in the ephemerides or in any related materials that they were meant to do so. The function for calculating planetary longitudes in System A is tied to an ecliptical model in which longitude is generated as a function of longitude [$\Delta\lambda = f(\lambda)$]. System B, on the other hand, generates longitudes as a function of the line number in the table [$\Delta\lambda = f(n)$], where n represents the number of a synodic occurrence in the sequence of such occurrences found as line-by-line tabulated entries. Accordingly, the period in a System A ecliptical model means the number of applications by the planet of the synodic arc corresponding to the number of revolutions

of the ecliptic, and hence to a precise return in longitude of the body in a given synodic appearance. In System B the period relation states only that a given number of lines of the table text will bring a return to a value for $\Delta\lambda$ after a given number of waves of the zigzag function, and as such refers to line numbers between same values. Consequently, System B's model will not bring a precise return to a particular longitude.

What does emerge from these systems is the recognition of the (real) problem of anomaly, that is, that the heavenly bodies do not move with constant regularity. As Neugebauer pointed out, the lunar anomaly is readily observed. The rapid daily progress of the moon makes the inequality of its motion detectable with respect to the fixed stars,[110] but not so the sun, which obviously cannot be observed to move with respect to the fixed stars at all and has much too small an anomaly to be discovered directly.[111] Indeed, that the Babylonians discovered the solar anomaly is plainly attested in the ephemerides' schemes, but how they came to it is still a puzzle.[112] In Neugebauer's estimation, it is the detection of these inequalities and the construction of mathematical models adequate to deal with them that goes to the theoretical dimension of this science. The longitudes and dates of phenomena tabulated in these tablets are derived consequences of a general model. In fact, the general status of the models could be considered a characteristic feature of the system. The phenomena of the sun, moon, and planets are all equally accommodated by the models, and indeed, ephemerides for each planet and the moon are attested, with the appropriate synodic periods built into each. The period relations in turn are the outcome of a progressively sophisticated interworking of observations and theoretization. Further, to schematize and quantify such aspects of celestial motion as the movement in latitude of the moon and the regression of the lunar nodes, not directly observable per se, points to a necessarily

[110] For discussion of the Babylonian underpinnings of Geminus, *Introductio astronomiae* 18.16–19, in relation to the concept of the mean motion of the moon, see A. C. Bowen and B. R. Goldstein, "Geminus and the Concept of Mean Motion in Greco–Latin Astronomy," *Archive for History of Exact Sciences* 50 (1996), pp. 157–85.

[111] Neugebauer notes, *HAMA*, p. 371, that "not only is it impossible to directly observe the sidereal motion of the sun but the extrema of the daily progress differ only by some 4 minutes of arc at points half a year apart."

[112] Neugebauer, *HAMA*, p. 372, citing Lis Bernsen, "On the Construction of Column B in System A of the Astronomical Cuneiform Texts," *Centaurus* 14 (1969), pp. 23–8. See also J. P. Britton, "Treatments of Annual Phenomena in Cuneiform Sources," in John M. Steele and Annette Imhausen, eds., *Under One Sky: Astronomy and Mathematics in the Ancient Near East*, AOAT 297 (Münster: Ugarit Verlag, 2002), pp. 39–40.

theoretical dimension in the work. In addition, some aspects internal to the ephemerides' numerical values reflect purely theoretical considerations, for example, the fixed mathematical relationship that ties the intervals between the zodiacal positions (longitudes) of the synodic phenomena to those of the column containing the dates (months and *tithis*). This relationship is such that the addition of a constant, derived from the mean values of longitude intervals and *tithis* intervals, that is, mean synodic arc and mean synodic time, respectively, will produce the dates from the zodiacal longitudes ($\Delta\lambda + C = \Delta\tau$). Or, indeed, by subtracting the constant, one can produce the longitudes from the dates ($\Delta\tau - C = \Delta\lambda$). The relationship between mean arc (in reference to longitude) and time (in reference to tithis) can thus be formulated as $\overline{\Delta\tau} - \overline{\Delta\lambda} = C$. The choice of the value for C, which varies with each planet, implies not only the conception of mean synodic arc and time, but also the idea that these occur at a fixed distance from the uniformly moving sun, that is, the mean, not the true, sun. The mean motion of the sun is therefore essential and fundamental to the definition and derivation of the planetary synodic arcs and times. It is a concept of no small significance, as Swerdlow explains:

Thus, the Scribes invented what we call the mean sun, which is implicit in all their planetary theory, and without essential change remained the foundation of planetary theory from Ptolemy, who referred motions, oppositions, and elongations of the planets to the mean sun, to Copernicus, who used it exactly the same way as Ptolemy, interpreted it geometrically as the center of the earth's orbit, and dignified it as the center of the planetary system for all purposes of mathematical astronomy. And the importance of this invention is still greater, for it is the uniform motion of the mean sun, measuring the arcs of the motions of the planets, that allows time to be taken as the principal independent variable in their planetary theory, and in this sense it stands behind the distinction between mean and true motion and the application of mean motion as a linear function of time in lunar and planetary theory from Ptolemy to the present, including treating time as the independent variable for the variation of parameters in the perturbation theory of modern celestial mechanics.[113]

Consideration of the problem of planetary and lunar synodic phenomena in this way involved a high degree of abstraction. And despite the use of the models to predict individual synodic appearances, the models were themselves abstract general descriptions of astronomical phenomena, as they could be applied equally well to all the celestial phenomena of interest

[113] Swerdlow, *The Babylonian Theory of the Planets*, p. 67.

to Babylonian astronomy. It is not only that the Babylonian mathematical schemes present general models for the description and prediction of natural phenomena, but also that concepts and constructs abstracted from empirical data and necessary for the mathematization and quantification of astronomical phenomena made the creation of these models and development of their application possible. These aspects of the mathematical astronomical branch of Mesopotamian celestial inquiry form the basis for the use of the term theory by modern expositors of this material.

As further testimony to the presence of theory in cuneiform celestial inquiry, and against claims that science only emerges in ancient Mesopotamia with the mathematical astronomy of the ephemerides, is the observation that an approach to celestial phenomena in a style clearly ancestral to the Late Babylonian ephemerides is found in earlier, sometimes much earlier texts. With reference to the lunar theory, Britton has shown the antecedents of the Late Babylonian ephemerides in texts of the two centuries or so before the earliest evidence of the final formulation of System A, first attested to in an ephemeris for the years 319 to 316 B.C., and System B, first attested to for 258 to 245 B.C.[114] Britton found that the problem of zodiacal anomaly was identified by 376 B.C. in the work on eclipse magnitudes, and solved by 316 B.C., at which point the System A lunar theory can be said to have reached its final form. In his investigation of pre-Seleucid astronomical texts, Britton concluded that complex problems were resolved through the progressive refinement of Systems A and B, and that this was due not only to the increased subtlety of the theory but also to continued interaction with empirical data.[115]

Another case in point is Tablet 14 of *Enūma Anu Enlil*, mentioned very briefly in Subsection 2.2.1. *Enūma Anu Enlil* Tablet 14 takes as its specific problem the duration of the moon's visibility at night. It constructs a linear zigzag function which will generate the value for lunar visibility in constant units for any day of the month and any month of the year.[116]

[114] Britton, "Scientific Astronomy in Pre-Seleucid Babylon," pp. 61–76. For the System A ephemeris, see A. Aaboe, *A Computed List of New Moons for 319 B.C. to 316 B.C. from Babylon: B.M.40094*, (Copenhagen: Kongelige Danske Videnskabernes Selskab Matematiskfysiske Meddelelser 37,3, 1969), and for the System B text, see Neugebauer, *ACT* No. 149. Britton makes clear here that the dates of these texts do not necessarily bear on the question of which system was developed first, and indeed, the question of the chronological development of the systems is still open.

[115] Britton, "Scientific Astronomy in Pre-Seleucid Babylon," p. 73.

[116] I am indebted to J. P. Britton for his elucidation of the astronomical significance and the mathematical nontriviality of this text during our collaboration on this material for a paper

It achieves this end by separating the effects first of lunar elongation, that is, the progressive variation in the distance between moon and sun over the course of a month, and second of the variation in the length of night throughout the year. Indeed, the computation of the variation in the lunar visibility necessitates the combination of two determinations, one, the fraction of the night the moon is visible over the course of a month, and two, the duration of night over the course of a year. That *Enūma Anu Enlil* Tablet 14 resolved such a complex astronomical problem into its appropriate components and constructed a simple yet nontrivial mathematical model to describe it, marks this text as unique for its early date. The dating of the tradition of *Enūma Anu Enlil* Tablet 14 is a matter of conjecture and approximation, but, as noted by Al-Rawi and George, two of the sources for Tablet 14, albeit written in the Neo-Assyrian and Neo-Babylonian periods, respectively, preserve a calendric tradition from the Old Babylonian period in which the assignment of the equinoxes and solstices are to the 15th day of Months XII, III, VI, and IX, pointing toward the likelihood that this table existed in the second millennium B.C.[117] Al-Rawi and George further point out, tables such as those of Tablet 14 "very probably existed independently before the compilation of the great series,"[118] which would place the origins of this schematic astronomy in the second millennium B.C.

Contemporary philosophical inquiry into the nature of theory in science offers new perspectives for the consideration of the cuneiform material. Since the heyday of the logical positivists and their view of scientific theories, philosophy of science has grown into a pluralistic discipline with a spectrum of views on the subject, so much so that it is difficult to describe the current state of affairs in any brevity. This is not the place to cover this ground, as our concern is not to advocate any particular position or survey current schools of thought, but to suggest that potential support for embracing Babylonian astronomy within a new and more inclusive historiography of science may indeed come from some corners of the philosophy of science.

presented at the American Oriental Society Meeting at Berkeley, CA, 1991. See also F. N. H. Al-Rawi and A. R. George, "Enūma Anu Enlil XIV and Other Early Astronomical Tables," *AfO* 38/39 (1991/1992), pp. 52–73.

[117] Al-Rawi and George, "Enūma Anu Enlil XIV," pp. 52–53, concerning IM 121332 from Tell Haddad and BM 40592 from Borsippa.

[118] Al-Rawi and George, "Enūma Anu Enlil XIV," p. 54.

Grandy contrasts the received or "standard view" with the so-called "nonstatement view" or "model-based view," which does not see theories as statements of universal generalizations that are true of the world, but as "a class of structures that are approximately isomorphic, under suitable interpretations, to parts of the world."[119] Formal, axiomatic, universal generalizations, results of the discovery of "laws of nature," no longer seem to be the *sine qua non* of scientific theory. The very notion of laws of nature has been found to be historically contingent,[120] and the ability of the purported laws to be descriptive of the real world has been challenged.[121] Such changes in outlook may remove some of the obstacle to the acknowledgment of theory in ancient Mesopotamian celestial science. Replacing objective laws of nature, independent of a human scientists' ability to discover them, are schemes, restricted generalizations, models of nature, human constructs, and philosophers holding a range of commitments to their status as representations of reality.[122]

What I mean by model in the context of Babylonian astronomical texts is not the same as is generally associated with the geometrical and kinematic models of Greek astronomy, that is, models according to which a planet is thought to move with respect to the fixed stars. In this sense, the Babylonian astronomers had no models of planetary motion. What they did have were mathematical schemes for the computation of synodic appearances. As such, the schemes were applied to a single planet in a given ephemeris table, and for the most part, a given ephemeris dealt with a single phenomenon, for example, first stations of Jupiter, or oppositions of the moon. Procedure texts, as they are called in the modern scholarly literature, give rules for calculation of the synodic phenomena, as in the following passage, which explains how the longitude of Jupiter is to be

[119] Grandy, "Theories of Theories," p. 218. See also Giere, *Science Without Laws*, Chap. 6, notes 1 and 2, for a bibliographical history of the model-based view, the roots of which he traces to the 1930s, 1940s, and 1950s.

[120] Giere, *Science Without Laws*, pp. 86–7.

[121] Nancy Cartwright, *The Dappled World: A Study of the Boundaries of Science* (Cambridge/New York: Cambridge University Press, 1999), Part I.

[122] The realism/antirealism debate is certainly beyond the scope of this discussion, but should at least be acknowledged for the significant place it still holds in philosophy of science. See Paul M. Churchland and Clifford A. Hooker, eds., *Images of Science: Essays on Realism and Empiricism*, with a reply from Bas C. Van Fraassen (Chicago/London: University of Chicago Press, 1985); David Papineau, *Reality and Representation* (Oxford: Blackwell, 1987).

computed from one occurrence of a synodic phenomenon to the next same phenomenon, such as from one first stationary point to the next first stationary point:

[From 25° Gemini to 30°] Scorpius add 30 (degrees). From 30° Scorpius to 25° Gemini add 36 (degrees). What [exceeds 25° Gemini multiply by 0;50 (and) add to 25° Gemini. What exceeds 30° Scorpius] multiply by [1; 1]2 (and) add to 30° Scorpius.[123]

Or the following, which instructs how to compute the synodic arcs of Jupiter and from these the dates of its appearances:

[Alternate (method): 33; 8,]45, the mean(−value) of the longitudes, multiply by 0; 1, 50, 40, and (you obtain) [1; 1, 8, 8,]20. Add to it 11;4 and (you obtain) 12; 5, 8, 8, 20. Put it down for the *gabaris* of (one) year (meaning the excess of the synodic period over 12 mean synodic months).... [From (one) appear]ance to (the next) appearance, (the arc) between them you put down. [12; 5, 8,]8, 20 you add to it and predict the [date]s.[124]

Although no Babylonian counterpart to the Greek kinematic astronomical models can be derived from the ephemerides or procedure texts, the mathematical description of the behavior of the synodic phenomena ascertainable directly from the ephemerides and supported by the procedure texts constitutes a number of models in much the same sense as Grandy's "class of structure that are approximately isomorphic, under suitable interpretations, to parts of the world."[125] The modern conventional terminology applied to these models has adopted the term system in its designations Systems A, A′, B, etc. In form, content, as well as their underlying mode of reasoning and use of empirical data, the Babylonian "Systems" achieved, in N. Cartwright's sense, "predictive closure... in highly restricted circumstances,"[126] and in this they appear to be continuous with all later astronomical theory. And although the ostensible aim was to predict phenomena, it seems that we do not understand the aim of Babylonian mathematical astronomy fully, as we do not really know if or how the values generated in the table texts were in fact used in any other context. Perhaps, indeed, the theory was a goal in and of itself.

[123] *ACT* No. 821 rev. 4–5, Neugebauer *ACT* Vol. II, p. 439. For an explanation of how this computation works, see A. Aaboe, *Episodes from the Early History of Astronomy* (New York/Berlin/Heidelberg: Springer-Verlag, 2001), pp. 42–4.

[124] *ACT* No. 812 Obv. I 7–10, see Neugebauer, *ACT* Vol. III, p. 393.

[125] See note 119 of this chapter.

[126] Cartwright, *The Dappled World,* p. 33.

It appears that the empirical and the predictive run through every one of the separate text categories, including those of explicit divinatory purpose and those of more or less exclusively astronomical interest. Closer consideration reveals the disparate weight given to these two methods as well as the disparate nature of these as methods in the various text types. These disparities account for genre boundaries and clarify the distinct methods and aims between the "astrological" and the "astronomical." In terms of the "pragmatic criterion," for example, the predictive nature of the omens is definable as the projected consequences of phenomena, understood as divine decisions, ascertained through consultation of a text, whereas the predictive nature of astronomy is definable as projected dates and positions of phenomena ascertained by a variety of computational models. In terms of the epistemological criterion, the question of whether the cuneiform texts that we wish to see as "scientific" exhibit the kinds of knowledge or ways of knowing that appear consistent with our expectations for "science," proves difficult when the variety of these cuneiform text genres are taken into account. As I have tried to make clear, this is a modern, not an ancient, question, but is worth considering both as a tool for understanding the ancient texts and reflexively for examining what we ourselves mean by the term science. This question will obviously be answered differently with respect to divination as opposed to the astronomical corpus. The standards by which the ancients identified "phenomena," natural and otherwise, and the role of empiricism in establishing these standards, vary within the text genres forming the corpus of Mesopotamian science. But more to the point, and particularly with respect to traditional ("foundationalist") epistemology, is that historical evidence mitigates claims to the special epistemological status of scientific knowledge and a scientific way of knowing. Empiricist foundationalism as one aspect of a normative epistemology has not only been questioned by historians, but has been given up entirely by contemporary philosophy of science.[127] Thus the problem of identifying and evaluating criteria for what we might designate a Mesopotamian science becomes a matter of reconstructing ancient systems of knowledge, or belief, and withholding arbitration on whether those systems are justifiably believed.

The ancient epistemological and pragmatic criteria can be seen to differ from one text genre to another, as might have been expected. In relation

[127] For example, R. Rorty, *Philosophy and the Mirror of Nature* (Ithaca, NY: Cornell University Press, 1979), or M. Williams, *Groundless Belief: An Essay of the Possibility of Epistemology* (Princeton, NJ: Princeton University Press, 1999).

to those of the astronomical texts, the objects of inquiry in celestial (and other) divination are far more diverse, the empirical underpinnings not as restricted and the goal to predict is of an entirely different order; apodoses indeed enabled the scribes to forecast the future, but only because the reference handbooks of omens provided, in the manner of a set of codified laws, the set of consequences established for the ominous phenomena. As far as the astronomical text genres are concerned, the scribes' goal to predict the phenomena was achieved by means of the construction of theoretical and quantitative models. Clearly, not all the phenomena included as omens in *Enūma Anu Enlil* lent themselves to quantitative astronomical methods of investigation. The culminating development of the astronomical program, the tradition of mathematical astronomy, was a part of the multifaceted intellectual culture I have tried to depict here. The characteristic beliefs of that culture in the divine nature of phenomena and in the possibility of divine communication through such phenomena as ominous signs, far from preventing the advance of mathematical astronomy, seem to have sustained it, as it was the cuneiform scholarly tradition that persisted long after the dissolution of the old Mesopotamian cultural life in the new Hellenistic milieu.

EPILOGUE

I T IS HARDLY MORE THAN 100 YEARS SINCE THE RECOVERY OF Babylonian astronomy, when, as Neugebauer said, "for the first time the words 'Babylonian astronomy' became endowed with a concrete meaning, fully comparable to that of 'Greek astronomy' enshrined in the *Almagest* or the *Handy Tables*."[1] Since that time, the relatively rapid period of decipherment and exposition of the contents of the Babylonian mathematical astronomy has not been matched by an equally rapid reception of Babylonian materials into the field of the history of science, that is, until relatively recently. By the mid-1960s those historians who continued to find the expression "Babylonian science" problematic and who were reluctant to include the cuneiform astronomical, and certainly the astrological, sources within the history of science were nonspecialists in the ancient Near East, for whom the Mesopotamian texts did not appear to be sufficiently explanatory or theoretical; indeed, their contents were viewed as merely practical or technical, therefore not meeting expectations for "science" then measured by standard western criteria. The fact that the astronomical texts were produced by scribes working within the religious framework of the Late Babylonian temples, and the preponderance of divination and astrology was furthermore seen as symptomatic of a phase before the emergence of science. In some works, the supposed prescientific historical period was found to correspond to a certain cognitive developmental phase as well, termed prelogical or mythopoeic, or the like. But even among assyriologists, the great divide between the rationality of science and the irrationality of magic played a role in the reconstruction of ancient science, as seen in Oppenheim's comment, from the mid-1960s,

[1] O. Neugebauer, "From Assyriology to Renaissance Art," *PAPS* 133 (1989), p. 394.

in which the rational explanation of phenomena is juxtaposed with the irrational practice of divination:

The relationship between astrology and mathematical astronomy is still imperfectly known. Undoubtedly, the earlier astrological material contains an as yet undetermined amount of genuine astronomical knowledge for the simple reason that astrological omens are derived from the observation of much the same phenomena whose irregularities the Babylonian astronomers tried later on to express by means of numerical relationships. Still, even while this scientific search for a rational explanation was going on, the same ever recurrent irregularities continued to speak to the astrologer and his public in terms of promise and warning concerning matters of state and private life.[2]

All of this has changed since the 1960s and 1970s. Increasingly the demarcation criteria formerly used to justify a rigorous separation of science from other forms of knowledge and practice were found to be neither necessary nor sufficient for a universal definition of science. The result was that the model of science that had once underpinned various arguments made against the existence of "science" in ancient Mesopotamia, such as were examined in Chapter 1, was reconceived. Simultaneously, a consciousness about potential anachronisms in the extension to premodern and nonwestern contexts of criteria assumed by the term science came to the fore. Now more historians of science are interested in the varieties of ways that cultures seem to engage with and represent the phenomenal world.[3]

Modern interpreters of Mesopotamian celestial science, particularly of celestial divination, still face the question of the explicit or implicit classification of the subject itself, in particular, the interpretation of its relation and contribution to the histories of religion, science, and magic. The

[2] A. L. Oppenheim, "Perspectives on M[e]sopotamian Divination," in *La Divination en Mésopotamie Ancienne, CRRAI* 14 (Paris: Presses Universitaires de France, 1966), p. 41. This would later be restated by Neugebauer as a "profound split among the professional 'astronomers' of the Late Babylonian period," meaning between the mathematical astronomy experts on the one hand, who, according to Neugebauer in this particular essay, had no interest in celestial omina, and on the other, the "men of the 'Diaries,'" who were still preoccupied by the traditional divination from astronomical phenomena. See Neugebauer, "From Assyriology to Renaissance Art," p. 393.

[3] Jan Golinski, *Making Natural Knowledge: Constructivism and the History of Science* (Cambridge: Cambridge University Press, 1998); Joseph Rouse, "Philosophy of Science and the Persistent Narratives of Modernity," *Studies in History and Philosophy of Science* 22 (1991), pp. 141–62; Ronald N. Giere, *Science Without Laws* (Chicago/London: The University of Chicago Press, 1999), approaches the same problem from a philosophical perspective.

applicability to the cuneiform evidence of distinctions traditionally implied between these domains is limited, and the terms magic, religion, and science cannot function as markers in a universally valid classificatory system.[4] As has been shown in this study, the qualities that define and contrast one from another in modern usage have limited bearing in the context of the ancient Near East. Although these terms are very difficult to avoid when we are engaged in analysis from outside, they create substantial problems. With reference to the omen texts, for example, we face an immediate problem when we investigate the relation of this material to science, in the sense of "natural inquiry," because we cannot equate omens with an inquiry into nature and as concerned exclusively with natural phenomena. If we are talking about the degree to which Babylonian scholars understood heavenly phenomena, we may be permitted the historical artificiality of separating astronomical texts from the other kinds of texts in which these specialists were trained. If, on the other hand, we are trying to understand the Babylonian scholars' conceptualization of the world, it is unintelligible to speak of the scribes' study and understanding of the phenomena, natural and invented, as distinct and separate from their study and understanding of the divine.

Whatever changes there were in astronomical technique that enabled the introduction of genethlialogical divination on the basis of the situation of the heavens at the time of birth, these do not suggest to me any fundamental change in conception of the role of the gods in relation to the phenomena, or any developing notion of "nature" as a sphere apart from the divine. To claim it is only with the evolution of quantitative predictive schemes that Mesopotamian culture participated in science merely projects back to the ancient Near East a now highly contested definition of science founded on features of much later western scientific tradition and assumed to have historically transcendent, if not universal, force. The achievement of mathematical astronomy in ancient Mesopotamia is undeniable, but seems to have been supported by a system in which none of the stakes we have long associated with science – rationalism, accuracy,

[4] The terms of this problem are set out in Alan F. Segal, "Hellenistic Magic: Some Questions of Definition," in R. Van den Broek and M. J. Vermaseren, eds., *Studies in Gnosticism and Hellenistic Religions Presented to Gilles Quispel on the Occasion of His 65th Birthday* (Leiden: Brill, 1981), pp. 349–75. Also useful is H. S. Versnel, "Some Reflections on the Relationship Magic–Religion," *Numen* 38 (1991), pp. 177–97. The limitations of the category "magic" as a universal classificatory term are discussed by John Skorupski, *Symbol and Theory: A Philosophical Study of Theories of Religion in Social Anthropology* (Cambridge: Cambridge University Press, 1976), p. 159.

demonstrative proof, or progress – seem to have mattered. By the same token, the presence of mathematical astronomy in late Babylonian culture did not introduce such values, nor alter the traditional world picture reflected in other texts of the scribal repertoire. Astronomy acted successfully to challenge a perceived cosmology for the first time only with the Copernican "revolution."

The context within which we speak of science in ancient Mesopotamia belongs squarely within the cuneiform scribal tradition, and seems to be characterized by a focus on phenomena, not only observable but conceivable, and both celestial and terrestrial. Within the class of celestial phenomena, these provided fields of inquiry in which observation, systematization and schematization, theoretization, computation, and prediction were developed and variously applied. As a consequence, we see the interdependence among diverse text types. The lunar phenomena included in horoscopes correlate closely with the main categories of lunar omens in *Enūma Anu Enlil,* such as the conjunction of the moon with fixed stars, the date of full moon visibilities around the middle of the month, the date of the last visible lunar crescent of the month, and eclipses. These lunar phenomena, however, were culled for the horoscopes, not from omens, but from astronomical sources that record either observed or computed phenomena, and so the technical terminology of astronomy as distinct from celestial divination was adopted in the horoscope texts. On the other hand, a departure from omens is clear in the form of the horoscope. The casuistic (if–then) formulation of omens is replaced in horoscopes with an enumeration of celestial data for the date of a birth, beginning usually with the lunar position on the specified day, sometimes a specified hour. In addition to the positions in the zodiac of the sun and five planets, other lunar data that have not taken place on the birth date are recorded, such as the Lunar Three and the dates of lunar eclipses. Further examples of differences between celestial divination and horoscopy may be cited in the horoscopes' reckoning of the lunar position, sometimes by Normal Stars and the planetary positions by the zodiacal signs, sometimes even degrees within zodiacal signs, neither one of which reference system is found in the celestial omens. The Normal Star reference system is best known from observational texts such as diaries. The zodiac is also found in the diaries, but the use of degrees of longitude in the zodiac points to the positional astronomy of the ephemerides. Terms such as *na* and KUR stem from a treatment of lunar phenomena not understood or used in lunar omens, but which were available in diaries and almanacs. Even greater disparity of form and content seems to mark

the celestial omen literature from the later astronomical genres, yet if lunar phenomena serve to illustrate, a clear descent from *Enūma Anu Enlil* can be seen from the organizational categories of phenomena comprising the first twenty-two tablets of *Enūma Anu Enlil*, that is, conjunctions with fixed stars, dates of opposition and conjunction of sun and moon, appearance of the crescent and the full lunar disk on those dates, and eclipses.

To what purpose lunar data such as *na*, KUR, and the latitude are included in a Babylonian horoscope is not made clear in the horoscope texts. We can only presume that there is some astrological significance for these elements. Although the *na* and KUR are observable new and full moon time intervals, the lunar latitude was considered exclusively in late texts concerned with eclipse prediction and in planetary procedure texts. Interestingly, in the horoscopes in which mention is made of the lunar latitude, indications that this is "favorable" occur in each case. There is the additional question of the relevance of the data not occurring on the birth date, which applies to most of the lunar data I have discussed, that is, the Lunar Three, eclipses, and latitude. Perhaps, as with the dates of solstices and equinoxes routinely included in a horoscope, only the one closest to the date of birth is included. In this case, the lunar data may similarly have been chosen because they occur in the month of birth. All the astronomical data therefore combine to form a picture of the heavens, not only at the time of birth, but also near enough to the birthday to effect some kind of meaning, positive or negative, for the native. Although the form in which these phenomena are recorded is influenced by the fact that they are derived from astronomical texts, some of which are produced on the basis of arithmetical schemes, the continuity with the ominous lunar phenomena enumerated above is still apparent.

I believe this continuity underscores the status of the early ominous phenomena as objects of an inquiry we may classify as scientific. In the treatment of lunar eclipses, for example, the phenomenon *qua* phenomenon was already of interest. On the evidence of the Old Babylonian celestial omens, lunar eclipses had been subject to the kind of intensive empirical consideration reserved for scientific objects. The protases of these early omens reflect a probing into the features of lunar eclipses, such as the date of occurrence, direction of shadow, duration, and color of the eclipsed moon, that one expects of "science." L. Daston has put it that

in contrast to quotidian objects, scientific objects broaden and deepen; they become ever more widely connected to other phenomena. . . . The sciences are fertile

in new objects, and the objects in turn are fertile in new techniques, differentiations and associates, representations, empirical and conceptual revelations.[5]

Whether the understanding of a given phenomenon was "true" or accurate is irrelevant to the issue of whether the phenomenon can be classified as an object of scientific inquiry as opposed to its belonging simply to daily or ordinary experience. Again, in Daston's terms,

> what can be ontologically enriched can also be impoverished; scientific objects can pass away as well as come into being. Sometimes they are banished totally from the realm of the real, as in the case of unicorns, phlogiston, and the ether. More often, they slip back into the wan reality of quotidian objects, which exist but do not thicken and quicken with inquiry.[6]

Mesopotamian divination provided the framework within which phenomena were described in a certain observation language; the schemata of the protases indicated what was deemed observable, and accordingly, the omen protases functioned as statements of potential observables. The mere inclusion of phenomena within omen series and the regular use of the verb "to observe" in the protases define the items of the protases as observable objects, and objects of knowledge, regardless of their physical ontological status. That some of these objects, for example, the lunar eclipses on impossible days, the ghosts, and so forth, seem to us of questionable ontology does not invalidate our discussion of whether there exists in Mesopotamian divination a context within which we can intelligibly speak of science, or entertain the question of whether that science had an empirical foundation. Other corpora from the history of science have posed similar problems of interpretation and classification. Paul Churchland has pointed out that

> Our history contains real examples of mistaken ontological commitments in both domains [the observational and the nonobservational]. For example, we have had occasion to banish phlogiston, caloric, and the luminiferous ether from our ontology–but we have also had occasion to banish witches and the starry sphere that turns about us daily. These latter items were as 'observable' as you please and were widely 'observed' on a daily basis. We are too often misled, I think, by our casual use of *observes* as a success verb: we tend to forget that, at any stage of our history, the ontology presupposed by our observational judgments remains

[5] See Daston, Introduction to L. Daston, ed., *Biographies of Scientific Objects*, p. 13.
[6] Ibid.

essentially speculative and wholly revisable, however entrenched and familiar it may have become.[7]

The interest in a lunar eclipse on the twentieth day of the month as an omen, although impossible, no more renders nonscientific the inquiry that conceived of such an eclipse than does the study of celestial spheres or spontaneous generation render nonscientific the inquiry from which we know of these "phenomena."

Apart from the historiographical question as to whether the Near Eastern texts can be construed as representative of science in some way, there is the interpretative question of how physical phenomena were regarded by the ancient scribes, especially in terms of their belief in what we would call a divine immanence in nature. Brown, for example, sees Babylonian astronomy as both generated by what he calls the "divination industry" and as ultimately altering the very worldview and religion of its practitioners, the scholars. He argues that scientific knowledge, which he understands to mean the planetary period relations, changed the basic view of the divine in the workings of the cosmos, by pushing the gods far enough away to create a sphere, "nature," as an object of scientific inquiry uninfluenced by belief in deities or a deity.[8] It has furthermore been suggested that the ability to predict the celestial phenomena themselves changed the Babylonians' attitude about the phenomena as signs. As Koch-Westenholz concluded,

Celestial phenomena could no longer be regarded as willed communications from the gods, and the old idea that 'signs' in heaven correlate with events on Earth, was abandoned. Instead, the planets and stars came to be seen as meaningful in themselves, imparting their characteristic qualities by their sheer physical presence at decisive moments of an individual's life, notably his birth.[9]

The horoscope texts do not provide sufficient evidence to support the idea that the heavenly bodies, as a result of their positions in the heavens being predicted, were considered to be determiners of human characteristics and fortunes apart from divine agency. There is consequently no basis for deducing stellar influence and determinism from Babylonian horoscopes. We can only say from the horoscopes that the heavenly bodies were viewed

[7] Paul M. Churchland, "The Ontological Status of Observables: In Praise of the Superempirical Virtues," in Paul M. Churchland and Clifford A. Hooker, eds., *Images of Science: Essay on Realism and Empiricism* (Chicago/London: University of Chicago Press, 1985), pp. 36–7.

[8] Brown, *Mesopotamian Planetary Astronomy–Astrology*, p. 234.

[9] Koch-Westenholz, *Mesopotamian Astrology*, pp. 51–2.

as capable of making aspects of human life predictable, and not necessarily in any way differently from that in *Enūma Anu Enlil*, despite the fact that the planetary positions were predicted, or derived from texts in which they were. Moreover, as is clear from Augustine's criticisms of astrology, it seems that, even in late antiquity, one rationale for astrology was indeed that the heavens did not cause but only signified the course of human life, the view also expressed by Plotinus's metaphoric reference to the stars as "heavenly writing."[10]

Because of the motivation of horoscopes to predict the life of a native from the arrangement of the planets on the date of birth, horoscopes are also rare among cuneiform astronomical texts in their goal to obtain positions of the seven planets for an arbitrary time rather than for the time of a synodic appearance. The function of these data, however, is consistent with the function of phenomena recorded in omens, in that the phenomena must have been interpretable on the basis of schemes designed for the purpose. The very idea of personal forecasts from celestial phenomena at the time of birth, although unique to the horoscopes, stems directly from divination whence omens from the date of a birth were derived, as known from the series *Iqqur īpuš*. Personal prognostication was also not entirely new, as divination for individuals based on their physiognomy is also attested. Neither of the obvious departures from the earlier tradition of Babylonian celestial divination, that is, use of the zodiac or the interest in personal forecasts from the heavens on the birth date, prevent the horoscopes from remaining wholly consistent with the system of divination as a whole. Indeed, stock apodoses known from noncelestial omen texts occur in horoscopes as the only indication of "predictions" for the life of the native. If indeed the planetary positions on the date of birth in a Babylonian horoscope functioned as celestial signs and were occasionally interpreted with omen apodoses, it seems fair to say that, on the basis of the horoscope texts alone, one cannot show the assumptions about the world that underpinned divination to have changed with the creation of horoscopic genethlialogy. The special relation between the individual and the cosmos implied by personal astrology may not be as innovative as it seems at first, but rather an extension of existing elements of traditional Mesopotamian divination.

Differences in form and in the manner of deriving and record-ing celestial phenomena amongst celestial omens, horoscopes, and late

[10] See Smoller, *History, Prophecy, and the Stars*, p. 27 and note 7, with reference to Augustine, *City of God*, Book 5, Chap. 1 (2:136 of the Loeb ed.).

astronomical texts do not argue against a fundamental continuity of what may be termed the worldview or conceptual framework behind these sciences. We simply lack the evidence to show that changes in methods and the growth of astronomical knowledge had any impact on traditional views about phenomena, the gods, and the cosmos. The ideological background for all the representative texts of scribal scholarship (*tupšarrūtu*), referring here to the beliefs concerning the relations divine–phenomenal–human that underpinned divination and magic, appears to have been sustained regardless of the invention of methods for the calculation of periodic astronomical phenomena. Colophons of late astronomical texts designate these forms of scribal learning as divine wisdom, expressed in phrases such as "the wisdom of Anu-ship," "exclusive knowledge of the great gods," and "secret knowledge of the masters." These tags evince a closely guarded tradition, one that valued its continuity with ancient (even antediluvian) sources of "knowledge." On this basis, there does not seem to be any warrant for an interpretation of the appearance of new textual genres, goals, or methods within *tupšarrūtu* as representing competing beliefs or values in the investigation of phenomena.

The fact that one can demonstrate direct dependence of horoscopes on texts in which astronomical phenomena are recorded (almanacs, diaries, goal-year texts, ephemerides) raises the question of the motivation for production of such astronomical records. Without that arsenal of astronomical records, presumably implying too the necessary knowledge of astronomy, both observational and theoretical, preparation of a horoscope is not possible. Moreover, the ability to determine planetary and lunar positions in the ecliptic with respect to degrees within the zodiacal signs, and for any given date, was dependent on an astronomical theory that did not exist much before the fifth century. The growing sophistication of computational astronomy appears then not only to have been utilized by the horoscope casters, but perhaps to have enabled to some degree the development of the new branch of personal astrology. In this activity were combined aspects of a variety of Babylonian astronomical texts, such as diaries and almanacs, variously observational and computational, as is seen in the incorporation within horoscopes of data from these diverse texts. In addition, the hybridization of birth omens and celestial divination to form the new genre itself underscores the common ground between different types of omens. It is precisely the composite character of horoscope texts that demonstrates the compatibility of the diverse strains of Mesopotamian celestial science, from divination to astronomy. The direct dependence of the horoscopes on astronomical classes of texts, as

well as their indirect dependence on celestial omens, suggests that these genres constituted well-defined parts of a single and continuous tradition. Lacking a term corresponding to science as we have come to define it, these texts were designated as products of the "art of the scribe," and more specifically, the "scribe of *Enūma Anu Enlil*." From our point of view, however, this multifaceted tradition may be referred to, for all the reasons explored in this study, as Babylonian "celestial science."

I have sought out criteria by means of which this celestial science may be examined, focusing in two directions, the epistemological and the pragmatic. As far as the omen protases containing (to us) ontologically suspect or even impossible entities are concerned, these were apparently an important part of the scientific enterprise of Mesopotamian divination, which suggests to me that we need to consider them if we are to investigate the nature of the system. Such an investigation requires that we not homogenize the contents of the omen series with that of the Neo-Assyrian diviners' letters, which do not report such impossible phenomena. It seems too obvious to have to say that, in the real world of the diviners' observations, such phenomena will not occur. The interesting issue is that impossible "phenomena" are conceived and included within omen works such as *Enūma Anu Enlil* and *Šumma izbu*. The presumption of a commonsense empiricism defined in terms of categorical distinctions between the real and the fantastic and predicated on a notion of an objective reality of sense data does not take adequate account of the evidence collected in omen protases or of the meaning of empirical data in any other scientific context. Even if we are able to explain away some phenomena, such as the lunar eclipses that are "observed" when they cannot occur, treating these not as astronomical, but rather as meteorological eclipses, we are still left with the "observations" of ghosts, demons, and other imaginary phenomena. Short of discovering some consistent exegetical method whereby all the ostensibly nonoccurring ominous phenomena can be explained, we can only note that, on the basis of the reference handbook of omens, *Enūma Anu Enlil*, the status of such phenomena as potential observables was as legitimate for the divination scholars as those we recognize as empirically true. To bracket these protases, designating them as "absurd," and then going on to discuss the empirical core of Babylonian omen science limits our ability to understand what phenomena the Babylonian scribes regarded as subjects worthy of inclusion in their compendia of knowledge. It limits our ability to penetrate, if it is at all possible, something about their conception of the world. If we do not regard contemporary physical science as "just a systematic exposure of the senses to the world," but "a way of thinking

about the world,"[11] why should we approach the Babylonian omens (or the astronomical texts) in that way? It seems to me perfectly reasonable to apply the term empirical in a characterization of Babylonian divination, and to view all the subjects of the protases as potential observables because these things belonged to the domain of their inquiry.

For my evaluation of the other major aspect of the Mesopotamian celestial sciences, their evident goal to predict, I borrowed Hesse's term "pragmatic criterion," but applied it more loosely so as to view both divination and astronomy in terms of their very different predictive aims. In the celestial and all other omens, predictions, that is, forecasts of future events, were the object. We can view the apodosis clauses containing these forecasts as predictions from phenomena, and indeed they functioned that way. But the scribes, in designating the contents of the apodoses as divine decisions, show us that the events of the apodoses were "predicted" not as consequences of experience or reason, but as matters of divine authority. For this very reason, magic was an intrinsic part of celestial and other divination practice, its purpose being to approach the deity, as one might a judge, to alter an untoward verdict. The fact that the omens establish relations between physical and social phenomena in the form of "predictions" further requires that we modify Hesse's sense of the pragmatic criterion, which was defined in relation only to physical science. On the other hand, the diviners also undertook the prediction of some of the lunar and planetary phenomena deemed ominous. In such cases, we have prediction in our sense, that is, on the basis of experience and reason. These two kinds of predictions are still present in the Babylonian horoscopes. The overall objective, to make a forecast for an individual's life was obtained on the basis of a variety of astronomical methods, all predictive in nature. For the justification of the relevance of Mesopotamian divination and horoscopy for the history of science, despite the incongruity between the two types of prediction found in those disciplines, perhaps we can appeal to the statement of N. Cartwright, "that it is the job of any good science to tell us how to predict what we can of the world as it comes and how to make the world, where we can, predictable in ways we want it to be."[12] Babylonian astronomy presents a convincing example of such a predictive science; its computational schemes effect the prediction of lunar and planetary synodic phenomena, but more importantly, the

[11] Norwood Russell Hanson, *Patterns of Discovery: An Inquiry into the Conceptual Foundations of Science* (Cambridge: Cambridge University Press, 1958), p. 30.

[12] Cartwright, *The Dappled World*, p. 181.

structures of the schemes reveal a number of generally applicable models for making celestial phenomena predictable.

The various relationships among the classes of texts discussed here are evidence for the practice of science in a culture where traditional systems of belief persist. The growth of knowledge therefore did not, in that context, take place at the expense of tradition. Although an astronomy based on excellent periods for the moon and planets was in place by the Achaemenid and early Seleucid periods, for the authors and practitioners of this system, astronomy was apparently a form of knowledge not unlike other systems already established within the traditional scribal repertoire. Indeed, the colophons of astronomical tables reflect the scribal commitment to tradition and the idea of the divine nature of knowledge. Access to this corpus was restricted, if we take the colophons at face value, and the illicit examination of the texts by those who were not trained to do so was considered to be an offense against the gods. The scribes were also evidently invested in the continuation of celestial divination, as evidenced by their copying of its reference work *Enūma Anu Enlil* until the latest period of the tradition of cuneiform writing itself. Because the preservation of *Enūma Anu Enlil* was not an isolated antiquarian occupation, but part of a broad traditional repertoire, including other divination series, liturgies, magic and medicine, the likelihood is that the worldview reflected in these texts was still viable to the very end of the cultural life of these scribes.

The fact that the perpetuation of the system represented by the omen series was not simply the result of an exercise in mechanical preservation is clear from the evidence of new texts appearing after circa 500 B.C. that are still compatible and consistent with the traditional system. Examples of such texts are the eclipse omen tablet in which lunar eclipses occur in the signs of the zodiac,[13] or the "esoteric Babylonian commentary," which has been reassessed in terms of Hellenistic zodiologia,[14] and indeed, the cuneiform nativities and horoscopes.[15] In the area of southern Mesopotamia, continuous preservation of Babylonian culture in cities

[13] See Rochberg-Halton, "New Evidence for the History of Astrology," pp. 115–40; also Weidner, *Gestirn-Darstellungen.*

[14] See R. D. Biggs, "An Esoteric Babylonian Commentary," *RA* 62 (1968), pp. 51–7, and Barbara Böck, "'An Esoteric Babylonian Commentary' Revisited," *JAOS* 120 (2000), pp. 615–20.

[15] Sachs, "Babylonian Horoscopes," pp. 49–75; also Rochberg-Halton, "TCL 6 13: Mixed Traditions in Late Babylonian Astrology," pp. 207–28.

such as Babylon, Borsippa, and Kutha, as suggested by C. Müller-Kessler,[16] also supports this view. Very late systems bearing the traces of *Enūma Anu Enlil* and the related hemerological series *Iqqur īpuš*, such as the Sasanian period Mandaean *Book of the Zodiac* (*Sfar Malwašia*), bear convincing testimony to the "continuity thesis."[17]

The development of Babylonian horoscopy in the middle of the first millennium B.C. serves to show relatedness within seemingly disparate genres of astronomical and astrological texts. Assuming relation rather than disparity between celestial divination and horoscopy on one hand, and astronomy on the other, the orientation to the physical world shared by the various branches of Babylonian celestial science may be characterized as one in which the gods and nature were still intertwined, and for which the metaphor of the gods' "heavenly writing" (*šiṭir šamê*) is so apt. Despite the dramatic developments in understanding celestial phenomena and the resulting ability to predict them that culminated after the fall of the Neo-Babylonian Empire, the worldview and conception of physical phenomena inherited from the earliest period of Mesopotamian history remained constant, or at least present, in the texts for the duration of the cuneiform scribal tradition. In the persistence of the epistemic authority, particularly of celestial divination but also of Babylonian astronomy, not only within Mesopotamia but in the later cultures that adopted these practices, perhaps there is further relation between the cuneiform scholarly endeavor to develop knowledge of the physical world and the intellectual activity we call science.

[16] Christa Müller-Kessler, "Aramäische Beschwörungen und astronomische Omina in Nachbabylonischer Zeit. Das Fortleben Mesopotamischer Kultur im Vorderen Orient," in Johannes Renger, ed., *Babylon: Focus Mesopotamischer Geschichte Wiege Frühes Gelehrsamkeit, Mythos in der Moderne: 2. Internationales Colloquium der Deutschen Orient-Gesellschaft 24.–26. März 1998 in Berlin* (Saarbrücken: SDV, Saarbrücker Druckerie und Verlag, 1999), pp. 427–43.

[17] See Rochberg, "The Babylonian Origins of the Mandaean Book of the Zodiac," pp. 237–47.

BIBLIOGRAPHY

This is a selected bibliography of works used in this study. For a more systematic compilation of works in the field of ancient Mesopotamian celestial sciences, see Hunger-Pingree, *Astral Sciences*, pp. 278–292.

Aaboe, A. 1955–6. "On the Babylonian Origins of Some Hipparchan Parameters," *Centaurus* 4, 122–5.

1958. "On Babylonian Planetary Theories," *Centaurus* 5, 209–77.

1964. "On Period Relations in Babylonian Astronomy," *Centaurus* 10, 213–31.

1964. *Episodes from the Early History of Mathematics* (New York: Random House).

1969. *A Computed List of New Moons for 319 B.C. to 316 B.C. from Babylon: B.M.40094* (Copenhagen: Kongelige Danske Videnskabernes Selskab Matematisk-fysiske Meddelelser 37,3).

1971. *Lunar and Solar Velocities and the Length of Lunation Intervals in Babylonian Astronomy* (Copenhagen: Kongelige Danske Videnskabernes Selskab Matematisk-fysiske Meddelelser 38,6).

1974. "Scientific Astronomy in Antiquity," in F. R. Hodson, ed., *The Place of Astronomy in the Ancient World* (London: Philosophical Transactions of the Royal Society A 276), 21–42.

1980. "Observation and Theory in Babylonian Astronomy," *Centaurus* 24, 14–35.

1992. "Babylonian Mathematics, Astrology, and Astronomy," in *The Cambridge Ancient History* III/2, 2nd ed. (Cambridge/New York/Port Chester/Melbourne/Sydney: Cambridge University Press), 276–92.

2001. *Episodes from the Early History of Astronomy* (New York/Berlin/Heidelberg: Springer-Verlag).

Aaboe, A., Britton, J. P., Hendersen, J., Neugebauer, O., and Sachs, A. J. 1991. *Saros Cycle Dates and Related Babylonian Astronomical Texts*, Transactions 81/6 (Philadelphia: American Philosophical Society).

Aaboe, A. and Henderson, J. 1975. "The Babylonian Theory of Lunar Latitude and Eclipses According to System A," *Archives internationales de l'histoire des sciences* 25, 181–222.

Aaboe, A. and Sachs, A. J. 1969. "Two Lunar Texts of the Achaemenid Period from Babylon," *Centaurus* 14, 1–22.

Abusch, T., Huehnergard, J., and Steinkeller, P., eds. 1990. *Lingering Over Words: Studies in Ancient Near Eastern Literature in Honor of William L. Moran*, Harvard Semitic Studies 37 (Atlanta, GA: Scholars Press).

Al-Rawi, F. N. H. and George, A. R. 1991–2. "Enūma Anu Enlil XIV and Other Early Astronomical Tables," *AfO* 38/39, 52–73.

Alster, B. 1976. "On the Earliest Sumerian Literary Tradition," *JCS* 28, 109–26.

Barnes, B., Bloor, D., and Henry, J. 1996. *Scientific Knowledge: A Sociological Analysis* (Chicago/London: University of Chicago Press).

Beaulieu, P.-A. 1989. *The Reign of Nabonidus King of Babylon 556–539 B.C.*, Yale Near Eastern Researches 10 (New Haven, CT/London: Yale University Press).

1992. "New Light on Secret Knowledge in Late Babylonian Culture," *ZA* 82, 98–111.

1993. "The Impact of Month-Lengths on the Neo-Babylonian Cultic Calendars," *ZA* 83, 66–87.

1997. "The Cult of *AN.ŠÁR*/Aššur in Babylonia After the Fall of the Assyrian Empire," *State Archives of Assyria Bulletin* 11, 55–73.

2000. *Legal and Administrative Texts from the Reign of Nabonidus*, Yale Oriental Series, 19 (New Haven, CT/London: Yale University Press).

Beaulieu, P.-A. and Britton, J. P. 1994. "Rituals for an Eclipse Possibility in the 8th Year of Cyrus," *JCS* 46, 73–86.

Beaulieu, P.-A. and Rochberg, F. 1996. "The Horoscope of Anu-Bēlšunu," *JCS* 48, 89–94.

Bernsen, L. 1969. "On the Construction of Column B in System A of the Astronomical Cuneiform Texts," *Centaurus* 14, 23–8.

Bezold, C. and Boll, F. 1911. *Reflexe astrologischer Keilinschriften bei griechischen Schriftstellern* (Heidelberg: Sitzungsberichte der Heidelberger Akademie der Wissenschaften, philosophisch–historische Klasse, Abh.7).

Biggs, R. D. 1967. "More Babylonian Prophecies," *Iraq* 29, 117–32.

1968. "An Esoteric Babylonian Commentary," *RA* 62, 51–8.

1971. "An Archaic Sumerian Version of the Kesh Temple Hymn from Tell Abū Ṣalābīkh," *ZA* 61, 193–207.

1985. "The Babylonian Prophecies and the Astrological Tradition," *JCS* 37, 86–90.

Black, J. and Green, A. 1992. *Gods, Demons, and Symbols of Ancient Mesopotamia: An Illustrated Dictionary* (Austin, TX: University of Texas Press).

Bobzien, S. 1998. *Determinism and Freedom in Stoic Philosophy* (Oxford: Clarendon).

Böck, B. 1999. "Babylonische Divination und Magie als Ausdruck der Denkstrukturen des altmesopotamischen Menschen," in Johannes Renger, ed., *Babylon: Focus mesopotamischer Geschichte, Wiege früher Gelehrsamkeit, Mythos in der Moderne*, Colloquien der Deutschen Orient-Gesellschaft 2 (Saarbrücken: Saarbrücken Druckerei und Verlag), 409–25.

2000. "'An Esoteric Babylonian Commentary' Revisited," *JAOS* 120, 615–20.

2000. *Die Babylonisch-Assyrische Morphoskopie*, *AfO* Supplement 27 (Vienna: Institut für Orientalistik der Universität Wien).

Borger, R. 1956. *Die Inschriften Asarhaddons, Königs von Assyrien*, *AfO* Supplement 9 (Graz: Im Selbtverlage der Herausgebers).

1957. "*Niṣirti bārûti*, Geheimlehre der Haruspizin," *BiOr* 14, 190–5.

Bottéro, J. 1974. "Symptomes, signes, écriture en Mésopotamie ancienne," in J. P. Vernant, ed., *Divination et rationalité* (Paris: Éditions du Seuil, Recherches anthropologiques), 70–196.

1992. *Mesopotamia: Writing, Reasoning, and the Gods,* trans. Zainab Bahrani and Marc van de Mieroop (Chicago/London: University of Chicago Press).

Bouché-Leclercq, A. 1879–82. *Histoire de la divination dans l'antiquité,* 4 vols. (Paris: Leroux).

1899. *L'astrologie grecque* (Paris: Leroux; reprinted, Brussels: Culture et Civilization, 1963).

Bowen, A. C. and Goldstein, B. R. 1988. "Meton of Athens and Astronomy in the Late Fifth Century B.C.," in E. Leichty, M. deJ. Ellis, and P. Gerardi, eds., *A Scientific Humanist: Studies in Memory of Abraham Sachs,* Occasional Publications of the Samuel Noah Kramer Fund 9 (Philadelphia: Babylonian Section, University Museum), 39–82.

1991. "Hipparchus' Treatment of Early Greek Astronomy: The Case of Eudoxus and the Length of Daylight," *PAPS* 135, 233–54.

1996. "Geminus and the Concept of Mean Motion in Greco–Latin Astronomy," *Archive for History of Exact Sciences* 50, 157–85.

Brack-Bernsen, L. 1993. "Babylonische Mondtexte: Beobachtung und Theorie," in Hannes D. Galter, ed., *Die Rolle der Astronomie in den Kulturen Mesopotamiens,* Grazer Morgenländische Studien 3 (Graz: GrazKult), 331–58.

1997. *Zur Entstehung der babylonischen Mondtheorie: Beobachtung und theoretische Berechnung von Mondphasen,* Boethius 40 (Stuttgart: F. Steiner).

1999. "Goal-Year Tablets: Lunar Data and Predictions," in N. M. Swerdlow, ed., *Ancient Astronomy and Celestial Divination* (Cambridge, MA/London: MIT Press), 149–77.

2002. "Predictions of Lunar Phenomena in Babylonian Astronomy," in J. M. Steele and A. Imhausen, eds., *Under One Sky: Astronomy and Mathematics in the Ancient Near East* (Münster: Ugarit-Verlag), 5–19.

Brack-Bernsen, L. and Hunger, H. 1999. "The Babylonian Zodiac: Speculations on Its Invention and Significance," *Centaurus* 41, 280–92.

Brack-Bernsen, L. and Schmidt, O. 1994. "On the Foundations of the Babylonian Column φ: Astronomical Significance of Partial Sums of the Lunar Four," *Centaurus* 37, 183–209.

Brinkman, J. A. 1990. "The Babylonian Chronicle Revisited," in T. Abusch, J. Huehnergard, and P. Steinkeller, eds., *Lingering Over Words: Studies in Ancient Near Eastern Literature in Honor of William L. Moran,* Harvard Semitic Studies 37 (Atlanta, GA: Scholars Press), 73–104.

Britton, J. P. 1989. "An Early Function for Eclipse Magnitudes in Babylonian Astronomy," *Centaurus* 32, 1–52.

1993. "Scientific Astronomy in Pre-Seleucid Babylon," in Hannes D. Galter, ed., *Die Rolle der Astronomie in den Kulturen Mesopotamiens,* Grazer Morgenländische Studien 3 (Graz: GrazKult), 61–76.

2002. "Treatments of Annual Phenomena in Cuneiform Sources," in J. M. Steele and A. Imhausen, eds., *Under One Sky: Astronomy and Mathematics in the Ancient Near East,* AOAT 297 (Münster: Ugarit-Verlag), 21–78.

Britton, J. and Walker, C. 1996. "Astronomy and Astrology in Mesopotamia," in Christopher Walker, ed., *Astronomy Before the Telescope* (London: British Museum Press), 42–67.

Brooke, J. H. 1991. *Science and Religion: Some Historical Perspectives* (Cambridge: Cambridge University Press).

Brooke, J. H., Osler, Margaret J., and van der Meer, Jitse M., eds. 2001. *Science in Theistic Contexts: Cognitive Dimensions, Osiris*, Vol. 16 (Chicago: University of Chicago Press).

Brown, D. 2000. *Mesopotamian Planetary Astronomy-Astrology*, Cuneiform Monographs 18 (Groningen: Styx Publications).

Brown, D. and Linssen, M. 1997. "BM 134701 = 1965-10-14-1 and the Hellenistic Period Eclipse Ritual from Uruk," *RA* 91, 147–65.

Buccellati, G. 1995. "Mesopotamian Magic as a Mythology and Ritual of Fate: Structural Correlations with Biblical Religion," in S. J. Denning-Bolle and E. Gerow, eds., *The Persistence of Religions: Essays in Honor of Kees W. Bolle* (Malibu, CA: Undena), 185–95.

Burke, P. 1986. "Strengths and Weaknesses in the History of Mentalities," *History of European Ideas* 7, 439–51.

Butler, S. A. L. 1998. *Mesopotamian Conceptions of Dreams and Dream Rituals*, AOAT 258 (Münster: Ugarit-Verlag).

Cagni, L. 1977. *The Poem of Erra*, Sources and Monographs, Sources from the Ancient Near East I/3 (Malibu, CA: Undena).

Cartwright, N. 1999. *The Dappled World: A Study of the Boundaries of Science* (Cambridge: Cambridge University Press).

Casaburi, M. C. 2001. "Il testo LBAT 1526 e la continuità della tradizione astromantica in Mesopotamia," in Simonetta Graziani, ed., *Studi sul Vicino Oriente Antico dedicati alla memoria di Luigi Cagni*, I, Series Minor 61 (Naples: Istituto universitario orientale), 85–99.

Cassirer, E. 1953. *Language and Myth*, trans. Susanne K. Langer (New York: Dover).

Charpin, D. 1985. "Les archives du devin Asqudum dans la résidence du 'Chantier A,'" *MARI* 4, 453–62.

Christie, J. R. R. 1993. "Aurora, Nemesis, and Clio," *British Journal for the History of Science* 26, 391–405.

Churchland, P. M. 1985. "The Ontological Status of Observables: In Praise of the Superempirical Virtues," in Paul M. Churchland and Clifford A. Hooker, eds., *Images of Science: Essay on Realism and Empiricism* (Chicago/London: University of Chicago Press), 35–47.

Cicero, *De Divinatione*, 1979 trans. W. A. Falconer (Cambridge, MA: Loeb Classical Library).

Claggett, M., ed. 1959. *Critical Problems in the History of Science* (Madison, WI/Milwaukee, WI/London: University of Wisconsin Press).

Clay, A. T. 1923. *Babylonian Records in the Library of J. Pierpont Morgan*, Part 4 (New Haven: Yale University Press).

Collon, D. 1995. *Ancient Near Eastern Art* (Berkeley, CA/Los Angeles: University of California Press).

Craig, J. A. 1899. *Astrological–Astronomical Texts* (Leipzig: J. C. Hinrichs).

1895–7. *Assyrian and Babylonian Religious Texts*, Assyriologische Bibliothek 13, 2 vols. (Leipzig: J. C. Hinrichs, reprinted 1974).

Cramer, F. H. 1954. *Astrology in Roman Law and Politics*, Memoirs 37 (Philadelphia: American Philosophical Society).

Crombie, A. C. 1959. "The Significance of Medieval Discussions of Scientific Method for the Scientific Revolution," in Marshall Clagett, ed., *Critical Problems in the History of Science* (Madison, WI/Milwaukee, WI/London: University of Wisconsin Press), 79–101.

Cunningham, A. and Williams, P. 1993. "De-centring the 'Big Picture': *The Origins of Modern Science* and the Modern Origins of Science," *British Journal for the History of Science* 26, 407–32.

Daston, L. 2000. "Preternatural Philosophy," in L. Daston, ed., *Biographies of Scientific Objects* (Chicago/London: University of Chicago Press), 15–41.

Davidson, D. 1974. "On the Very Idea of a Conceptual Scheme," *Proceedings and Addresses of the American Philosophical Association* 47, 5–20.

Dear, P., ed. 1997. *The Scientific Enterprise in Early Modern Europe: Readings from Isis* (Chicago/London: University of Chicago Press).

Dolby, R. G. A. 1979. "Classification of the Sciences: The Nineteenth Century Tradition," in Roy F. Ellen and David Reason, eds., *Classifications in Their Social Context* (London/New York/San Francisco: Academic), 167–93.

Donbaz, V. and Koch, J. 1995. "Ein Astrolab der dritten Generation: NV.10," *JCS* 47, 63–84.

Dossin, G. 1939. "Les archives économiques du Palais de Mari," *Syria* 22, 97–113.

Doty, L. T. 1988. "Nikarchos and Kephalon," in E. Leichty, M. DeJ. Ellis, and P. Gerardi, eds., *A Scientific Humanist: Studies in Memory of Abraham Sachs*, Occasional Publications of the Samuel Noah Kramer Fund, 9 (Philadelphia: Babylonian Section, University Museum), 95–118.

Downey, S. B. 1988. *Mesopotamian Religious Archictecture: Alexander Through the Parthians* (Princeton, NJ: Princeton University Press).

Eamon, W. 1994. *Science and the Secrets of Nature: Books of Secrets in Medieval and Early Modern Culture* (Princeton, NJ: Princeton University Press).

Ebeling, E. 1919. Keilschrifttexte aus Assur religiösen Inhalts, 2 vols. (Leipzig: J. C. Hinrichs).

1931. *Tod und Leben nach den Vorstellungen der Babylonier* (Berlin/Leipzig: de Gruyter).

1953. *Die Akkadische Gebetsserie "Handerhebung"* (Berlin: Akademie-Verlag).

1953. *Literarische Keilschrifttexte aus Assur* (Berlin: Akademie-Verlag).

Edzard, D. O. 1997. *Gudea and His Dynasty*, The Royal Inscriptions of Mesopotamia, Early Periods, Vol. 3/1 (Toronto/Buffalo/London: University of Toronto Press).

Epping, J. 1889. *Astronomisches aus Babylon, Stimmen aus Maria Laach Ergänzungsheft* 44 (Freiburg im Breisgau: Herder'sche Verlagshandlung).

Falkenstein, A. 1941. *Topographie von Uruk I: Uruk zur Seleukidenzeit*, Ausgrabungen der Deutschen Forschungsgemeinschaft in Uruk-Warka 3 (Leipzig: Harrassowitz).

1966. "'Wahrsagung' in der sumerischen Überlieferung," in *La divination en Mésopotamie ancienne et dans les régions voisines: XIVe Rencontre Assyriologique Internationale* (Paris: Presses Universitaires de France), 45–68.

Farber, F. 1987. "Neues aus Uruk: Zur Bibliothek des Iqīša," *WO* 18, 26–42.

Feyerabend, P. K. 1981. *Problems of Empiricism*, Philosophical Papers Vol. 2 (Cambridge/New York/Port Chester/Melbourne/Sydney: Cambridge University Press).

Finkel, I. L. 1988. "Adad-apla-iddina, Esagil-kīn-apli, and the Series SA.GIG," in E. Leichty, M. deJ. Ellis, and P. Gerardi, eds., *A Scientific Humanist: Studies in Memory of Abraham Sachs*, Occasional Publications of the Samuel Noah Kramer Fund, 9 (Philadelphia: Babylonian Section, University Museum), 143–59.

Finkelstein, J. J. 1963. "Mesopotamian Historiography," *PAPS* 107, 461–72.

Flint, V. I. J. 1991. *The Rise of Magic in Early Medieval Europe* (Princeton, NJ: Princeton University Press).

Foster, B. R. 1974. "Wisdom and the Gods in Ancient Mesopotamia," *Orientalia* NS 43, 344–54.

—— 1993. *Before the Muses: An Anthology of Akkadian Literature* (Bethesda, MD: CDL).

Frankfort, H., Frankfort, Mrs. H. A., Wilson, J. A., and Jacobsen, T. 1946. *Before Philosophy: The Intellectual Adventure of Ancient Man* (Chicago/London: University of Chicago Press, Pelican reprint, 1961).

Frazer, J. G. 1911. *The Golden Bough: A Study in Magic and Religion*, Part I, Vol. 1: *The Magic Art and the Evolution of Kings*, 3rd ed. (London: Macmillan).

Freedman, S. M. 1998. *If a City is Set on a Height: The Akkadian Omen Series Šumma Alu ina Mēlê Šakin*, Vol. 1: *Tablets 1–21*, Occasional Publications of the Samuel Noah Kramer Fund 17 (Philadelphia: Babylonian Section, University Museum).

Fuller, S. 2000. *Thomas Kuhn: A Philosophical History for Our Times* (Chicago/London: University of Chicago Press).

Furlani, G. 1928. "Sul concetto del destino nella religione babilonese e assira," *Aegyptus* 9, 205–39.

Gasche, H., Armstrong, J. A., Cole, S. W., and Gurzadyan, V. G. 1998. *Dating the Fall of Babylon: A Reappraisal of Second-Millennium Chronology*, Mesopotamian History and Environment Series 2, Memoirs 4 (Ghent: University of Ghent and the Oriental Institute of the University of Chicago).

Geller, M. J. 1990. "Taboo in Mesopotamia," *JCS* 42, 105–17.

—— 2000. "The Survival of Babylonian Wissenschaft in Later Tradition," in A. Aro and R. M. Whiting, eds., *The Heirs of Assyria, Melammu Symposia* 1 (Helsinki: The Neo-Assyrian Text Corpus Project), 1–6.

Gentner, D. 1982. "Are Scientific Analogies Metaphors?" in D. Miall, ed., *Metaphor: Problems and Perspectives* (Brighton, England: Harvester Press), 106–32.

Gentner, D. and Jeziorski, M. 1989. "Historical Shifts in the Use of Analogy in Science," in B. Gholson, W. R. Shadish, Jr., R. A. Neimeyer, and A. C. Houts, eds., *Psychology of Science: Contributions to Metascience* (Cambridge/New York: Cambridge University Press), 296–325.

George, A. R. 1986. "Sennacherib and the Tablet of Destinies," *Iraq* 48, 138–46.

—— 1988. "Babylonian Texts from the Folios of Sidney Smith," *RA* 82, 151–5.

—— 1992. *Babylonian Topographical Texts* (Leuven: Uitgeverij Peeters).

—— 1993. *House Most High: The Temples of Ancient Mesopotamia* (Winona Lake, IN: Eisenbrauns).

—— 1999. "E-Sangil and E-temen-anki, The Archetypal Cult-Centre," in Johannes Renger, ed., *Babylon: Focus mesopotamischer Geschichte, Wiege früher Gelehrsamkeit, Mythos in der Moderne*, Colloquien der Deutschen Orient-Gesellschaft 2 (Saarbrücken: Saarbrücken Druckerei und Verlag), 67–86.

Gibbs, R. W. Jr. 1993. "Process and Products in Making Sense of Tropes," in A. Ortony, ed., *Metaphor and Thought* (Cambridge/New York: Cambridge University Press), 252–76.

Giere, R. N. 1988. *Explaining Science: A Cognitive Approach* (Chicago/London: University of Chicago Press).

1999. *Science Without Laws* (Chicago/London: University of Chicago Press).

Gieryn, T. F. 1999. *Cultural Boundaries of Science: Credibility on the Line* (Chicago/London: University of Chicago Press).

Goetze, A. 1947. *Old Babylonian Omen Texts*, Yale Oriental Series 10 (New Haven, CT/London: Yale University Press).

Goldstein, B. R. 2002. "On the Babylonian Discovery of the Periods of Lunar Motion," *JHA* 33, 1–13.

Goldstein, B. R. and Bowen, A. C. 1983. "A New View of Early Greek Astronomy," *Isis* 74, 330–40; reprinted in Michael H. Shank, ed., *The Scientific Enterprise in Antiquity and the Middle Ages* (Chicago/London: University of Chicago Press, 2000), 85–95.

1991. "The Introduction of Dated Observations and Precise Measurement in Greek Astronomy," *Archive for History of Exact Sciences* 43, 93–132.

Golinski, J. 1998. *Making Natural Knowledge: Constructivism and the History of Science* (Cambridge: Cambridge University Press).

Goodnick-Westenholz, J. 1998. "Thoughts on Esoteric Knowledge and Secret Lore," in Jiří Prosecký, ed., *Intellectual Life of the Ancient Near East*, CRRAI 43 (Prague: Academy of Sciences of the Czech Republic Oriental Institute), 451–62.

Gould, J. B. 1970. *The Philosophy of Chrysippus* (Leiden: Brill).

Grandy, R. E. 1992. "Theories of Theories: A View from Cognitive Science," in John Earman, ed., *Inference, Explanation, and Other Frustrations: Essays in the Philosophy of Science* (Berkeley, CA/Los Angeles/Oxford: University of California Press), 216–33.

Grasshoff, G. 1999. "Normal Star Observations in Late Babylonian Astronomical Diaries," in N. M. Swerdlow, ed., *Ancient Astronomy and Celestial Divination* (Cambridge, MA/London: MIT Press), 97–147.

Grayson, A. K. 1975. *Assyrian and Babylonian Chronicles*, Texts from Cuneiform Sources 5 (Locust Valley, NY: J. J. Augustin).

Grenfell, B. P., Hunt, A. S., et al. 1898–1998. *The Oxyrhynchus Papyri*, 65 vols. (London: Egypt Exploration Society, Greeco-Roman Memoirs).

Guinan, A. K. 1996. "Left/Right Symbolism in Mesopotamian Divination," *State Archives of Assyria Bulletin* 10, 5–10.

1997. "Divination," in W. W. Hallo, ed., *The Context of Scripture*, Vol. I (Leiden/New York/Cologne: Brill), 421–6.

Hacking, I. 1975. *Why Does Language Matter to Philosophy?* (Cambridge: Cambridge University Press).

1982. "Language Truth and Reason," in M. Hollis and S. Lukes, ed., *Rationality and Relativism* (Cambridge, MA: MIT Press), 48–66.

Hallo, W. W. 1963. "On the Antiquity of Sumerian Literature," *JAOS* 83, 167–76.

1970. "The Cultic Setting of Sumerian Poetry," in André Finet, ed., *Actes de la XVIIe Rencontre assyriologique internationale*, CRRAI 17 (Ham-sur-Heure: Comité belge de recherches en Mésopotamie), 116–34.

1988. "The Nabonassar Era and Other Epochs in Mesopotamian Chronology," in E. Leichty, M. deJ. Ellis, and P. Gerardi, eds., *A Scientific Humanist: Studies in Memory of Abraham Sachs*, Occasional Publications of the Samuel Noah Kramer Fund 9 (Philadelphia: Babylonian Section, University Museum), 175–90.

1991. "The Concept of Canonicity in Cuneiform and Biblical Literature: A Comparative Appraisal," in K. Lawson Younger, Jr., William W. Hallo, and Bernard F. Batto, eds., *The Biblical Canon in Comparative Perspective: Scripture in Context IV, Ancient Near Eastern Texts and Studies* (Lewiston/Queenston/Lampeter: Edwin Mellen), Vol. 11, 1–19.

Hanson, N. R. 1958. *Patterns of Discovery: An Inquiry Into the Conceptual Foundations of Science* (Cambridge: Cambridge University Press).

Harper, R. F. 1892–1914. *Assyrian and Babylonian Letters Belonging to the Kouyunjik Collection of the British Museum* (Chicago: University of Chicago Press; reprinted by N. and N. Press, 1977).

Heessel, N. P. 2000. *Babylonisch-assyrische Diagnostik*, AOAT 43 (Münster: Ugarit Verlag).

Helm, P. R. 1980 "'Greeks' in the Neo-Assyrian Levant and 'Assyria' in Early Greek Writers," Ph.D. dissertation (Philadelphia: University of Pennsylvania).

Hesse, M. 1966. *Models and Analogies in Science* (Notre Dame, IN: University of Notre Dame Press).

1978. "Theory and Value in the Social Sciences," in C. Hookway and P. Pettit, eds., *Action and Interpretation in the Philosophy of the Social Sciences* (Cambridge: Cambridge University Press), 1–16.

Hodson, F. R., ed. 1974. *The Place of Astronomy in the Ancient World* (London: Philosophical Transactions of the Royal Society A 276).

Hollis, M. and Lukes, S., eds. 1982. *Rationality and Relativism* (Cambridge, MA: MIT Press).

Horowitz, W. 1989–90. "Two MUL.APIN Fragments," *AfO* 36/37, 116–17.

1993. "Mesopotamian Accounts of Creation," in N. S. Hetherington, ed., *Encyclopedia of Cosmology: Historical, Philosophical, and Scientific Foundations of Modern Cosmology* (New York/London: Garland), 387–97.

1998. *Mesopotamian Cosmic Geography* (Winona Lake, IN: Eisenbrauns).

Horton, R. 1967. "African Traditional Thought and Western Science," *Africa* 37, Nos. 1 and 2 reprinted in B. R. Wilson, ed., *Rationality* (Oxford: Blackwell, 1970), 131–71.

1993. *Patterns of Thought in Africa and the West: Essays on Magic, Religion and Science* (Cambridge: Cambridge University Press).

Horton, R. and Finnegan, R., eds. 1973. *Modes of Thought: Essays on Thinking in Western and Non-Western Societies* (London: Faber and Faber).

Huber, P. J. 1958. "Ueber den Nullpunkt der babylonischen Ekliptik," *Centaurus* 5, 192–208.

1982. *Astronomical Dating of Babylon I and Ur III*, Occasional Papers on the Near East 1/4 (Malibu, CA: Undena).

1987. "Dating by Lunar Eclipse Omina with Speculations on the Birth of Omen Astrology," in J. L. Berggren and B. R. Goldstein, eds., *From Ancient Omens to Statistical Mechanics: Essays on the Exact Sciences Presented to Asger Aaboe* (Copenhagen: University Library), 3–13.

1999/2000. "Astronomical Dating of Ur III and Akkad," *AfO* 46/47, 50–79.

2000. "Astronomy and Ancient Chronology," *Akkadica* 119–20, 159–76.

Huber, P. J. and de Meis, S. 2004. *Babylonian Eclipse Observations from 750 B.C. to 1 B.C.* (Milan: Mimesis).

Hunger, H. 1968. *Babylonische und assyrische Kolophone*, AOAT 2 (Neukirchen-Vluyn: Verlag Butzon & Bercker Kevelaer).

1976. "Astrologische Wettervorhersagen," *ZA* 66, 234–60.

1976. *Spätbabylonische Texte aus Uruk*, Ausgrabungen der Deutschen Forschungsgemeinschaft in Uruk-Warka 9 (Berlin: Gebr. Mann Verlag).

1992. *Astrological Reports to Assyrian Kings*, SAA 8 (Helsinki: Helsinki University Press).

1995. "Ein kommentar zu Mond-Omina," in M. Dietrich and O. Loretz, eds., *Vom alten Orient zum alten Testament: Festschrift für Wolfram Freiherrn von Soden zum 85. Geburtstag am 19. Juni 1993*, AOAT 240 (Neukirchen-Vluyn: Verlag Butzon & Bercker Kevelaer), 105–18.

1999. "Non-Mathematical Astronomical Texts and Their Relationships," in N. M. Swerdlow, ed., *Ancient Astronomy and Celestial Divination* (Cambridge, MA/London: MIT Press), 77–96.

Hunger, H. and Pingree, D. 1989. *MUL.APIN: An Astronomical Compendium in Cuneiform*, *AfO* Supplement 24 (Horn, Austria: Ferdinand Berger & Söhne).

1999. *Astral Sciences in Mesopotamia* (Leiden/Boston/Cologne: Brill).

Hyspicles, *Anaphorikos*. Ed. and trans. V. de Falco and M. Krause with O. Neugebauer, 1966 (Göttingen: Vandenhoeck and Ruprecht).

Jacobsen, T. 1976. *The Treasures of Darkness: A History of Mesopotamian Religion* (New Haven, CT/London: Yale University Press).

Jones, A. 1991. "The Adaptation of Babylonian Methods in Greek Numerical Astronomy," *Isis* 82, 441–53.

1993. "Evidence for Babylonian Arithmetical Schemes in Greek Astronomy," in H. Galter, ed., *Die Rolle der Astronomie in den Kulturen Mesopotamiens*, Grazer Morgenländischen Studien 3 (Graz: GrazKult), 77–94.

1999. *Astronomical Papyri from Oxyrhynchus*, Vols. 1 and 2, Memoirs 233 (Philadelphia: American Philosophical Society).

2002. "Babylonian Lunar Theory in Roman Egypt: Two New Texts," in J. M. Steele and A. Imhausen, eds., *Under One Sky: Astronomy and Mathematics in the Ancient Near East*, AOAT 29 (Münster: Ugarit-Verlag), 167–74.

Kilmer, A. D. 1978. "A Note on the Babylonian Mythological Explanation of the Lunar Eclipse," *JAOS* 98, 372–4.

King, L. W. 1896. *Babylonian Magic and Sorcery* (London: Luzac).

1912. *Babylonian Boundary-Stones and Memorial-Tablets in the British Museum* (London: British Museum).

Kingsley, P. 1995. *Ancient Philosophy, Mystery, and Magic: Empedocles and Pythagorean Tradition* (Oxford: Clarendon).

Kittay, E. F. 1987. *Metaphor: Its Cognitive Force and Linguistic Structure* (Oxford: Clarendon).

Koch, J. 1989. *Neue Untersuchungen zur Topographie des babylonischen Fixsternhimmels* (Wiesbaden: Harrassowitz).

1992. "Der Sternkatalog BM 78161," *WO* 23, 39–67.

1995. "Der Dalbanna-Sternenkatalog," *WO* 26, 43–85.

Köcher, F. and Oppenheim, A. L. 1957. "The Old-Babylonian Omen Text VAT 7525," *AfO* 18, 62–80 (with Appendix by H. G. Güterbock).

Koch-Westenholz, U. 1993. "Mesopotamian Astrology at Hattusas," in Hannes D. Galter, ed., *Die Rolle der Astronomie in den Kulturen Mesopotamiens*, Grazer Morgenlandische Studien 3 (Graz: GrazKult), 231–46.

1995. *Mesopotamian Astrology: An Introduction to Babylonian and Assyrian Celestial Divination* (Copenhagen: Carsten Niebuhr Institute of Near Eastern Studies, Museum Tusculanum Press).

1999. "The Astrological Commentary *Šumma Sîn ina tāmartišu* Tablet I," in Rika Gyselen, ed., with Anna Caiozzo, Pascal Charlier, and Salvo de Meis, *La science des cieux: Sages, mages, astrologues, Res Orientales* 12 (Bures-sur-Yvette: Groupe pour l'étude de la civilisation du Moyen-Orient), 149–26.

2000. *Babylonian Liver Omens: The Chapters manzazu, padanu and pan takalti of the Babylonian Extispicy Series Mainly From Assurbanipal's Library* (Copenhagen: Carsten Niebuhr Institute Publications 25).

Kramer, S. N. 1961. *Sumerian Mythology* (New York/Evanston/London: Harper & Row).

Kraus, F. R. 1936. "Ein Sittenkanon in Omenform," *ZA* 43, 77–113.

1939. *Texte zur babylonischen Physiognomatik, AfO* Supplement 3 (Berlin: Archiv für Orientforschung).

Kugler, F. X. 1900. *Die Babylonische Mondrechung. Zwei Systeme der Chaldäer über den Lauf des Mondes und der Sonne* (Freiburg im Breisgau: Herder).

1907–1924. *SternKunde und Sterndienst in Babel*, 2 vols. (Münster: Aschendorff).

1913–1914. *SternKunde und Sterndienst in Babel, Engänzungen zum ersten und zweiten Buch*, 2 vols. (Münster: Aschendorff). For Ergänzungshef 3, see Schaumberger.

Kuhn, D. 1966. "Is good thinking scientific thinking?" in David R. Olson and Nancy Torrance, eds., *Modes of Thought: Explorations in Culture and Cognition* (Cambridge: Cambridge University Press), 261–81.

Kuhn, T. S. 1962. *The Structure of Scientific Revolutions* (Chicago: University of Chicago Press; 2nd ed. 1970).

Kuhrt, A. 1987. "Survey of Written Sources Available for the History of Babylonia Under the Later Achaemenids," in H. Sancisi-Weerdenburg, ed., *Achaemenid History I: Sources, Structures and Synthesis*, Proceedings of the Groningen 1983 Achaemenid History Workshop (Leiden: Nederlands Instituut voor het Nabije Oosten), 147–57.

Kuhrt, A. and Sherwin-White, S. 1987. "Xerxes' Destruction of Babylonian Temples," in H. Sancisi-Weerdenburg and A. Kuhrt, eds., *Achaemenid History II. The Greek Sources*, Proceedings of the Groningen 1984 Achaemenid History Workshop (Leiden: Nederlands Instituut voor het Nabije Oosten), 69–78.

Labat, R. 1941. "Un almanach babylonien," *RA* 38, 13–40.

1951. *Traité akkadien de diagnostics et pronostics médicaux* (Leiden: Brill).

1952. "Un calendrier cassite," *Sumer* 8, 17–36.

1965. *Un calendrier Babylonien des travaux des signes et des mois (séries Iqqur Îpuš)* (Paris: Librairie Honoré Champion).

Lambert, W. G. 1957–8. "A Part of the Ritual for the Substitute King," *AfO* 18, 109–12.

1959–60. "The Ritual for the Substitute King – A New Fragment," *AfO* 19, 119.

1960. *Babylonian Wisdom Literature* (Oxford: Clarendon).

1962. "A Catalogue of Texts and Authors," *JCS* 16, 59–77.

1966. *Enūma Eliš: The Babylonian Epic of Creation, The Cuneiform Text.* Text established by W. G. Lambert and copied out by Simon B. Parker (Oxford: Clarendon).

1967. "Enmeduranki and Related Matters," *JCS* 21, 126–38.

1976. "A Late Assyrian Catalogue of Literary and Scholarly Texts," in B. Eichler, ed., *Cuneiform Studies in Honor of Samuel Noah Kramer,* AOAT 25 (Neukirchen-Vlyun: Verlag Butzon & Bercker Kevelaer), 313–18.

Landsberger, B. 1937–1985. *Materialien zum sumerischen Lexikon,* 17 vols. (Rome: Pontifical Biblical Institute).

1969. "Über Farben im Sumerisch-akkadischen," *JCS* 21, 139–73.

Landsberger, B. and Bauer, T. 1927. "Zu neuveröffentlichten Geschichtsquellen der Zeit von Asarhaddon bis Nabonid," *ZA* 37, 61–98.

Landsberger, B. and von Soden, W. 1965. *Die Eigenbegrifflichkeit der babylonischen Welt. Leistung und Grenze sumerischer und babylonischer Wissenschaft* (Darmstadt: Wissenschaftliche Buchgesellschaft).

Langdon, S. 1912. *Neubabylonischen Königsinschriften,* VAB 4 (Leipzig: J. C. Hinrichs).

1935. *Babylonian Menologies and the Semitic Calendars* (London: The British Academy).

Larsen, M.T. 1987. "The Mesopotamian Lukewarm Mind: Reflections on Science, Divination and Literacy, "in F. Rochberg-Halton, ed., *Language, Literature and History: Philological and Historical Studies Presented to Erica Reiner* (New Haven, CT: American Oriental Society), 203–25.

Laudan, L. 1996. *Beyond Positivism and Relativism: Theory, Method, and Evidence* (Oxford/Boulder, CO: Westview).

Lawson, J. N. 1994. *The Concept of Fate in Ancient Mesopotamia of the First Millennium: Toward an Understanding of Šīmtu* (Wiesbaden: Harrassowitz).

Leichty, E. 1970. *The Omen Series Šumma Izbu,* Texts from Cuneiform Sources 4 (Glückstadt: J. J. Augustin).

Lévy-Bruhl, L. 1922. *La mentalité primitive* (Oxford: Clarendon); translated by Lilian Clare as *Primitive Mentality* (Oxford: Clarendon, 1923).

Lieberman, S. 1987. "A Mesopotamian Background for the So-Called *Aggadic* 'Measures' of Biblical Hermeneutics?," *HUCA* 58, 157–225.

1990. "Canonical and Official Cuneiform Texts: Towards an Understanding of Assurbanipal's Personal Tablet Collection," in T. Abusch, J. Huehnergard, and P. Steinkeller, eds., *Lingering Over Words: Studies in Ancient Near Eastern Literature in Honor of William L. Moran,* Harvard Semitic Studies 37 (Atlanta, GA: Scholars Press), 305–36.

Lindberg, David C. 1992. *The Beginnings of Western Science: The European Scientific Tradition in Philosophical, Religious, and Institutional Context, 600 B.C. to A.D. 1450* (Chicago/London: University of Chicago Press).

Lindberg, D. C. and Westman, R. S. 1990. *Reappraisals of the Scientific Revolution* (Cambridge: Cambridge University Press).

Livingstone, A. 1986. *Mystical and Mythological Explanatory Works of Assyrian and Babylonian Scholars* (Oxford: Clarendon).

1989. *Court Poetry and Literary Miscellanea,* SAA 3 (Helsinki: University of Helsinki Press).

Lloyd, G. E. R. 1966. *Polarity and Analogy: Two Types of Argumentation in Early Greek Thought* (Cambridge: Cambridge University Press).

1979. *Magic, Reason and Experience: Studies in the Origins and Development of Greek Science* (Cambridge: Cambridge University Press).

1990. *Demystifying Mentalities* (Cambridge: Cambridge University Press).

1991. "Right and Left in Greek Philosophy," in G. E. R. Lloyd, ed., *Methods and Problems in Greek Science* (Cambridge: Cambridge University Press), 27–48.

1991. "The Debt of Greek Philosophy and Science to the Ancient Near East," in G. E. R. Lloyd, ed., *Methods and Problems,* 278–98.

1992. "Greek Antiquity: The Invention of Nature," in J. Torrance, ed., *The Concept of Nature* (Oxford: Clarendon), 1–24.

1996. *Adversaries and Authorities: Investigations into Ancient Greek and Chinese Science* (Cambridge: Cambridge University Press).

2002. *The Ambitions of Curiosity: Understanding the World in Ancient Greece and China* (Cambridge: Cambridge University Press).

Long, A. A. 1982. "Astrology: Arguments Pro and Contra," in J. Barnes, J. Brunschwig, M. Burnyeat, and M. Schofield, eds., *Science and Speculation: Studies in Hellenistic Theory and Practice* (Cambridge: Cambridge University Press), 165–92.

Long, P. O. 2001. *Openness, Secrecy, Authorship: Technical Arts and the Culture of Knowledge From Antiquity to the Renaissance* (Baltimore/London: Johns Hopkins University Press).

Lynch, M. P. 2001. *Truth in Context: An Essay on Pluralism and Objectivity* (Cambridge, MA/London: MIT Press).

Machinist, P. and Tadmor, H. 1993. "Heavenly Wisdom," in Mark E. Cohen, Daniel C. Snell, and David B. Weisberg, eds., *The Tablet and the Scroll: Near Eastern Studies in Honor of William W. Hallo* (Bethesda, MD: CDL), 146–51.

Malinowski, B. 1954. *Magic, Science, and Religion and Other Essays* (New York: Doubleday Anchor Books; reprinted by Waveland Press, 1992).

Matouš, L. 1961. "L'almanach de Bakr-Awa," *Sumer* 17, 17–59.

Maul, S. M. 1994. *Zukunftsbewältigung: Eine Untersuchung altorientalischen Denkens anhand der babylonisch–assyrischen Löserituale (Namburbi)* (Mainz am Rhein: Verlag Philipp von Zabern).

1999. "How the Babylonians Protected Themselves Against Calamities Announced by Omens," in Tzvi Abusch and Karel van der Toorn, eds., *Mesopotamian Magic: Textual, Historical, and Interpretative Perspectives* (Groningen: Styx Publications), 123–9.

Mayer, W. R. 1976. *Untersuchungen zur Formensprache der Babylonischen 'Gebetsbeschwörungen',* Studia Pohl, Series Maior 5 (Rome: Biblical Institute Press).

1997. "Der Gott Assur und die Erben Assyriens," in R. Albertz, ed., *Religion und Gesellschaft: Studien zu ihrer Wechselbeziehung in den Kulturen des antiken vorderen Orients,* AOAT 248 (Münster: Ugarit-Verlag), 15–23.

Mayer, W. R. and van Dijk, J. J. 1980. *Texte aus dem Rēš-Heiligtum in Uruk-Warka,* Baghdader Mitteilungen Beiheft 2 (Berlin: Gebr. Mann Verlag).

McEwan, G. J. P. 1981. "Arsacid Temple Records," *Iraq* 43, 131–43.

1981. *Priest and Temple in Hellenistic Babylonia,* Freiburger Altorientalische Studien 4 (Wiesbaden: Franz Steriner Verlag).

McMullin, E. 1988. "The Shaping of Scientific Rationality: Construction and Constraint," in E. McMullin, ed., *Construction and Constraint: The Shaping of Scientific Rationality* (Notre Dame, IN: University of Notre Dame Press), 1–47.

Meissner, B. 1925. "Über Genethlialogie bei den Babyloniern," *Klio* 19, 432–34.

Miall, D., ed. 1982. *Metaphor: Problems and Perspectives* (Brighton, England: Harvester Press).

Michalowski, P. 1987. "Charisma and Control: On Continuity and Change in Early Mesopotamian Bureauratic Systems," in McGuire Gibson and Robert D. Biggs, eds., *The Organization of Power: Aspects of Bureaucracy in the Ancient Near East*, Studies in Ancient Oriental Civilization 46 (Chicago: The Oriental Institute of the University of Chicago), 55–68.

——— 1990. "Presence at the Creation," in T. Abusch, J. Huehnergard, and P. Steinkeller, eds., *Lingering Over Words: Studies in Ancient Near Eastern Literature in Honor of William L. Moran*, Harvard Semitic Studies 37 (Atlanta, GA: Scholars Press), 381–96.

Millen, R. 1985. "The Manifestation of Occult Qualities in the Scientific Revolution," in M. J. Osler and P. L. Farber, eds., *Religion, Science and Worldview: Essays in Honor of Richard S. Westfall* (Cambridge: Cambridge University Press), 185–216.

Moren, S. 1977. "A Lost 'Omen' Tablet," *JCS* 29, 65–72.

——— 1978. "The Omen Series 'Šumma Alu': A Preliminary Investigation," Ph.D. dissertation (Philadelphia: University of Pennsylvania).

Morris, S. P. 1992. *Daidalos and the Origins of Greek Art* (Princeton, NJ: Princeton University Press).

Müller-Kessler, C. 1999. "Aramäische Beschwörungen und astronomische Omina in Nachbabylonischer Zeit. Das Fortleben Mesopotamischer Kultur im Vorderen Orient," in Johannes Renger, ed., *Babylon: Focus Mesopotamischer Geschichte Wiege Frühes Gelehrsamkeit, Mythos in der Moderne: 2. Internationales Colloquium der Deutschen Orient- Gesellschaft 24.–26. März 1998 in Berlin* (Saarbrücken: Saarbrücker Druckerie und Verlag), 427–43.

Nersessian, N. 1984. *Faraday to Einstein: Constructing Meaning in Sciencific Theories* (Dordrecht/Boston/London: Kluwer Academic).

Neugebauer, O. 1950. "The Alleged Babylonian Discovery of the Precession of the Equinoxes," *JAOS* 70, 1–8.

——— 1955. *Astronomical Cuneiform Texts*, 3 vols. (London: Lund Humphries).

——— 1963. "The Survival of Babylonian Methods in the Exact Sciences of Antiquity and the Middle Ages," *PAPS* 107, 529–35.

——— 1969. *The Exact Sciences in Antiquity*, 2nd ed. (New York: Dover).

——— 1975. *A History of Ancient Mathematical Astronomy*, 3 vols. (Berlin/Heidelberg/New York: Springer-Verlag).

——— 1983. *Astronomy and History: Selected Essays* (New York/Berlin/Heidelberg/Tokyo: Springer-Verlag).

——— 1988. "A Babylonian Lunar Ephemeris from Roman Egypt," in E. Leichty, M. deJ. Ellis, and P. Gerardi, eds., *A Scientific Humanist: Studies in Memory of Abraham Sachs*, Occasional Publications of the Samuel Noah Kramer Fund 9 (Philadelphia: Babylonian Section, University Museum), 301–4.

——— 1989. "From Assyriology to Renaissance Art," *PAPS* 133, 391–403.

Neugebauer, O. and Pingree, D. 1970–1. *The Pañcasiddhāntikā of Varāhamihira* (Copenhagen: Danske Vidensk. Selskab, Histor.-Filos. Skrifter 6,1 and 6,2).

Neugebauer, O. and Sachs, A. J. 1952–3. "The 'Dodekatemoria' in Babylonian Astrology," *AfO* 16, 65–6.

1967. "Some Atypical Astronomical Cuneiform Texts, I," *JCS* 21, 183–218.

1969. "Some Atypical Astronomical Cuneiform Texts, II," *JCS* 22, 92–111.

Neugebauer, O. and van Hoesen, H. B. 1959. *Greek Horoscopes* (Philadelphia: American Philosophical Society).

Nissen, H. J., Damerow, P., and Englund, R. 1993. *Archaic Bookkeeping: Early Writing and Techniques of Economic Administration in the Ancient Near East,* trans. Paul Larsen (Chicago/London: University of Chicago Press).

Nock, A. D. 1925. "Studies in the Greco-Roman Beliefs of the Empire," *JHS* 45, 84–101; reprinted in Z. Stewart, ed., *Arthur Darby Nock: Essays on Religion and the Ancient World* (Oxford: Clarendon, 1972), 45–8.

Offner, G. 1950. "A propos de la sauvegarde des tablettes en Assyro-Babylonie," *RA* 44, 135–43.

Olson, D. R. and Torrance, N., eds. 1996. *Modes of Thought: Explorations in Culture and Cognition* (Cambridge/New York: Cambridge University Press).

Oppenheim, A. L. 1956. *The Interpretation of Dreams in the Ancient Near East,* Transactions 46/3 (Philadelphia: American Philosophical Society).

1966. "Perspectives on Mesopotamian Divination," in *La divination en Mésopotamie ancienne et dans les régions voisines, CRRAI* 14 (Paris: Presses Universitaires de France), 35–43.

1969. "Divination and Celestial Observation in the Last Assyrian Empire," *Centaurus* 14, 97–135.

1974. "A Babylonian Diviner's Manual," *JNES* 33, 197–220.

1977. *Ancient Mesopotamia: Portrait of a Dead Civilization* (Chicago/London: University of Chicago Press, rev. edition by E. Reiner).

1978. "Man and Nature in Mesopotamian Civilization," in C. C. Gillespie, ed., *Dictionary of Scientific Biography,* Vol. 15, Supplement I (New York: Scribner's), 634–66.

Ortony, A., ed. 1979. *Metaphor and Thought* (Cambridge/New York: Cambridge University Press; 2nd ed. 1993).

Pannekoek, A. 1961. *A History of Astronomy* (New York: Dover).

Papineau, D. 1987. *Reality and Representation* (Oxford: Blackwell).

Parker, R. A. 1959. *A Vienna Demotic Papyrus on Eclipses- and Lunar-Omens* (Providence, RI: Brown University Press).

Parpola, S. 1970. *Letters from Assyrian Scholars to the Kings Esarhaddon and Assurbanipal, Part I,* AOAT 5/1 (Neukirchen-Vluyn: Verlag Butzon & Bercker Kevelaer).

1974. "A Letter from Šamaš-šumu-ukīn to Esarhaddon," *Iraq* 34, 21–34.

1983. *Letters from Assyrian Scholars to the Kings Esarhaddon and Assurbanipal, Part II: Commentary and Appendices,* AOAT 5/2 (Neukirchen-Vluyn: Verlag Butzon & Bercker Kevelaer).

1993. *Letters from Assyrian and Babylonian Scholars,* SAA 10 (Helsinki: Helsinki University Press).

1993. "Mesopotamian Astrology and Astronomy as Domains of the Mesopotamian 'Wisdom,'" in Hannes D. Galter, ed., *Die Rolle der Astronomie in den Kulturen Mesopotamiens,* Grazer Morgenlandische Studien 3 (Graz: GrazKult), 47–59.

1993. "The Assyrian Tree of Life," *JNES* 52, 161–298.

1997. *Assyrian Prophecies,* SAA 9 (Helsinki: Helsinki University Press).

Paul, S. 1973. "Heavenly Tablets and the Book of Life," *Journal of the Near Eastern Society of Columbia University* 5, 345–53.

Pearce, L. E. and Doty, L. T. 2000. "The Activities of Anu-belšunu, Seleucid Scribe," in Joachim Marzahn and Hans Neumann, eds., *Assyriologica et Semitica, Festschrift für Joachim Oelsner anläßich seines 65. Geburtstages am 18. Februar 1997,* AOAT 252 (Münster: Ugarit-Verlag), 331–41.

Pedersen, O. 1993. *Early Physics and Astronomy: A Historical Introduction,* rev. ed. (Cambridge: Cambridge University Press).

Pettinato, G. 1998. *La scrittura celeste: la nascita dell' astrologia in Mesopotamia* (Milan: Mondadori).

Pingree, D. 1963. "Astronomy and Astrology in India and Iran," *Isis* 54, 229–46.

1968. *The Thousands of Abū Ma'shar* (London: The Warburg Institute, University of London).

1973. "The Mesopotamian Origin of Early Indian Mathematical Astronomy," *JHA* 4, 1–12.

1978. "History of Mathematical Astronomy in India," in C. C. Gillespie, ed., *Dictionary of Scientific Biography,* Vol. 15, Supplement I (New York: Scribner's), 533–633.

1982. "Mesopotamian Astronomy and Astral Omens in other Civilizations," in H. Nissen and J. Renger, eds., *Mesopotamien und seine Nachbarn* (Berlin: Dietrich Reimer Verlag), 613–31.

1987. "Venus Omens in India and Babylon," in F. Rochberg-Halton, ed., *Language, Literature and History: Philological and Historical Studies Presented to Erica Reiner* (New Haven, CT: American Oriental Society), 293–316.

1992. "Hellenophilia v. The History of Science," *Isis* 83, 554–63, reprinted in Michael H. Shank, ed., *The Scientific Enterprise in Antiquity and the Middle Ages* (Chicago/London: University of Chicago Press, 2000), 30–9.

1997. *From Astral Omens to Astrology: From Babylon to Bīkāner,* Serie Orientale Roma 78 (Rome: Istituto Italiano per l'Africa e l'Oriente).

Pingree, D. and Walker, C. 1988. "A Babylonian Star Catalogue: BM 78161," in E. Leichty, M. deJ. Ellis, and P. Gerardi, eds., *A Scientific Humanist: Studies in Memory of Abraham Sachs,* Occasional Publications of the Samuel Noah Kramer Fund 9 (Philadelphia: Babylonian Section, University Museum), 313–22.

Plotinus. 1965. *The Enneads,* 2nd ed., trans. Stephen McKenna (London: Faber and Faber).

Pongratz-Leisten, B. 1999. *Herrschaftswissen in Mesopotamien,* State Archives of Assyria Studies 10 (Helsinki: University of Helsinki Press).

Pritchard, J. B. 1969. *Ancient Near Eastern Texts,* 3rd ed. (Princeton, NJ: Princeton University Press).

Quine, W.v O. 1995. *From Stimulus to Science* (Cambridge, MA/London: Harvard University Press).

Reiner, E. 1960. "Fortune-Telling in Mesopotamia," *JNES* 19, 23–35.

1961. "The Etiological Myth of the 'Seven Sages,'" *Orientalia* N.S. 30, 1–12.

1982. "A Manner of Speaking," in G.van Driel, ed., *Zikir Šumim: Assyriological Studies Presented to F. R. Kraus on the Occasion of his Seventieth Birthday,* Studia Francisci Scholten memoriae dicata 5 (Leiden: Brill), 282–9.

1983. "Babylonian Birth Prognoses," *ZA* 72, 124–38.

1985. *Your Thwarts in Pieces Your Mooring Rope Cut: Poetry from Babylon and Assyria,* Michigan Studies in the Humanities 5 (Ann Arbor, MI: University of Michigan Press).

1990. "Nocturnal Talk," in T. Abusch, J. Huehnergard, and P. Steinkeller, eds., *Lingering Over Words: Studies in Ancient Near Eastern Literature in Honor of William L. Moran* (Atlanta, GA: Scholars Press), 421–4.

1995. *Astral Magic in Babylonia*, Transactions 85/4 (Philadelphia: American Philosophical Society).

1996. "Suspendu entre ciel et terre . . . ," in H. Gasche and B. Hrouda, eds., *Collectaneo Orientalia: Histoire, arts de l'espace et industrie de la terre, etudes offertes en hommage à Agnès Spycket*, Civilisations du Proche-Orient Serie 1. Archéologie et environment 1 (Neuchâtel/Paris: Recherches et publications), 311–13.

2000. "Early Zodiologia and Related Matters," in A. R. George and I. L. Finkel, eds., *Wisdom, Gods and Literature: Studies in Assyriology in Honour of W. G. Lambert* (Winona Lake, IN: Eisenbrauns), 421–7.

2004. " Constellation into Planet," in Charles Burnett, Jan Hogendijk, K. Plofer, and M. Yano, eds., *Studies in the History of the Exact Sciences in Honour of David Pingree* Leiden: Brill), 3–15.

Reiner, E. and Pingree, D. 1978, 1981, 1998. *Babylonian Planetary Omens*, 3 Parts (Malibu, CA: Undena; and Groningen: Styx Publications).

Reisner, G. A. 1896. *Sumerisch-babylonische Hymnen nach Thontafeln griechischer Zeit*, Mittheilungen aus der orientalischen Sammlungen, Heft 10 (Berlin: W. Spemann).

Renger, J. 1967/1969. "Untersuchungen zum Priestertum der altbabylonischen Zeit," *ZA* 58, 110–88/*ZA* 59, 104–230.

Rheinberger, H.-J. 2000. "Cytoplasmic Particles: The Trajectory of a Scientific Object," in L. Daston, ed., *Biographies of Scientific Objects* (Chicago/London: University of Chicago Press), 270–94.

Rich, C. J. 1818. *Memoir on the Ruins of Babylon*, 3rd ed. (London: Longman, Hurst, Rees, Orme and Brown).

Ritter, E. K. 1965. "Magical Expert (=*Āšipu*) and Physician (=*Asû*): Notes on Two Complementary Professions in Babylonian Medicine," in *Studies in Honor of Benno Landsberger on His 75th Birthday*, Assyriological Studies 16 (Chicago and London: The University of Chicago Press), 299–321.

Roaf, M. and Zgoll, A. 2001. "Assyrian Astroglyphs: Lord Aberdeen's Black Stone and the Prisms of Esarhaddon," *ZA* 91, 264–95.

Rochberg, F. 1992. "The Culture of Ancient Science: Some Historical Reflections," *Isis* 83, 547–53, reprinted in M. H. Shank, ed., *The Scientific Enterprise in Antiquity and the Middle Ages* (Chicago/London: University of Chicago Press), 23–9.

1993. "Mesopotamian Cosmology," in N. S. Hetherington, ed., *Encyclopedia of Cosmology: Historical, Philosophical, and Scientific Foundations of Modern Cosmology* (New York/London: Garland), 398–408.

1993. "The Cultural Locus of Astronomy in Late Babylonia," in H. Galter, ed., *Die Rolle der Astronomie in den Kulturen Mesopotamiens*, Grazer Morgenländische Studien 3 (Graz: GrazKult), 31–45.

1996. "Personifications and Metaphors in Babylonian Celestial Omina," *JAOS* 116, 475–85.

1998. *Babylonian Horoscopes*, Transactions 88/1 (Philadelphia: American Philosophical Society).

1999. "Empiricism in Babylonian Omen Texts: Problems in the Classification of Mesopotamian Divination as Science," *JAOS* 119, 559–69.

1999. "Continuity and Change in Omen Literature," in B. Böck, E. Cancik-Kirschbaum and T. Richter, eds., *Munuscula Mesopotamica: Festschrift für Johannes Renger*, AOAT 267 (Münster: Ugarit-Verlag), 415–25.

1999–2000. "The Babylonian Origins of the Mandaean Book of the Zodiac," *Aram* 11–12, 237–47.

2000. "Scribes and Scholars: The *ṭupšar Enūma Anu Enlil*," in Joachim Marzahn and Hans Neumann, eds., *Assyriologica et Semitica, Festschrift für Joachim Oelsner anläßich seines 65. Geburtstages am 18. Februar 1997*, AOAT 252 (Münster: Ugarit-Verlag), 359–75.

2003. "Heaven and Earth: Divine–Human Relations in Mesopotamian Celestial Divination," in S. Noegel, J. Walker, and B. Wheeler, eds., *Prayer, Magic, and the Stars in the Ancient and Late Antique World* (University Park, PA: Pennsylvania State University Press), 169–85.

2004. "A Babylonian Rising Times Scheme in Non-Tabular Astronomical Texts," in Charles Burnett, Jan Hogendijk, K. Plofker, and M. Yano, eds., *Studies in the History of the Exact Sciences in Honour of David Pingree* (Leiden: Brill), 56–94.

Rochberg-Halton, F. 1982. "Fate and Divination in Mesopotamia," *AfO* Supplement 19, 363–71.

1984. "New Evidence for the History of Astrology," *JNES* 43, 115–40.

1984. "Canonicity in Cuneiform Texts," *JCS* 36, 127–44.

1987. "TCL 6 13: Mixed Traditions in Late Babylonian Astrology," *ZA* 77, 207–28.

1987. "Elements of the Babylonian Contribution to Hellenistic Astrology," *JAOS* 108, 51–62.

1987. "The Assumed 29th *ahû*-tablet of *Enūma Anu Enlil*, "in F. Rochberg-Halton, ed., *Language, Literature and History: Philological and Historical Studies Presented to Erica Reiner*, American Oriental Series 67 (New Haven, CT: American Oriental Society), 327–50.

1988. *Aspects of Babylonian Celestial Divination: The Lunar Eclipse Tablets of Enūma Anu Enlil, AfO* Supplement 22 (Horn, Austria: Ferdinand Berger & Söhne).

1989. "Babylonian Horoscopes and Their Sources," *Orientalia* N. S. 58, 102–23.

1989. "Babylonian Seasonal Hours," *Centaurus* 32, 146–70.

1991. "The Babylonian Astronomical Diaries," *JAOS* 111, 323–31.

1991. "Between Observation and Theory in Babylonian Astronomical Texts," *JNES* 50, 109–11.

Rorty, R. 1979. *Philosophy and the Mirror of Nature* (Ithaca, NY: Cornell University Press).

Roth, M. T. 1988. "ina amat DN₁u DN₂ lišlim," *Journal of Semitic Studies* 33, 1–9.

Rouse, J. 1991. "Philosophy of Science and the Persistent Narratives of Modernity," *Studies in History and Philosophy of Science* 22, 141–62.

Ruby, J. E. 1995. "Origins of Scientific 'Law,'" in Friedel Weinert, ed., *Laws of Nature: Essays on the Philosophical, Scientific and Historical Dimensions* (Berlin/New York: de Gruyter), 289–315.

Sachs, A. J. 1948. "A Classification of the Babylonian Astronomical Tablets of the Seleucid Period," *JCS* 2, 271–90.

1952. "A Late Babylonian Star Catalog," *JCS* 6, 146–50.

1952. "Babylonian Horoscopes," *JCS* 6, 49–74.

with the co-operation of J. Schaumberger, 1955. *Late Babylonian Astronomical and Related Texts*, copied by T. G. Pinches and J. N. Strassmaier (Providence, RI: Brown University Press).

1974. "Babylonian Observational Astronomy," in F. Hodson, ed., *The Place of Astronomy in the Ancient World* (London: Philosophical Transactions of the Royal Society 276), 43–50.

1976. "The Latest Datable Cuneiform Tablets," in Barry L. Eichler, ed., *Kramer Anniversary Volume. Cuneiform Studies in Honor of Samuel Noah Kramer*, AOAT 25 (Neukirchen-Vluyn: Verlag Butzon & Bercker Kevelaer), 379–98.

Sachs, A. J. and Hunger, H. 1988–2001. *Astronomical Diaries and Related Texts from Babylonia*, 5 vols. (Vienna: Verlag der Österreichischen Akademie der Wissenschaften).

Saggs, H. W. F. 1978. *The Encounter with the Divine in Mesopotamia and Israel* (London: Athlone).

Sahlins, M. 1995. *How "Natives" Think: About Captain Cook, For Example* (Chicago/London: University of Chicago Press).

Salmon, W. C. 1998. *Causality and Explanation* (New York/Oxford: Oxford University Press).

Sambursky, S. 1959. *Physics of the Stoics* (London: Routledge and Kegan Paul).

Schaumberger, J. 1935. Ergänzungsheft 3 to Kugler, *SSB* (Münster: Aschendorff).

1952. "Die Ziqpu-Gestirne nach neuen Keilschrifttexten," *ZA* 50, 214–29.

Scurlock, J. 1999. "Physician, Exorcist, Conjurer, Magician: A Tale of Two Healing Professionals," in Tzvi Abusch and Karel van der Toorn, eds., *Mesopotamian Magic: Textual, Historical, and Interpretative Perspectives* (Groningen: Styx Publications), 69–79.

Searle, J. R. 1993. "Metaphor," in A. Ortony, ed., *Metaphor and Thought*, 2nd ed. (Cambridge/New York: Cambridge University Press), 83–111.

Segal, A. F. 1981. "Hellenistic Magic: Some Questions of Definition," in R. Van den Broek and M. J. Vermaseren, eds., *Studies in Gnosticism and Hellenistic Religions Presented to Gilles Quispel on the Occasion of His 65th Birthday* (Leiden: Brill), 349–75.

Seidl, U. 2001. "Das Ringen um das richtige Bild des Šamaš von Sippar," *ZA* 91, 120–32.

Sherwin-White, S. and Kuhrt, A. 1993. *From Samarkhand to Sardis: A New Approach to the Seleucid Empire* (Berkeley, CA/Los Angeles: University of California Press).

Sjöberg, Å. and Bergmann, E. 1969. *The Collection of the Sumerian Temple Hymns*, Texts from Cuneiform Sources 3 (Locust Valley, NY: J. J. Augustin).

Skorupski, J. 1976. *Symbol and Theory: A Philosophical Study of Theories of Religion in Social Anthropology* (Cambridge: Cambridge University Press).

Slotsky, A. 1993. "The Uruk Scheme Revisited," in H. Galter, ed., *Die Rolle der Astronomie in den Kulturen Mesopotamiens* (Graz: Beiträge zum 3. Grazer Morgenländischen Symposion, Grazer Morgenländische Studien 3), 359–66.

Smith, S. 1924. *Babylonian Historical Texts* (London: Methuen).

Smoller, L. A. 1994. *History, Prophecy, and the Stars: The Christian Astrology of Pierre d'Ailly, 1350–1420* (Princeton, NJ: Princeton University Press).

Solmsen, F. 1960. *Aristotle's System of the Physical World* (Ithaca, NY: Cornell University Press).

Speiser, E. A. 1967. "Ancient Mesopotamia," in Robert C. Dentan, ed., *The Idea of History in the Ancient Near East* 4th ed. (New Haven, CT: Yale University Press), 37–76.

Sperber, D. 1982. *On Anthropological Knowledge: Three Essays* (Cambridge/London/ New York: Cambridge University Press).

Starr, I. 1983. *The Rituals of the Diviner*, Bibliotheca Mesopotamica 12 (Malibu, CA: Undena).

——— 1990. *Queries to the Sungod: Divination and Politics in Sargonid Assyria*, SAA 4 (Helsinki: Helsinki University Press).

Steele, J. M. 2000. "A 3405: An Unusual Astronomical Text from Uruk," *Archive for History of Exact Sciences* 55, 103–35.

——— 2000. "Eclipse Prediction in Mesopotamia," *Archive for History of Exact Sciences* 54, 421–54.

——— 2000. *Observations and Predictions of Eclipse Times by Early Astronomers* (Dordrecht/Boston/London: Kluwer Academic).

——— 2001–2. "The Meaning of BAR DIB in Late Babylonian Astronomical Texts," *AfO* 48/49, 107–12.

——— 2002. J. M. Steele and A. Imhausen, eds., *Under One Sky: Astronomy and Mathematics in the Ancient Near East*, AOAT 297 (Münster: Ugarit-Verlag).

——— 2003. "Planetary Latitudes in Babylonian Mathematical Astronomy," *JHA* 34, 1–21.

Steele, J. M and Stephenson, F. R. 1997. "Lunar Eclipse Times Predicted by the Babylonians," *JHA* 28, 119–31.

Stol, M. 1992. "The Moon as Seen by the Babylonians," in D. J. W. Meijer, ed., *Natural Phenomena: Their Meaning, Depiction and Description in the Ancient Near East* (Amsterdam/Oxford/New York/Tokyo: Koninklijke Nederlandse Akademie van Wetenschappen Verhandelingen, Afd. Letterkunde, Nieuwe Reeks, deel 152), 245–77.

Streck, K. M. 1916. *Assurbanipal und die letzten assyrische Könige bis zum untergange Nineveh's* (Leipzig: J. C. Hinrichs), Vol. 2.

Swerdlow, N. M. 1993. "Montucla's Legacy: The History of the Exact Sciences," *Journal of the History of Ideas* 54, 299–328.

——— 1998. *The Babylonian Theory of the Planets* (Princeton, NJ: Princeton University Press).

——— ed. 1999. *Ancient Astronomy and Celestial Divination* (Cambridge, MA/London: MIT Press).

——— 1999. "The Derivation of the Parameters of Babylonian Planetary Theory with Time as the Principal Independent Variable," in N. M. Swerdlow, ed., *Ancient Astronomy and Celestial Divination* (Cambridge, MA/London: MIT Press), 255–98.

Tallqvist, K.1938. *Akkadische Götterepitheta* (Helsinki: Studia Orientalia edidit Societas Orientalis Fennica VII; reprinted Hildesheim: Georg Olms Verlag, 1974).

Tambiah, S. J. 1985. *Culture, Thought, and Social Action: An Anthropological Perspective* (Cambridge, MA: Harvard University Press).

Tester, S. J. 1987. *A History of Western Astrology* (Woodbridge, Suffolk, England: Boydell).

Thompson, R. C. 1923. *Assyrian Medical Texts From the Originals in the British Museum* (London: H. Milford, Oxford University Press).

——— 1930. *The Epic of Gilgamesh: Text, Transliteration, and Notes* (Oxford: Clarendon).

Toomer, G. J. 1984. *Ptolemy's Almagest* (New York/Berlin/Heidelberg/Tokyo: Springer-Verlag).

——— 1988. "Hipparchus and Babylonian Astronomy," in E. Leichty, M. deJ. Ellis, and P. Gerardi, eds., *A Scientific Humanist: Studies in Memory of Abraham Sachs*,

Occasional Publications of the Samuel Noah Kramer Fund 9 (Philadelphia: Babylonian Section, University Museum), 353–62.

Trigger, B. 1989. *A History of Archaeological Thought* (Cambridge: Cambridge University Press).

Unger, E. 1931. *Babylon: Die heilige Stadt nach der Beschreibung der Babylonier* (Berlin: de Gruyter; reprinted 1970).

Ungnad, A. 1941–4. "Besprechungskunst und Astrologie in Babylonien," *AfO* 14, 251–84.

van der Spek, R. J. 1985. "The Babylonian Temple During the Macedonian and Parthian Domination," *BiOr* 42, 542–62.

1987. "The Babylonian City," in A. Kuhrt and S. Sherwin-White, eds., *Hellenism in the East* (Berkeley, CA/Los Angeles: University of California Press), 57–74.

1992. "Nippur, Sippar, and Larsa in the Hellenistic Period," in M. De Jong Ellis, ed., *Nippur at the Centennial*, Occasional Publications of the Samuel Noah Kramer Fund 14 (Philadelphia: Babylonian Section, University Museum), 235–60.

1993. "The Astronomical Diaries as a Source for Achaemenid History," *BiOr* 50, 91–101.

van der Waerden, B. L. 1941. " Zur babylonischen Planetenrechnung," *Eudemus* 1, 23–48.

1949. "Babylonian Astronomy II. The Thirty-Six Stars," *JNES* 8, 6–26.

with contributions by Peter Huber. 1974. *Science Awakening II. The Birth of Astronomy* (Leiden: Noordhoff International Publishing; New York: Oxford University Press).

van Dijk, J. A. and Mayer, W. R. 1980. *Texte aus der Rēš-Heiligtum in Uruk-Warka*, Baghdader Mitteilungen Beiheft 2 (Berlin).

van Driel, G. 1969. *The Cult of Aššur* (Assen:Van Gorcum and Comp. N. V.-Dr. H. J. Prakke and H. M. G. Prakke).

van Soldt, W. H. 1995. *Solar Omens of Enuma Anu Enlil: Tablets 23 (24)-29 (30)* (Leiden: Nederlands Historisch-Archaeologisch Instituut Te Istanbul).

Veldhuis, N. 1997. "Elementary Education at Nippur: The Lists of Trees and Wooden Objects," Ph.D. dissertation (Groningen: Rijksuniversiteit Groningen).

1998. "TIN.TIR = Babylon, The Question of Canonization," *JCS* 50, 77–85.

Verderame, L. 2002. *Le Tavole I–VI della serie astrologica Enūma Anu Enlil*, Nisaba 2 (Messina: Dipartimento di science dell'antichità, Università di Messina).

Versnel, H. S. 1991. "Some Reflections on the Relationship Magic–Religion," *Numen* 38, 177–97.

Vickers, B. 1984. "Analogy versus Identity: The Rejection of Occult Symbolism, 1580–1680," in Brian Vickers, ed., *Occult and Scientific Mentalities in the Renaissance* (Cambridge/New York: Cambridge University Press; reprinted 1986), 95–163.

1988. "On the Function of Analogy in the Occult," in Ingrid Merkel and Allen G. Debus, eds., *Hermeticism and the Renaissance: Intellectual History and the Occult in Early Modern Europe* (Washington: Folger Shakespeare Library; and London and Toronto: Associated University Presses), 265–92.

Vickery, J. B. 1973. *The Literary Impact of* The Golden Bough (Princeton, NJ: Princeton University Press).

Virolleaud, C. 1905–12. *L'astrologie chaldéenne, le livre intitulé "enuma (Anu)^{ilu} Bêl"*, publié, transcrit et traduit, fascicules 1–14 (Paris: P. Geuthner).

Walker, C. B. F. 1995. "The Dalbanna Text: A Mesopotamian Star-List," *WO* 26, 27–42.

ed. 1996. *Astronomy Before the Telescope* (London: British Museum Press).

Walker, C. B. F. and Hunger, H. 1977. "Zwölfmaldrei," *MDOG* 109, 27–34.

Wartofsky, M. 1968. *Conceptual Foundations of Scientific Thought: An Introduction to the Philosophy of Science* (London: Macmillan).

Weidner, E. F. 1915. *Handbuch der Astronomie* (Leipzig: J. C. Hinrichs; reprinted 1976), Vol. 1.

1941–4. "Die astrologische Serie Enûma Anu Enlil," *AfO* 14, 172–95, 308–18.

1954–6. "Die astrologische Serie Enûma Anu Enlil," *AfO* 17, 71–89.

1959–60. "Ein astrologischer Sammeltext aus der Sargonidenzeit," *AfO* 19, 105–13.

1963. "Astrologische Geographie im Alten Orient," *AfO* 20, 117–21.

1967. *Gestirn-Darstellungen auf babylonischen Tontafeln* (Graz: Hermann Böhlaus Nachf., Österreichische Akademie der Wissenschaften, Philos.-histor. Kl., S. B. 254, 2).

1968–9. "Die astrologische Serie Enûma Anu Enlil," *AfO* 22, 65–75.

Weisberg, D. B. 1969–70. "An Old Babylonian Forerunner to Šumma Ālu," *HUCA* 40, 87–104.

West, M. L. 1997. *The East Face of Helicon: West Asiatic Elements in Greek Poetry and Myth* (Oxford: Clarendon).

Westbrook, R. 2000. "Codification and Canonization," in E. Lévy, ed., *La codification des lois dans l'antiquité*, Travaux du centre de recherche sur le Proche-Orient et la Grèce Antiques 16 (Université Marc Bloch de Strasbourg), 33–47.

Wetzel, F. 1957. *Das Babylon der Spätzeit*, Wissenschaftliche Veröffentlichung der Orient-Gesellschaft 62 (Berlin: Gebr. Mann).

Wiggermann, F. 1992. "Mythological Foundations of Nature," in Diederik J. W. Meijer, ed., *Natural Phenomena: Their Meaning, Depiction and Description in the Ancient Near East* (Amsterdam/Oxford/New York/Tokyo: Koninklijke Nederlandse Akademie van Wetenschappen Verhandelingen, Afd. Letterkunde, Nieuwe Reeks, deel 152), 279–306.

Williams, M. 1999. *Groundless Belief: An Essay of the Possibility of Epistemology* (Princeton, NJ: Princeton University Press).

Wilson, B. R. 1970. *Rationality* (Oxford: Blackwell).

Zimmern, H. 1901. *Beiträge zur Kenntnis der Babylonischen Religion* (Leipzig: J .C. Hinrichs).

1928. "Šimat, sīma, Tychē, Manat," *Islamica* 2, 574–84.

NAME INDEX

Akkadian Personal Names

SUBJECT INDEX